Video Basics

Herbert Zettl

San Francisco State University

Wadsworth Publishing Company

I(T)P™ An International Thomson Publishing Company

Belmont ■ Albany ■ Bonn ■ Boston ■ Cincinnati ■ Detroit ■ London ■ Madrid ■ Melbourne
Mexico City ■ New York ■ Paris ■ San Francisco ■ Singapore ■ Tokyo ■ Toronto ■ Washington

Communications Editor: Katherine Hartlove
Editorial Assistant: Janet Hansen
Production Services Coordinator: Gary Mcdonald
Production: Ideas to Images
Designer and Art Director: Gary Palmatier
Print Buyer: Diana Spence
Permissions Editor: Robert Kauser
Copy Editor: Kim Saccio
Technical Illustrator: Ideas to Images
Cover Designer: Gary Palmatier, Ideas to Images
Cover Photographers: Lara Hartley and Herbert Zettl
Compositor: Ideas to Images
Printer: Quebecor Printing/Hawkins

The audio signature used on the cover and title page of this book represent the spoken words *Video Basics* as they are digitally represented in Adobe Premiere, a nonlinear video editing program.

The photo credits shown on page 382 of this book are an extension of this copyright page.

The company Image and Imagination, Inc., or Triple-I, is entirely fictitious, and any resemblance to an actual video studio is unintended.

Wadsworth Publishing Company
10 Davis Drive
Belmont, California 94002
USA

International Thomson Publishing Europe
Berkshire House 168-173
High Holborn
London, WC1V7AA
England

Thomas Nelson Australia
102 Dodds Street
South Melbourne 3205
Victoria, Australia

Nelson Canada
1120 Birchmount Road
Scarborough, Ontario
Canada M1K 5G4

International Thomson Editores
Campos Eliseos 385, Piso 7
Col. Polanco
11560 México D.F. México

International Thomson Publishing GmbH
Königswinterer Strasse 418
53227 Bonn
Germany

International Thomson Publishing Asia
221 Henderson Road
#05-10 Henderson Building
Singapore 0315

International Thomson Publishing Japan
Hirakawacho Kyowa Building, 3F
2-2-1 Hirakawacho
Chiyoda-ku, Tokyo 102
Japan

Library of Congress Cataloguing-in-Publication Data
Zettl, Herbert.
 Video basics / Herbert Zettl.
 p. cm.
 Includes bibliographical references and index.
 ISBN 0-534-24786-5
 1. Television cameras. 2. Cinematography. 3. Television–
–Production and direction. I. Title.
TR882.5.Z48 1994
778.59—dc20 94-24487
 CIP

Dedication

To Rebecca Hayden
Publisher and Artist

About the Author

Herbert Zettl is a professor of Broadcast Communication Arts at San Francisco State University, where he teaches in the areas of television production and media aesthetics. Prior to joining the SFSU faculty, he worked at KOVR (Sacramento-Stockton) and as a producer-director at KPIX, the CBS affiliate in San Francisco. He participated in a variety of CBS and NBC network television productions. He has been a consultant on television production and media aesthetics for universities and professional broadcasting operations here and abroad, and is currently engaged in various experimental television productions.

Zettl's other books include the *Television Production Handbook* and *Sight-Sound-Motion: Applied Media Aesthetics*, both of which have been translated into other languages. His numerous articles on television production and media aesthetics have appeared in major media journals in this country as well as Europe and Asia. He has read key papers on television production and media aesthetics at a variety of communication conventions.

Preface

VIDEO BASICS is designed to help you generate worthwhile ideas and show you ways to translate these ideas into effective video messages. I have come to realize that simply adding new technologies and production techniques to an existing text engenders too complex a learning task for the video production novice. To meet today's and tomorrow's video production demands, I had to rethink the principal objectives and meet them in ways that are easily accessible and manageable within realistic time limits. *Video Basics* is not a simple digest of my comprehensive *Television Production Handbook,* fifth edition; it is a new book that selects and combines the key elements of the video production process and its people, its production tools and their use, and its aesthetic factors. I hope that my focus on the *basics* of video will not lead you to think that video production is easy; rather, I hope it will help you learn the process as painlessly as possible.

DEVELOPING *VIDEO BASICS*

Here are some of the key ideas that guided me in developing this book:

Video

Video is used throughout this text as a more inclusive term than *television.* Many of today's productions are done outside the traditional television station environment, for nonbroadcast purposes. *Video,* then, is not meant to distinguish commercial from noncommercial, or highly artistic creations from routine programs. It encompasses the full range of today's electronically delivered moving images.

Basics

This book covers tools, concepts, and activities essential for you to get started in video production without any prior knowledge of the field. The principal ideas are highlighted throughout the text as "Key Concepts."

Content

Part I of *Video Basics* takes a look at production processes and people and at how to generate ideas. *Part II* deals with the tools necessary to create effective video images and sound. *Part III* concentrates on video recording and editing devices and processes. Finally, *Part IV* discusses talent and the studio and field production environments.

Approach

All too often, enthusiastic newcomers to video production forget that manipulating equipment is less important than having something important to say. To show you that significant ideas and efficient production processes must precede the use of tools for their encoding, *Video Basics* takes you from idea and production process to the tools and techniques necessary to bring about the production and, finally, to the production environment and the talent who perform in it.

Digital and Synthetic Images

Digital technology is no longer an add-on; it is an integral part of video production technology and processes. Digital processes, such as nonlinear editing and desktop video, are discussed wherever appropriate. Video images are no longer dependent on the video camera but can be computer-generated as well. Such synthetic image creation is mentioned in the sections on special effects, interactive video, multimedia, and virtual reality. Even if you have no immediate access to synthetic image making, you need to be aware of such practices so that you can be comfortable and competitive in the various fields of today's video production.

Aesthetics

Because *Video Basics* is designed as a well-rounded learning tool, the aesthetic principles of video production are extensively featured throughout this text. This aesthetic emphasis should help you understand not only *how* to achieve a specific video or audio effect, but also *why*.

Support Materials

To expand upon the concepts presented in *Video Basics*, I have developed the *Video Basics Workbook*. This workbook is designed to test your knowledge of the basics of video production and strengthen your knowledge and skills in this field. Also available is *Video Producer: A Video Production Lab*, an interactive CD-ROM title that will give you the feel of hands-on experience. To get your copy of the *Video Basics Workbook* or *Video Producer: A Video Production Lab*, please visit your local bookseller.

A GUIDE TO LEARNING WITH VIDEO BASICS

Here are examples of some of the key features of *Video Basics* that may help you understand and apply the various elements of video production:

Production Model

The effect-to-cause production model, introduced early on, is designed to make video production maximally effective and efficient. It also serves as a tool for the evaluation of various production steps.

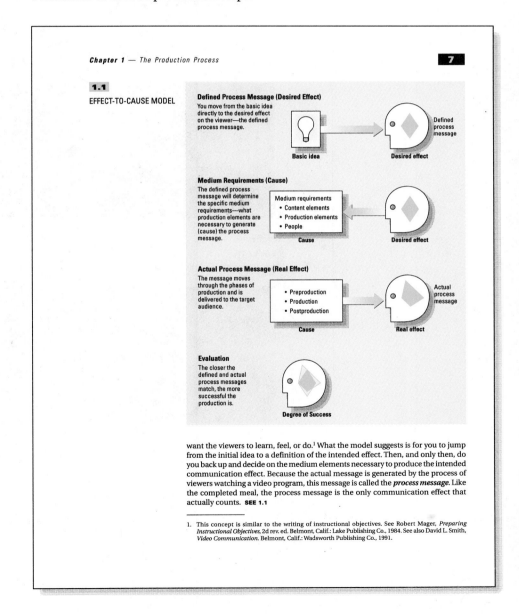

Chapter 1 — The Production Process **7**

1.1

EFFECT-TO-CAUSE MODEL

Defined Process Message (Desired Effect)
You move from the basic idea directly to the desired effect on the viewer—the defined process message.

Basic idea Desired effect Defined process message

Medium Requirements (Cause)
The defined process message will determine the specific medium requirements—what production elements are necessary to generate (cause) the process message.

Medium requirements
• Content elements
• Production elements
• People

Cause Desired effect

Actual Process Message (Real Effect)
The message moves through the phases of production and is delivered to the target audience.

• Preproduction
• Production
• Postproduction

Cause Real effect Actual process message

Evaluation
The closer the defined and actual process messages match, the more successful the production is.

Degree of Success

want the viewers to learn, feel, or do.[1] What the model suggests is for you to jump from the initial idea to a definition of the intended effect. Then, and only then, do you back up and decide on the medium elements necessary to produce the intended communication effect. Because the actual message is generated by the process of viewers watching a video program, this message is called the ***process message***. Like the completed meal, the process message is the only communication effect that actually counts. **SEE 1.1**

1. This concept is similar to the writing of instructional objectives. See Robert Mager, *Preparing Instructional Objectives,* 2d rev. ed. Belmont, Calif.: Lake Publishing Co., 1984. See also David L. Smith, *Video Communication.* Belmont, Calif.: Wadsworth Publishing Co., 1991.

Computers

The role of the computer and other digital video and audio equipment, such as desktop video, is stressed throughout the text. The creation of synthetic (noncamera) video and audio by the computer, and the various aspects of virtual reality, have become an important aspect of video production and are, therefore, discussed in addition to more traditional production methods.

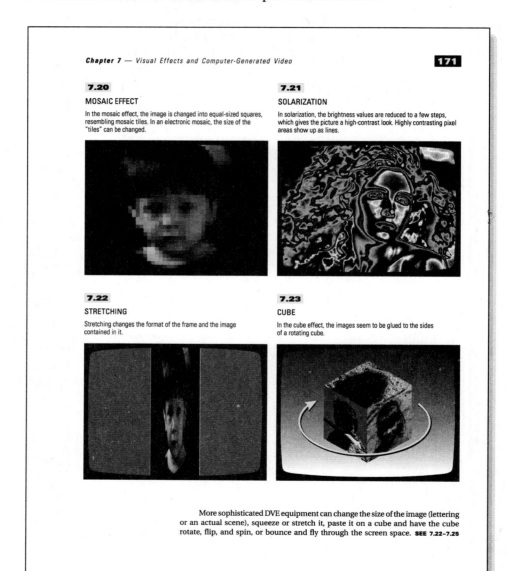

Chapter 7 — *Visual Effects and Computer-Generated Video*

171

7.20

MOSAIC EFFECT

In the mosaic effect, the image is changed into equal-sized squares, resembling mosaic tiles. In an electronic mosaic, the size of the "tiles" can be changed.

7.21

SOLARIZATION

In solarization, the brightness values are reduced to a few steps, which gives the picture a high-contrast look. Highly contrasting pixel areas show up as lines.

7.22

STRETCHING

Stretching changes the format of the frame and the image contained in it.

7.23

CUBE

In the cube effect, the images seem to be glued to the sides of a rotating cube.

More sophisticated DVE equipment can change the size of the image (lettering or an actual scene), squeeze or stretch it, paste it on a cube and have the cube rotate, flip, and spin, or bounce and fly through the screen space. **SEE 7.22–7.25**

Multimedia and CD-ROM

More and more video production is done not just for on-the-air or cable transmission to a mass audience, but for the creation of CD-ROM multimedia programs, distributed to highly select audiences. These processes are introduced where appropriate.

Studio and Field Productions

Modern television requires us to move freely between multicamera studio and single-camera field productions. Both production techniques are integrated throughout this book.

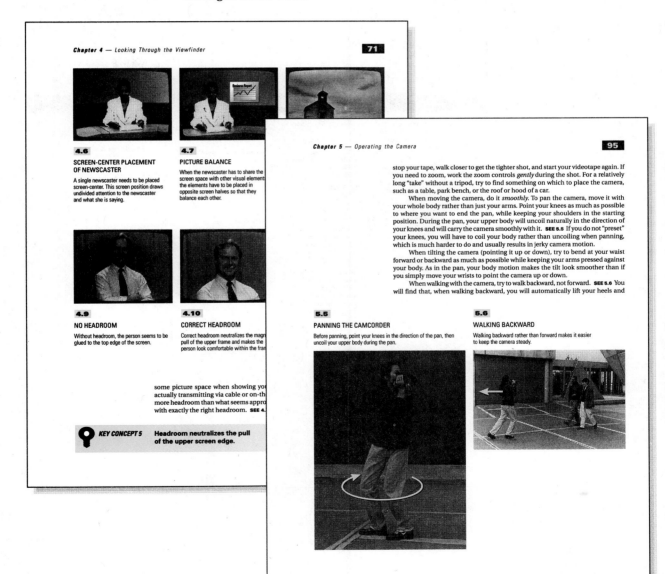

Chapter 4 — Looking Through the Viewfinder 71

4.6
SCREEN-CENTER PLACEMENT OF NEWSCASTER
A single newscaster needs to be placed screen-center. This screen position draws undivided attention to the newscaster and what she is saying.

4.7
PICTURE BALANCE
When the newscaster has to share the screen space with other visual elements the elements have to be placed in opposite screen halves so that they balance each other.

4.9
NO HEADROOM
Without headroom, the person seems to be glued to the top edge of the screen.

4.10
CORRECT HEADROOM
Correct headroom neutralizes the magn pull of the upper frame and makes the person look comfortable within the fra

some picture space when showing yo
actually transmitting via cable or on-th
more headroom than what seems appro
with exactly the right headroom. **SEE 4.**

KEY CONCEPT 5 Headroom neutralizes the pull of the upper screen edge.

Chapter 5 — Operating the Camera 95

stop your tape, walk closer to get the tighter shot, and start your videotape again. If you need to zoom, work the zoom controls *gently* during the shot. For a relatively long "take" without a tripod, try to find something on which to place the camera, such as a table, park bench, or the roof or hood of a car.

When moving the camera, do it *smoothly*. To pan the camera, move it with your whole body rather than just your arms. Point your knees as much as possible to where you want to end the pan, while keeping your shoulders in the starting position. During the pan, your upper body will uncoil naturally in the direction of your knees and will carry the camera smoothly with it. **SEE 5.5** If you do not "preset" your knees, you will have to coil your body rather than uncoiling when panning, which is much harder to do and usually results in jerky camera motion.

When tilting the camera (pointing it up or down), try to bend at your waist forward or backward as much as possible while keeping your arms pressed against your body. As in the pan, your body motion makes the tilt look smoother than if you simply move your wrists to point the camera up or down.

When walking with the camera, try to walk backward, not forward. **SEE 5.6** You will find that, when walking backward, you will automatically lift your heels and

5.5
PANNING THE CAMCORDER
Before panning, point your knees in the direction of the pan, then uncoil your upper body during the pan.

5.6
WALKING BACKWARD
Walking backward rather than forward makes it easier to keep the camera steady.

Key Terms

The key terms used in each chapter appear at the beginning of the chapter and reappear as part of the glossary. They are intended to prepare you for the terminology in each chapter and serve as a quick reference as needed. Words listed in the key terms are usually ***boldfaced*** whenever they first appear in the text.

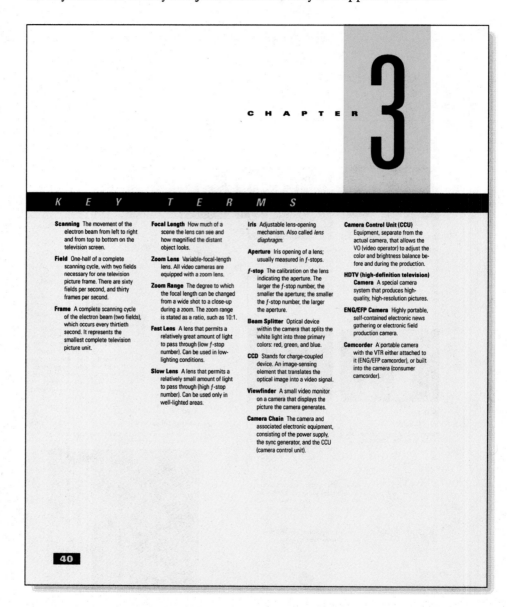

C H A P T E R **3**

K E Y T E R M S

Scanning The movement of the electron beam from left to right and from top to bottom on the television screen.

Field One-half of a complete scanning cycle, with two fields necessary for one television picture frame. There are sixty fields per second, and thirty frames per second.

Frame A complete scanning cycle of the electron beam (two fields), which occurs every thirtieth second. It represents the smallest complete television picture unit.

Focal Length How much of a scene the lens can see and how magnified the distant object looks.

Zoom Lens Variable-focal-length lens. All video cameras are equipped with a zoom lens.

Zoom Range The degree to which the focal length can be changed from a wide shot to a close-up during a zoom. The zoom range is stated as a ratio, such as 10:1.

Fast Lens A lens that permits a relatively great amount of light to pass through (low *f*-stop number). Can be used in low-lighting conditions.

Slow Lens A lens that permits a relatively small amount of light to pass through (high *f*-stop number). Can be used only in well-lighted areas.

Iris Adjustable lens-opening mechanism. Also called *lens diaphragm.*

Aperture Iris opening of a lens; usually measured in *f*-stops.

ƒ-stop The calibration on the lens indicating the aperture. The larger the *f*-stop number, the smaller the aperture; the smaller the *f*-stop number, the larger the aperture.

Beam Splitter Optical device within the camera that splits the white light into three primary colors: red, green, and blue.

CCD Stands for charge-coupled device. An image-sensing element that translates the optical image into a video signal.

Viewfinder A small video monitor on a camera that displays the picture the camera generates.

Camera Chain The camera and associated electronic equipment, consisting of the power supply, the sync generator, and the CCU (camera control unit).

Camera Control Unit (CCU) Equipment, separate from the actual camera, that allows the VO (video operator) to adjust the color and brightness balance before and during the production.

HDTV (high-definition television) Camera A special camera system that produces high-quality, high-resolution pictures.

ENG/EFP Camera Highly portable, self-contained electronic news gathering or electronic field production camera.

Camcorder A portable camera with the VTR either attached to it (ENG/EFP camcorder), or built into the camera (consumer camcorder).

Key Concepts

The key concepts are intended to help you focus on and remember the major ideas and issues in each chapter. They should also aid you in seeing and making connections between communication purpose, people, equipment, and various production processes.

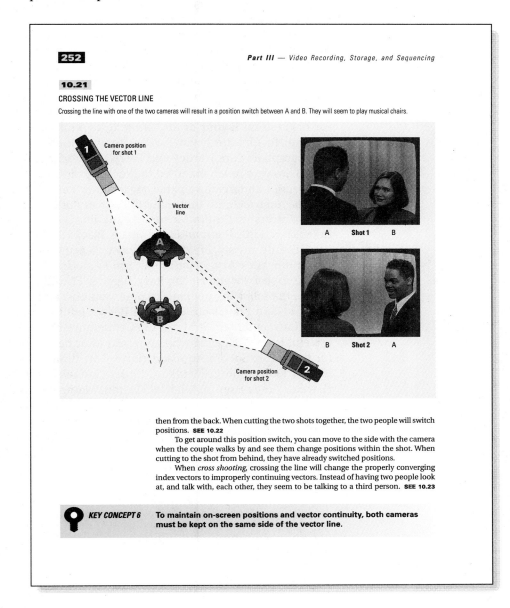

10.21

CROSSING THE VECTOR LINE

Crossing the line with one of the two cameras will result in a position switch between A and B. They will seem to play musical chairs.

then from the back. When cutting the two shots together, the two people will switch positions. **SEE 10.22**

To get around this position switch, you can move to the side with the camera when the couple walks by and see them change positions within the shot. When cutting to the shot from behind, they have already switched positions.

When *cross shooting*, crossing the line will change the properly converging index vectors to improperly continuing vectors. Instead of having two people look at, and talk with, each other, they seem to be talking to a third person. **SEE 10.23**

KEY CONCEPT 6 **To maintain on-screen positions and vector continuity, both cameras must be kept on the same side of the vector line.**

ACKNOWLEDGMENTS

Such a book cannot be written without the generous help of many knowlegable people. Before thanking all of them, however, I would like to express my deep gratitude to Rebecca Hayden, formerly publisher with Wadsworth, and now consulting publisher, who not only had the vision for such a new book, but the dedication, persistence, and sense of humor to help me get it done. Again, thank you, Becky! As usual, she was ably supported by a very talented Wadsworth publishing team. I am indebted to John Boykin, development editor; Katherine Hartlove, communication editor; Joshua King, editorial assistant; Gary Mcdonald, production services coordinator; and Amy Satran, multimedia development manager. Also, special thanks to Gary Palmatier of Ideas to Images for his expertise in designing the book and directing the illustrations; to Robaire Ream for his tasteful layout of art and text; to Kim Saccio for her thoughtful copy editing; to Elizabeth von Radics for her meticulous proofreading; and to photographers Lara Hartley and Larry Mannheimer for their fine pictures.

I am very much indebted to the video production experts who reviewed the manuscript and made valuable suggestions: Peter R. Gershon, University of West Florida; August Grant, University of Texas at Austin; Gary W. Larson, North Dakota State University; Danita McAnally, Amarillo College; Collin Pillow, University of Arkansas at Little Rock; and John Walsh, Black Hills State University, South Dakota.

Finally, my sincere thanks to my colleagues in the Broadcast and Electronic Communication Arts Department, San Francisco State University—John Barsotti, Ron Compesi, Joshua Hecht, Jerry Higgins, Hamid Khani, and Winston Tharp, as well as the following people and organizations: Phil Arnone and Ed Cosci, KTVU, Oakland–San Francisco; and John Beebe, Jeff Caton, Jeff Katzman, Jeff Larsen, Chris Pitts, and Marc Straka of the Cooperative Media Group, San Francisco. I am grateful to the following who appeared in or helped with new photographs shot for this book: Socoro Aquilar-Uriarte, Lori Branson-Malm, Adrian De Michele, Robert Dousa, Serge Fiankan, Emily Gonzales, Alicia Leona Goodwin, Lesa Herrera, Tanya Hordin, Michael Huston, Mathew David Johnson, Olivia Jungius, Pai-Ya Kuo, Denise Lawrence, Jeffrey Morris, Michelle Morton, Amy Mou, Luis Nachbin, Jun Otsuki, Renée Palmatier, Angela Rigg, Paul Sanguinetti, David Saykin, Matt Selinger, Elizabeth Ulrich, Andrew Wright, and Tiffany Yeh.

My wife, Erika, gets my ongoing admiration for her patience, encouragement, and advice on how to get through tough writing spots.

H.Z.

Contents

PART II
Image Creation and Control 37

PART III
Video Recording, Storage, and Sequencing 212

PART

I

C O N T E N T S

The Production Process

The Production Team: Who Does What When?

Production Processes and People

CONGRATULATIONS! You have just been invited for an interview by Image and Imagination, Inc., a small but highly respected independent video production company. The company, known as Triple-I, is looking for a few interns who are "creative and who are willing to learn how to use their creativity within an exceptionally efficient and effective production process." The company specializes in producing a variety of corporate video programs, such as instructional and promotional videotapes, and general commercials that range from advertising breakfast cereals to political candidates. It has also produced several award-winning MTV programs. Your invitation letter includes some sample interview questions: "How would you move from the initial program idea to the finished video production? What specific production steps would you recommend? Why? How could you make this production process maximally efficient and effective?" Obviously, these questions could have been asked just as well by the program or production manager of a large local or network television station.

Take a few minutes and think about how you would answer these questions. As you will discover, these seemingly simple questions are surprisingly difficult to answer. What follows will give you some suggestions on how to move from the initial idea to the finished production; and it will show you how to do it in a systematic way with a minimum of wasted effort and time.

Preproduction Preparation of all production details.

Production The actual activities in which an event is videotaped and/or televised.

Postproduction Any production activity that occurs after the production. Usually refers to either videotape editing or audio sweetening.

Process Message The message actually received by the viewer in the process of watching a video program.

Defined Process Message The desired effect of the program on the viewer.

Medium Requirements All personnel, equipment, and facilities needed for a production, as well as budgets, schedules, and the various production phases.

Actual Process Message The real effect of the program on the viewer.

The Production Process

WHEN **watching old movies** in which a producer appears, you may get the idea that producers always smoke cigars, never take off their hats, and that their main job is to quarrel with writers about ideas and with stars about money. This image of producers and their activities couldn't be farther from the truth. Today's producers seldom smoke cigars or wear hats, and their main concerns are not in arguing with star performers, but rather in coordinating a great many production details.

One minute, as a producer, you may argue with the writer about the script; the next, you may be busy trying to find a reasonable sanitary service to deliver portable facilities for the on-location cast and crew. Both activities are equally important in the production process. The head of the Triple-I production company tells you that a good producer is not the one who comes up once in a great while with some grand idea, but the one who works diligently and leaves nothing to chance. A good producer is a stickler for detail. Even if you have a superb team of experienced production people, you need to double- and triple-check with everybody about whether the assigned tasks are accomplished at the specified time. The credo of a good producer is to triple-check everything.

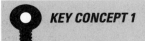 **KEY CONCEPT 1** **A good producer triple-checks everything.**

Over the years, certain routines—production processes—have developed that can facilitate your complex coordination job and help you keep on top of things. These processes include a variety of chores you need to do *before* the production, *during* the actual production activities, and *after* the production. In production lingo, we speak of preproduction, production, and postproduction phases.

In *preproduction*, you develop the initial program idea, define the type of audience you would like to have receive your program, and then select the people and television equipment necessary to translate your initial idea into effective video and audio images. Meticulous preproduction is a key factor in maximizing your video production efficiency and effectiveness.

In *production*, you actually translate, or *encode*, the original program idea into a television program. Production involves the operation and coordination of production and technical people and a variety of production equipment.

In *postproduction*, you select the best program bits and pieces, enhance their picture and sound quality as necessary, and then assemble them into a coherent whole—the television program. For complicated programs that require a great deal of editing, the postproduction phase takes the longest.

You should now be able to answer Triple-I's question of how you would move from initial idea to the finished video production: from preproduction to production and then to postproduction. But what about Triple-I's request for specific production steps and how to make them effective and efficient? To answer these questions, you need to learn more about an approach—a model—that will guide you in achieving these admittedly difficult goals. This is called the *effect-to-cause production model*. Here are some of the specific ideas we will discuss in this chapter—

THE EFFECT-TO-CAUSE PRODUCTION MODEL
Basic program idea; defined effect on the viewer; medium requirements including equipment, facilities, and people; and evaluating the actual effect on the viewer

GENERATING IDEAS
Clustering and brainstorming

THE EFFECT-TO-CAUSE PRODUCTION MODEL

Like any conceptual model, the effect-to-cause production model is not a foolproof system that works every time you use it. But it can help you in deciding on the essential steps for a variety of productions and on how to streamline the various production phases. It is based on the realization that the only message that actually counts is not the one you start with but the one that is finally perceived by the viewer. This process is a little bit like cooking. The final success of your cooking is not measured by what ingredients you used (the initial idea), but whether your guests like to eat it (the message actually received). Wouldn't it make sense, then, to start with an idea of how the meal should finally look and taste and then figure out what ingredients you need for such a meal?

The effect-to-cause production model works on the same principle. Once you have developed the initial program idea, you move directly to what, ideally, you

Defined Process Message (Desired Effect)
You move from the basic idea directly to the desired effect on the viewer—the defined process message.

Basic idea

Defined process message

Desired effect

Medium Requirements (Cause)
The defined process message will determine the specific medium requirements—what production elements are necessary to generate (cause) the process message.

Medium requirements
• Content elements
• Production elements
• People

Cause

Desired effect

Actual Process Message (Real Effect)
The message moves through the phases of production and is delivered to the target audience.

• Preproduction
• Production
• Postproduction

Cause

Real effect

Actual process message

Evaluation
The closer the defined and actual process messages match, the more successful the production is.

Degree of Success

want the viewers to learn, feel, or do.[1] What the model suggests is for you to jump from the initial idea to a definition of the intended effect. Then, and only then, do you back up and decide on the medium elements necessary to produce the intended communication effect. Because the actual message is generated by the process of viewers watching a video program, this message is called the ***process message***. Like the completed meal, the process message is the only communication effect that actually counts. **SEE 1.1**

1. This concept is similar to the writing of instructional objectives. See Robert Mager, *Preparing Instructional Objectives*, 2d rev. ed. Belmont, Calif.: Lake Publishing Co., 1984. See also David L. Smith, *Video Communication*. Belmont, Calif.: Wadsworth Publishing Co., 1991.

As you can see, the effect-to-cause model shows four distinct processes: (1) to move from the basic idea to the defined process message (desired effect on the viewer); (2) to determine what medium requirements are necessary to generate the defined effect (the cause); (3) to take the actual process message through the production phases; and (4) to evaluate the actual effect and to see to what extent the defined process message and the actual process message overlap. Let's discuss these elements in detail.

Basic Idea

You must have some idea of what meal to prepare before starting to cook. The same is true in video production. Running around and taking pictures with your camcorder before deciding on what it is you want to tell your viewers is a wasteful activity at best. An effective production process depends on a fairly clear idea of what you want to communicate. For example, suppose you have just moved to Big City, and your daily commute prompts you to "do something about these crazy Big City drivers." You are certainly not ready at this point to plunge into production. Changing your idea to "do a documentary about the crazy Big City drivers" is no improvement. If you were proposing such a documentary to the Triple-I people, they would probably ask you what the documentary is all about and why you chose a documentary in the first place. What you need to do is to think more about what exactly you want your viewers to learn through your program about becoming better drivers. The more precise your definition of the intended effect—the *process message*—is, the easier it is for you to decide on the necessary appropriate production format and procedures.

Note, however, that your initial production idea is usually rather vague and rarely concise enough to serve as a definition of the desired communication effect. This way of thinking is perfectly normal. As a matter of fact, you should engage in some initial brainstorming about the various program possibilities before defining the desired process message. But you should not move on to specific production details without a precisely defined process message.

Defined Process Message (Effect)

To "do something about the crazy Big City drivers" is a noble cause, but it says little about how to go about it. It probably implies that you want to help the drivers to become more disciplined, responsible, and courteous than they presently are, and to use television to do so. This is a tall order. You may well decide that you need to devote a whole program series to this goal, rather than a single program, to even partially achieve such a large and difficult task. If so, each program should feature a highly specific learning objective for the viewers. As in most learning tasks, specific objectives are usually more effective than global ones: several small steps are more easily managed by the learner than a few large ones.

Rather than attacking all the bad habits of the "crazy Big City drivers," you can now isolate a single problem that is especially bothersome to you and that you consider to be of special importance. For instance, you may find that the misuse or nonuse of turn signals has become a serious threat to traffic safety. Rather than attacking all the bad habits of Big City drivers all at once, you can

now isolate a single problem: to persuade the drivers to make proper use of turn signals. All you need to do now is to restate this objective a little so that it can serve as a ***defined process message*** (the desired effect): *The process message should demonstrate to Big City drivers the proper use of turn signals and persuade them to use turn signals accordingly.*

This statement has all the necessary ingredients of a useful process message. It defines the desired audience *(Big City drivers)* and what you want the viewers to learn, feel, or do. In this case, you want them to learn when and how turn signals should be used *(demonstrate…the proper use of turn signals),* and then motivate them to use them *(persuade them to use turn signals accordingly).* Such precise information will help you greatly in deciding just what the program should contain and how to go about making it. We will come back to this example in the section on medium requirements.

 KEY CONCEPT 2 **The defined process message describes the desired communication effect.**

But what do you do when the program objective is much more general or when you want to reach a general rather than a specific audience? Do you still need to come up with a process message? Yes, you do, except that the process message in this case will not be as precise as in the turn signal case. Even a more general process message will give you a clue as to what facilities and people you will need to translate the basic idea into an actual video program.

For example, you may have a sincere desire "to make a video on the homeless," in order to make the people who have comfortable homes more aware of what it means to be homeless. You will probably think of a documentary that shows people sleeping in the street, on park or subway benches, or pushing shopping carts that hold their entire possessions. You may have some scenes in mind that contrast the homeless against the more fortunate members of our society, such as elegantly dressed people rushing past the homeless, on their way to some gala performance.

Although you may have many such powerful images in mind, what exactly is it that you want the viewers to feel, learn, or do? Is the documentary approach the most appropriate program format to achieve this effect? You can't really answer these questions until you have a more precise idea of the program effect—some kind of process message. Here is one possibility: *The process message should make viewers experience, at least temporarily, what it feels like to be homeless.*

Compared to the turn signal program, this process message is less precise. The audience is much more general (*viewers* instead of *Big City drivers*), and the desired effect is to generate a feeling (to *experience…what it feels like to be homeless* rather than to accomplish a learning task (to *demonstrate…the proper use of turn signals*). But this process message still contains important production clues. The main objective is to make us *feel*, at least for a moment, what it is to be homeless. To learn various statistics about the number of homeless in your city, or how many use public shelters, is much less important than generating empathy, a feeling that reaches into the life of the homeless. This statement opens up new production approaches.

Rather than showing a great number of homeless people, you could follow one person for one day and focus on the many problems this person encounters and the frustrations and fears connected with being homeless. The problem with this approach is that people who are not homeless will have a hard time really feeling what this person is going through. To generate real empathy for somebody homeless, you may not want to show a longtime homeless person, but somebody who recently became homeless. For example, how would you feel if during a first-time visit to a large city far from home you had your wallet or purse stolen? All of a sudden, you have no money, no identification, no credit cards, no idea of where you are. You have become homeless. Most people you see ignore you, or become suspicious and walk away when you ask for help. Fortunately, you remember your long-distance credit code; but the first public phone you find is out of order. The second one works, but connects you with your friend's answering machine. It gets dark and chilly, and it begins to rain. You can take it from there.

As you can see, even this relatively general process message has opened up new possibilities for approaching the subject and contains some clues to the medium requirements necessary to translate this idea into a television program. You have made a big step toward fulfilling Triple-I's creativity requirement. In addition, your creative efforts are not random, but centered around a basic theme or task. What follows will help you with Triple-I's second major requirement of "exceptional production efficiency and effectiveness."

Medium Requirements (Cause)

Once you know what you want to do, you must finally do it. The most ingenious program idea is worthless if it remains in your head. We have now arrived at the production, or "cause," step in the effect-to-cause model. (Refer to figure 1.1.) This translation step is what we normally call *production*. It involves the effective and efficient use of the various *medium requirements*, such as content elements (defined process message, audience analysis, script), equipment and other facilities (cameras, lighting, sound equipment, videotape recorders, editing equipment, studio or field location, and so forth), and people (who work in front of and behind the camera). Just selecting these various medium elements requires a thorough knowledge of the various production people and facilities. The overall guide to production requirements and specific procedures is, once again, a clearly stated process message.

Without going into too much detail, let's see what the process message of properly using turn signals can tell us about major medium requirements. Here it is again: *The process message should demonstrate to Big City drivers the proper use of turn signals and persuade them to use turn signals accordingly.*

This process message states rather clearly who the intended audience is (Big City drivers) and what the major content of the show is all about (demonstrate the use of turn signals and persuade the drivers to do likewise).

Target audience Because you are dealing with a learning task (to help drivers use turn signals in a proper way), you need to know as much as possible about the target audience, Big City drivers. The more you know about the target audience,

the easier it is for you to decide on what to show and how to show it in order to generate the desired process message.

In this case, you would have to learn all about the driving and living habits of Big City drivers. Do the majority of Big City drivers actually ignore turn signals? If so, in what situations? This type of information will tell you what examples to use in your video presentation. How can you reach most efficiently the majority of your target audience? Showing your program when most of the target audience is on the road will certainly not help your mission.

Producers of commercial advertising do extensive audience research before moving from the process message to the medium requirements. They would certainly want to know the percentage of male and female drivers in Big City, the various age groups of the drivers, their income levels, education, what kind of work they do, and especially where they live. They would also like to know the driving habits of people who don't commute. These data will give the researchers a *demographic profile* of the typical Big City driver.

If the process message is totally persuasion-oriented, as in commercial advertising, the producers are also interested in what and how much television the target audience watches, what newspapers, magazines, and books they read, the music they listen to, what clothes they wear, what they buy and where they buy it, and so forth. This information on the target audience's general lifestyle provides the producers with *psychographic* data. Such audience analysis is especially important when you are designing a program that is distributed by on-the-air telecast or cable. If you are engaged in corporate or instructional video production, your audience is much more clearly defined. If, for instance, your process message is to help new bank employees cash a check, or fifth graders to learn the multiplication tables, you do not have to draw up demographic or psychographic profiles. Nevertheless, you need to find out when and under what circumstances the audience will be viewing your program. The more you know about the target audience, the easier it will be to translate the defined process message into medium requirements, and the more efficient the whole production process becomes. The Triple-I people will be happy to hear this.

Now you need to translate your good intentions and process message into an actual video program. Such a translation process requires that you have a clear idea what you want to show and say—the *content*—and what *equipment, facilities*, and *people* you need to produce the program that will cause the actual process message to occur.

Content To show good or bad driving habits, you need to be out on the streets in traffic. You could, for example, videotape rush hour traffic and then point out how many drivers change lanes or turn without bothering to use turn signals, and then explain the potential danger of such omissions. You could then set up driving situations in which you show the benefits of using turn signals properly. By now, a rather detailed shooting script is definitely in order.

When writing the script, you must consider two more factors: *money* and *time*. Despite all your good intentions and your desire to rival in your production the style of an elaborate Hollywood movie, you will not succeed unless you have the Hollywood budget and production time to match. Money and time are production factors as real as cameras and microphones. You simply cannot do a six-camera

show when you have only two available; likewise, you cannot do a million-dollar production if you have only five hundred to spend. If you have only four weeks to do a production, don't write, or use, a script that requires on-location shooting in different parts of the world and two months of postproduction.

Equipment and facilities We already know that most of the production will happen "on location," rather than in a studio. This factor is important in selecting the equipment necessary for such a field production. A major portion of this book is devoted to helping you learn exactly what equipment you would need for such a shoot and for the various postproduction tasks.

People Just how many production people you need depends on your detailed script. In any case, you must have a producer who is in charge of the whole production, a director who is responsible for and guides the day-to-day production activities, various assistants, and a skilled production crew. You also need "talent"— people who appear on camera, do the voice-over narration, or portray various traffic experts if the script calls for this. Finally, you need people who drive the demonstration cars and others who help you facilitate the production.

You can readily see why even a simple production can run into quite a bit of money, assuming that you have to pay for all the people and equipment involved. It also requires careful planning and coordination of a great variety of people and machines.

 KEY CONCEPT 3 **The medium requirements include content elements (defined process message, audience analysis, script), production elements (equipment, facilities, schedules), and people (talent, nontechnical and technical production people).**

Actual Process Message (Real Effect)

Regardless of how much planning and preparation you put into cooking your meal, it is successful only if somebody enjoys eating it. So it is with video production. No matter how much effort you put into your production and how carefully you follow the defined process message, the only thing that really matters is whether your production has the desired effect on your target audience. The closer the *actual process message*—the message the viewers perceive in the communication process— is to the defined process message, the more successful your production.

Evaluation

If you were to ask a number of television producers how they evaluate their shows, they would probably give you some vague answers: "Well, I just see whether a certain scene works or not," or, "If it feels right, it's usually OK." Some others might tell you

that they ask their neighbors how they liked the show, or that they don't have time to do any formal evaluations. As in any other creative endeavor, the "right feel" for something is an important and often useful criterion. But when asked to be maximally efficient in your production, you need more precise methods of evaluation. As usual, the effect-to-cause model is of some help.

Formative evaluation If you intend to honor Triple-I's request for "maximum efficiency and effectiveness," you cannot wait until the end of your production to see whether it is good or bad. Rather, you need to check every major phase *during* the production and see whether you can proceed to the next step, or whether you must back up to improve the previous one. This procedure is often called *formative evaluation.*

 KEY CONCEPT 4 **Formative evaluation is when you evaluate each production phase while the production is in progress.**

Before moving to the medium requirements, for example, you should reexamine your original program idea and especially the definition of the process message. Does it contain all the necessary and useful elements, such as target audience and the desired communication effects? Is it precise enough to guide you toward the production steps? If yes, you can go on to the medium requirements; if no, you need to do more thinking about what it is you want to accomplish with your video production.

When moving to the medium requirement section of the model, you must examine whether you really need all the equipment and people you have listed. If you had to cut your budget severely, what would you eliminate? Could you still function properly in light of the defined process message, or would you have to come up with a new one? You can also become quite specific, and carefully monitor the production schedule, or examine the raw footage before asking the editor to "cut the show."

Summative evaluation This step includes the final evaluation of the finished production and, more important, the actual effect of the production on the intended audience—the process message.

 KEY CONCEPT 5 **Summative evaluation means the final evaluation of the finished production and the actual effect of the production on the audience.**

When you are done with a video production, you need to look at it as objectively as possible and evaluate it in the context of the defined process message. Does the production seem to trigger the desired communication effect?

With all due respect to your keen judgment and evaluation skills, the final success of your production depends on the real effect of your production on the viewers. The closer the actual and defined process messages match, the more successful the communication is.

Be aware that your final evaluation is easily influenced by what you know about the production and the various major and minor production crises you had to overcome. For instance, you may be dismayed over a missed shot, even if the one that is in the show is perfectly appropriate. In any case, don't ever apologize to an audience for a missed shot or sound effect; once you have committed yourself to showing your production in public, you must stand solidly behind it.

 KEY CONCEPT 6 **The closer the actual and defined process messages match, the more successful the communication is.**

The problem with this type of summative evaluation is that it is very hard to assess the actual effect of a program on a large, general audience. This is why rating services are content with projecting the number of viewers rather than measuring the program's impact. The problem with ratings is that we have erroneously come to equate the number of viewers with the quality of the program and a good match between defined and actual process messages.

When you have a small, highly specific audience—such as high school or college students taking a particular class—a summative evaluation is much easier to do. In this case, you can simply have the students fill out a questionnaire at the end of the program. Although such a response is much harder to get from the audience of an over-the-air telecast, you could still try to solicit responses by telling the audience what you want and where to write or call. By asking the right questions, you can assess the emotional impact of your show, at least to a certain extent.

Although the effect-to-cause production system cannot guarantee a perfect production, it can guide you to a reasonably effective approach without a lot of trial and error. Properly applied, it should certainly help you meet Triple-I's requirement of making the "production process maximally efficient and effective."

GENERATING IDEAS

But that's not all. There is one more condition put forward by the Triple-I people. They would like you eventually to combine production efficiency and effectiveness with "exceptional creativity" in generating significant project ideas and in translating these ideas into effective video programs. This condition is a tall order. You could argue that creativity is difficult to define and that the creative process remains largely a mystery. But such an argument is unlikely to be viewed as creative—and you would probably not score too highly as a new intern.

In video production, creativity means coming up with good ideas on a rather *consistent basis* and according to a *strict time schedule*. In video production, you need to call up your creativity on demand. Often the clock dictates when to be creative. The production schedule will not allow you to wait for the occasional inspiration and creative spark.

What you need to do is develop some practical techniques that will help ignite your imagination and inventiveness on call. These techniques may not generate creativity, but they will help you *unlock* creative ideas buried somewhere inside you, help bring them up to your consciousness, and make them readily available. Two well-known and often-used devices for unlocking ideas are *clustering*[2] and *brainstorming.*[3]

Clustering

Take a piece of paper and write a single word that seems somehow central to your basic program idea or process message in the middle of the sheet and circle it. Now write down and circle another word that is somehow associated with your key word, and connect the two with an arrow. **SEE 1.2** Write down other word associations and connect them to the last one circled.

In a short time, you will have created a cluster of words or ideas. Don't try to *design* a cluster or be logical about it. Work fast, so that you will not be tempted to ponder over your associations. Let your mind flow freely. When you feel that your ideas are exhausted, don't force yourself to find more connections or more logical ones. According to Gabriele Rico, one of the clustering pioneers, the idea cluster has a natural limit.[4] You will probably know when you have enough branches and when it is time to stop. Once you are at that point, look at the finished diagram and search for possible patterns. These patterns will inevitably reveal some novel

2. "Clustering" as an idea-unlocking technique was developed by Gabriele Lusser Rico in her book, *Writing the Natural Way.* Los Angeles: J. P. Tarcher, Inc., 1983.

3. See James L. Adams, *Conceptual Blockbusting*, 3d ed. Redding, Mass.: Addison-Wesley, 1990.

4. See Rico, *Writing the Natural Way*, pp. 28–37.

1.2

PARTIAL CLUSTER

Note that clustering starts with a central idea and then branches out in various directions, depending on what you consider connected to it.

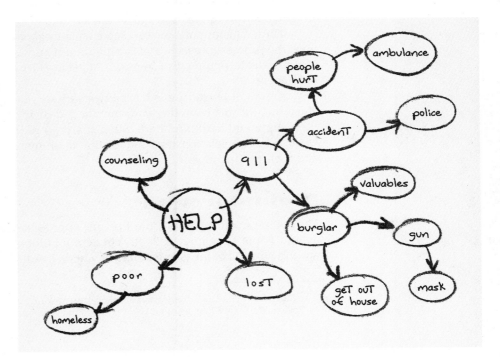

1.3

COMPLETE CLUSTER

Once you have listed the connections most apparent to you, stop. The cluster will then suggest new ideas or novel approaches to old ideas. It may also trigger new clusters.

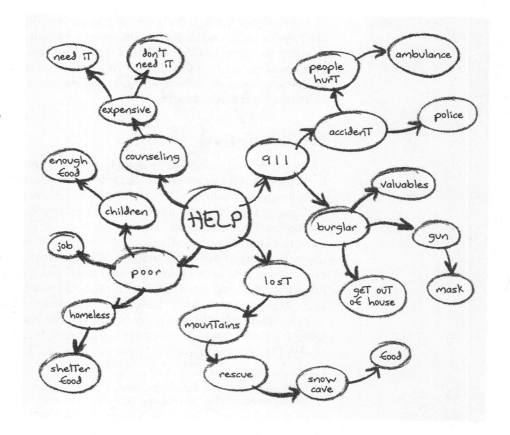

connections and relationships that were hidden to you before. Quite likely, they will provide you with new insights. **SEE 1.3**

These cluster patterns can serve as springboards for the general program idea, the process message, and the medium requirements. If one word or phrase is especially intriguing yet seems out of place, start a new cluster—but leave the old one alone.

Although clustering is basically a solitary activity, you can also do team clustering. In this case, the team members design their individual clusters, but then share and compare them. Such sharing produces new patterns and new clues to various relationships and ideas and, ultimately, to new process messages and their productions.

Brainstorming

A friend tells you that the Triple-I people engage frequently in brainstorming or, as one Triple-I member calls it, "conceptual blockbusting."[5] By freely tossing around all sorts of ideas, regardless of whether or not they make any immediate

5. Adams, *Conceptual Blockbusting*. See also Robert H. McKim, *Experiences in Visual Thinking*, 2d. ed. Boston, Mass.: PWS Engineering, 1980.

sense, they hope to break through the usual conceptual blocks and generate novel ideas and approaches. She describes one of their usual brainstorming procedures as follows.

About ten or twelve people sit in a circle. In the middle of the circle is a small audiotape recorder. One of the people (P-1 = person 1) starts with:

P-1: "Knock, knock!"

P-2: "Who's there?"

P-3: "Me."

P-4: "Me who?"

P-5: "Me-me."

P-6: "Oh, it's Mimi, the turtle from down the street."

P-7: "Come in, Mimi!"

P-8: "Hi, I'm Mimi, the turtle from down the street."

P-9: "Yes, we know. But what are those funny shoes you are wearing?"

P-10: "My new running shoes. By the way, I got first place."

P-1 (again): "I beat the rabbit!"

P-2: "You should be disqualified."

And so forth. (If you like, you can continue this brainstorming session.)

As you can see, the idea sequence is anything but logical. According to your friend, the story developed into several even more bizarre incidents that generated much laughter. When the brainstorming people had finally run out of ideas and energy, they stopped and listened to the recording. During the playback several of them took notes. Some of these brainstorming ideas may well show up in a commercial for air-cushioned athletic shoes.

Triple-I's session contains all the ingredients of successful brainstorming: (1) It is best done with several people. (2) You start out with a general idea or task (selling a new brand of athletic shoes), and then let everybody call out whatever springs to mind. (3) Let all minds roam freely, and do not pass judgment on any of the ideas. All ideas, however far out they may be, are equally valid. (4) Record all ideas, either by having someone write them down or by putting them on audiotape. (5) Once all ideas are down, the team reviews what was said and looks for relevant ideas or associations.

Yes, this technique is quite similar to clustering, except that in clustering you create a visual pattern that reveals some of the interrelationships of the various ideas by the time you have finished your clustering. Brainstorming may generate ideas of greater variety and profusion than clustering, but they are trickier to pattern and more difficult to use in defining a process message or in translating it into a video experience.

KEY CONCEPT 7 **Successful clustering and brainstorming depend on a free, intuitive, and noncritical flow of ideas.**

Well, the Triple-I people should certainly be pleased with your knowledge of how to make production maximally efficient and effective, and how to generate significant ideas. But before moving on to learning about the key people involved and the more technical aspects of video production, and to make sure that you will not miss any of the important production aspects when talking to the Triple-I producer, let's go over the main points in this chapter. Or, to borrow his favorite and frequent advice to his production crew: "Once again, remember..."

ONCE AGAIN, REMEMBER...

Production Process

This process is divided into three phases: preproduction, production, and postproduction. In preproduction, the program idea is developed, and the medium requirements (people, equipment, and facilities) determined. Production involves coordination, production, technical people, and a variety of production equipment. In postproduction, the best program bits and pieces are selected and put into a coherent whole—the video program.

Effect-to-Cause Production Model

This model shows how to move from the basic program idea to the definition of the intended effect on the viewers and how this defined process message dictates what medium elements (people, equipment, and facilities) to use to generate—cause—the intended effect. It also implies evaluating the production process and the actual effect on the viewers. The more closely the actual process message (real effect) matches the defined one, the more successful the production is.

Generating Ideas

In video production, creativity means coming up with good ideas on a consistent basis within strict time and budget limits. Two helpful methods are clustering and brainstorming. Clustering means connecting in a graphlike fashion words that are somehow related to a central idea. The finished cluster contains important clues to formulating the basic idea and defining the process message. Brainstorming is a free, totally noncritical expression of ideas that may or may not have anything to do with the basic program idea. It frees the mind from set patterns.

KEY CONCEPTS

- A good producer triple-checks everything.

- The defined process message describes the desired communication effect.

- The medium requirements include content elements (defined process message, audience analysis, script), production elements (equipment, facilities, schedules), and people (talent, nontechnical and technical production people).

- Formative evaluation is when you evaluate each production phase while the production is in progress.

- Summative evaluation means the final evaluation of the finished production and the actual effect of the production on the audience.

- The closer the actual and defined process messages match, the more successful the communication is.

- Successful clustering and brainstorming depend on a free, intuitive, and noncritical flow of ideas.

KEY TERMS

Preproduction Team Consists of people who plan the production. The preproduction team normally includes the producer, director, writer, art director, and technical supervisor or the TD. Large productions may include also a composer and a choreographer. In charge: producer.

Production Team Consists of a variety of nontechnical and technical people, such as producer and various assistants (associate producer and PA), the director and assistant (AD), and the talent and production crew. In charge: director.

Postproduction Team Normally consists of the video editor and, for complex productions, a sound designer who remixes the sound track.

Floorplan A diagram of scenery, properties, and set dressings drawn on a grid.

Above-the-Line Category for nontechnical personnel, such as producers, directors, and talent.

Below-the-Line Category for technical personnel, including camera operators, floor persons, and audio engineers.

Production Schedule A time line that lists the start times of major production events.

The Production Team: Who Does What When?

IF you are a painter, you can do everything yourself: coming up with the idea, buying the materials, preparing the canvas, struggling with form and color, and finally signing and dating the finished work. You could even do the selling without any other people involved. The whole creative process is entirely in your control.

This is not the case in video production, unless you are simply video-taping your vacation adventures. Although you could possibly do a simple production all by yourself, professional productions usually involve a group of people—a production team—each member performing a clearly defined function. When watching some productions in a television station and at Triple-I, it was easy enough to spot the people who worked the cameras, set up the microphones, or adjusted the lights. But there were several people who looked worried but seemed to do little else. To help you understand the people involved in video production, what they do and how they work together, this chapter explains—

THE PRODUCTION TEAMS
The preproduction team, the production team, and the postproduction team

PASSING THE BUCK
What happens when production people do not work as a team

TAKING AND SHARING RESPONSIBILITY
What happens when production people know their functions and work as a team

PRODUCTION SCHEDULE
How to set up an effective time line for the production

You may best understand who does what by dividing the team into people involved in the *preproduction, production,* and *postproduction* stages. The preproduction team includes people primarily involved with the *planning* of the production; the production team is made up of people who *translate* the ideas into *actual video pictures and sound;* and the postproduction people put all the various *videotape segments together* and give the whole production the *final polish.*

Some production people are involved in only one of these stages; others may be involved in all three of them. As you can readily see, you no longer have complete control of the whole creative process. Unlike the painter, you must learn to work as an effective team member. Being an effective team member means that you know exactly what is expected of you when assigned to a specific production position, and also what everybody else is supposed to be doing. Once you know who is supposed to do what, you can establish effective communication among the team members and let them know when specific things have to be done. A production schedule, or production time line, is essential in coordinating the efforts of all the different team members.

TEAM MEMBERS

The size and makeup of the production team depend on the scope of the production. You will find that a specific production away from the studio, called electronic field production (EFP), may need only three people: camera operator, audio and videotape recorder (VTR) operator, and director. But a live sports telecast may keep thirty people more than busy.

Let's find out who is normally involved in the three primary major production stages: preproduction, production, and postproduction.

Preproduction Team

The primary responsibility of the ***preproduction team*** is to develop the idea for the video production and plan its production so that the translation process of idea to pictures and sound is as efficient as possible. The people normally involved in this initial idea-generating phase are the producer, writer, director, and scene designer or art director.

The original idea may come from the corporate manager ("do a fifteen-minute videotape showing that the customer is our most precious commodity"), or the producer ("do a pilot of our new medical series"), or it may come from a concerned citizen ("I would like to do a show on the pros and cons of timber clear-cutting"). Often, specific show ideas are the product of several people brainstorming together.

Once the general idea is born, it is nurtured through all preproduction stages by the *producer.* As a producer, you have to state the specific purpose of the show—the process message—and prepare a *budget* for the entire production.

Once you have the necessary funding, you need to hire and/or coordinate all additional personnel, equipment, and production activities. You or your associate producer will then have to come up with a *production schedule* that indicates specifically who is supposed to do what and the times when the assigned tasks are to be done.

The next step is writing the script. The writer interprets the defined process message into a video production and writes down what he or she wants the viewers to see and hear. This production step is obviously a crucial one. It often determines the production format—such as instructional show, interactive multimedia show, or documentary—and the style and quality of the production. The script serves as the guide for all production activities.

Scripts are almost always rewritten several times. Sometimes the content isn't quite accurate and needs some corrections. At other times, the words sound too stilted and academic when actually spoken, or there may be some shots that are unnecessary or too difficult to produce. For all these reasons, good video writers do not come cheap. Settle on a fee before delivery of the script.

The *director* translates the script into specific video and audio images, and selects the necessary production crew and equipment. The sooner the director is brought into the preproduction process, the better. For example, the director may work with the writer early on to ensure the most effective interpretation of the defined process message. He or she may even help the writer with the basic approach, such as changing the original idea of producing a brief instructional tape into an interactive multimedia experience, or a documentary into a dramatic format, or a company president's address into a town-hall-type forum. The director can also help the art director with ideas about the specific environment in which the event is to take place, or even a specific style of graphics to be used.

The *art director* is responsible for the set design or the location for a specific show. He or she is also in charge of decorating the set and designing the various graphics, such as titles and charts. The art director must create an environment that fits the overall style of the show and that facilitates the anticipated production procedures. Even the most beautifully designed set is useless if there is not enough room for camera movement and microphones, or if it cannot be properly lighted.

The art director prepares a *floorplan*, which is a diagram of scenery, stage properties (tables, chairs), and set dressings (wall hangings, lamps, plants) drawn on a grid, as shown in figure 13.16. The floorplan is an important preproduction guide for the director. With a good floorplan, the director can visualize the major shots and place the cameras accordingly. The *lighting director (LD)* can use the floorplan to determine the basic lighting setup before ever entering the studio.

Finally, the floorplan enables the *floor manager* to put up and decorate the set. When the production takes place at a remote location such as in a hospital hallway or in the corporate manager's office, the art director will probably want to do some rearranging of furniture, wall hangings, or equipment in order to make the location look good to the video camera rather than the naked eye. Sometimes a special *property manager,* who selects all the props used in the show, is involved in the preproduction process.

The preproduction team may also include a *technical supervisor* or the *TD (technical director)*, especially if the production is rather complex and happens "in the field." The TD can determine ahead of time just what technical facilities are necessary for the proposed production. For instance, the TD may want to check on the available electric power, or what lights are necessary to boost the illumination in a lecture room. A preproduction technical survey is especially important if the production is to be a live telecast.

Small production companies or television stations often combine the various roles. The functions of the producer and director, and even the writer, might be carried out by a single person—the producer-director—and the floor manager might also act as art director and property manager.

Large productions also include on the preproduction team several writers, a costume designer, a composer, and a choreographer.

Production Team

The actual ***production team*** consists of a variety of people. The nontechnical members include the producer and various assistants (associate producer and production assistant), the director, the associate director (if it is a complex show), and the talent. Whereas the major part of the producer's job is in preproduction, the director is totally involved in the actual production phase.

The production crew, which is made up of technical and nontechnical personnel, normally includes the floor manager and floor persons (grips), the TD (technical director), camera operators, the LD (lighting director), video and audio engineers, videotape operator, and the C.G. (character generator) operator. In a large production, there is an additional engineering supervisor, as well as various costume people, a property manager, makeup people, and hairdressers.

Postproduction Team

The ***postproduction team*** is rather small and normally consists of a postproduction editor and the director. The editor will try to make sense of the various videotape segments and put them into the order indicated by the script. The director will guide the editor in the selection and sequencing of shots. If you (as the director) have a good editor and a rather explicit script, you will have relatively little to do. You may want to see a "rough-cut," or an "off-line" version before you give the editor the go-ahead to prepare the final "on-line" videotape. If the postproduction requires more complex editing, you may have to sit with the editor throughout the process to select most of the shots and determine their sequence.

Complex postproduction may also include extensive manipulation of sound, also called *audio sweetening*. It consists of remixing, adding, or replacing small or large portions of the original sound track, and can take more time and effort than editing pictures. Major sound postproduction is done by a *sound designer*.

Most producers stay away from postproduction at least until the first rough-cut is done. However, some producers cannot stay away from the editing room and get intimately involved in every decision. Such fervor is, despite all good intentions, not always appreciated by either the editor or the director.

The accompanying tables summarize the major *nontechnical* and *technical* personnel and their principal functions. **SEE 2.1 AND 2.2**

2.1

NONTECHNICAL PRODUCTION PERSONNEL

PERSONNEL	FUNCTION
A B O V E - T H E - L I N E	
Executive Producer	In charge of one or several programs or program series. Coordinates with client, station or corporate management, advertising agencies, investors, and talent and writer's agents. Approves and manages budget.
Producer	In charge of an individual production. Is responsible for all personnel working on the production and for coordinating technical and nontechnical production elements. Often doubles as writer and director.
Associate Producer (AP)	Assists producer in all production matters. Often does the actual production coordination jobs, such as telephoning talent and making sure that deadlines are kept.
Studio and Field Producers	In large operations, studio and field producers are assigned different producing responsibilities: the studio producer takes care of all studio productions; the field producer of all field productions.
Production Assistant (PA)	Assists producer and director during the actual production. Takes notes of comments made by the producer or director during rehearsals. These notes serve as a guide for the crew to fix minor production flaws before the final taping.
Director	In charge of directing talent and technical operations. Is ultimately responsible for transforming a script into effective video and audio messages. In smaller operations, also assumes the producer's responsibilities.
Associate Director (AD)	Assists director during the actual production. Often does timing for director. In complex multicamera productions, helps to "ready" various operations (such as presetting specific camera shots or calling for a special graphic effect).
Talent	Refers, not always accurately, to all performers and actors who regularly appear on video.
Actor	Someone who portrays someone else on camera.
Performer	Someone who appears on camera in nondramatic activities. Always portrays himself or herself.
Announcer	Reads narration but does not appear on camera. If on camera, the announcer moves up into the talent category.
Writer	Writes video scripts. In smaller station operations, or in corporate video, the writer's function is often assumed by the director or the producer or by somebody hired on a freelance basis.
Art Director	In charge of creative design aspects of show (set design and location, graphics).
Music Director/Conductor	Responsible for music group in large productions, such as the band that plays in variety shows. Can also be the person who picks all the recorded music for a specific show or show series.
Choreographer	Arranges all movements of dancers.

2.1

NONTECHNICAL PRODUCTION PERSONNEL *(continued)*

PERSONNEL	FUNCTION
BELOW-THE-LINE	
Floor Manager	Also called *floor director* or *stage manager.* In charge of all activities on the studio floor, such as setting up scenery, getting talent into place, and relaying all director's cues to talent. In the field, the floor manager is basically responsible for preparing the location for the "shoot" and for cuing all talent.
Floor Persons	Also called *grips, stagehands,* or *facilities persons.* Set up and dress sets. Operate cue cards or other prompting devices. Sometimes operate microphone booms. Assist camera operators in moving camera dollies and pulling camera cables. In small operations, also act as wardrobe and makeup people. Set up and ready all nontechnical facilities in the field.
Makeup Artist	Does the makeup for all talent (in large productions only).
Costume Designer	Designs and sometimes constructs various costumes for dramas, dance numbers, and children's shows (in large productions only). Sometimes classified as above-the-line personnel.
Property Manager	Maintains and manages use of various set and hand properties, such as tables, chairs, office furniture (set properties), and telephones, coffee cups, flashlights (hand properties)—for large productions only. In smaller operations, properties are managed by the floor manager.

Sometimes the production people are divided into *above-the-line* and *below-the-line* personnel. These designations are not clear-cut and have more to do with who pays whom than who does what. In general, *above-the-line* personnel are preproduction and supervisory people; *below-the-line* personnel are involved in production and postproduction. **SEE 2.3**

PASSING THE BUCK

In preparation for your Triple-I interview and to learn as much as possible about the basic workings of the production team, you managed to get permission from a medium-sized local television station to watch the videotaping of a visiting rock group.

When you get to the studio well before the scheduled time for videotaping, the production is already in the wrap-up stage. Neither the musicians nor the production people look too happy. The PA (production assistant) tells you that the taping session had been pushed ahead by three hours because of the band's tight schedule. It becomes quite obvious that the taping session did not go as planned. There are small groups of people on the studio floor engaged in rather lively discussions. Let's listen in on what they are saying.

2.2

TECHNICAL PRODUCTION PERSONNEL

The technical production personnel includes engineers who are actually engaged in engineering functions, such as installing and maintaining new electronic equipment; it also includes people who operate such equipment. Because operating much of the electronic equipment, such as cameras, switchers, character generators, and videotape editing machines, does not require engineering knowledge, most of the operation of television equipment is performed by nonengineering personnel.

PERSONNEL	FUNCTION
ABOVE-THE-LINE	
Chief Engineer	In charge of all technical personnel, budgets, and equipment. Designs electronic systems, including signal transmission facilities, and overseas installations, day-to-day operations, and all maintenance.
Assistant Chief Engineer or Engineering Supervisor	Assists the chief engineer in all technical matters and operations. Is often involved in preproduction activities of large productions.
BELOW-THE-LINE	
Technical Director (TD)	In charge of all technical setups and operations during a production. Does the actual switching in a studio production. Often acts as technical crew chief.
Lighting Director (LD)	In charge of studio and field lighting; normally for large productions only.
Camera Operators	Also called *videographers* or *shooters*. Operate studio and field cameras. Sometimes also do the lighting for a show.
Video Operator	Also called *video engineer* or *shader*. Adjusts the camera controls for optimal camera pictures (also called *shading*). Sometimes doubles as maintenance engineer.
Videotape Operator	Operates videotape recorders during the production. In small field productions, the audio technician doubles as VTR (videotape recorder) operator.
Videotape Editor	Operates videotape editing equipment. Often makes creative editing decisions as well.
Sound Designer	In charge of "designing" the sound track of a complex production, such as a drama, commercial, or large corporate assignment. Sometimes listed as above-the-line nontechnical personnel.
Audio Engineer	Often called *audio technician*. In charge of all audio operations in production and, in the absence of a sound designer, in postproduction. Operates audio console during the show.
Maintenance Engineer	A true engineering position. Maintains all technical equipment and troubleshoots during productions.

ABOVE-THE-LINE AND BELOW-THE-LINE PERSONNEL

ABOVE-THE-LINE

Production people	Executive Producer
	Producer and Associates
	Director and Associates
	Chief Engineer and Associates
Idea people	Writer
	Art Director
	Composer
	Choreographer
Talent	Performers
	Actors

BELOW-THE-LINE

Technical people	Technical Director
	Lighting Director
	Maintenance Engineers
Production—technical	Camera Operator
	Video Operator
	Audio Engineer
	Videotape Operator
	Videotape Editor
Production—nontechnical	Floor Manager
	Floor Persons
	Grips
	Property Manager
	C.G. Operator
	Makeup and Wardrobe

In one group, the band manager is complaining about poor scheduling and the "static look" of the show, and the lead singer about the "bad sound." The executive producer tries to appease the band members, while the producer is accusing everybody of not communicating with him. The director defends his overall visual concept and personal style and accuses the musicians of not understanding the "true nature of video." The band manager mutters something about the sloppy contract and the lack of coffee during rehearsals.

Some crew and band members vent their frustrations about technical problems. They argue about which microphones should have been used and where they should have been placed, and about light levels that were much too low for good pictures. The LD counters by saying that she had practically no time for adequate lighting, mainly because she lost three hours of setup time. The musicians complain that the sound levels were too low, while the camera operators say that the music was too loud and they could not hear the director's instructions in their headsets. They felt lost, especially since the director had not briefed them ahead of time on what shots to get.

The floor manager and his floor crew still wonder why they had no floorplan. It would have kept them from moving the heavy platform from place to place until the director was finally satisfied with its location.

Everyone seems concerned with passing the buck and blaming everybody else for the various production problems. But what should have been done to minimize or avoid these problems? Before reading on, write down the major complaints of the band and production members and, by referring to tables 2.1 and 2.2, try to figure out who should have done what. Now compare your notes with the recommendations below.

Situation: Taping session was pushed ahead by three hours because of the band's tight schedule.

Responsibility: Producer. He should have coordinated the band's schedule more carefully with his production schedule. Moving up a shooting schedule by three hours will force the crew to work unreasonably fast, inviting serious production mistakes.

Situation: The band's manager complains about poor scheduling and the "static look" of the show. The lead singer is unhappy with the sound as recorded.

Responsibility: Again, the producer is responsible for scheduling and should have double-checked with the band manager exactly when the band would be available for the studio production. The "static look" complaint is aimed at the show's director, and the "bad sound" at the audio engineer who chose

the type and position of the microphones and who did the sound mixing. Ultimately, the TD is responsible for all technical processes, including the sound pickup and mixing. The producer should have brought the lead singer, the band manager, and the audio engineer together in the preproduction phase to discuss the particular sound requirements. The producer should have also arranged for the band manager to meet with the director to discuss the visual requirements and the overall "look" of the band's performance. The director could then have discussed his ideas about the "true nature of video" with the band manager. Even if the initiative did not come from the producer, the director and audio engineer should have pressed for such a meeting. Obviously, there was little communication among the members of the production team. The blame for the sloppy contract goes to the band manager and the executive producer, and the PA should have arranged for more coffee.

Situation: *The choice of microphones and their placement is being challenged. The band members complain that sound levels of the "foldback"—during which the sound as mixed is played back to the band members—were too low. The camera operators could not hear the director's instructions because of the band's high-volume sound and were without direction.*

Responsibility: The type of microphones used and their placement is clearly the responsibility of the audio engineer. As pointed out before, a preproduction meeting with the key members of the band could have avoided most of the sound problems, including the low playback levels, despite the drastically reduced setup time. The intercommunication problems between the director and the camera operators should have been anticipated by the director or the TD. Even the best intercom headsets will not function when used close to high-volume sound sources, such as a rock band. The director could have minimized this problem by meeting with the camera operators ahead of time to discuss with them the principal shots for each camera.

Situation: *The light levels were too low for good pictures.*

Responsibility: The LD is responsible for the low light levels. Her excuse is that the setup time was shortened by a full three hours; and she had no floorplan to do even the most rudimentary preproduction planning. But she could have contacted the director during the preproduction stage, or at least two days before the production, and asked about the floorplan and the lighting requirements for the show. In addition, when there is a lack of time, it is more sensible to illuminate the set with a generous amount of overall light rather than limited areas with highly specific light beams. (See chapter 6 for more detailed lighting techniques.)

Situation: *The floor manager and his crew lacked a floorplan, which resulted in needlessly moving a heavy platform.*

Responsibility: A floorplan would have told the floor crew the exact location of the platform on which the musicians perform. It would also have helped the LD to decide on the basic lighting setup, and the director on the basic camera positions. The lack of a floorplan is a direct result of bad communication among the preproduction team and, therefore, the ultimate responsibility of the producer. The director should have consulted with the

art director about the set and the floorplan during preproduction, and then asked the art director why the floorplan was not done according to schedule. The TD, LD, and floor manager should have asked the director for the floorplan before the actual production date.

As you can see, a production team can operate properly only if everybody is aware of his or her specific function. All members must be in constant communication with one another during the preproduction and production phases, and everybody must take full responsibility for the task assigned. More thorough preproduction could have averted many of these problems.

KEY CONCEPT 1 **Know the functions and responsibilities of each member of the nontechnical and technical production staffs.**

TAKING AND SHARING RESPONSIBILITY

Fortunately, a subsequent visit to a field production of an MTV segment turns out to be a much happier experience than your studio encounter.

When you get to the location where the "MTV shoot" is taking place, you find a whole section of the street already blocked off by the local police and you have to show your pass. You find action everywhere. The audio engineer and assistants are adjusting the loudspeakers, and the camera operators are checking out some shots. You are greeted by the floor manager and introduced to the producer and director of the show segment. Despite the bustling activity, the producer seems amazingly calm and takes time out to explain to you what the MTV segment is all about: the lead singer drives an old Cadillac convertible down the street to a stop sign, where the dancers are to mob his car.

Some of the dancers are already practicing their routine, while others are coming out of a large trailer that serves as the talent's makeup and dressing facility. Everybody seems relaxed, and you sense purpose and competence in what each team member is doing. The director checks the schedule, posted by the trailer, and asks the floor manager to call for a run-through. There is instant activity: the dancers take their positions, the car is moved to the starting point, the camera operators get their opening shots, and the audio people start the playback of the specific sound track. As far as you can tell, the run-through goes very smoothly. The crew and talent also seem happy with the outcome. Nevertheless, the director calls for a brief meeting of crew and talent to discuss some production problems.

The PA reads the notes that were dictated to him by the producer and director during the run-through:

- ☐ "Dancers in the back can't hear music."

- ☐ "Johnny (the lead singer driving the Cadillac) can't see the mark."

- ☐ "Shadows too harsh on him when stopped."

- ☐ "Need a tighter shot of Johnny."

☐ "We should be looking up at Johnny, not down on him."

☐ "Johnny is sweating too much. Light reflects off his nose."

☐ "Lots of dirt in the dancing area."

☐ "We can see audio cables in the background."

☐ "Some dancers are blocking Johnny on a close-up."

Which people would you ask to take care of these minor production problems? Let's look at the notes again.

"Dancers in the back can't hear music."

> Correction by audio engineer.

"Johnny (the lead singer driving the Cadillac) can't see the mark."

This means that Johnny can't see the mark on the curb that tells him exactly where to stop the car. The mark has to be moved higher up, to a telephone pole.

> Correction by floor manager.

"Shadows too harsh on him when stopped."

> Correction by floor persons (also called grips) under the direction of LD.

"Need a tighter shot of Johnny."

> Correction by director and, ultimately, by camera operator.

"We should be looking up at Johnny, not down on him."

The producer looks at the director. She turns to the specific camera operator.

> Correction by director and, ultimately, by camera operator.

"Johnny is sweating too much. Light reflects off his nose."

The director looks at the makeup person. This problem has nothing to do with lighting.

> Correction by makeup person.

"Lots of dirt in the dancing area."

> Correction by floor manager and floor crew.

"We can see audio cables in the background."

The audio engineer says that he will take care of it.

> Correction by audio assistant and floor persons.

"Some dancers are blocking Johnny on a close-up."

> Correction by director and choreographer.

After this brief meeting, the director calls for a fifteen-minute "reset" break during which the various production crew members go about correcting the problems mentioned. After the reset period, she checks the production schedule

and calls for another run-through. The following three hours are taken up by more rehearsals, two more such brief production meetings, often called "notes," and several "takes." The floor manager calls for a "wrap" (the completion of all production activities) a half hour ahead of schedule.

Contrary to the studio show of the rock band, this MTV field production was obviously prepared well in preproduction. During production, the members of the nontechnical and technical staffs knew what they had to do, how to communicate, and how to share responsibilities. The various "notes" meetings were an effective and efficient way to identify major and minor production problems and to make sure that the people responsible took care of them. You may find that, in complex productions, some directors schedule as much as one-third of the total rehearsal time for such "notes" meetings and "reset" periods.

 KEY CONCEPT 2 **Establish and maintain effective communication among all production personnel.**

PRODUCTION SCHEDULE

As you recall from the MTV production, the producer, floor manager, and the PA periodically checked the schedule to see whether the production was on time. Like the script, a ***production schedule*** (or time line) is essential to proper production coordination. The production schedule can show large blocks of time, such as the various due dates for preproduction, or it can be detailed and show a minute-by-minute breakdown of the actual production activities.

Here is an example of a rather loose production schedule for a fifteen-minute studio interview with the president of City College.

INTERVIEW TIME LINE

March 1	Confirmation by college president.
March 2	First preproduction meeting. Interview format ready.
March 4	Second preproduction meeting. Script ready. Floorplan ready.
March 5	All facilities requests due, including sets and props requests.
March 9	Production. Studio 1.
March 10	Postproduction, if any.
March 14	Air date.

The time line for this relatively uncomplicated production shows only the major meeting and due dates. Note the four-day lead from the due date for all facilities requests (March 5) to the actual production date (March 9). This lead time is necessary to ensure that the studio and all facilities requested are available.

The schedule for the actual production is much more detailed, and breaks the day into blocks of time for certain activities.

PRODUCTION SCHEDULE MAY 25: INTERVIEW (STUDIO 1)

8:00 A.M.	Crew call
8:30–9:00 A.M.	Technical meeting
9:00–11:00 A.M.	Setup and lighting
11:00–12:00 P.M.	Meal
12:00–12:15 P.M.	Notes and reset
12:15–12:30 P.M.	Briefing of president (Green Room)
12:30–12:45 P.M.	Run-through and camera rehearsal
12:45–12:55 P.M.	Notes
12:55–1:10 P.M.	Reset
1:10–1:15 P.M.	Break
1:15–1:45 P.M.	Taping
1:45–1:55 P.M.	Spill
1:55–2:10 P.M.	Strike

Let's examine more closely each of the scheduled activities.

Crew call This is the time when all production crew members (floor manager and assistants, TD, LD, camera operators, audio people, and other equipment operators) are expected to show up and start working.

Technical meeting This meeting includes the major nontechnical and technical people: producer, director, host, PA, floor manager, TD, LD, and audio engineer. The director will briefly explain the process message and how she expects the show to look (bright lighting, fairly tight shots of the college president). This meeting is also to double-check on all technical facilities and the scenery and props.

Setup and lighting According to the floorplan, the setup is rather easy for the floor manager and his crew. The lighting is routine and does not require any special effects. The two hours allotted should be sufficient for both activities.

Meal It is important that everybody be back from lunch at exactly 12:00 P.M., which means that everybody has to be able to leave the studio at exactly 11:00 A.M., even if there are still minor setup and lighting details left. Minor adjustments can be made during the reset time.

Notes and reset If there are no major setup and equipment problems, the period set aside for "notes" may be considerably shorter. The available time can then be spent on a more leisurely reset, that is, fine-tuning the lighting, moving a plant that may interfere with the person in front of it, cleaning the coffee table, and so forth.

Briefing of president While the production crew is getting ready for the first run-through and camera rehearsal, the producer, the interview host, the PA, and

(sometimes) the director meet with the college president in the Green Room to go over the aspects of the program. The Green Room is a small, comfortable room specifically set up for such briefing sessions.

Run-through and camera rehearsal This run-through is to familiarize the guest with the studio environment and procedures, to check on the various camera shots, and to rehearse the opening and closing of the show. It is rather brief, to keep the guest as fresh as possible. Because of severe time constraints, news interviews are normally not rehearsed. The producer may brief the guest during camera setup and lighting.

Notes and reset The run-through and camera rehearsals will inevitably reveal up some minor problems with the lighting or audio. The floor manager may want to straighten the president's tie and put a little makeup on his forehead to hide the perspiration.

Break Even if you work within a tight schedule, it is important to give the talent and crew a brief break just before the production. This will help to relax everybody and separate the rehearsal from the actual taping.

Taping The scheduled time allows for a few false starts or closings. However, the fewer takes there are, the fresher the interview will be.

Spill This is a grace period to fix up things that went wrong unexpectedly. For example, the director might use this time to redo the introduction by the host because the president's name was inadvertently misspelled in the opening titles.

Strike This activity does not refer to a protest by the crew, but to the clearing of the studio of all scenery, properties, and equipment.

Such a detailed production schedule is especially important for an EFP (electronic field production). The EFP schedule normally includes additional items, such as loading and unloading of equipment, and transportation to and from the remote location.

Once you have a production schedule, you must stick to it. The best schedule is useless if you don't observe the deadlines or the blocks of time designated for a specific production activity. Experienced producers and directors move on to the next segment according to the production schedule, regardless of whether they have accomplished everything in the previous one. If you ignore the time limits too many times, your schedule becomes meaningless.

KEY CONCEPT 3 **Establish a realistic production schedule and stick to it.**

As you can see, knowing the functions of every member of the production team and coordinating them according to a precise schedule are essential to effective and efficient video productions. Your knowledge of production processes and personnel should impress the folks at Triple-I.

 O N C E A G A I N , R E M E M B E R . . .

Team Members

The members perform nontechnical and technical functions. Nontechnical people do not normally operate equipment; technical people do. The nontechnical people are also called above-the-line personnel, and the technical people, below-the-line personnel.

Preproduction Team

These people plan the production. This team normally includes the producer, director, writer, art director, and technical supervisor (TD). Small production companies or television stations often combine preproduction functions (such as producer-director); larger productions employ additional preproduction personnel, such as a composer or a choreographer.

Production Team

This team consists of a variety of nontechnical and technical people, including the producer and various assistants (associate producer and PA), the director and assistant (AD), and the talent. The production crew usually includes the floor manager and floor persons (grips), TD, camera operators, lighting director (LD), video engineer, audio engineer, videotape operator, and C.G. operator. In preproduction, the producer is in charge of coordinating the various people and production details; in the production phase, the director is in charge.

Postproduction Team

This team normally consists of the editor and, in more complex productions, a sound designer, who remixes the sound track. The director and occasionally the producer guide the editor in the selection and sequencing of shots.

Floorplan

The floorplan shows the type and location of a studio set, the necessary stage properties (furniture), and set dressings (wall hangings, lamps, plants).

Production Schedule

A schedule is essential for proper production coordination and production efficiency.

KEY CONCEPTS

- Know the functions and responsibilities of each member of the nontechnical and technical production staffs.

- Establish and maintain effective communication among all production personnel.

- Establish a realistic production schedule and stick to it.

P A R T II

PART II

CONTENTS

Image Creation and Control

CONGRATULATIONS again! The Triple-I people interviewing you were so impressed with your ideas about creativity, working as a team, and production effectiveness that they offered you the prestigious internship. What they want you to do now is learn as much as possible about video equipment and its use.

In part II, you will learn how to operate video tools, how to create video images, and how to render them most effective. Video images are created by the video camera or by computer. Because the video camera produces electronic images of what the camera lens sees, these images are called *lens-generated*. Images that are created by a computer, such as the letters in titles or animated graphics of weather maps, are *synthetic*, or *computer-generated,* images. Most video productions use a combination of both.

The creation of "audio images," or sound, can be a reproduction of real sounds or the generation of synthetic sounds. *Microphone-generated* sounds are quite similar to the lens-generated visual images: both are faithful reproductions of the sights and sounds around us. *Computer-generated* audio images, generally called *synthesized sound*, can either imitate natural sounds or create a whole new idiom. As in video, reproduced and synthesized sounds are often combined for heightened effect.

Image control implies not only the technical control of pictures and sound—such as specific lighting techniques or audio mixing techniques. It also implies aesthetic control—how to compose pictures and sound for maximum communication effect.

Scanning The movement of the electron beam from left to right and from top to bottom on the television screen.

Field One-half of a complete scanning cycle, with two fields necessary for one television picture frame. There are sixty fields per second, and thirty frames per second.

Frame A complete scanning cycle of the electron beam (two fields), which occurs every thirtieth second. It represents the smallest complete television picture unit.

Focal Length How much of a scene the lens can see and how magnified the distant object looks.

Zoom Lens Variable-focal-length lens. All video cameras are equipped with a zoom lens.

Zoom Range The degree to which the focal length can be changed from a wide shot to a close-up during a zoom. The zoom range is stated as a ratio, such as 10:1.

Fast Lens A lens that permits a relatively great amount of light to pass through (low f-stop number). Can be used in low-lighting conditions.

Slow Lens A lens that permits a relatively small amount of light to pass through (high f-stop number). Can be used only in well-lighted areas.

Iris Adjustable lens-opening mechanism. Also called *lens diaphragm.*

Aperture Iris opening of a lens; usually measured in f-stops.

f-stop The calibration on the lens indicating the aperture. The larger the f-stop number, the smaller the aperture; the smaller the f-stop number, the larger the aperture.

Beam Splitter Optical device within the camera that splits the white light into three primary colors: red, green, and blue.

CCD Stands for charge-coupled device. An image-sensing element that translates the optical image into a video signal.

Viewfinder A small video monitor on a camera that displays the picture the camera generates.

Camera Chain The camera and associated electronic equipment, consisting of the power supply, the sync generator, and the CCU (camera control unit).

Camera Control Unit (CCU) Equipment, separate from the actual camera, that allows the VO (video operator) to adjust the color and brightness balance before and during the production.

HDTV (high-definition television) Camera A special camera system that produces high-quality, high-resolution pictures.

ENG/EFP Camera Highly portable, self-contained electronic news gathering or electronic field production camera.

Camcorder A portable camera with the VTR either attached to it (ENG/EFP camcorder), or built into the camera (consumer camcorder).

The Video Camera

B**EFORE going to the next Triple-I shoot,** you feel that you should get a camcorder and try it out so you have some idea of how to take effective pictures. After all, a good camcorder is an important prerequisite for producing an effective videotape that will show the Triple-I people just how good a camera operator you are. But while looking at all the cameras in the store, you overhear the salesperson explaining television scanning to another customer. According to the salesperson, knowing how a video image is formed is basic to understanding video equipment. What if the Triple-I people ask you how the video image is formed? Here is some information that will not only help you feel more comfortable during this Triple-I production, but will also help you understand how a video camera works. Before getting ahead of ourselves, let's see what this chapter will offer—

▪ **BASIC IMAGE FORMATION**
Scanning process

▪ **BASIC CAMERA FUNCTION AND ELEMENTS**
Basic function, lens, beam splitter, imaging device, and viewfinder

▪ **TYPES OF CAMERAS**
Studio cameras, ENG/EFP cameras and camcorders, and the various cable connectors

BASIC IMAGE FORMATION

You may have been annoyed by the large back of your television set, especially when trying to place it in a tight corner. But this large back is necessary for the creation of the video image. The back end of the monochrome (black-and-white) picture tube houses the *electron gun* that emits a tiny but sharp *electron beam*. This beam is guided through the long neck of the picture tube to scan the face of the tube, which

3.1

VIDEO IMAGE
FORMATION

The electron gun in the back
end of the picture tube
generates an electron beam.
This beam is guided through the
long neck of the tube to scan
the thousands of dots covering
the face of the tube.

is covered with thousands of tiny phosphorous dots. The stronger the beam, the brighter the dots will light up. **SEE 3.1** When the beam is too weak to get the dots to glow, the screen appears to be black. When the beam hits the dots at full strength, the screen looks white.

A color set has three electron guns in the back of the tube that emit three separate electron beams. The face of the color picture tube has neatly arranged groups of red, green, and blue dots, which are activated by these three beams. One of the beams is always designated to hit the red dots, the second to hit the green dots, and the third to hit the blue dots. **SEE COLOR PLATE 4** Various combinations of the these three primary colors provide all the colors you see on the video screen. We will discuss these three primary colors and how they mix into all others in chapter 6.

Scanning Process

The electron beam, which is emitted by the electron gun, scans the television screen much as you read, from left to right and from top to bottom. Unlike a person reading, however, the beam skips every other line during its first scan, *scanning* only the odd-numbered lines. **SEE 3.2A** Then the beam returns to the top of the screen and scans all the even-numbered lines. **SEE 3.2B** When all odd-numbered lines are scanned, which takes exactly 1/60 sec., we have one *field*. The subsequent scanning of all even-numbered lines, which takes another 1/60 sec., produces another field. The two fields, which take 1/30 sec., make up one *complete picture*, called a *frame*. **SEE 3.2C** Thus, we have sixty fields, or thirty frames, per second.

 KEY CONCEPT 1 **A television frame is made up of two scanning fields. There are thirty frames (or sixty fields) per second.**

3.2

TELEVISION SCANNING

A The electron beam first scans all odd-numbered lines, from left to right and from top to bottom. This first scanning cycle produces a field.

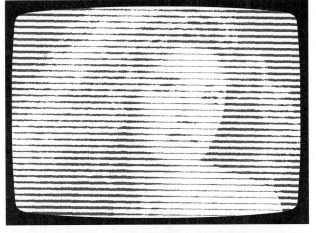

B The electron beam jumps back up to the top again and scans all even-numbered lines. This second scanning cycle produces a second field.

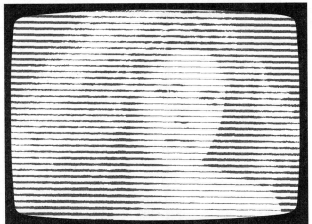

C The two fields (the scanning of all odd- and even-numbered lines) make up a complete television picture, called a frame.

A complete television frame in our NTSC system consists of 525 scanning lines (NTSC stands for National Television System Committee). You can find more information about the NTSC system later in this chapter. The high-definition television (HDTV) picture has over twice as many scanning lines as the regular television picture. The HDTV electron beam must scan 1,125—generally spoken as "eleven twenty-five"—scanning lines in the 1/30 second it takes to complete one television frame. This results in a sharper picture.

BASIC CAMERA FUNCTION AND ELEMENTS

Now you feel ready to purchase your new camcorder. And here it is, right in front of you! While excited about this new camera, you are also beginning to have some doubts about whether you actually got a really good deal, as the salesperson assured you. You vaguely remember some of the technical jargon he used while demonstrating the camera: "two-chip high-resolution imaging device," "fast, 10:1 power zoom lens," "high variable shutter speed," "auto iris, auto focus, and auto white balance," "built-in character generator," "goes down to three lux," "low-noise gain," "flying erase head," "high signal-to-noise ratio," "built-in time code generator," "XLR connector." He didn't mention anything as elementary as the basic scanning process.

Although the salesperson assured you that the camera is easy to operate, you now find many buttons whose functions are unfamiliar to you. A casual glance through the manual makes it quite clear that this is not bedtime reading.

Don't worry. You bought a good product. Let's translate the technical jargon into what the camera can actually do. Then we can take a closer look at the features and learn when and how to use them for optimal image creation and control. Don't take the following brief translations as precise or complete definitions; they merely explain what these camera features can do for you.

Two-chip high-resolution imaging device This means that your camera will produce excellent color, good light and dark contrast, and a sharp picture.

Fast, 10:1 power zoom lens "Fast" has nothing to do with how fast you can zoom in or out; it means that the lens lets enough light through to shoot under low-light conditions. The "10:1 power" lets you move smoothly from a wide vista to a tight close-up view, or the other way, by pressing a single toggle switch.

High variable shutter speed The shutter prevents a fast-moving object from looking blurred. The higher the shutter speed, the less likely a fast-moving object will look blurred.

Auto iris, auto focus, and auto white balance Auto iris means that the lens will sense how much light there is on the scene and will adjust the amount of light passing through so the picture looks neither too dark nor too washed out, but just about right. The auto focus device helps you to retain reasonably sharp focus even if you or the object you are videotaping moves. Auto white balance means that the colors look fairly true, regardless of whether you shoot outdoors on a bright summer day or indoors under candlelight.

Built-in character generator You can print some titles or the date of recording over the scene you are taking.

Goes down to three lux You can take pictures even in very low lighting conditions.

Low-noise gain This has nothing to do with the amount of noise you hear when using the camera. Instead, it has to do with the camera producing bright pictures even in a low-lighting environment without additional lights. The picture loses little of its original crispness.

Flying erase head This is a feature of the camcorder's videotape recorder. It lets you edit in the camera, so you can join several scenes without picture breakup at the connections.

High signal-to-noise ratio This ratio has nothing to do with high-volume sound sources, but with relative picture quality. A high signal-to-noise ratio means that the picture signal is much stronger than the inevitable electronic interference. Your pictures look crisp and are fairly immune to interference.

Built-in time code generator Each "frame" of your videotape has a number like a street address or the numbers on your film negative that will help you locate a specific spot on the videotape for finding a scene or for precise editing.

XLR connector You can plug in a professional microphone without the need for an adapter.

Function

The main function of the video camera is to translate the optical image that the lens sees into a corresponding video picture. More specifically, the camera *converts an optical image into electrical signals that are reconverted by a television receiver into visible screen images.*

To fulfill this function, each video camera needs three basic elements: (1) the lens, (2) the camera itself, and (3) the viewfinder. **SEE 3.3**

3.3

BASIC CAMERA ELEMENTS

The video camera has three main elements: the lens, the camera itself, and the viewfinder.

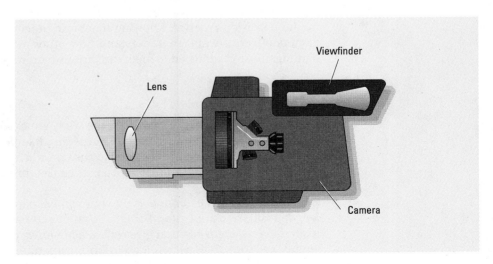

Viewfinder

Lens

Camera

FUNCTIONS OF THE CAMERA

The video camera translates the optical light image as seen by the lens into a corresponding picture on the screen. The light reflected off an object is gathered and transmitted by the lens to the beam splitter, which splits the white light into red, green, and blue light beams. These light beams are then transformed by CCDs into electrical energy, which is amplified and processed, and then reconverted into video pictures by the viewfinder.

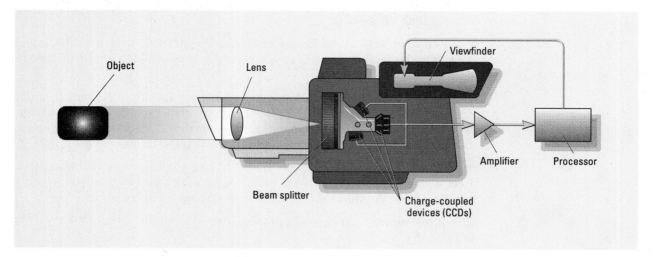

The *lens* selects a portion of the scene at which you point the camera and produces a sharp optical image of it. The *camera* contains a *beam splitter* and an *imaging* or *pickup* device that converts the optical image of the lens into weak electrical currents or signals, which are amplified and further processed by a variety of electronic components. The *viewfinder* reconverts these electrical signals into video pictures of the lens-generated scene. **SEE 3.4**

To explain this process, we will start with how a lens operates and sees a particular portion of a scene, then move to how the beam splitter and the imaging device work, and, finally, to how the video signal is reconverted to a video picture by the television receiver. Knowing this basic process will help you to use your camera effectively and to understand how other production elements, such as lighting, must be adjusted to meet the various requirements of the camera.

The Lens

Lenses determine what cameras can see. They are classified by their *focal length* (or *angle of view*) and by their *speed*. *Focal length* indicates how much of a scene we can see through a lens from a specific position and how magnified distant objects look. Speed refers to how much light a lens can let through.

Focal length The *zoom lens* on your camera can change from a *short-focal-length* position to a *long-focal-length* position and back in one continuous move. A *short-focal-length* position gives you a *wide-angle view*. This is why short-focal length, or "short," lenses on a still photo camera are called *wide-angle* lenses. To bring your zoom lens into the *extreme wide-angle* position, you need to zoom

3.5

WIDE-ANGLE LENS VIEW

The wide-angle lens shows a wide vista, with the far objects looking quite small.

3.6

NARROW-ANGLE LENS VIEW

The narrow-angle, or telephoto, lens shows only a narrow portion of the scene, with the background objects magnified so that they are similar in size to the foreground object.

3.7

NORMAL LENS VIEW

The normal lens shows a vista and a perspective that are similar to what we actually see.

all the way out. You will see a relatively large portion of the scene in front of you, but the middle and background objects look quite small and, therefore, far away. SEE 3.5

Zooming all the way in will put your zoom lens into a *long-focal-length* position. Your zoom lens will now give you a much narrower, but enlarged, view of the selected scene. This is why the long-focal-lens position is also referred to as the *narrow-angle*, or *telephoto*, position. SEE 3.6

When you stop your zoom in the middle of the zoom range (between the extreme wide-angle and narrow-angle positions), you are more or less in the *normal lens* position. The angle of view of a *normal lens* approximates what you would see when looking directly at the scene. SEE 3.7

Because the zoom lens gives you a great variety of focal lengths between its extreme wide-angle and narrow-angle positions, it is also called a *variable-focal-length* lens.

Zoom range　The *zoom range* refers to how close a view you can achieve when zooming in from the farthest wide-angle position to the closest narrow-angle position. The higher the first number of the ratio is, the closer you can get to the object from the farthest wide-angle position. You may remember that the salesperson praised the 10:1 (ten-to-one) zoom lens ratio of your camcorder. This zoom lens lets you narrow and magnify the field of view ten times when zooming

MAXIMUM WIDE-ANGLE AND NARROW-ANGLE POSITIONS OF 10:1 ZOOM LENS

A 10:1 zoom lens can narrow the angle of view by ten times. It seems to bring a portion of the scene closer to the camera.

in from the farthest wide-angle position to the closest narrow-angle position. In practical terms, you can move in to a pretty good close-up from your wide-angle shot. An 8:1 ratio will not get you this close a view. In other words, the lens on your camcorder has a good zoom ratio. **SEE 3.8**

Some of the large cameras used in the coverage of sports or other outside events have lenses with zoom ratios of 40:1 or more. These lenses are as large as, or sometimes even larger than, the camera to which they are attached. With such a lens, you can zoom in from a wide shot of the total football field to a close-up of the quarterback's face. The large zoom range is necessary because these cameras are usually fixed on top of the stadium, far away from the event. Instead of the camera moving closer to the event, as you can with your camcorder, the zoom lens must bring the event closer to the camera.

The focal length of a lens influences how much you see of a scene and how close it seems to you (the field of view). It also influences how much you can move the camera and how the pictures look to the viewer. You will read more about these aspects in chapters 4 and 5.

Lens speed As pointed out earlier, "speed" refers to how much light can pass through a lens to the imaging device. A *fast lens* can let a relatively great amount of light pass through; a *slow lens* is more limited in how much light it can transmit. In practice, a fast lens allows you to produce acceptable pictures in a darker environment than a slow lens. Fast lenses are, therefore, more useful than slow ones; but they are also more expensive.

You can tell whether a lens is fast or slow by looking at the lowest *f*-stop number on the lens, such as *f*/1.4 or *f*/2.0. The lower the number, the faster the lens.

Lens iris and *f*-stops Like the pupil of your eye, all lenses have an *iris* that controls how much light can pass through. In a bright environment, the iris of your

3.9

IRIS CONTROL RING

The *f*-stop calibration is printed on a ring that controls the iris opening, or aperture, of the lens.

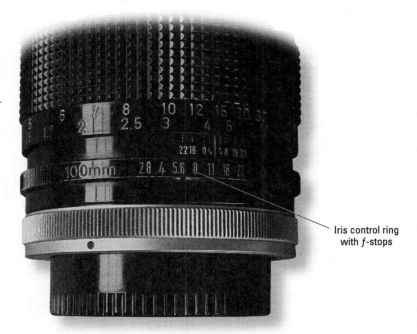

Iris control ring
with *f*-stops

eye contracts to a smaller opening, restricting the amount of light going through; in a dim environment, it expands to a larger opening, admitting more light.

The *lens iris*, or *diaphragm*, operates the same way. The center of the iris has an adjustable hole, called the ***aperture***, that can be made large or small. By changing the aperture, or iris opening, you control how much light the lens lets fall in. When there is little light, you can make the hole bigger and let more light through. This is called "opening the lens," or "opening the iris." When there is a great amount of light, you can make the hole smaller to restrict the light going through the lens. In so doing, you "close down" the lens or iris. You can thus control the exposure of the picture so that it looks neither too dark (not enough light) nor too washed out (too much light).

Now you can explain a fast or slow lens in more technical terms: A fast lens transmits more light at its maximum aperture (iris opening) than a slow one.

The standard by which we measure how much light is admitted through the lens is called the ***f-stop***. All lenses have a ring at their base with a series of *f*-stop numbers printed on them (such as 2, 4, 5.6, 8, 11, 16) that control the iris opening. **SEE 3.9** When you turn the ring so that *f*/2 lines up with the little mark on the lens, you have "opened" the lens to its maximum aperture. It now lets as much light pass through as it possibly can. When you turn the ring to *f*/16, the lens is "stopped down" to its minimum aperture, letting very little light pass through. A fast lens should have a maximum aperture of *f*/2.8 or better. Good lenses go as low as *f*/1.4, or occasionally even to *f*/1.2. When checking the lens on your camcorder, you see that its maximum aperture is *f*/2. Besides having a good zoom ratio, your lens is also quite fast.

Notice that the *f*-stop numbers mean just the opposite from what you expect them to be: *The lower the f-stop number, the larger the aperture and the more light is transmitted. The higher the f-stop number, the smaller the aperture and the less light is transmitted.* **SEE 3.10**

3.10

f-STOP SETTINGS

The higher the *f*-stop number, the smaller the iris opening and the less light is transmitted by the lens. The lower the *f*-stop number, the larger the iris opening and the more light is transmitted by the lens.

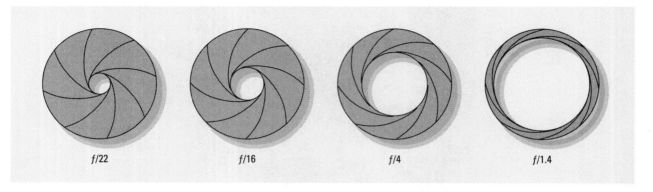

f/22 f/16 f/4 f/1.4

 KEY CONCEPT 2 **The lower the *f*-stop number, the larger the aperture and the more light is transmitted. A fast lens has a low minimum *f*-stop number (such as *f*/1.4).**

 KEY CONCEPT 3 **The higher the *f*-stop number, the smaller the aperture and the less light is transmitted. A slow lens has a relatively high minimum *f*-stop number (such as *f*/4.5).**

Auto iris One of the features that the salesperson tried to impress you with was the auto iris. Rather than having to turn the iris control ring to the proper *f*-stop by hand, the *auto iris* adjusts itself automatically to the optimal aperture. The camera reads the light level of the scene and tells the auto iris to open up or close down until the resulting picture is neither too dark nor too light. Such an automated feature is not without drawbacks, however. We will consider possible advantages and disadvantages of an auto iris in chapter 5.

Beam Splitter

One of the main components within the camera itself is the *beam splitter*, which separates ordinary white light into its three *primary* colors: red, green, and blue. When technical people talk about *RGB*, they are referring to the red, green, and blue *primary* light colors or their corresponding signals. Red, green, and blue are called "primaries" because they are the basic light colors from which all others can be mixed. All the colors of the lens-generated image are separated by the beam splitter into these three light primaries. Do not confuse the light primaries, also

3.11

PRISM BLOCK

The prism block contains prisms and filters that split the incoming light images as produced by the lens into the three light primaries and direct them into their CCDs.

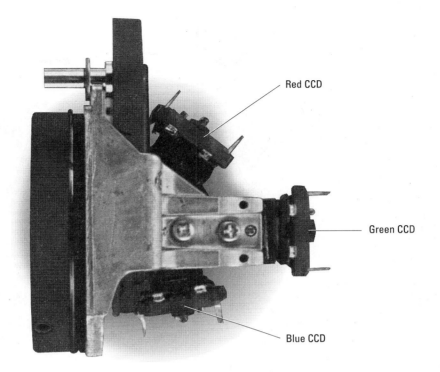

Red CCD

Green CCD

Blue CCD

called *additive* primaries, with the subtractive primary colors used in painting. We will discuss why they are called additive primaries and how they mix into other colors in chapter 6.

The actual beam splitter consists of a series of prisms and filters locked into a *prism block*. **SEE 3.11** The prism block splits the incoming light into three colored beams—red, green, and blue—then directs the RGB light beams into their corresponding imaging devices. The imaging devices then transform these beams into electric energy, the RGB video signals. **SEE COLOR PLATE 1**

Imaging Device

A second main component inside the camera is the imaging device. The imaging device, or *pickup device,* transduces (changes) light into electric energy. The imaging device in most modern cameras and all camcorders is a *CCD,* often called a "chip." *CCD* stands for *charge-coupled device.* It is a relatively small solid-state silicon chip that contains horizontal and vertical rows of thousands of light-sensing picture elements, called *pixels.* Each pixel can translate the light energy it receives into a corresponding electric current.

Pixels function very much like the individual tiles in a mosaic, or the dots in a color print. The more you have in a given picture area, the sharper the image will be. **SEE 3.12** Similarly, the more pixels your CCD ("chip") contains, the sharper the resulting screen image. A high-resolution chip means that it has a great many pixels.

You may find that some of the older studio cameras do not have CCDs as the imaging device, but pickup tubes. Although the tubes produced sharp images, they were highly vulnerable to bright lights and extreme contrast. Pointing a tube into a strong light source would seriously damage—and often destroy—the rather

PICTURE RESOLUTION

The picture on the right is made up of more dots than the one on the left. It has a higher resolution and looks sharper.
The more pixels a CCD contains, the higher the resolution of the video image.

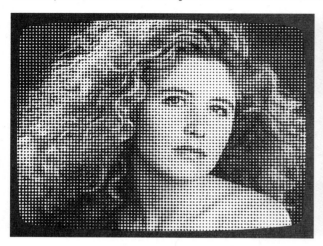

expensive tube. They also made the cameras rather large and heavy. Some of the HDTV (high-definition television) cameras still use tubes because they produce a higher-resolution (sharper) picture than the CCD cameras.

 KEY CONCEPT 4 **The CCD imaging device converts light into electric energy.**

Professional cameras normally contain three CCDs—one for each of the RGB light images. But most small semiprofessional or consumer camcorders have two CCDs, or only a single one. In a camera with two chips, a special filter splits the light into two primary light colors (usually red and green), with the third being reconstructed automatically by the camera. When the camera contains only a single chip, the incoming white light is divided by a filter into all three primary colors, which are then processed as individual signals by the single CCD. Even if the single chip is high-quality, with many thousands of pixels, it can devote only one-third of its pixels to each color. The color information and resolution have necessarily less fidelity than if three chips were used.

The advantage of single-chip cameras is their small size. You will find that even single-chip cameras can produce pictures of astonishing quality, and that a good two-chip camera can seriously challenge the three-chip camera in color fidelity and resolution. The 10:1 zoom lens and the two-CCD imaging device definitely puts your camcorder into the higher-quality camera class.

Video signal processing The electric charges that come from the pixels are extremely weak and need to be amplified before they can be further processed into a video signal. The final video signal, which produces the pictures on a television

set, is then transported to the camera viewfinder and to the built-in videotape recorder, or one attached to the camera, as shown in figure 3.4. This signal processing consists of combining the RGB color signals with another signal that carries the brightness or black-and-white information of the image. The combined color signals make up the *chrominance channel,* or *"C"* signal (*chroma* is Greek for *color*). The black-and-white signal is called the *luminance* or *"Y"* signal (*lumen* is Latin for *light*). Both the C and the Y signals are merged into a *composite* signal, called the *NTSC signal,* or *NTSC* for short. **SEE COLOR PLATE 2** Remember, NTSC stands for National Television System Committee.

KEY CONCEPT 5 **The composite color signal combines an RGB chrominance channel with a black-and-white luminance channel.**

Viewfinder

The *viewfinder* is a small video monitor attached to the camera that shows a close image of what the camera sees. Most viewfinders are *monochrome,* which means they show in black-and-white the color pictures the camera produces. Some of the more expensive cameras have color viewfinders, which greatly aid the camera operator in picture composition. The viewfinders on camcorders are quite small and need to be enlarged by a small magnifying glass. On large studio cameras, however, viewfinders are relatively large and resemble small television sets.

TYPES OF CAMERAS

If you were to go back to the studio and field productions and look at the cameras rather than the people, you would find that in the studio they use rather large cameras mounted on special pedestals, and much smaller ones in the field. But even the field cameras are considerably larger than your camcorder. We will use camera size and usage to categorize the various types of cameras.

The large, high-quality cameras you normally find in television studios are, appropriately enough, called *studio* cameras. The smaller cameras used in field production are called *ENG/EFP* (electronic news gathering/electronic field production) or simply *field* cameras. Your small camcorder is normally called a *consumer* or *small-format* camcorder. The difference between a camera and a camcorder is that the camcorder (from *cam*era and re*corder*) has a videotape recorder attached to it or solidly built into it to form a single, inseparable unit.

Studio Cameras

Studio cameras are large cameras that are too heavy to be maneuvered without the aid of a pedestal or some other kind of camera mount. **SEE 3.13** They are typically used in studio productions such as interviews, news, game shows, and also in big remote telecasts, such as sports events.

3.13

STUDIO CAMERA

High-quality studio cameras contain three CCDs and many electronic controls. They have a large lens and viewfinder attached, which makes the whole camera head much heavier than an ENG/EFP camera.

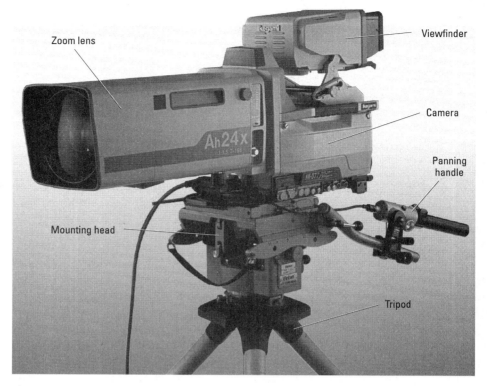

Zoom lens

Viewfinder

Camera

Panning handle

Mounting head

Tripod

Studio cameras are built to produce exceptionally high-quality pictures under a variety of conditions. They all have three CCDs, special control equipment, and a large, high-quality zoom lens. To ensure optimal picture quality at any given moment during the production, the studio camera is hooked up via cable to a variety of equipment that supplies power and permits manual control of various electronic and optical functions, such as the lens iris. Unlike the ENG/EFP camera or a small camcorder, the studio camera cannot function by itself but must be connected to external power and control equipment. Because the camera and the associated equipment are necessarily linked together, they are called a *camera chain*.

Camera chain The standard *camera chain* consists of four parts: (1) the camera itself, which—as the front part of the chain—is called the *camera head;* (2) the *power supply;* (3) the *sync generator;* and (4) the *camera control unit,* or simply, *CCU.* **SEE 3.14**

The *power supply* feeds the necessary electricity to the camera head through the camera cable. Unlike ENG/EFP cameras or camcorders, studio cameras cannot be powered by batteries. The power supply is built into the CCU.

The *sync generator* produces the uniform electrical pulse that is necessary to synchronize the scanning of the video pictures in a variety of equipment (such as video monitors and viewfinders).

The *camera control unit (CCU)* has two major functions: setup and control. *Setup* refers to the adjustments made when the camera is first powered up. The video operator (VO), who is in charge of the camera setup and picture control during

3.14

STANDARD CAMERA CHAIN

The standard camera chain consists of the camera head (the actual camera), the power supply, the sync generator, and the camera control unit (CCU).

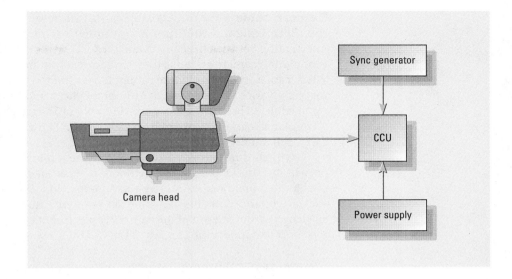

Camera head

Sync generator

CCU

Power supply

3.15

CAMERA CONTROL UNIT (CCU)

The CCU has a variety of controls with which the VO (video operator) can continuously monitor and adjust picture quality.

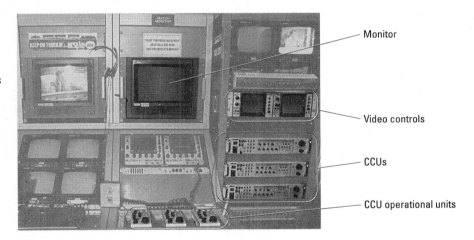

Monitor

Video controls

CCUs

CCU operational units

the production, will make sure that the colors the camera delivers are true, that the iris is at the proper setting, and that the camera is adjusted for the brightest spot in the scene (white level adjustment) and darkest spot (black level or pedestal adjustment) so that we can see the major steps within this contrast range. Fortunately, the VO is greatly aided in this task by a computerized setup panel.

Assuming that the camera is fairly stable, which means that the camera retains the setup values over a period of time, during production the video operator usually needs to adjust only the lens iris, by moving a remote iris control knob or lever on the CCU. **SEE 3.15**

 KEY CONCEPT 6 **The camera chain consists of the camera head (actual camera), a power supply, a sync generator, and a camera control unit (CCU).**

Camera cable The camera cable carries the power to the camera and transports the picture signal, the intercommunication signal, and various technical information between the camera and the CCU. Some cables are designed for analog (nondigital) camera systems; they have a great number of wires packed into them. These cables, called multicore cables, have a limited reach (up to 2,000 feet or 600 meters). Newer cameras use the thinner, lighter, and more flexible triax or fiber-optic cables. They also have a considerably farther reach than multicore cables. A triax cable can reach about 5,000 feet (or 1,500 meters), and a fiber-optic cable can reach almost 2 miles (3,000 meters).

 Why do studio cameras need such a great reach? Because they are used not only in the studio, but also at "remotes"—scheduled events that happen outside the studio—that need extremely high-quality video. When covering sports events such as golf tournaments, downhill ski races, or auto races, the cameras are often so far away from the rest of the camera controls that even a 2-mile cable may prove too short to connect the camera to the CCU.

Connectors Whenever you work with several pieces of equipment that need to be hooked together to form a video or audio system, you need the appropriate cables and especially the right connectors. Despite careful preproduction, many productions have had to be delayed or even canceled because the connectors for camera or audio cables did not fit. You will find that one of the most important tasks when taking equipment out in the field is to check the interconnecting cables and connectors. Although you may hear production people call all connectors "plugs," regardless of whether they represent the male or female part of the connector, it is more precise to call the male part of the connector *plug*, and the female part *jack*. **SEE 3.16** Figure 3.16 shows the standard video connectors. (The standard audio connectors are shown in figures 8.24 and 8.25.)

 Most professional video equipment uses BNC connectors for the video coax cable, and XLR connectors for audio cables. The large UHF connector is rarely used today. Consumer equipment normally uses RCA phono, or mini, plugs and jacks. But because we are constantly seeking to make video equipment smaller and more compact, you may well find that small connectors will be used also for professional-quality equipment.

3.16

STANDARD VIDEO CONNECTORS

The standard video connectors are BNC; UHF connector (used for older equipment); and RCA phono (also used for audio). There are adapters available that let you join each of these connectors with the others.

BNC

UHF

RCA phono

HDTV Camera

The *HDTV (high-definition television) camera* delivers an extremely sharp picture. It also produces better colors and more subtle light/dark contrast steps than the regular studio camera. It was developed primarily to replace the film camera in the production of electronic cinema. Compared to the normal television picture, the HDTV picture is horizontally stretched. Instead of the normal height-to-width ratio of a television picture, which is three units high and four units wide, the HDTV picture is three units high and more than five units wide (or, more accurately, nine units high and sixteen units wide). This relationship between height and width is called the *aspect ratio*.

To achieve an extremely high-resolution image, the HDTV cameras need special lenses, special imaging devices (high-quality CCDs or pickup tubes), special signal-processing equipment, special viewfinders and monitors, and special videotape recorders. As you can see, the HDTV system is not compatible with regular video equipment. It is not used in normal television production, but for such specialized applications as electronic filmmaking, medical research, and the production of commercials. It is also quite expensive.

ENG/EFP Cameras

The *ENG/EFP camera* (electronic news gathering/electronic field production camera) is portable and designed to be carried and operated by a single person. Although it is considerably smaller than the studio camera, it contains the whole camera chain in the camera itself. The camera is usually battery-powered, but can also be powered through a camera cable. It has built-in automatic controls that greatly aid the camera operator in maintaining quality pictures with a minimum of adjustment. ENG/EFP cameras have much smaller zoom lenses and viewfinders than studio cameras and are considerably lighter. **SEE 3.17**

3.17

ENG/EFP CAMERA

A high-quality ENG/EFP camera has three CCDs and contains all parts of the camera chain in the camera itself. It can be battery-operated or connected to an external power source and an RCU (remote control unit).

Carrying handle

Viewfinder

Zoom lens

Camera

You may recall the camera setup during the MTV production described in chapter 2: two of the EFP cameras were mounted on tripods and one was carried by the operator. All were connected by cable to a small remote truck. Why have cables when the cameras are basically self-contained?

First, although the ENG/EFP cameras are capable of running on batteries, it is often better for them to receive their power from an external source. External power frees you from having to worry about running out of batteries during a long shoot.

Second, while the built-in CCUs produce good pictures for each individual camera, it is important to control the color match of all three cameras during the production. One video operator can control the pictures of each camera with individual portable CCUs, called *RCUs* (remote control units). **SEE 3.18** Such continual adjustment ensures that the pictures of all three cameras match in color and contrast, even if they shoot against different backgrounds or under different lighting conditions.

3.18

REMOTE CONTROL UNIT

The RCU is connected with the ENG/EFP camera by a camera cable. It overrides the controls built into the ENG/EFP camera and enables a VO to continually adjust the pictures for optimal quality. The cable also supplies power to the camera and carries intercommunication between camera operator and the people at the RCU.

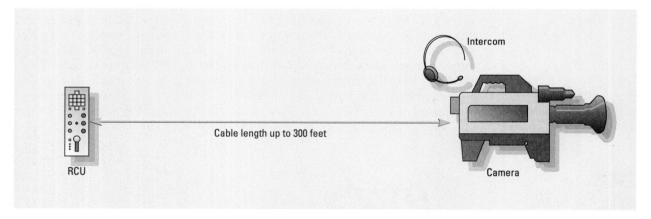

Third, without the additional weight of a videotape recorder (VTR), the camera is considerably lighter and easier to operate.

Fourth, because the director can see on a monitor what the camera operators see in their viewfinders, he or she can give the camera operators the necessary instructions over the intercom headsets while the scene is in progress. All these production advantages certainly outweigh by far the slight disadvantage of having the cameras tethered to a remote truck. Apparently, the director and TD of the MTV shoot knew what they were doing.

Dockable ENG/EFP camera Of course, you could not use such a setup when running after a news event, or when shooting scenes for a documentary. In these cases, you would need a portable VTR that is connected to the camera by a short cable, or "docked" with the camera. *Docking* means that the VTR can be plugged into the back of the camera to form a single camcorder unit. **SEE 3.19**

3.19

DOCKABLE ENG/EFP CAMERA

This type of ENG/EFP camera can be docked with (plugged into) a variety of small videotape recorders, thus forming a single camcorder unit.

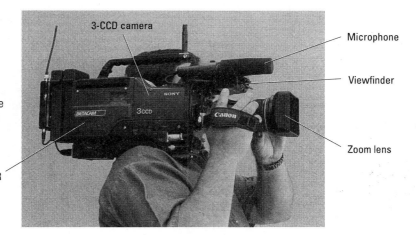

3-CCD camera

Microphone

Viewfinder

Zoom lens

Betacam VTR

Studio conversion of ENG/EFP camera Although the quality of the best ENG/EFP camera is below that of the best studio camera, high-quality ENG/EFP cameras are often used in place of studio cameras. The reasons for substituting ENG/EFP cameras for the larger studio cameras are that ENG/EFP cameras are considerably cheaper and easier to handle than studio cameras. To adapt an ENG/EFP camera to studio conditions, you need to replace the small viewfinder with a larger one, attach a faster lens that has a zoom ratio more appropriate for studio dimensions, and affix special cables for focus and zoom control. **SEE 3.20**

3.20

STUDIO CONVERSION OF ENG/EFP CAMERA

Converting a high-quality ENG/EFP for studio use requires a large viewfinder, a lens with a zoom ratio appropriate for the size of the studio, special cables that allow zooming and focusing from the operator's position, and special mounting devices for a tripod or studio pedestal.

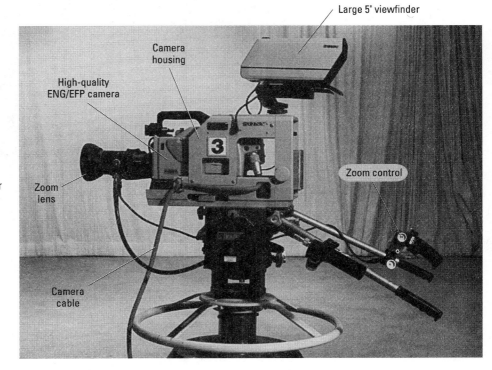

Large 5" viewfinder

Camera housing

High-quality ENG/EFP camera

Zoom control

Zoom lens

Camera cable

Camcorder

A *camcorder* is either an ENG/EFP camera docked with a VTR, or a camera that has its VTR solidly built into it. Most high-quality ENG/EFP cameras are "dockable," which allows you to attach different videotape recorders. Most small-format camcorders have their VTR built into the camera. All camcorders have an external microphone, called the *camera microphone*, and a jack for an additional microphone. Some have a small camera light attached to illuminate a small area during ENG or to provide additional illumination. **SEE 3.21**

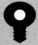 *KEY CONCEPT 7* **A camcorder has its VTR attached or built into the camera.**

3.21

CONSUMER, OR SMALL-FORMAT, CAMCORDER

The consumer, or small-format, camcorder contains one, two, or three CCDs, automatic control equipment, some titling devices, and a built-in VTR. Some of the three-chip consumer camcorders rival their larger and more expensive ENG/EFP camcorders and are referred to as "prosumer" models.

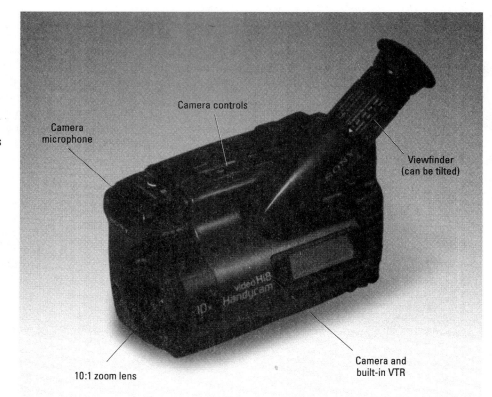

Camera controls

Camera microphone

Viewfinder (can be tilted)

10:1 zoom lens

Camera and built-in VTR

What's the Difference?

When you compare the pictures you took with your consumer camcorder to a similar scene shot with an expensive and much larger, heavier professional camcorder, you may have trouble seeing any difference in picture quality. Even professional camera operators are occasionally surprised by the excellent picture quality of the consumer camcorders, especially when there is plenty of light available. What, then, is the difference? Why bother with the heavier and much more expensive equipment?

The most obvious difference is that professional cameras can accept an external sync signal that makes all cameras scan exactly the same way. This synchronized scanning is especially important when you want to switch instantly from one camera to another, as during a live pickup of a football game. Most professional cameras have better lenses than the consumer camcorders. ENG/EFP camera lenses have a higher zoom ratio, a smoother zoom mechanism, and a wider maximum aperture than the camcorder lenses.

ENG/EFP cameras also have additional electronics that produce high-quality pictures that will not deteriorate substantially when sent over the air or when put on videotape. The better the pictures you send to the videotape recorder or transmitter, the better they look when seen on the television receiver.

But don't worry. You don't need a high-end ENG/EFP camera to produce interesting videotapes or to show the Triple-I people how creative you are with the camera. You can be sure that the Triple-I people will judge the quality of your videotaped segment more by what pictures you shoot and how you frame them than by the number of pixels per square inch. The discussion in chapter 4 about looking through the viewfinder will help you do just that.

ONCE AGAIN, REMEMBER...

Basic Image Formation

The video image is accomplished by an electron beam (or beams) that scans the face of the picture tube, which is lined with phosphorous dots. The beam first scans the odd-numbered lines of dots from left to right and from top to bottom, which produces the first field, and then the even-numbered lines, which produces the second field. Two complete fields make up a television frame. There are thirty frames per second.

Basic Camera Elements

These include the lens, the beam splitter, the imaging device—which is usually a CCD (charge-coupled device)—and the viewfinder.

Lenses

Lenses are classified by the focal length, angle of view, and speed. The zoom lens has a variable focal length. The zoom range is stated in a ratio, such as 10:1 (can show the object ten times closer from the extreme wide-angle position). A fast lens lets a relatively large amount of light pass through; a slow lens relatively little. The speed of the lens is determined by the maximum aperture, or iris opening. The specific aperture is indicated by f-stops.

Beam Splitter and Imaging Device

These devices change the optical image of the lens to a video signal. The beam splitter divides the light that comes through the lens into a red, a green, and a blue (RGB) light beam. The imaging device—a CCD—transduces (changes) the colored light beams into electric energy.

Studio Camera

This is a large, high-quality camera typically used in the studio. It is normally mounted on a studio pedestal. The camera chain consists of the camera itself, a power supply, a sync generator, and the CCU (camera control unit).

ENG/EFP Camera

This is a portable camera, designed to be carried and operated by a single person. It contains the whole camera chain in the camera itself, and it is normally battery-powered. When docked (connected) with a small videotape recorder, it becomes a camcorder. All consumer camcorders have their VTRs built-in.

KEY CONCEPTS

- A television frame is made up of two scanning fields. There are thirty frames (or sixty fields) per second.

- The lower the *f*-stop number, the larger the aperture and the more light is transmitted. A fast lens has a low minimum *f*-stop number (such as *f*/1.4).

- The higher the *f*-stop number, the smaller the aperture and the less light is transmitted. A slow lens has a relatively high minimum *f*-stop number (such as *f*/4.5).

- The CCD imaging device converts light into electric energy.

- The composite color signal combines an RGB chrominance channel with a black-and-white luminance channel.

- The camera chain consists of the camera head (actual camera), a power supply, a sync generator, and a camera control unit (CCU).

- A camcorder has its VTR attached or built into the camera.

Field of View The portion of a scene visible through a particular lens; its vista. Expressed in symbols, such as CU for close-up.

Long Shot (LS) Object seen from far away or framed very loosely. The extreme long shot shows the object from a great distance. Also called *establishing shot*.

Medium Shot (MS) Object seen from a medium distance. Covers any framing between a long shot and a close-up.

Close-up (CU) Object or any part of it seen at close range and framed tightly. The close-up can be extreme (extreme or big close-up) or rather loose (medium close-up).

Over-the-Shoulder Shot (O/S) Camera looks over the camera-near person's shoulder (shoulder and back of head included in shot) at the other person.

Cross-Shot (X/S) Similar to over-the-shoulder shot, except that the camera-near person is completely out of the shot.

Vector A directional screen force. There are graphic, index, and motion vectors.

Headroom The space left between the top of the head and the upper screen edge.

Noseroom The space left in front of a person looking or pointing toward the edge of the screen.

Leadroom The space left in front of a laterally moving object or person.

Psychological Closure Mentally filling in missing visual information that will lead to a complete and stable configuration.

Z-axis Indicates screen depth. Extends from camera lens to horizon.

Depth of Field The area in which all objects, located at different distances from the camera, appear in focus. Depends primarily on the focal length of the lens, its f-stop, and the distance from the camera to the object.

Looking Through
the Viewfinder

AS soon as you point your camera** at some object or event, you need to make certain decisions about what to shoot and how to shoot it. Its relatively small screen has made video into a close-up medium. Because of this requirement, and often limited presentation time, you cannot usually show an entire event. You must select only the most significant details and then show them in the most effective way possible.

This selection process depends on how much time you have to study the event. If you have to cover a breaking news event, there is little time for you to study it in depth. Nevertheless, you must try to grasp its substance and select those details that enable the viewer to reconstruct the event. For example, a close-up of a worried onlooker during a fire may be much more telling about the people trapped inside than flames shooting out of the house. Stay away from sensational or cute shots, especially if they do not tell the real story.

If you are preparing an event, such as the "demo reel" for Triple-I, your selection of event details can, and should, be much more deliberate.

Effective camera operation depends not just on which details you choose to show, but on how you show them on the screen. In addition to a keen and sensitive eye, you need a basic knowledge of picture aesthetics—how to frame static or moving objects and events.

 KEY CONCEPT 1 **Select those event details that tell the real story with clarity and impact.**

A familiarity with some basic compositional principles will help you not only to produce pictures that have impact and meaning, but also to understand how and when to use the camera's operational controls and the zoom lens positions. The technical and operational features of the camera

are not designed to make aesthetic decisions for you, but rather to carry out your decisions as faithfully and efficiently as possible.

We have all had, at least once, the rather trying experience of watching someone's vacation videotapes. Unless the person shooting the videotapes was an expert camera operator, you probably saw an incessantly moving view that shifted almost randomly from object to object, annoyingly fast zooms, shots with too much sky or too much ground, and people who seemed to be glued either to the sides or the top of the screen, or who had background trees or telephone poles growing out of their heads.

To help you avoid such aesthetic pitfalls, let's take a closer look at—

THE BASICS OF FRAMING A SHOT
Field of view, vectors, composition, and psychological closure

MANIPULATING PICTURE DEPTH
Z-axis, lenses and perceived z-axis length, lenses and depth of field, and lenses and perceived z-axis speed

CONTROLLING CAMERA AND OBJECT MOTION
Camera movement and zooms, and shooting moving objects

FRAMING A SHOT

The most basic considerations in framing a shot are how much territory you include in your shot, how close an object appears to the viewer, where to place the object relative to the screen edges, and how to make viewers perceive a complete object when only parts of it are visible on the screen. In the terminology of photographic arts, including video, these factors are discussed as (1) field of view, (2) vectors, (3) composition, and (4) psychological closure.

Field of View

Field of view refers to how close the object seems to the viewer, or how much of the "field," or scenery, in front of you is in the shot.

When organized by how close we see the object, we have five field-of-view designations: *extreme long shot* (ELS or XLS), *long shot (LS)*, *medium shot (MS)*, *close-up (CU)*, and *extreme close-up* (ECU or XCU). **SEE 4.1**

When categorized by how much of a person we see, the shots are called (1) *bust shot*, which frames the upper part of a person, (2) *knee shot*, which shows the person approximately from the knees up, (3) *two-shot*, which shows two people or objects in the frame, (4) *three-shot*, which shows three people or objects in the frame, (5) *over-the-shoulder shot (O/S)*, which shows the camera looking at someone over the shoulder of another person nearer to the camera, and (6) *cross-shot (X/S)*, which looks alternately at one or the other person, with the camera-near person completely out of the shot. **SEE 4.2**

4.1

FIELD OF VIEW DISTANCE STEPS

The field of view distance steps are relative and depend on how a long shot or close-up is visualized.

Extreme long shot (ELS or XLS)
or cover shot

Long shot (LS)
or full shot

Medium shot (MS)
or waist shot

Close-up (CU)

Extreme close-up
(ECU or XCU)

4.2

AREA FIELD OF VIEW

Other shot designations tell where the subject is cut off by the upper or lower part of the frame, or by how many subjects are in the frame or how they are arranged in it.

Bust shot

Knee shot

Two-shot
(two people in the frame)

Three-shot
(three people in the frame)

Over-the-shoulder
(O/S) shot

Cross-shot
(X/S)

The field of view is relative, which means what you consider a close-up, someone else may think of as a medium shot. Because of the relatively small size of the video screen, the close-up is the most frequently used field of view in video production.

You can change the field of view either by moving the camera closer to the event or farther away from it, or by changing the focal length of the lens by zooming in or out. As you learned in chapter 2, zooming in will put the lens into the narrow-angle (telephoto) position and bring the subject closer to the camera for a close-up (CU) view. When you zoom out, the lens will gradually assume a wide-angle position and show more territory farther away. There are important visual differences between moving the camera closer or farther away from the subject and zooming in and out. We will take up these differences in the section on controlling camera and object motion later in this chapter.

KEY CONCEPT 2 **Video is a close-up medium.**

Vectors

A *vector* is a directional force with various strengths. This concept will help you understand and control the various screen forces generated by someone looking or pointing in a specific direction, moving in a particular direction, or even by the horizontal and vertical lines of a room, desk, or door. A thorough understanding of vectors will aid you in blocking—designing—effective movement of talent and cameras. There are three basic vectors: (1) *graphic vectors*, (2) *index vectors*, and (3) *motion vectors*.

Graphic vectors These vectors are created by lines or an arrangement of stationary objects that lead the eye in a particular direction. Look around you. You are surrounded by graphic vectors, such as the horizontal and vertical lines that are formed by this book you are reading, the window and door frames in the room, or the line where the walls meet the ceiling. The cars neatly lined up in a parking lot create graphic vectors, as does the horizon line, or the painted lines on a freeway. **SEE 4.3**

Index vectors These vectors are created by something that points *unquestionably* in a certain direction, such as an arrow, a one-way street sign, or somebody looking or pointing in a specific direction. **SEE 4.4** The difference between graphic and index vectors is that index vectors are much more definite as to direction. Going against the index vector of a one-way sign may confuse your mental map as well as physically shake you up.

Motion vectors This vector is created by an object that is actually moving, or is perceived to be moving, on the screen. People walking, a car speeding along the highway, a bird in flight—all form motion vectors. For an illustration of motion vectors, put this book away and look around you where things are moving; they cannot be illustrated by a still picture.

4.3

GRAPHIC VECTORS

Graphic vectors are created by lines or an arrangement of stationary objects that lead the eye in a particular direction. These construction pillars and beams create prominent graphic vectors.

4.4

INDEX VECTORS

Index vectors are created by someone or something that points unquestionably in a certain direction.

 KEY CONCEPT 3 **Vectors are directional forces within the screen that influence composition and the blocking of talent and cameras.**

Composition

Our perceptual faculties are always striving to help stabilize the chaotic world around us. Good picture composition helps us in this task. Some of the most basic compositional factors involve (1) subject placement, (2) headroom and leadroom, and (3) the horizon line.

4.5

SCREEN-CENTER PLACEMENT

The most stable screen position is screen-center. All screen forces are neutralized at this point.

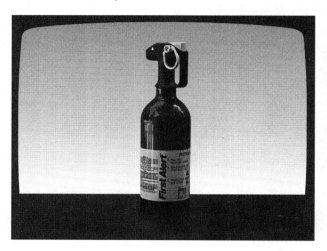

Subject placement The most stable and prominent picture area is screen-center. If you want to draw attention to a single subject, place it there. **SEE 4.5** The same goes for framing a person who is addressing viewers directly, such as a newscaster or a company president. **SEE 4.6**

 KEY CONCEPT 4 **The most stable picture area is screen-center.**

If the newscaster has to share screen space with a visual, such as the secondary frame that contains illustrative material, you obviously need to move the newscaster to one side, not only to make room for the visual, but also to balance the two picture elements within the frame. **SEE 4.7** Sometimes when you frame large vistas that contain a distinct single vertical element, such as a telephone pole, tree, or old fence post, you can place the single vertical element off-center, at about the one-third or two-thirds mark of screen width. Such a nonsymmetrical framing, in which the two halves of the screen contain different visual elements, makes the picture look more dynamic and the horizon less divided than if you place the vertical object exactly at midpoint. **SEE 4.8**

Headroom and leadroom Somehow, the edges of the video screen seem to act like magnets and attract objects close to them. This pull is especially strong at the top and bottom edges of the screen. For example, if you frame an executive so that his head touches the upper screen edge, his head seems to be pulled up, or even attached, to the frame. **SEE 4.9** To counteract this pull, you must leave adequate space, called *headroom*. **SEE 4.10**

If you leave too much headroom, the bottom edge exerts its force and seems to pull the executive against the bottom edge. **SEE 4.11** Because you inevitably lose

4.6

SCREEN-CENTER PLACEMENT OF NEWSCASTER

A single newscaster needs to be placed screen-center. This screen position draws undivided attention to the newscaster and what she is saying.

4.7

PICTURE BALANCE

When the newscaster has to share the screen space with other visual elements, the elements have to be placed in opposite screen halves so that they balance each other.

4.8

NONSYMMETRICAL FRAMING

A prominent horizontal line can best be divided by a vertical object located at about one-third the distance from either the left or the right screen edge. This way, the screen is not divided visually into two equal halves, which makes for a more dynamic and interesting composition.

4.9

NO HEADROOM

Without headroom, the person seems to be glued to the top edge of the screen.

4.10

CORRECT HEADROOM

Correct headroom neutralizes the magnetic pull of the upper frame and makes the person look comfortable within the frame.

4.11

TOO MUCH HEADROOM

Too much headroom tends to dwarf the person and push the image against the lower half of the screen.

some picture space when showing your videotape on a television set, or when actually transmitting via cable or on-the-air channel, you should leave just a little more headroom than what seems appropriate. This way the viewer will see framing with exactly the right headroom. **SEE 4.12**

KEY CONCEPT 5 **Headroom neutralizes the pull of the upper screen edge.**

4.12

HEADROOM FOR TRANSMISSION

The framing on the left is correct for the viewfinder display, but the inevitable picture loss during transmission requires more initial headroom. The framing on the right is, therefore, more appropriate.

Picture loss

The sides of the frame contain similar graphic "magnets" that seem to pull persons or objects toward them, especially when they are oriented toward one or the other side of the screen. **SEE 4.13** Do you feel that this is a good composition? Of course not. The person seems to push his nose into the right screen edge. Correct framing requires some breathing room in front of his nose to reduce the force of his glance and the pull of the screen edge. This is why this type of lead-room is called *noseroom*. **SEE 4.14**

The same principle operates when you frame someone moving laterally. **SEE 4.15** You must leave some room in the direction of movement to show where the person is going and to absorb some of the directional energy.

Because the camera must be somewhat ahead of someone's motion and should lead the action, rather than follow, this is called *leadroom*. It is not always easy to keep proper leadroom for a moving person or object, especially if the subject moves rather quickly. A good rule of thumb is to leave about two-thirds of screen space ahead of the moving person or object. **SEE 4.16**

With an understanding of vectors, we can explain more accurately the basic compositional principles just discussed. When we place a telephone pole or fence post somewhat off-center to divide a smooth horizon line, we basically divide a prominent horizontal graphic vector with a strong vertical one. In order not to divide the screen symmetrically—into two equal halves—by the vertical vector, we place it at approximately the one-third mark of the screen width. This way, the horizontal vector is divided into balanced yet more dynamic proportions than in a symmetrical division.

If someone is looking or pointing directly screen-left or screen-right, you must give this vector some room to play out by leaving some leadroom in the direction indicated, as shown in figure 4.14. As soon as the person looks straight into the

4.13

NO NOSEROOM

Without any space between the nose and the screen edge, the person seems to be glued to the screen edge or crashing into it.

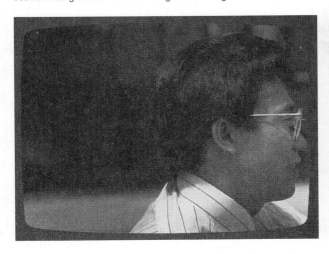

4.14

PROPER NOSEROOM

This noseroom is sufficient to counter the pull of the screen and the force of the glance.

4.15

NO LEADROOM FOR MOTION

Without proper leadroom, the laterally moving subject or object seems oddly restricted by the screen edge.

4.16

PROPER LEADROOM FOR MOTION

With proper leadroom, the laterally moving subject or object seems to move freely in the given direction.

camera, however, the index vector loses its force. Consequently, you must adjust your camera so that the person is placed screen-center. The same principle applies for motion vectors. If someone is running laterally to the camera, you must pan your camera ahead of the person in order to compensate for the strong motion vector, as illustrated in figure 4.16.

As you can see, leadroom must compensate for two screen forces: the magnetic pull of the frame and, especially, the directional force of strong index or motion vectors. It is this combination of forces that causes a composition to look so bad when no leadroom or inadequate leadroom is given.

KEY CONCEPT 6 **Leadroom neutralizes the index or motion vector force and the pull of the frame.**

Horizon line Normally we expect to have buildings and people stand upright on level ground. This principle is especially important if you shoot outdoors and where you have distinct vertical and horizontal graphic vectors. For instance, when shooting a reporter standing on a street corner, make sure that the background lines (graphic vectors) are parallel to the upper and lower screen edges. **SEE 4.17** A slight tilt of the handheld camcorder may not readily show up on the foreground person, but is easily detectable by the tilted horizon line.

Sometimes you may want to upset a stable environment and deliberately tilt the camera and, with it, the horizon line. A tilted horizon line can make the picture more dynamic and give it more aesthetic energy. Of course, the subject matter must lend itself to such aesthetic manipulation. **SEE 4.18** Tilting the camera on a dull speaker will not improve his speech; it will simply alert the viewer to sloppy camera work.

4.17

LEVEL HORIZON LINE

When framing a person standing in front of a prominent background, make sure that the horizon line is level.

4.18

TILTING THE HORIZON LINE

A tilted horizon line increases the dynamic tension of the event.

4.19

PSYCHOLOGICAL CLOSURE

We perceive these three dots as a triangle by mentally filling in the missing parts.

4.20

FRAMING A CLOSE-UP

A properly framed close-up leads our eyes into off-screen space to complete the figure.

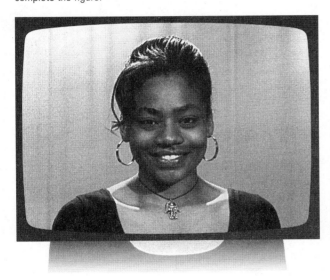

Psychological Closure

Our minds try to make sense out of the multitude of impressions we receive every second and to stabilize the world around us as much as possible. Our perceptual mechanism does this by ignoring most sense impressions that are not immediately relevant, and by combining visual cues or filling in missing visual information, to arrive at complete and stable configurations. This process is called *psychological closure*, or *closure* for short.

Take a look at the three dots at the upper left. Although we see only three separate dots, we perceive a triangle. Through psychological closure, we have automatically filled in the missing lines. **SEE 4.19**

Now look at the close-up to the left. **SEE 4.20** Again, you mentally fill in the rest of the subject's body although you actually see only her head and shoulders on the screen.

The graphic vectors of the shoulders that led your eye outside the frame helped you to apply closure, or to fill in the missing parts. One of the most important principles in framing a close-up in which only part of the subject is shown is to provide sufficient visual clues (graphic vectors) that enable the viewer to complete the figure mentally in off-screen space. Below are two different ECUs (extreme close-ups) of the same person. Which one do you prefer? **SEE 4.21A**

4.21

PROPER AND IMPROPER FRAMING

A Here are two extreme close-ups. Which provides the more desirable psychological closure?

4.21

PROPER AND IMPROPER FRAMING *(continued)*

 This extreme close-up is improperly framed because it invites us to apply closure within the frame (a circle) without pointing into off-screen space.

C This framing points properly into off-screen space and makes us apply closure to the whole figure.

Most likely, you chose the framing on the right as the better ECU. You were correct. But why? Because the framing on the right provides ample visual cues that make it easy to apply closure, to extend the lines of the head and neck and to project the missing parts beyond the frame. **SEE 4.21C** In the framing on the left, however, there are practically no visual cues that would lead us into off-screen space. In fact, our perceptual mechanism is happy with having found a stable configuration within the frame: the head forms a circle. **SEE 4.21B** As far as our automatic perception is concerned, there is no need to go beyond the frame, because we could readily find one of the most stable configurations: a circle. The disagreement between our experience—which tells us that there must be a body attached to the head—and our automated perception—which is perfectly happy with the circlelike configuration—is the principal reason why we feel uncomfortable with such a composition.

KEY CONCEPT 7 **Close-ups that show only part of the object must provide sufficient visual cues for closure in the off-screen space.**

Psychological closure can also produce visual paradoxes and bad compositions by having us combine parts of the foreground and background into a single configuration. Examples are the rubber plant on the set that always seems to grow out of the guest's head, or the telephone pole that extends out of the person standing in front of it. **SEE 4.22** Although we know that such elements are in the

4.22

UNDESIRABLE CLOSURE

Because of our tendency to stabilize the environment, we perceive this background object to be part of the main figure.

background, our perceptual urge for stable figures makes us perceive these visual paradoxes as a single unit.

When looking through the viewfinder, you must learn to see not only the foreground (target) object but also what is *behind* it. By looking behind the target object or scene, you will readily discover potential closure problems, such as the lamp that seems to sit on the performer's head. "Looking behind" may also reveal other visual hazards, such as billboards, garbage cans, camera cables, or light stands.

MANIPULATING PICTURE DEPTH

So far, we have been concerned mainly with organizing the two-dimensional area of the video screen.[1] Now we explore the depth dimension. Whereas the height and width of the video screen have definite limits, the depth dimension extends from the camera lens clear to the horizon. Although illusory, the screen depth, or *z-axis* (a term borrowed from geometry), is the most flexible screen dimension. You can place many more objects along the z-axis than along the width of the screen, and you can have objects move toward and away from the camera at any speed without having to worry about losing the objects in the viewfinder or not leaving enough leadroom.

Defining the Z-axis

If you point your camera at the cloudless sky, you have just about as long a z-axis as you can get; but it does not show its depth. In order to show screen depth, you need to define the z-axis by placing objects or people along it. The traditional way of creating the illusion of depth is to have objects placed along the z-axis so that you can identify a distinct foreground, middleground, and background. **SEE 4.23**

1. For more information on picture composition, see Herbert Zettl, *Sight Sound Motion*, 2d ed. Belmont, Calif.: Wadsworth Publishing Co., 1990.

FOREGROUND, MIDDLEGROUND, BACKGROUND

A distinct division of the z-axis into foreground (rocks), middleground (boat), and background (hills) will create the illusion of depth.

FOREGROUND OBJECT IN INDOOR SET

The prominent foreground piece increases the illusion of depth.

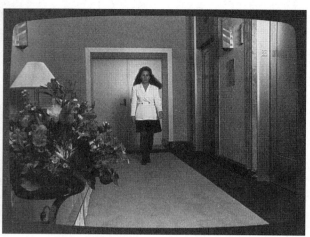

Even in a relatively small set, a prominent foreground piece will help define the z-axis and suggest screen depth. **SEE 4.24**

Lenses and Z-axis Length

The focal length of a lens has a great influence on our perception of z-axis length and on the distance of objects placed along the z-axis.

Wide-angle position When zoomed all the way out (wide-angle position), the z-axis appears to be *longer* than it really is, and the objects seem to be *farther apart* than they really are. **SEE 4.25**

Narrow-angle position When zoomed all the way in (narrow-angle or telephoto position), the z-axis seems to be *shorter* than it really is and reduces the distance between the objects placed along it. The z-axis and its objects seem *compressed.* **SEE 4.26**

Lenses and Depth of Field

You have probably noticed that when you are zoomed all the way in (with your lens in the telephoto position), you have more trouble keeping an object traveling along the z-axis in focus than when you are zoomed all the way out to a wide-angle position. Also, when zoomed in, the z-axis area that is in focus is considerably more shallow than when zoomed out. We call this area *depth of field.* **SEE 4.27**

4.25

WIDE-ANGLE Z-AXIS

The wide-angle lens stretches the z-axis and increases the perceived distance between objects.

4.26

NARROW-ANGLE Z-AXIS

The narrow-angle (telephoto) lens shrinks the z-axis and compresses the distance between objects.

4.27

DEPTH OF FIELD

The area of the z-axis in which the objects appear in focus is called *depth of field*.

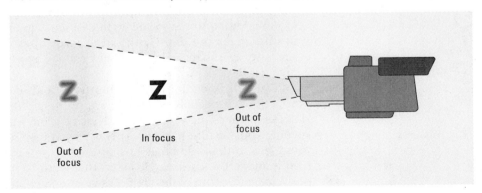

In the narrow-angle position, lenses have a shallow depth of field. This means that if you are focused on the foreground object, the middleground and background are out of focus. If you shift your focus to an object located in the middleground, the foreground and background objects are out of focus. **SEE 4.28** If you focus on the background, the middleground and foreground objects are out of focus. Also, an object can move only a short distance along the z-axis before it gets out of focus.

SHALLOW DEPTH OF FIELD

Narrow-angle (or telephoto) lenses have a shallow depth of field.
When zoomed in, the depth of field is shallow.

GREAT DEPTH OF FIELD

Wide-angle lenses have a great depth of field. When zoomed out, the
depth of field is great.

A wide-angle position creates a great depth of field. This means that objects that are widely scattered along the z-axis are all in focus. For example, when you focus on the foreground object in a large depth of field, the middleground and background objects remain in focus as well, and an object can travel a great distance along the z-axis without getting out of focus. **SEE 4.29**

An addition to the focal length of a lens (zoom lens position), its aperture also influences the depth of field. A large aperture (small *f*-stop number) contributes to a shallow depth of field; a small aperture (large *f*-stop number) to a large depth of field.

You will find that a great depth of field is desirable for most routine productions. Especially when you are running after a news story, you want to show as much of the event as clearly as possible without having to worry about keeping your picture in focus. This is why you should *zoom out* and keep your zoom lens in the wide-angle position. When you need to get a closer shot, you simply move the camera closer to the event. With the lens in a wide-angle position, your depth of field remains great enough to keep in focus, regardless of whether you or the object moves.

In a more deliberate production there are many instances where a shallow depth of field is preferred. For example, you may be asked to show the relationship between two components of a machine. You can do this by having an arrow connect the two parts, but you can also line them up along the z-axis and shift your focus from one component to the other. This *racking focus* will show the relationship in a more subtle, perhaps more compelling way, than the arrow. By focusing on the target object while keeping everything else out of focus, you can emphasize the target without eliminating the environment. A shallow depth of field shows the viewer what is important without isolating it from its surroundings.

KEY CONCEPT 8 With the zoom lens in a narrow-angle position (zoomed all the way in), you have a shallow depth of field. Keeping focus is difficult. With the zoom lens in a wide-angle position (zoomed all the way out), you have a great depth of field. Keeping focus is relatively easy.

Lenses and Z-axis Speed

Because a narrow-angle lens position compresses the z-axis, the movement of objects along the z-axis is equally compressed. When *zoomed all the way in,* cars seem much more crowded and moving *more slowly* than they actually are. When *zoomed all the way out,* they seem to be farther apart and moving much *faster* than they actually are. Simply by putting your zoom lens in a narrow-angle or wide-angle position, you can manipulate the viewer's perception of how fast objects move along the z-axis.

If you now want to show how crowded the highway is and how slow the traffic moves during rush hour, what zoom lens position would you use? You probably opted correctly for the narrow-angle position. The narrow-angle lens compresses the z-axis and, consequently, shows the cars crowding each other and moving very slowly toward or away from you. But when you want to intensify the speed of a champion bicycler or a dancer's leap, you zoom out. With your lens in a wide-angle position, the z-axis is elongated and the movement is duly accelerated.

KEY CONCEPT 9 A narrow-angle lens position (zoomed all the way in) compresses the z-axis and slows down z-axis motion. A wide-angle lens position (zoomed all the way out) stretches the z-axis and speeds up z-axis motion.

CONTROLLING CAMERA AND OBJECT MOTION

Here we can cover only a few of the main aesthetic principles of camera and object motion. These principles include some of the most obvious dos and don'ts of moving the camera, zooming, and blocking (arranging) object movement for the camera. You will find additional information about controlling camera and object motion in subsequent chapters.

Controlling Camera Movement and Zooms

If there is any one sign that points to an inexperienced camera operator, it is excessive camera movement and zooms. Like most of us, you probably have had to sit through a few showings of videotapes in which the camera moved aimlessly from point to point and continually zoomed in and out. When watching such footage, the wildly roaming camera reminds us more of a firefighter's hose than photographic artistry, and the fast out-of-focus zooms produce more eyestrain than dramatic impact.

The moving camera For some reason, inexperienced camera operators think that it is the camera that has to do the moving rather than the object in front of it, especially when there is not much object motion. If nothing moves, so be it. Your aesthetic energy does not come from unmotivated camera movement, but rather from the event itself, whether it is in motion or not.

If there are any hard-and-fast aesthetic rules in camera operation, this is one of them: *Always try to keep the camera as steady as possible and have the people and objects in front of your camera do the moving.* The problem with an incessantly moving camera is that it draws too much attention to itself. It is, after all, the event you want to show the viewer and not aimless camera movement.

If you need to show variety to provide the viewer with different points of view, you should shift camera angles or move your camera in or out rather than zoom. Even if there is absolutely no movement in the event, different angles and fields of view will provide enough change to give the viewers more information about the event and to keep their interest up. To restrict your camera moves, you should mount your camera on a tripod or other camera support whenever possible, even if your camera is quite small. We will discuss handling the camera with or without camera mounts in chapter 5.

 KEY CONCEPT 10 **Whenever possible, keep the camera still and let the event do the moving.**

Fast zooms Fast, unmotivated zooms are as annoying as the needlessly roving camera. The major problem is that the zoom—even more than camera motion—is a highly visible technique that easily draws attention to itself. The worst thing you can do is to follow a fast zoom-in or zoom-out with an equally fast zoom in the opposite direction. What you should do is rest on the target object for a while after a zoom, and then switch to another angle and point of view. Constant zooming in and out will make the viewers feel cheated: first you bring the event to them through zooming in, only to take it away again immediately after by zooming out.

Unless you are planning a highly dramatic effect, your zoom should remain largely unnoticed by the viewer. If you have to zoom, do it slowly. Zooming in to a close-up increases tension; zooming out releases it.

Generally, you will find that it is easier to start with a close-up view of the object and then zoom out than to do it the other way around. Zooming out from a close-up will also make it easier to keep in focus than when zooming in, especially if you do not have time to preset (adjust) your zoom lens. You will learn more about presetting a zoom lens in chapter 6. But even with auto-focus, fast zooms cause focus problems. The auto-focus "radar" simply does not have enough time to keep up with constantly changing picture requirements.

KEY CONCEPT 11 **Avoid fast and constant zooming in and out.**

Zoom versus dolly There is an important aesthetic difference between a zoom and a *dolly*. Dollying means moving the camera along the z-axis toward or away from the object either by carrying the camera or, more often, by means of a camera support (see chapter 5). When you *zoom in or out,* the *event* seems to move *toward or away from the viewer;* in a *dolly-in or dolly-out,* the *viewer* seems to move with the camera *toward or away from the event.* If, for example, you want to show that the ringing telephone bears an important message, you zoom in on the phone, rather than dolly in. The fast zoom almost catapults the phone toward the screen and the viewer. But when you want to have the viewer identify with a student who is late for class, you dolly the camera toward the empty chair rather than zoom in on it. The dolly will take the viewer into the classroom and to the empty chair. A zoom would bring the chair to the viewer (and the student), and that rarely happens, even in a rather friendly classroom atmosphere. The reason for this aesthetic difference is that the camera remains stationary during the zoom, while it is actually moving into the scene during a dolly.

KEY CONCEPT 12 **A zoom-in brings the object to the viewer;**
 a dolly-in takes the viewer to the object.

Controlling Object Motion

Despite all the theory on providing leadroom for a laterally moving object, it is hard to keep it properly framed, especially if it moves swiftly or if you are composing a rather tight shot. Sometimes, even experienced camera operators have trouble following an object when it moves quickly along the x-axis (screen-left or screen-

right) in a tight shot. Just try following somebody moving sideways fairly close to your camera; you will be glad just to keep the person in your viewfinder. But when the same person walks in a straight line along the z-axis (toward or away from your camera), you will have little trouble keeping the person in the shot and properly framed—even if he or she walks briskly. Because of the relatively small size of the video screen, blocking people along the z-axis rather than the x-axis is not only easier on the camera operator but also produces shots that have greater impact.

Blocking means staging people in various precise positions in a set and having them move and do certain things in a predetermined way. *Z-axis blocking* makes it relatively easy to keep several people in a single shot and to capture their movements without excess camera motion. By putting your lens in a wide-angle position, z-axis movement can look quite dramatic and spectacular without putting too much strain on the camera operator or the performer. Also, as you have just learned, the wide-angle lens provides a large enough depth of field so that any focus adjustment becomes unnecessary. **SEE 4.30**

Even when you have no control over the event and cannot influence the blocking, as is the case in most ENG (electronic news gathering), you can still place your camera so that the object motion conforms to the aesthetic requirements of the small screen and the stable camera. Simply position your camera in such a way that most of the object movement happens along the z-axis. For example, if you cover a parade, don't stand on the sidewalk and try to capture the various bands and floats as they move past you—step onto the street and shoot against the oncoming parade traffic. With your zoom lens in the wide-angle position, you will have little trouble covering the event in long shots and close-ups while staying in focus.

KEY CONCEPT 13 **Z-axis movement is well suited to the aesthetic requirements of the small video screen and is relatively simple to shoot.**

You should now be able to impress the Triple-I people with a videotape that attests to your skills and sensitivity in selecting effective shots, and especially to your knowledge of picture aesthetics. Now it's time to take just one more look at the footage you shot and see whether your shots are free of compositional mistakes and whether you moved your camera and worked your zooms with optimal effectiveness.

4.30

Z-AXIS BLOCKING

Blocking along the z-axis suits the small video screen.

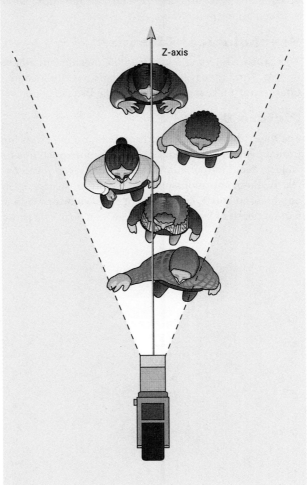

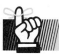

ONCE AGAIN, REMEMBER...

Field of View

The field of view is usually expressed in five shots, ranging from extreme long shot to extreme close-up. Other shot designations refer to how much of a person we see (such as bust shot or knee shot) or how many people are in a shot (two-shot or three-shot). In an over-the-shoulder shot, we see the shoulder and the head of the camera-near person. A cross-shot is closer, with the camera-near person out of the shot.

Vectors

Vectors are directional screen forces of various strengths. There are graphic vectors, which suggest a direction through lines or objects that form a line; index vectors, which point unquestionably in a specific direction; and motion vectors, which show a screen image in motion.

Psychological Closure

This process refers to our perceptual mechanism that completes incomplete figures. Through psychological closure, we are able to mentally "see" a complete figure even if it is shown only partially in a close-up.

Picture Depth

The depth dimension depends on defining the z-axis into foreground, middleground, and background. Wide-angle zoom positions make the z-axis look longer. Objects seem farther apart, and their movement seems faster than it actually is. Narrow-angle positions make the z-axis look shorter. Objects seem more compressed and their movement seems slower. Wide-angle lens positions show a great depth of field; narrow-angle lens positions show a shallow one.

KEY CONCEPTS

- Select those event details that tell the real story with clarity and impact.

- Video is a close-up medium.

- Vectors are directional forces within the screen that influence composition and the blocking of talent and cameras.

- The most stable picture area is screen-center.

- Headroom neutralizes the pull of the upper screen edge.

- Leadroom neutralizes the index or motion vector force and the pull of the frame.

- Close-ups that show only part of the object must provide sufficient visual cues for closure in the off-screen space.

- With the zoom lens in a narrow-angle position (zoomed all the way in), you have a shallow depth of field. Keeping focus is difficult. With the zoom lens in a wide-angle position (zoomed all the way out), you have a great depth of field. Keeping focus is relatively easy.

- A narrow-angle lens position (zoomed all the way in) compresses the z-axis and slows down z-axis motion. A wide-angle lens position (zoomed all the way out) stretches the z-axis and speeds up z-axis motion.

- Whenever possible, keep the camera still and let the event do the moving.

- Avoid fast and constant zooming in and out.

- A zoom-in brings the object to the viewer; a dolly-in takes the viewer to the object.

- Z-axis movement is well suited to the aesthetic requirements of the small video screen and is relatively simple to shoot.

KEY TERMS

Pan Horizontal turning of the camera.

Tilt To point the camera up or down.

Cant Tilting the camera sideways.

Pedestal To move the camera up or down via a studio pedestal.

Dolly To move the camera toward (dolly in) or away from (dolly out) the object.

Truck or Track To move the camera laterally by means of mobile camera mount.

Arc To move the camera in a slightly curved dolly or truck.

Crane or Boom To move the boom of the camera crane up or down.

Tongue To move the boom with the camera from left to right or right to left.

Tripod A three-legged camera mount.

Mounting Head A device that connects the camera to its support. Also called *pan and tilt head.*

Studio Pedestal Heavy camera dolly that permits raising and lowering of the camera while on the air.

Cam Head A camera mounting head that permits extremely smooth tilts and pans.

White Balance The adjustments of the color circuits in the camera to produce a white color in lighting of various color temperatures (relative bluishness or reddishness of white light).

Calibrate the Zoom Lens To preset a zoom lens to keep in focus throughout the zoom.

Operating the Camera

LET'S watch a tourist who is itching for something interesting to shoot with his brand-new camcorder. He quickly takes aim at the picturesque clock tower of city hall, tilts his camera up to the flag on top, zooms in on the flag, zooms out again, tilts down to the clock, zooms in on clock, zooms out again, continues to tilt down to the old oak doors, zooms in on the doors, out again, pans over to the park bench where a bird is finishing its lunch, pans over again to city hall, zooms in on the sign that tells about the city hall's colorful history, zooms out again to catch a small child feeding pigeons, zooms in on one of the more aggressive pigeons who refuses to stay in the frame.

Although such camera handling may be good exercise for the arm and the zoom mechanism, it rarely produces satisfactory footage. Such unmotivated camera motion produces images that seem restless and unsettling for anyone except, perhaps, the person who shot them. The tourist would have done much better had his camera been mounted on a small tripod.

When a small camcorder is handheld, camera movements are virtually unrestricted. But when it is mounted on a tripod, the camera movements become much more restricted. Initially, you will probably feel that a tripod constrains your artistry and that it is much better to handhold the camera, so long as it is not too heavy. However, after some experience in camera operation, you will discover that it is actually easier to operate the camera and control picture composition when the camera is mounted on some kind of support. In fact, the art of operating a camera is not as dependent on its electronic design or basic operational controls as it is on its size and especially on how it is mounted.

With this knowledge, you will surely surprise the Triple-I people with your professional restraint of camera movement and your steady camera handling.

This chapter deals with—

■ **BASIC CAMERA MOVEMENTS**
 Pan, tilt, pedestal, dolly, truck, and others

■ **CAMERA MOUNTS AND HOW TO USE THEM**
 The handheld and shoulder-mounted camera, tripods,
 the studio pedestal, and special camera mounts

■ **OPERATIONAL FEATURES**
 White balancing, focusing, zooming, and some general
 operational guidelines

BASIC CAMERA MOVEMENTS

The various camera mounts are designed to steady the camera and to help you move the camera as easily and smoothly as possible. To understand the features and functions of camera mounting equipment, you should first learn about the major camera movements. They are called the same regardless of whether the camera is carried on your shoulder or mounted on a tripod, studio pedestal, or some other camera support.

There are nine basic camera movements: (1) *pan;* (2) *tilt;* (3) *cant;* (4) *pedestal;* (5) *dolly;* (6) *truck* or *track;* (7) *arc;* (8) *crane* or *boom;* and (9) *tongue.* Sometimes the zoom is also included in the major camera movements, although the camera itself does not normally move during a zoom. **SEE 5.1**

Pan Turning the camera horizontally, from left to right or right to left. To *pan right* means to swivel or move the camera clockwise so that the lens points more to the right; to *pan left* means to swivel or move the camera counterclockwise so that the lens points more to the left. For example, if you need more leadroom for an object that moves screen-left, you need to pan left. If you need more noseroom for someone standing too close to the right screen edge, you need to pan right.

Tilt Making the camera point up or down. A "tilt up" means to point the camera gradually up. A "tilt down" means that you point the camera gradually down. If you need more headroom to counter the pull of the upper frame, you need to tilt up somewhat. If you have too much headroom and want to see more of the neck and shoulders of a person in a close-up, you need to tilt down.

Cant Tilting the camera sideways. You can cant the camera either left or right. When you "cant left," the horizon line will be slanted uphill: its low point will be screen-left, and its high point screen-right. You will recall that a slanted horizon line will make the picture appear less stable, thereby increasing the energy of the event. Canting a camera is easy with the handheld or shoulder-mounted camera; but you cannot cant a camera supported by a camera mount.

Pedestal Elevating or lowering the camera on a center column of a tripod or a studio pedestal. To "pedestal up," you crank or pull up the center column, thereby raising the camera. To "pedestal down," you crank or pull down the center column,

5.1

MAJOR CAMERA MOVEMENTS

The major camera movements are pan, tilt, cant, pedestal, dolly, truck or track, arc, crane or boom, and tongue.

thereby lowering the camera. This camera motion puts the camera into different vertical positions, which means that the camera sees the scene as though you were looking at it from the top of a ladder or while kneeling on the floor. You can "pedestal" a handheld camera by simply raising it slowly above your head or lowering it to the ground.

Dolly Moving the camera toward or away from an object in more or less a straight line (along the z-axis) by means of a mobile camera mount. When you *dolly in*, you move the camera closer to the object; when you *dolly out*, or *dolly back*, you move the camera farther away from the object. As you recall from chapter 4, in a dolly, the viewer seems to be *moving with the camera in or out of* the scene.

With the handheld or shoulder-mounted camera, you simply walk the camera toward or away from the scene along the z-axis. Some directors call this dollying in or out even if the camera is not mounted on a camera dolly; others simply call for you to get closer or to back up.

Truck or Track Moving the camera laterally by means of mobile camera mount. When you *truck right* or *truck left*, you move the camera mount to the right or left with the camera pointing at a right angle to the direction of the travel. If you want to follow somebody walking on the sidewalk, you would truck with your camera alongside on the street, with the lens pointing at the person. When trucking, you must be especially careful to leave sufficient leadroom for the lateral motion.

Tracking often means the same as trucking. Sometimes, tracking refers simply to a moving camera keeping up with a moving object. With a handheld or shoulder-mounted camera, you walk parallel to the moving object while keeping your camera pointed at it.

Arc Moving the camera in a slightly curved dolly or truck movement. To *arc left* means that you dolly in or out in a camera-left curve, or truck left in a curve around the object; to *arc right* means that you dolly in or out in a camera-right curve, or truck to the right in a curve around the object. With the handheld or shoulder-mounted camera, you simply walk in a slight arc while pointing the camera at the scene. Arcing is often required to reveal more of the camera-far person in an over-the-shoulder shot where the camera-near person is blocking or nearly blocking our view of the camera-far person. **SEE 5.2**

Crane or Boom Moving the camera up or down on a camera crane or jib arm. A crane is a rather bulky device that can lift the camera and its operator, and sometimes a second person (usually the director), up to 30 feet above ground in one impressive sweep. The crane itself is moved by a driver and an assistant. A jib arm is a simpler crane that can be handled by a single camera operator, as shown in figure 5.19. The effect of a crane or boom movement is somewhat similar to pedestaling up or down, except that the camera swoops in a vertical arc over a much greater distance. You could, for instance, use a boom to move the camera from an extreme overhead long shot of dancers to a below-eye-level close-up of one of them,

5.2

CAMERA-FAR PERSON PARTIALLY BLOCKED—THEN CORRECTED

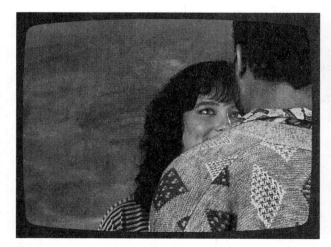

A In this over-the-shoulder shot, the camera-near person partially blocks the camera-far person.

B The camera-far person is properly revealed through arcing left.

with the camera now shooting from close to the floor. To *crane up* or *boom up* means to raise the boom with the attached camera; to *crane down* or *boom down* means to lower the boom and the attached camera. Simply holding your small camcorder high above your head and then swooping it down close to floor level will not duplicate the feeling of a crane motion. Unless you are 10 feet tall, there is simply not enough height difference between the extreme high and low camera positions to simulate a crane motion.

Tongue Moving the whole camera from left to right or right to left with the boom of a camera crane or jib arm. When you *tongue* left or right, the camera usually points in the same general direction, with only the boom swinging left or right. Tonguing creates an effect similar to a truck, except that the horizontal arc of the boom with the camera is usually much wider and can be much faster than a truck. Tonguing is often combined with a boom-up or boom-down movement. For example, you could use the tonguing effect to follow and intensify the fluid lateral movement of dancers.

 The crane and tongue movements are somewhat of a special effect. Even if you have access to a crane, use such extreme camera movements sparingly and only if they contribute to the shot intensity. If the scene is not spread out too much, you may be able to simulate a tonguing motion with your handheld camera by swinging the camera from left to right or right to left rather than panning. But without a large crane or jib, you will not be able to duplicate the sweeping lateral motion of tonguing.

Zoom Changing the focal length of a lens through the use of a zoom control while the camera remains stationary. To *zoom in* means to change the lens gradually to a narrow-angle position, thereby making the scene appear to move closer to the viewer; to *zoom out* means to change the lens gradually to a wide-angle position, thereby making the scene appear to move farther away from the viewer. Although the effect of a zoom is one of *the object moving toward or away from the screen* rather than the camera moving into or out of the scene, the zoom is usually classified as one of the camera "movements."

CAMERA MOUNTS AND HOW TO USE THEM

You can support your camera (1) by carrying it with your hands or on your shoulder, (2) with a tripod, (3) with a studio pedestal, and (4) with several other special camera mounting devices. They all influence greatly, if not dictate, how you operate the camera.

The Handheld and Shoulder-Mounted Camera

We have already mentioned that the small, handheld camcorder invites excessive camera motion. You can point it easily in any direction and move it from point to point effortlessly. While such high mobility can be an asset, it is also a liability. Too much camera movement draws attention to itself and away from the things you

want to show. Unless you have an image stabilizer built into your camera that absorbs minor camera wiggles, you will find that it is quite hard to keep the handheld camera steady. When zoomed all the way in (with your lens in the narrow-angle, or telephoto, position), it is almost impossible to avoid some shaking and unsteadiness in the handheld shot.

To keep the handheld camera as steady as possible, support the camera in the palm of one hand and use the other hand to support the "camera" arm or the camera itself. **SEE 5.3** Press your elbows toward your body, inhale, and hold your breath during the shot. The lack of oxygen will obviously limit the length of your shot, and that is probably a good thing. Shorter takes that show a variety of viewpoints are much more interesting than a long take with constant panning and zooming. There are shoulder mounts for small camcorders that reduce the wobbles to some extent. In any case, bend your knees slightly when shooting or, better, lean against some sturdy support, such as a building, wall, parked car, or lamppost to increase the stability of your camera. **SEE 5.4**

Always keep your lens in the wide-angle position (zoomed out) in order to minimize the camera wiggles in your shot. If you need to get closer to the scene,

5.3

HOLDING THE SMALL CAMCORDER

The small camcorder is steadied by both hands, with the elbows pressed against the body.

5.4

STEADYING THE CAMERA OPERATOR

Leaning against some object will steady the camera operator and the camera.

stop your tape, walk closer to get the tighter shot, and start your videotape again. If you need to zoom, work the zoom controls *gently* during the shot. For a relatively long "take" without a tripod, try to find something on which to place the camera, such as a table, park bench, or the roof or hood of a car.

When moving the camera, do it *smoothly*. To pan the camera, move it with your whole body rather than just your arms. Point your knees as much as possible to where you want to end the pan, while keeping your shoulders in the starting position. During the pan, your upper body will uncoil naturally in the direction of your knees and will carry the camera smoothly with it. **SEE 5.5** If you do not "preset" your knees, you will have to coil your body rather than uncoiling when panning, which is much harder to do and usually results in jerky camera motion.

When tilting the camera (pointing it up or down), try to bend at your waist forward or backward as much as possible while keeping your arms pressed against your body. As in the pan, your body motion makes the tilt look smoother than if you simply move your wrists to point the camera up or down.

When walking with the camera, try to walk backward, not forward. **SEE 5.6** You will find that, when walking backward, you will automatically lift your heels and

5.5

PANNING THE CAMCORDER

Before panning, point your knees in the direction of the pan, then uncoil your upper body during the pan.

5.6

WALKING BACKWARD

Walking backward rather than forward makes it easier to keep the camera steady.

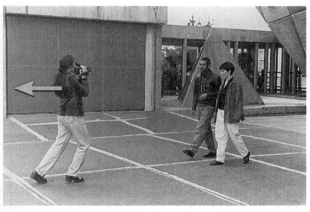

walk on the balls of your feet. Your feet rather than your legs will act as shock absorbers. Your body, and with it your camera, will tend to glide rather than bounce up and down.

For special shots, you can tilt the camera sideways, raise it above your head, and shoot over the people or other obstacles in front of you, or you can lower it close to the ground to get some low-angle views. Most viewfinders can be adjusted (at least tilted up and down) so that you can still see what you are shooting during these special maneuvers. Sometimes you may find that the only way to get a good shot is to hold the camera way above your head and aim it more or less in the direction of the event.

This is not the time to worry about proper framing or general picture quality; the task is to get some kind of picture of the event.

ENG/EFP cameras or camcorders are too large and heavy to be handheld for any length of time and are best supported by your shoulder. While the shoulder-mounted camera is slightly more restrictive than the small handheld camcorder, the basic moves are much the same.

Assuming that you are right-handed, carry the camera on your right shoulder and slip your right hand through the support strap on the zoom lens to hold the camera and operate the zoom lens. Your left hand is now free to steady the camera and work the focus ring at the front of your zoom lens. **SEE 5.7** You need to adjust the viewfinder to fit your prominent (usually right) eye. Some camera operators keep the left eye open to see where they are going; others prefer to close it in order to concentrate on the viewfinder image. If you are left-handed, reverse the procedures. Some viewfinders can be flipped over for the left eye, and there are lenses that have straps and zoom operating controls for the left hand.

KEY CONCEPT 1 **Keep the handheld or shoulder-mounted camera as steady as possible and zoomed-out when moving.**

5.7

THE SHOULDER-
MOUNTED ENG/EFP
CAMCORDER

The larger camcorder is carried on the shoulder. One hand slips through a special strap that is attached to the lens, leaving the fingers free to operate the zoom control. The other hand steadies the camera and operates the focus ring.

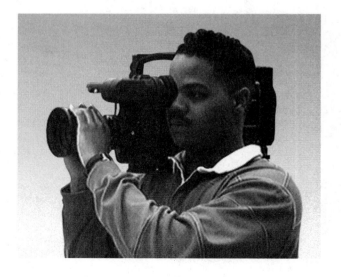

■ The Tripod-Supported Camera

Unless you are running after a breaking news story, the best way to keep the camcorder or ENG/EFP camera steady and the movements as smooth as possible is to support it on a ***tripod*** or some other kind of camera mount. The collapsible tripod has been the major camera support for the still photographer for quite some time, and has proved just as effective for the videographer who uses portable cameras.

A good tripod should be light but sturdy enough to support the camera as it moves. Its collapsible legs (pods) must lock securely into place at any extension point and should have rubber cups and spikes at the tips of the legs. The rubber cups prevent the tripod from slipping on a smooth surface, as do the spikes on a rough surface.

Most professional tripods come with a *spreader*, a triangular base mount that locks the tips in place and prevents the legs from spreading no matter how much weight is put on them. **SEE 5.8** More elaborate tripods have a center column that enables you to elevate and lower the camera. All good tripods should have an air bubble at the top ring so that you can see whether the tripod is level.

5.8

TRIPOD WITH SPREADER

The tripod has three adjustable pods that are sometimes secured by a spreader.

Spreader

5.9

MOUNTING HEAD FOR LIGHT CAMERA

The mounting head permits smooth pans and tilts. Its pan and tilt mechanism can be adjusted to various degrees of drag, and it can be locked.

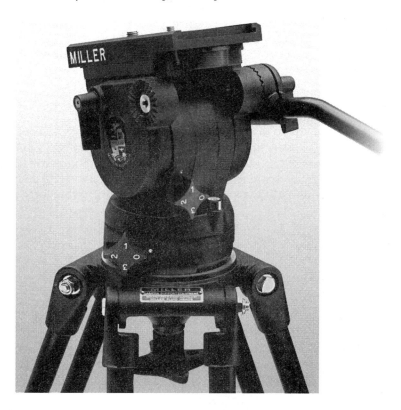

Camera mounting head One of the most important parts of your tripod is its camera *mounting head*. This device, also called the *pan and tilt head*, lets you attach and remove the camera quickly and safely without help from anybody else. It also permits smooth pans and tilts. Most tripod mounting heads have a load limit of between 30 and 45 pounds—ample to hold even the most elaborate ENG/EFP camcorder. You move the mounting head (and with it the camera) with the panning handle that is attached to it. **SEE 5.9** Lifting the handle makes the camera *tilt down;* pushing it down makes the camera *tilt up.* Moving the panning handle to the *left* makes the camera *pan right;* moving it to the *right* makes the camera *pan left.*

A good mounting head must give a certain resistance to your panning and tilting. This prevents a jerky, uneven pan or tilt. The tilt and pan "drag" can be adjusted to fit the weight of your camera and your drag preference. A small camcorder needs a lighter drag adjustment than a heavy ENG/EFP camcorder; some people favor a rather loose or a slightly tighter pan and tilt drag, regardless of camera weight.

5.10

WEDGE MOUNT

The wedge mount allows you to attach the camera to the tripod or other mount and place the camera in a balanced position.

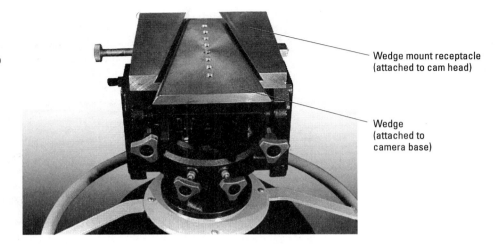

Wedge mount receptacle
(attached to cam head)

Wedge
(attached to
camera base)

The mounting head also has a *tilt and pan lock* mechanism that prevents the camera from moving horizontally or flopping forward or backward when unattended. Make sure to *lock your mounting head* every time your leave the camera unattended, no matter how briefly.

Wedge mount This mechanism, also called the *quick release plate*, makes it easy for you to mount the camera and position it so that it is perfectly balanced each time you put it on the tripod or any other camera mount. The wedge mount consists of a wedgelike plate that is attached to the bottom of the camera and that slides into the wedgelike receptacle attached to the mounting head. **SEE 5.10**

When switching from a handheld to a tripod-supported camera, you will find that the tripod restricts your use of the camera rather severely. With a tripod-mounted camera, you can no longer run with the camera, lift it above your head, shoot from close to ground level, cant it, or swing it wildly through the air. You are limited to panning and tilting and, if you have a center column, to a rather modest camera elevation. Why use a tripod?

▶ The tripod steadies the camera, whether you are zoomed in or out.

▶ Your pans and tilts will be much smoother than with a handheld camera.

▶ The tripod will keep you from moving the camera excessively, which is a positive rather than a negative factor in good camera work.

▶ You will get less tired with the camera on the tripod than on your shoulder or in your hand.

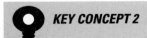 **KEY CONCEPT 2** **Whenever possible, put your camcorder or ENG/EFP camera on a tripod.**

5.11

TRIPOD DOLLY

The tripod can be mounted on a three-wheel dolly, which permits quick repositioning of the camera.

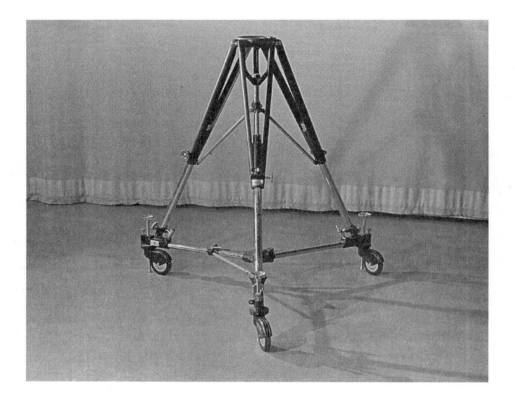

The tripod dolly In order to dolly or truck with the tripod-mounted camera, you must put the tripod on a three-caster dolly base. **SEE 5.11** The dolly base is simply a spreader with wheels. When the casters are in a freewheeling position, you can dolly, truck, and arc. Most professional dollies let you lock the casters in a specific position for straight-line dollying. Make sure to check the floor to see whether it is smooth enough for an "on-air" move while the camera is hot (operating). When moving the tripod dolly, you usually push, pull, and steer the dolly with your left hand while guiding the panning handle and camera with your right hand.

When your camera or camcorder is connected to a camera cable, you must adjust the cable guards so that the cable does not get wedged under the dolly casters. **SEE 5.12**

The field dolly When dollying on a rough surface, such as gravel or grass, you need to mount your tripod on a field dolly. A field dolly consists of a plywood platform supported by four wheels with large pneumatic tires. The steering mechanism works like the one you may remember from your red Radio Flyer wagon. A large handle turns the front wheels in the desired direction and lets you pull or push the entire platform. **SEE 5.13** When operating the camera, you can stand on the dolly or walk alongside while the dolly operator pulls or pushes it along the dolly path. When the surface is especially rough, you can underinflate the tires to make your trip smoother. Many dollies are homemade and constructed from parts readily available in most large hardware stores.

5.12

CABLE GUARDS

The cable guards prevent the dolly wheels from running over the camera cable. They must be close enough to the studio floor to push the cable aside.

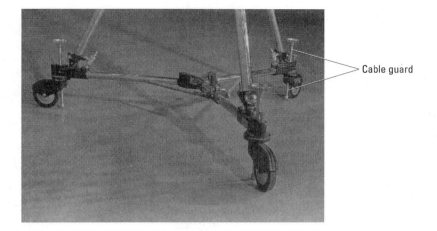

Cable guard

5.13

FIELD DOLLY

The field dolly has a platform with four pneumatic tires that support the tripod-mounted camera and the camera operator.

The Studio Pedestal

Studio cameras, or EFP cameras that are converted to studio cameras, are usually mounted on studio pedestals. A *studio pedestal* is a relatively expensive camera mount that supports even the heaviest of cameras and additional equipment, such as a teleprompter. The studio pedestal lets you pan, tilt, truck, arc, and pedestal while the camera is "on the air." By turning a large steering wheel, you can move the camera in any direction; by pulling it up or pushing it down, you can change the camera height. The telescoping center column must be balanced so that the camera stays put at any pedestal height, even if you let go of the

5.14

STUDIO PEDESTAL

The studio pedestal permits you to pan, tilt, truck, arc, and pedestal while the camera is on the air. If equipped with a telescoping column, you can move the camera from about 2 feet to about 10 feet above the studio floor.

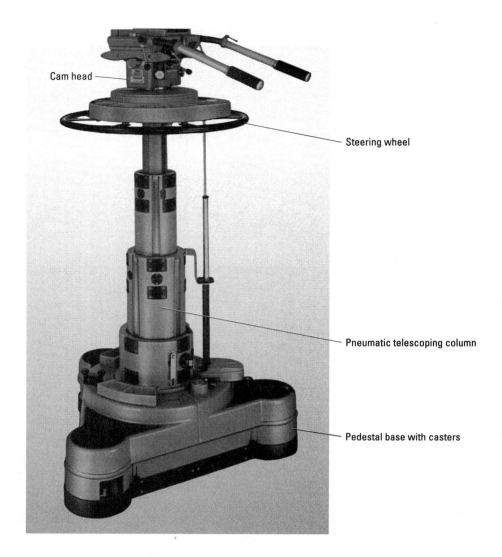

Cam head

Steering wheel

Pneumatic telescoping column

Pedestal base with casters

steering wheel. If the camera begins to creep up or down by itself, the center column must be rebalanced. **SEE 5.14**

Parallel and tricycle steering You can put the studio pedestal into a parallel or tricycle steering position. In the parallel steering position, the steering wheel points all casters in the same direction. **SEE 5.15A** Parallel steering is used for all normal camera moves. In the tricycle position, only one wheel is steerable. **SEE 5.15B** You use this steering position if you need to rotate the pedestal itself in order to move it closer to a piece of scenery or the studio wall.

Cam friction head Like the tripod, the center column of the studio pedestal has a camera mounting head attached to it. To accommodate the combined weight of studio camera and teleprompter, the customary tripod head has been replaced by a much heavier camera mount, called a ***cam head***. Its operational controls are similar to those of the mounting heads for lightweight cameras:

5.15

PARALLEL AND TRICYCLE STEERING

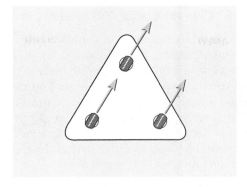

A In the parallel steering position, three casters steer in the same direction.

B In the tricycle steering position, only one wheel is steerable.

pan and tilt drag, locking devices, the wedge mount receptacle, and panning handles. **SEE 5.16** The two panning handles allow you to pan and tilt smoothly while simultaneously operating the attached zoom and focus controls. Instead of the three cable guards of the tripod dolly, you need to adjust the whole skirt (housing) of the pedestal base to prevent the cable from getting caught in the casters.

Before operating the studio camera, always unlock the mounting head and adjust the pan and tilt drags. When leaving the camera unattended, even for a short time, lock the mounting head and cap the lens (put the metal or plastic cap over the front of the lens).

 KEY CONCEPT 3 **Always lock the mounting head when leaving the camera unattended.**

5.16

MOUNTING HEAD FOR HEAVY CAMERA

The studio camera mounting head is designed for heavy cameras and accessory equipment and permits smooth pans and tilts despite the camera weight.

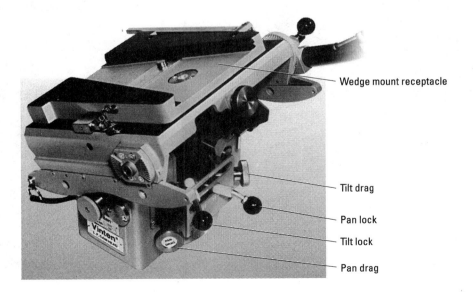

Wedge mount receptacle

Tilt drag

Pan lock

Tilt lock

Pan drag

■ **Special Camera Mounts**

Special camera mounts range from robotic pedestals whose movements are computer-controlled to large cranes that can swoop the camera with its operator as high as 30 feet above ground to common beanbags and shopping carts. Here is an area where you can put your imagination and creativity to work. On smooth ground, a simple shopping cart can give you almost as smooth a dolly as a studio pedestal costing several thousand dollars more. Mounting a small camcorder on a skateboard and pulling it along a smooth surface can give you an interesting low-angle trucking shot. The following five figures show some of the more commonly used special camera mounts. **SEE 5.17–5.21**

5.17	**5.18**
ROBOTIC PEDESTAL	STEADYCAM®
The robotic pedestal is a computer-steered studio pedestal that can pan, tilt, dolly, truck, pedestal, and zoom according to computer instructions instead of those of a camera operator. It is used mainly for news presentations.	This camera mount allows the camera operator to walk, run, or jump with the camera remaining steady. It is quite heavy, and also quite expensive. The image stabilizers built into some of the small camcorders perform almost equally well.

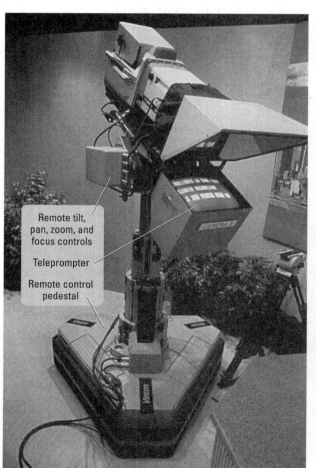

Remote tilt, pan, zoom, and focus controls

Teleprompter

Remote control pedestal

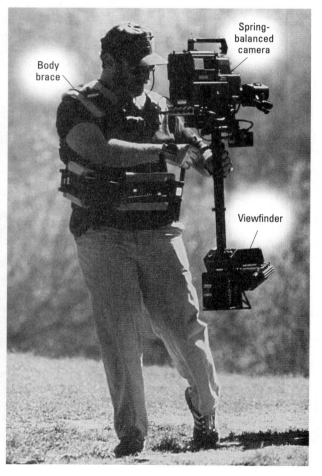

Spring-balanced camera

Body brace

Viewfinder

5.19

COLLAPSIBLE JIB ARM

The lightweight jib arm can do pretty much everything a heavy camera crane can do, except carry the camera operator and the director aloft. It can be easily disassembled and transported in a car to a remote location.

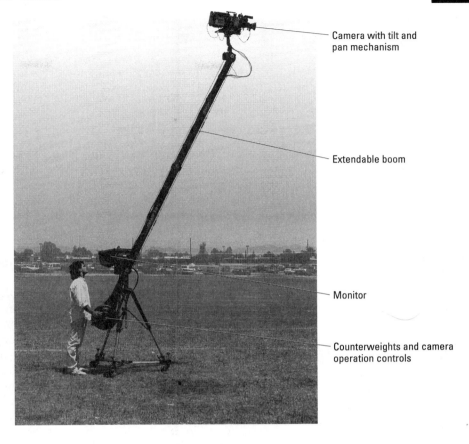

Camera with tilt and pan mechanism

Extendable boom

Monitor

Counterweights and camera operation controls

5.20

SHORT-ARM JIB

This light counterbalanced camera support can be clamped to just about anything; it can be moved up and down and tongued just like a big crane.

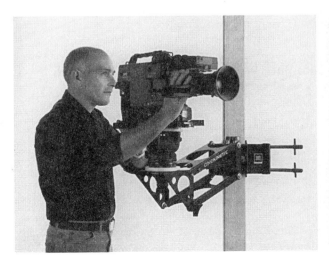

5.21

BEANBAG

This small canvas bag is filled not with beans, but a highly flexible synthetic material that adjusts to any camera configuration. Like a pillow, it cuddles the camera and protects it from minor shocks. You can tie it to practically any moving object.

OPERATIONAL FEATURES

Now that you know how to frame a shot and move the camera about, you need to pay attention to (1) white balancing, (2) focusing, and (3) zooming.

White Balancing

White balancing means adjusting the red, green, and blue chroma channels in the camera so that a white sheet of paper looks white on the television screen, regardless of whether the light that illuminates the sheet is reddish, as a candle, or bluish, as outdoor light. Most small camcorders do this automatically, which means that the camera senses the nature of the light in which you are shooting and adjusts to it automatically, assuming that you have set the white balance switch to the proper setting, such as "outdoors" or "indoors."

Professional ENG/EFP cameras have a semiautomatic white balance control that is more accurate than the fully automatic ones. The disadvantage is that you need to white balance every time you move into a new lighting environment, such as from indoor light to outdoors, or from the fluorescent lights of a supermarket to the manager's office that is illuminated by a table lamp.

To *white balance* your camera with the semiautomatic system, you focus on a white sheet, a white shirt, or even a clean tissue and then press the white balance button. Some camera bags have a white rectangle sewn into them so that you will always have something for white balancing. The viewfinder display (usually a flashing light) will tell you when the camera is seeing true white. Make sure that the white object fills the entire screen area and that it is located in the light that *actually illuminates* the scene you are shooting. For example, don't white balance your camera in the hallway or outside the stage doors and then run up to the stage runway where models parade the latest designs. If you do, you may find that the video colors are quite different from the actual colors the models wore. (The reason for such color shifts will be explained in chapter 6.) You need to white balance every time you move into a new lighting environment, even if the light seems the same to your eyes.

When operating a studio camera or an ENG/EFP camera that is connected to a camera cable, the video operator takes care of the white balancing from the CCU (camera control unit) or the RCU (remote control unit).

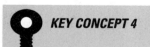 *KEY CONCEPT 4* **Unless you have a fully automatic white balance system, you need to white balance every time you enter a new lighting environment.**

Focusing

Normally, we want to have all pictures on the screen appear in focus (sharp and clear). You can achieve focus by *manual* or *automatic* controls.

Manual focus All ENG/EFP and studio cameras must be focused manually. The ENG/EFP focus control is a ring at the front of the lens that you can turn

5.22

MANUAL FOCUS ON ENG/EFP CAMERAS

The focus control on ENG/EFP cameras is a ring at the front of the lens, which can be turned by hand.

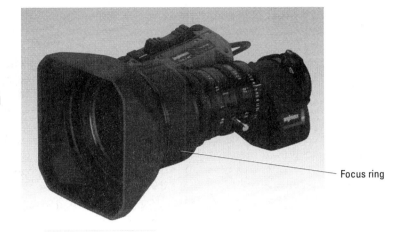

Focus ring

5.23

MANUAL FOCUS CONTROL ON STUDIO CAMERAS

The focus control on studio cameras is a twist grip attached to the left panning handle. To focus, you turn it either clockwise or counterclockwise.

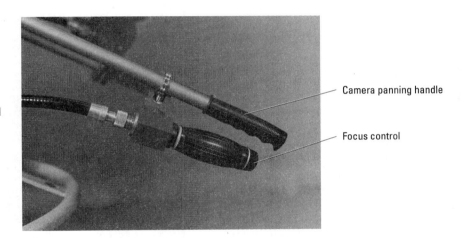

Camera panning handle

Focus control

clockwise or counterclockwise. **SEE 5.22** When operating a studio camera, you keep in focus by turning a twist grip mounted on the left panning handle and connected to the zoom lens by cable. **SEE 5.23**

Some of the small camcorders have a focusing system that is driven by a little motor. Instead of turning the twist grip or the focus ring of the lens, you simply press one of two buttons to get the lens into focus. The problem with this system is that it is considerably slower than turning the focus ring, and it is difficult to get the motor to stop exactly at the sharpest focus point without some tweaking.

Presetting the zoom lens *Calibrating the zoom lens*, or presetting, means that you need to adjust your zoom lens so that it will maintain focus during the entire zoom. Let's practice presetting your zoom lens for a simple EFP assignment and for a studio production.

Let's assume that you are to videotape a sales manager's pep talk to her company. During the videotaping, you are asked to zoom in to a fairly tight close-up of the sales chart to show the dramatic rise of sales for the past six months. But when you try to zoom in from the medium shot of the sales manager to the tight

close-up of the chart, it gets woefully out of focus and becomes unreadable. What happened? You neglected to preset, or calibrate, your lens before zooming in for the close-up.

To preset your lens, you must first zoom in to the desired close-up of the chart and then bring the chart into focus by turning the focus ring at the front of the ENG/EFP lens, and then zoom back to the medium shot of the sales manager. She and the chart will remain in focus during all subsequent in and out zooms, provided that she and the camera do not move. However, as soon as you reposition the camera, or if the sales manager moves the easel, you will need to recalibrate the lens.

Now, let's move into the studio where your camera is assigned to cover a classical pianist from the side so that you can zoom in from a medium shot to a tight close-up of the keyboard and the pianist's hands. How do you preset your zoom lens for this? You zoom in for a tight close-up of the keyboard and bring your lens into focus (by turning the twist grip on the left panning handle). But exactly where on the keyboard? Probably at the far end of the keyboard, because then you can zoom in and out and stay in focus regardless of whether the pianist displays his virtuosity at the near or far end.

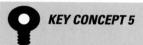

KEY CONCEPT 5 **To preset (calibrate) a zoom lens, zoom in as closely as possible on the target object and bring it into focus. All subsequent zooms will remain in focus. Every time the camera or the subject moves, you need to recalibrate.**

Automatic focus Most small camcorders are equipped with an automatic focusing system, called the *autofocus*. You probably remember that one of the camcorder features your salesperson pitched was the autofocus. Through some electronic wizardry (reading the angle of a little radar beam or measuring the contrast) the camera focuses on the various objects in a scene all by itself. Most of the time, these systems work well. But there are times when the camera is fooled or gets confused by very bright or low-contrast scenes and leaves you with a blurred image. Or it may not know exactly which object in the picture you want to bring into focus. You may not want to focus on the obvious foreground object but instead on the middleground. The autofocus will not be able to read your artistic intent and will proudly focus on the most prominent object closest to the camera. To achieve such a *selective focus* (see "Depth of field" which follows), you need to switch from autofocus to manual.

Depth of field As we have already mentioned in chapter 4, the shallower the depth of field, the more critical the focus becomes. The greater the depth of field, the less you have to worry about keeping the camera in focus. You also recall that the more you zoom in (with the lens getting progressively more narrow-angle), the shallower your depth of field becomes; the more you zoom out (to a wide-angle view) the greater the depth of field becomes. In addition, depth of field is also influenced by the distance from your camera to the subject.

Which assignment would probably give you more focus problems: the coverage of evening rush-hour, when you must zoom in to a fairly tight shot in order to compress the heavy bridge traffic; or the coverage of a midday parade from street level with the zoom lens in the extreme wide-angle position? Definitely, the first one. But why? The low light level, the resulting large lens aperture, and the long focal-length (telephoto) position of the zoom lens (see chapter 4) combine into a rather shallow depth of field. In contrast, the high midday light levels for the parade (resulting in a small lens aperture) and the wide-angle position of the zoom lens give you such a great depth of field that you probably won't have to turn your focus ring even once.

You will find that if you move your camera extremely close to the object, your depth of field will shrink even if your lens is zoomed out to the wide-angle position. Because the distance of camera to object influences the depth of field as does the focal length of the lens, we can say that, in general, tight close-ups have a *shallow depth of field.* **SEE 5.24**

5.24

DEPTH OF FIELD IN CLOSE-UPS

Regardless of the focal length of your lens, close-ups have a shallower depth of field than long shots.

 KEY CONCEPT 6 **The depth of field is dependent on the focal length of the lens, the aperture, and the distance of camera to object.**

Zooming

All small and ENG/EFP camcorders have a rocker switch attached to the lens that activates the zoom mechanism. By pressing down on the front of the switch, usually labeled "T" for telephoto or tight, you trigger a little motor that rearranges various lens elements in the zoom lens for the zoom-in effect; by pressing down the back end of the switch, labeled "W" for wide, you zoom out. This *servo-zoom* mechanism, which is activated by your zoom rocker switch, keeps your zooming

5.25

CAMCORDER ZOOM CONTROL

The camcorders have a rocker switch near the lens that controls the zooming-in and zooming-out motion.

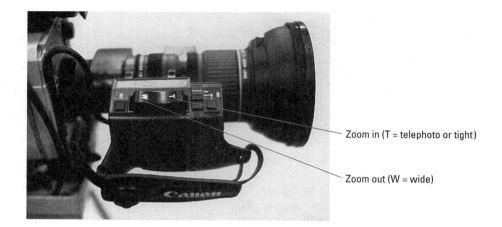

Zoom in (T = telephoto or tight)

Zoom out (W = wide)

5.26

STUDIO ZOOM CONTROL

The zoom control of the studio camera is a rocker switch that is attached to the right panning handle and activated by the thumb of your right hand.

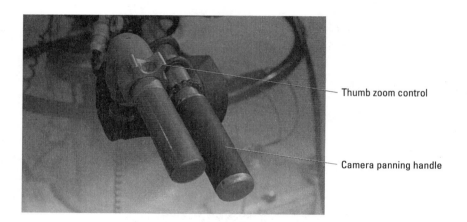

Thumb zoom control

Camera panning handle

at a constant speed. **SEE 5.25** Some cameras give you a choice between a slow and fast zoom speed. ENG/EFP lenses have an additional manual zoom control, which allows you to override the servo-zoom mechanism for very fast zooms.

Studio cameras have a similar rocker switch mounted on the right panning handle. This thumb-operated switch is connected by cable to the servo-zoom mechanism of the studio lens. By pressing the right side of the switch, you zoom in; by pressing the left side, you zoom out. **SEE 5.26**

Because the servo-zoom control makes zooming relatively easy, you may be tempted to zoom in and out rather than move the camera closer or farther away. Again, remember to *keep your zooming to a minimum.* Frequent and unmotivated zooming reveals the inexperience of the camera operator as readily as excessive camera movement.

KEY CONCEPT 7 **Keep your zooming to a minimum.**

GENERAL GUIDELINES

Whether you are operating a small camcorder or a large studio camera, treat it with *extreme care*—as with all electronic equipment. Always be mindful of your and others' safety. Do not risk your neck and the equipment to get an especially spectacular shot that merely embellishes, rather than tells, the story. Do not abandon standard operational procedures for the sake of expediency. Whatever you do, use common sense.

Like bicycling, you can learn to operate a camera only by doing it. However, the following guidelines can make learning easier and also serve as useful checklists.

CHECKLIST: CAMCORDERS AND ENG/EFP CAMERAS

☑ **Don't expose the camera to the elements** Never leave the camera unprotected in the sun or in a hot car. Also, watch that the viewfinder is not pointed into the sun; the magnifying glass in the viewfinder can collect the sun's rays and melt the viewfinder housing and electronics. Use plastic covers, called "raincoats," when shooting in the rain or extreme cold. In case of emergency, a plastic grocery bag will do.

☑ **Leave the camera with care** Lock the mounting head on your tripod whenever you leave the camera unattended. When putting the camera down, place it upright. Laying it on its side may damage the viewfinder or attached microphone.

☑ **Use the lens cap** Even if your camera can be "capped" internally by preventing light from reaching the imaging device, always put the metal or plastic cap over the front of the lens. This lens cap keeps the light off the imaging device and protects the front surface of your expensive zoom lens.

☑ **Use fully charged batteries** Make sure that the nickel-cadmium (nicad) battery is fully charged. Many batteries develop a "memory," which means that they signal a full charge even if they are only partially charged. To avoid this problem, always discharge the batteries fully before charging them. Battery dischargers/chargers are commercially available (sometimes called *battery reconditioners*) that discharge the battery before automatically switching over to the charging cycle.

Do not drop the batteries or expose them to extreme heat. Always carry a fully charged spare battery and an AC power pack, which converts the standard 110 volts AC (alternating current) to the appropriate DC (direct current) and serves as power supply as well as battery charger.

Unless your main battery recharges the small auxiliary battery in your camera that drives the clock and maintains other electronic values, you need to replace it from time to time, very much like your watch battery. Always carry a spare battery and a spare fuse.

☑ **Verify your videotapes** Make sure your videotape cassettes fit your camcorder. Even if the cassettes look similar from the outside, they may not fit

your particular camcorder. Always take a few additional videotape cassettes along. Running out of tape in the middle of an important event is as frustrating as running out of battery power.

☑ *Examine your connections* Check *all connectors*, regardless of what they connect, to see whether they fit their designated plugs, as shown in figure 3.16. Use adapters only in an emergency; an adapter is by design a stopgap and, as such, the source of potential trouble. If your ENG/EFP camera is connected to a cable, check its reach. Plug in the external microphone to see whether the microphone connectors fit the plug on your camera. Small camcorders normally use smaller (RCA or phono) connectors; all larger ENG/EFP camcorders have three-pin (XLR) connectors (see chapter 8 for further information on audio connectors).

☑ *Test the camera* Even when you are in a hurry, do a brief test recording to see whether your camcorder operates properly. Bring headphones along to check the audio. Use the same power supply and connectors you intend to use during the actual videotaping. Check the full range of your zoom lens and your focus. In extremely cold or damp weather conditions, zoom lenses sometimes stick or give up altogether.

☑ *Set your switches* Have all the switches, such as auto or manual focus, auto iris, zoom speed, and shutter speed, in the desired positions. The faster the action in front of your camera, the higher the shutter speed must be in order to prevent the moving object from blurring. However, higher shutter speeds require higher light levels.

☑ *Perform a white balance* White balance your camera before beginning with the videotaping, unless you have a fully automatic system. Be sure to white balance under the light that actually illuminates the event.

☑ *Always capture audio* Always turn on the camera microphone and record sound with the pictures. This sound will help you identify the location of the event, and it will provide background and continuity for postproduction editing.

☑ *Heed the warning signs* Take note of caution signals and try to take care of the problem immediately. You may be able to dismiss the "low light level" warning on your camera if you are not concerned with picture quality; but you simply cannot ignore a "low battery" warning.

CHECKLIST: STUDIO CAMERAS

☑ *Get in touch and in control* Put on your headset to establish contact with the control room and the video operator. Unlock the mounting head and adjust the pan and tilt drag. Pedestal up and down to get a feel for the pedestal range and motion. A properly balanced pedestal should keep the camera stable at any given vertical position.

☑ ***Tame your cables*** Make sure your cable guards are close enough to the floor to prevent your camera from rolling over the camera cable. Uncoil the cable and check its reach. To avoid the inevitable tug of the cable during a dolly, tie it to the pedestal, but leave enough slack so that you can freely pan, tilt, and pedestal.

☑ ***Test zoom and focus*** Ask the video engineer to uncap your camera so that you can rack through your zoom and focus range and, if necessary, adjust the viewfinder. Practice presetting the zoom lens and see whether the scene remains in focus during subsequent zooms.

☑ ***Practice your moves*** Mark the critical camera positions with masking tape. Write down all on-air camera moves so that you can set your zoom lens in the wide-angle position before the required move.

☑ ***Move gracefully*** Ask the floor person to help you steer the camera during an especially tricky move. If your cable gets tangled up during a dolly, don't drag the whole mess along. Signal the floor person to untangle it for you. When dollying or trucking, start slowly to overcome the inertia of the heavy dolly, and slow down just before the end of the dolly. When raising or lowering the camera, brake the pedestal column before it reaches its maximum or minimum height; otherwise, your camera and your picture will receive a hefty jolt.

☑ ***Don't jump the red light*** Watch for the tally light (the red light inside your viewfinder and on top of the camera) to go out before moving the camera into a new position or presetting the zoom. The tally light tells the camera operator, the talent, and the studio production crew which camera is "hot" (on the air). During special effects, your tally light may remain on even if you think that your shot is finished. Normally, the ENG/EFP camera or camcorder has only a viewfinder tally light, but not another one on top of the camera. This viewfinder tally light tells only you, the camera operator, when the camera is operating.

☑ ***Avoid nervous camera movements*** Keep your eyes on the viewfinder and correct *slowly* for minor compositional defects. If a subject bounces back and forth on a close-up, do not try to keep it in the frame at all costs. It is better to let it move out of the frame from time to time than to play catchup by rapid panning.

☑ ***Let the director direct*** Always follow the director's instructions, even if you think that he or she is wrong. Do not try to outdirect the director from your position. But do alert the director if you are asked to do such impossible things as dollying or trucking on the air with your lens in the narrow-angle position.

☑ ***Be observant and attentive*** Be aware of all other activities around you. Pay special attention to where the other cameras are and to where they are asked to move. By listening to the director's instructions, you will be able to stay out of the way of the other cameras. When moving your camera, especially backward, watch for obstacles that may be in your path. Ask a floor person to guide you. Avoid unnecessary chatter on the intercom.

☑ ***Anticipate*** Try to line up the next shot before the director calls for it, even if you work without a shot sheet that lists the nature and sequence of your shots. For example, if you hear on the intercom that the other camera is on air with a close-up, pull out to a medium shot or get a different angle to provide the director with another field of view. Do not duplicate the shot of the other camera.

☑ ***Put your tools away properly*** At the end of the show, wait for the "all clear" signal before preparing your camera for shutdown. Ask the video operator to cap the camera. As soon as the viewfinder goes dark, release the tilt and pan drag, lock the mounting head, and put the metal cap on the front of the lens. Park the camera in its usual place and coil the cable in the customary figure-eight loops.

Your knowledge of camera operation and your checklist will certainly impress the Triple-I people. But now you need to practice handling the camera as much as possible.

ONCE AGAIN, REMEMBER...

Camera Movements

The movements include the pan, tilt, cant, pedestal, dolly, truck, arc, crane or boom, and tongue. The zoom is also included, although the camera does not move.

Camera Mounts

These include a variety of tripods, studio pedestals, or special mounts, such as the camera jib arm or camera crane.

Camera Mounting Head

This device is a mechanism that connects the camera to the tripod or studio pedestal. It facilitates pans and tilts.

White Balancing

This procedure is necessary to adjust the camera to various lighting conditions. It needs to be done every time the camera operates under new lighting conditions, unless it has a fully automatic white balance mechanism.

Presetting the Zoom Lens

This step is also called calibrating the zoom lens. It needs to be done every time the camera or the subject in front of the camera moves. To preset a zoom, the lens must be zoomed in on the farthest target object and brought into focus. All subsequent wider-angle zoom positions will be in focus.

KEY CONCEPTS

- Keep the handheld or shoulder-mounted camera as steady as possible and zoomed-out when moving.

- Whenever possible, put your camcorder or ENG/EFP camera on a tripod.

- Always lock the mounting head when leaving the camera unattended.

- Unless you have a fully automatic white balance system, you need to white balance every time you enter a new lighting environment.

- To preset (calibrate) a zoom lens, zoom in as closely as possible on the target object and bring it into focus. All subsequent zooms will remain in focus. Every time the camera or the subject moves, you need to recalibrate.

- The depth of field is dependent on the focal length of the lens, the aperture, and the distance of camera to object.

- Keep your zooming to a minimum.

Directional Light Light that illuminates a relatively small area with a distinct light beam. Directional light, produced by spotlights, creates harsh, clearly defined shadows.

Diffused Light Light that illuminates a relatively large area with an indistinct light beam. Diffused light, created by floodlights, produces soft shadows.

Lux European standard unit for measuring light intensity. One lux is the amount of 1 lumen (one candle-power of light) that falls on a surface of 1 square meter located 1 meter away from the light source. 10.75 lux = 1 foot-candle. Most lighting people figure roughly 10 lux = 1 foot-candle.

Foot-candle The unit of measurement of illumination, or the amount of light that falls on an object. One foot-candle is the amount of light from a single candle that falls on a 1-square-foot area located 1 foot away from the light source. See *Lux*.

Baselight Even, nondirectional (diffused) light necessary for the camera to operate optimally. Refers to the overall light intensity.

Light Intensity The amount of light falling on an object that is seen by the lens. Measured in lux or foot-candles. Also called *light level*.

Attached Shadow Shadow that is on the object itself. It cannot be seen independently of (detached from) the object.

Cast Shadow Shadow that is produced by an object and thrown (cast) onto another surface. It can be independent of the object.

Falloff The speed (degree) with which a light picture portion turns into shadow areas. Fast falloff means that the light areas turn abruptly into shadow areas and there is a great difference in brightness between light and shadow areas. Slow falloff indicates a very gradual change from light to dark, and a minimal brightness difference between light and shadow areas.

Additive Primary Colors Red, green, and blue. Ordinary white light (sunlight) can be separated into the three primary light colors. When these three colored lights are combined in various proportions, all other colors can be reproduced.

Color Temperature Relative reddishness or bluishness of light, as measured in Kelvin degrees. The norm for indoor video lighting is 3,200°K, for outdoors, 5,600°K.

Kelvin Degrees The standard scale for measuring color temperature, or the relative reddishness or bluishness contained in white light.

Gel Generic name for color filter put in front of spotlights or floodlights to give the light beam a specific hue. *Gel* comes from *gelatin*, the filter material used before the invention of much more heat- and moisture-resistant plastic material. Also called *color media*.

Spotlight A lighting instrument that produces directional, relatively undiffused light.

Floodlight A lighting instrument that produces diffused light.

C-clamp A metal clamp with which lighting instruments are attached to the lighting batten.

Key Light Principal source of illumination. Usually a spotlight.

Fill Light Additional light on the opposite side of the camera from the key light to illuminate shadow areas and thereby reduce falloff. Usually done with floodlights.

Back Light Illumination from behind the subject and opposite the camera.

Photographic Principle The triangular arrangement of key, back, and fill lights, with the back light opposite the camera and directly behind the object, and the key and fill lights on opposite sides of the camera and to the front and side of the object. Also called *triangle lighting*.

Triangle Lighting The triangular arrangement of key, back, and fill lights. Also called *photographic principle*.

Background Light Illumination of the set pieces and backdrop. Also called *set light*.

Light Plot A plan, similar to a floorplan, that shows the type, size (wattage), and location of the lighting instruments relative to the scene to be illuminated and the general direction of the light beams.

Incident Light Light that strikes the object directly from its source. To measure incident light, the light meter is pointed at the camera lens or into the lighting instruments.

Reflected Light Light that is bounced off the illuminated object. To measure reflected light, the light meter is pointed close to the object from the direction of the camera.

Light, Color, Lighting

THE lighting director of Triple-I, with a reputation for being one of the best LDs around, does strange things. He insists on using large reflectors and additional lights when shooting a beach scene, even with the midday sun blazing down. But later on when the fog has rolled in and the day beings to look rather dreary, he seems rather unconcerned about additional lights or reflectors. Back in the studio, he complains about the lack of adequate lighting instruments when trying to re-create the light of a single candle in a studio scene. His assistant has a single answer to your questions about such strange lighting procedures: "It's all a matter of shadow control." Thank you—but what, exactly, does this mean?

What the assistant is implying is that good lighting calls not only for deliberate illumination—where the light falls, whether the light used is soft or harsh, and what color the light has. It also calls for meticulous shadow control—where the shadows fall, and whether they should be prominent or not. It is, after all, the interplay of light and shadows that makes us see objects and their environments and feel about them in a specific way.

 KEY CONCEPT 1 **Lighting means deliberate illumination and shadow control.**

In this chapter, you will learn about—

- **LIGHT**
 Directional and diffused light, light intensity, and how to measure it

- **SHADOWS**
 Attached and cast shadows, and falloff control

■ **COLOR**
Additive and subtractive mixing, the color television receiver and generated colors, and color temperature and white balancing

■ **LIGHTING INSTRUMENTS**
Spotlights, floodlights, and studio and portable instruments

■ **LIGHTING TECHNIQUES**
Operation of lights, the photographic or triangle lighting principle, field lighting, and measuring illumination

LIGHT

Although the Triple-I lighting assistant was right in saying that lighting is primarily a matter of shadow control, you nevertheless need to control the light in order to manipulate shadows. Lighting requires the careful application of two basic types of light and the control of their intensity.

■ Types of Light

No matter how the light is technically generated, you will work with two basic types: *directional* and *diffused.*

Directional light means that its beam is rather precise, which causes harsh shadows. The sun, your flashlight, and the headlights of your car all produce directional light. You can aim directional light at a specific area without much spill into other areas.

Diffused light causes a more general illumination. Its diffused beam spreads out very quickly and illuminates a large area. Because diffused light seems to come from all directions (omnidirectional), it has no clearly defined shadows—they seem soft and transparent. A good example of diffused light occurs on a foggy day, when the fog operates like a huge diffusion filter for the sun. Watch the shadows during bright sunlight and on an overcast or foggy day; they are quite distinct and dense in sunlight, but hardly visible in fog. The fluorescent lighting in department stores or elevators uses diffused light exclusively. You cannot use diffused light to illuminate a precisely defined area; rather, diffused light is often used to illuminate large areas.

■ Light Intensity

An important aspect of lighting is controlling the intensity of light, or how much light falls onto an object. Intensity is measured in European *lux*, or American *foot-candles* (ft-c). If you have foot-candles and want to find lux, multiply the foot-candle

figure by 10. Twenty foot-candles are approximately 200 lux ($20 \times 10 = 200$). If you have lux and want to find foot-candles, divide the lux number by 10. Two thousand lux are approximately 200 ft-c ($2,000:10 = 200$).[1]

You may hear the LD (lighting director) or VO (video operator) complain that there is not enough baselight. ***Baselight*** refers to the overall ***light intensity***. You determine baselight levels by pointing a light meter (which reads foot-candles or lux) from the illuminated object or scene *toward the camera*. As you recall, you need a certain amount of light to activate the imaging device and other electronics in the camera to produce an optimal video signal at a given f-stop. If there is insufficient light even at the maximum aperture (lowest f-stop number), you need to activate the *gain* circuits of the camera. Most consumer camcorders do this automatically. Studio and EFP/ENG cameras need to have the gain activated either via the CCU (camera control unit) or through a switch on the ENG/EFP camera. The gain will boost the weak video signal electronically. Unfortunately, the higher the gain, the "noisier" the picture becomes.

You may recall the salesperson telling you that your camera "goes down to 3 lux"—at 1/3 ft-c, this is an extremely low light level—and that it has a "low-noise gain." Despite such low-noise gain circuits, the dark portions of your picture will begin to show small colored specks that resemble miniature snowstorms. An adequate baselight level will prevent such problems. This is why even top-of-the-line cameras still need about 2,000 lux (200 ft-c) at an f-stop of about 5.6 for optimal picture quality. High baselight levels will also slow down the falloff throughout the scene and thus render all shadows less dense without eliminating them. If your baselight level is too low, you can open the iris, increase the gain, or—better yet—add one or two floodlights that produce highly diffused light and shine them onto the scene.

You can control light intensity by controlling the distance of the lighting instrument to the object. The closer the instrument is to the subject, the more intense the illumination. By putting diffusion material in front of the lighting instrument, or, more common, by using an electronic dimmer, you can reduce light intensity. Like the gas pedal in your car, which controls the amount of gasoline reaching the engine, the dimmer controls the amount of electricity (voltage) reaching the light bulb. Most modern dimmers are computer-controlled and highly precise.

SHADOWS

Although we are quite conscious of light and light changes, we are usually unaware of shadows, unless we seek comfort in them on a particularly hot day, or if they interfere with what we want to see. Because shadow control is such an important aspect of lighting, you need to take a closer look at shadows and how they influence our perception.

1. One lux is the light that falls on the surface of 1 square meter (roughly 3×3 feet), generated by a single candle that burns at a distance of 1 meter.

Once you are aware of shadows, you will be surprised by the great variety of shadows that surround you. Some seem part of the object, such as the shadows on your coffee cup; others seem to fall onto other surfaces, such as the shadow of a telephone pole that is cast onto the street. Some shadows are dark and dense as though they were brushed on with thick, black paint; others are so light and subtle that they are hard to see. Some change gradually from light to dark; others do so quite abruptly.

Despite the great variety of shadows, we have only two basic types: *attached* and *cast*. The relative lightness and darkness of the shadows and how they vary are aspects of *falloff*.

Attached Shadows

Attached shadows seem affixed on the object and cannot be seen independently of it. Take your coffee cup and hold it next to your window or a table lamp. The shadow opposite the light source (window or table lamp) on the cup is the attached shadow. No matter whether you wiggle the cup or move it up and down, the attached shadow will remain part of the cup. **SEE 6.1**

6.1

ATTACHED SHADOW

The attached shadow is always bound to the illuminated object. It cannot be seen separately from the object.

Attached shadows help us to perceive the basic form of an object. Without attached shadows, the actual shape of an object may remain ambiguous when seen as a picture. In the figure at the top of the facing page, the object on the left looks like a triangle; but when you see it with the attached shadows, the triangle becomes a cone. **SEE 6.2**

Attached shadows also contribute to texture. A great amount of prominent attached shadows emphasizes texture; without them, things look smoother. Attached shadows on a Styrofoam ball make it look like a moonscape; but when the attached shadows are removed through flat lighting, the ball looks rather smooth. **SEE 6.3–6.4**

6.2

ATTACHED SHADOWS DEFINE SHAPE

The attached shadows help define the basic shape of the object. Without attached shadows, we perceive a triangle on the left; with attached shadows, we perceive a cone on the right.

6.3

ROUGH TEXTURE

Prominent attached shadows emphasize texture. The surface of this Styrofoam ball looks rough.

6.4

SMOOTH TEXTURE

Here, the attached shadows are almost eliminated. The surface of this Styrofoam ball looks relatively smooth.

6.5

ATTACHED SHADOWS MINIMIZED

To emphasize the smoothness of this model's face, attached shadows are kept to a minimum.

6.6

TEXTURE EMPHASIZED

The prominent attached shadows reveal the rich texture of this basket.

If you had to shoot a commercial for skin lotion, you would want to light the model's face in such a way that the attached shadows are so soft that they are hardly noticeable. **SEE 6.5** But if you are asked to emphasize the delicate texture of a woven basket, you would need to light for prominent attached shadows. **SEE 6.6** Exactly how to control attached shadows will be taken up in the lighting techniques section later in this chapter.

KEY CONCEPT 2 **Attached shadows reveal form and texture.**

Because we normally see the main light source coming from above (the sun, for example), we are used to seeing the attached shadows fall below protrusions and indentations. When you now lower the principal light source so that it illuminates an object, such as a face, from below eye level, we experience this departure from the norm as mysterious or spooky. **SEE 6.7** There is probably not a single science fiction or horror movie that does not use such a shadow-reversal effect at least once.

Cast Shadows

Unlike attached shadows, *cast shadows* can be seen independently of the object that is causing them. If you make some shadow pictures on a wall, for instance, you can focus on the shadows without showing your hand. The shadows of

6.7

REVERSAL OF ATTACHED SHADOWS

The below-eye-level light source causes the attached shadows to fall opposite their expected positions. We interpret such unusual shadow placement as ghostly or mysterious.

6.8

CAST SHADOWS

Cast shadows are usually cast by the object on some other surface. In this case, the cast shadows of the traffic sign and fence fall on the street.

telephone poles, traffic signs, or trees cast on the street or on the wall of a nearby building are all examples of cast shadows. Even if the cast shadows touch the base of the objects causing them, they remain cast shadows and will not become attached ones. **SEE 6.8**

Cast shadows help us see where the object is located relative to its surroundings and to orient us in time, at least to some extent. Take another look at figure 6.8. The cast shadows of the fence and the stop sign do not stretch too far along the street but are fairly close to the base of the gate. The relatively short cast shadows indicate late morning or early afternoon.

 KEY CONCEPT 3 **Cast shadows help to tell us where things are and when events take place.**

▌ **Falloff**

Falloff indicates the degree of change from light to shadow. More specifically, it refers to the relative abruptness—the "speed"—with which the light area turns into the shadow area, or the brightness contrast between the light and shadow sides of an object. When the change from light to dense shadow is extremely abrupt, we speak of *fast falloff.* It indicates a sharp edge or corner. **SEE 6.9** A *slow falloff* shows a more gradual change from light to shadow side; the gradual shading indicates a curved object. **SEE 6.10**

6.9

FAST FALLOFF

The change of light to shadow areas on these buildings is very sudden. The falloff is extremely fast, indicating an edge or corner.

6.10

SLOW FALLOFF

The attached shadow on this balcony gets gradually darker. The falloff is relatively slow, indicating a curved surface.

Fast falloff can also mean that there is a high contrast between the light and shadow sides of a face. When the shadow side is only slightly darker than the light side and highly transparent, we have slow falloff. If both sides of the face are equally bright, we no longer have any falloff. As you can see, texture also depends on falloff. Fast falloff lighting will show wrinkles in a face; slow falloff or no falloff lighting will hide them.

KEY CONCEPT 4 **Falloff defines the contrast between light and dark areas and how quickly light turns into shadow.**

When generating lighting effects with a computer, the relationship between attached and cast shadows and the rate of falloff have to be carefully calculated. For example, if you simulate a light source striking the object from screen-right, the attached shadows must obviously be placed on its screen-left side (opposite from the light source). Also, the cast shadows must point in the screen-left direction. If you now pretend to move the light source in a counterclockwise direction (closer to the camera), the attached as well as the cast shadows must move with it—to stay opposite the light source. If you move the light source higher, the cast shadows become shorter. If you move the light source lower, the cast shadows become longer. It helps to have actual photos to work from, to make sure the shadows are logically placed. Such careful attention to shadow consistency is also important if you cut a live scene electronically into a photographic or painted background.

COLOR

Chapter 3 promised you some more detailed information on color and its use in video. In this section, we focus on (1) the basic process of color mixing, (2) the color television receiver and generated colors, and (3) color temperature and white balance.

Additive and Subtractive Color Mixing

You will undoubtedly recollect our conversation about the beam splitter that divides the white light transmitted by the lens into the three primary light colors—red, green, and blue—and how we can produce all video colors by adding the red, green, and blue light in certain proportions. These are called *additive primary colors* because we mix them by *adding* one colored light beam on top of others.

If you had three identical slide projectors, you could put a red slide into one, a green slide in the second, and a blue slide in the third and aim them at the screen so that their beams overlap slightly. **SEE COLOR PLATE 3** What you would see is similar to the three overlapping circles shown in the illustration.

As you can see, red light and green light add up to *yellow;* red and blue to a bluish red called *magenta;* and green and blue to a greenish blue called *cyan.* Where all three primary light colors overlap, you get white. By dimming all three projectors equally, you get a variety of grays. By turning them all off, you get black (obviously). By dimming any one or all projectors independently, you can achieve a wide variety of colors.[2] For example, if you have the red projector burn at full intensity, and the green one at two-thirds intensity with the blue projector turned off, you get some kind of orange. The more you dim the green projector, the more reddish your orange becomes.

 KEY CONCEPT 5 **The additive primary light colors are red, green, and blue.**

You may remember from your finger-painting days that the primary colors were red, blue, and yellow, and that mixing red and green paint together does not produce a clean yellow, but rather a muddy dark brown. But paint mixes differently from light. When paint is mixed, its built-in filters subtract certain colors (light frequencies) rather than add them. We call this mixing process *subtractive color mixing.* Because the video system processes colored light rather than paint, we will concentrate on additive mixing.

2. On some projectors, such dimming will also reduce power to the projector's blower motor. If so, do not throttle the power too much or for too long a period. If you do this you run the risk of overheating the entire lamp assembly.

The Color Television Receiver and Generated Colors

The color television set also works on the additive color-mixing principle. Instead of the three slide projectors, a color television receiver has three electron guns in the neck of the picture tube that shoot their beams at many tiny red, green, and blue dots clustered on the inside of the television screen. One of the three guns is designated to hit the red dots, the other the green dots, and the third the blue dots. **SEE COLOR PLATE 4** The harder they hit the dots, the more the dots light up. If your "red" gun and "green" gun hit their dots with full intensity, with the blue gun turned off, you get yellow. When all three guns fire at full intensity, you get white; at half intensity, you get gray. When they hit their respective dots with little but equal intensity, you get a very dark gray. As you can see, all three guns work overtime when you are watching a black-and-white show.

Because the video signal consists of electrical energy rather than actual colors, couldn't we produce certain colors without a camera simply by stimulating the three electron guns with certain voltages? Yes, definitely! In a slightly more complex form, this process is used by the computer to generate literally thousands of colors. The various colors in titles or other graphic displays, and the controversial colorizing of black-and-white movies, are all based on the principle of additive color mixing and generating colors by computer.

Color Temperature and White Balancing

In chapter 5 you learned how to white balance; now you will learn *why*. The reason you need to white balance the camera is that not all light sources produce light of the same "whiteness." For instance, a candle will produce a more reddish light than the supermarket's fluorescent lights, which burn with a more bluish light. Even the same light source does not always produce the same light. The beam of a flashlight with a weak battery looks quite reddish; when fully charged, the flashlight throws a more intense, and also whiter, light beam. The camera needs to adjust to these differences in order to keep color the same in different lighting environments.

Color temperature The standard by which we measure the relative reddishness or bluishness of white light is called **color temperature**. The color differences of white light are measured in **Kelvin degrees** (K). The more *bluish* the white light looks, the *higher* the color temperature; the more *reddish* it is, the *lower* its color temperature.

Keep in mind that color temperature has nothing to do with how hot the actual light source gets. You can touch a fluorescent tube, even though it burns at a high color temperature; but you wouldn't do the same with the incandescent light bulb in your reading lamp, which burns at a much lower color temperature.

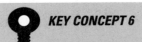
KEY CONCEPT 6 Color temperature measures the relative reddishness or bluishness of white light. Reddish white light has a low color temperature; bluish white light has a high color temperature.

CP-1

RGB BEAM SPLITTER

The prism block consists of prisms and filters that split the incoming white light into the three additive primary colors— red, green, and blue—and direct these colored light beams into their corresponding CCDs.

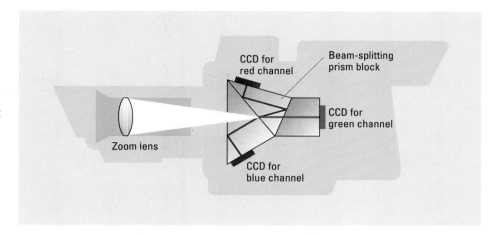

CP-2

NTSC SIGNAL

The NTSC video signal combines the chrominance (C) or RGB color channel with the luminance (Y) or black-and-white channel.

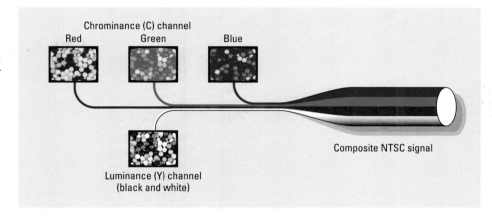

CP-3

ADDITIVE COLOR MIXING

When mixing colored light, the additive primaries are red, green, and blue. All other colors can be achieved by mixing certain quantities of red, green, and blue light. For example, the additive mixture of red and green light produces yellow.

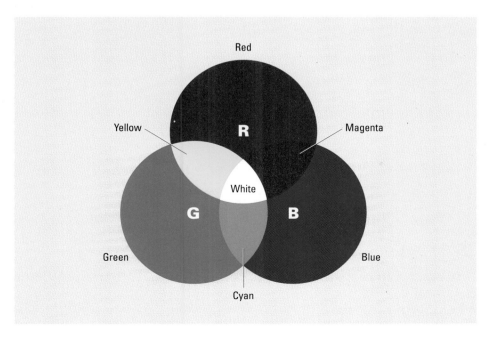

CP-4

IMAGE FORMATION FOR COLOR VIDEO

The color receiver has three electron guns, each responsible for either the red, green, or blue signal. Each of the beams is assigned to its color dots.

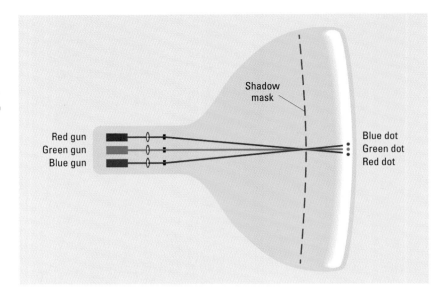

CP-5

CHROMA KEY EFFECT: WEATHERCAST

A In this chroma key, the weathercaster stands in front of a blue background.

B During the key, the blue background is replaced by this computer-enhanced satellite photo.

C The weathercaster seems to stand in front of the satellite photo.

CP-6

CHROMA KEY EFFECT: WINDOW

A In this chroma key, the newscaster sits in front of a blue background.

B During the key, the blue background is replaced by this ESS cityscape.

C The newscaster seems to sit in front of a picture window overlooking the city.

CP-7

GRAPHICS PROGRAM

Graphics programs offer a variety of lines and brush strokes, surface textures, and a wide choice of colors.

CP-8

FRACTAL IMAGE

Some computer programs allow you to "paint" irregular images using mathematical formulas.

CP-9

MORPHING

Here an image of a woman changes gradually into an image of a man.

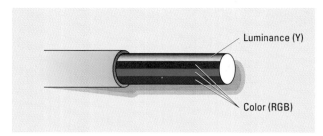

CP-10

COMPOSITE SYSTEM

The composite system uses a video signal that carries the combined luminance (brightness) and color information. It needs a single wire to be transported and is recorded on videotape as a single signal. It is the standard NTSC system.

CP-11

Y/C COMPONENT SYSTEM

The Y/C component system separates the Y (luminance) and C (color) information, but combines the two signals on the videotape. It needs two wires to transport the two separate signals. Special Y/C accessory equipment is needed.

CP-12

RGB SYSTEM

The RGB system (also called the RGB component system) separates the three RGB signals throughout the recording process. It needs three wires to transport the signal. All accessory equipment must be able to process the three separate channels.

CP-13

MULTIMEDIA DISPLAY

In this display, a lighting plot is interpreted into the actual lighting effect.

CP-14

MULTIMEDIA EXERCISE

In this multimedia display, the user can manipulate the focal length of a zoom lens and see the results in the special display window.

Because outdoor light is much more bluish than normal indoor illumination, two color temperature standards have been developed: 5,600°K for outdoor illumination and 3,200°K for indoor illumination. All the lighting instruments you use to simulate outdoor lighting burn at the relatively high 5,600°K color temperature. This means that their white light approximates the bluishness of outdoor light. The standard lighting instruments for indoor use (studio lights or portable lights for EFP) burn at the lower 3,200°K, and their "white" light is more reddish.

Because color temperature is measured by the relative bluishness or reddishness of white light, couldn't you raise the color temperature of an indoor light by putting a slightly blue filter in front of it, or lower the color temperature of an outdoor lamp by using a slightly orange filter? Yes, you can certainly do this. Such color filters, called *gels* or color media, are a convenient way of converting outdoor instruments for indoor lighting and indoor instruments for outdoor lighting. Similar filters are used in some cameras for rough white balancing.

White balancing As you recall, white balancing means adjusting the camera so that it reproduces a white object as white on the screen regardless of whether it is illuminated by a high color temperature source (the sun at high noon, fluorescent lamps, 5,600°K instruments), or a low color temperature source (candlelight, incandescent lights, 3,200°K instruments). When put on automatic white balance, the camera adjusts the RGB (red, green, blue) signals electronically so that they mix into white. You can also use the manual control, which means that you have to white balance on a white object. The camera locks in on this balance and remembers it until you switch to automatic or rebalance your camera in a different lighting environment.

Some of the larger cameras do the first rough white balancing with a bluish or orange filter, very much as you have just done, to change the color temperature of outdoor and indoor lights. In the high color temperature (bluish) outdoor light, the camera uses an orange filter to reduce the bluishness, and then fine-tunes the white balance by electronically adjusting the RGB mix. These cameras have a white balance lever that can be positioned at various points of Kelvin degrees, or are controlled from the CCU (camera control unit) or RCU (remote control unit).

Proper white balancing is very important for color continuity. For example, if you videotape a performer outdoors who wears a white dress, and then indoors, her dress should not look bluish in the first scene and reddish in the second; it should look equally white in both. Because the outdoor light of an overcast sky has a much higher color temperature than bright sunlight, you may have to rebalance your cameras when the fog lifts or clouds dissipate.

LIGHTING INSTRUMENTS

Despite the many lighting instruments available, there are basically only two types: *spotlights* and *floodlights*. Spotlights are primarily designed to throw a directional, defined beam that illuminates a specific area. They cause harsh, dense shadows. Floodlights produce a great amount of nondirectional, diffused light that causes very soft shadows. Some floodlights generate such slow falloff that you think they

are a shadowless light source. The heavier and more powerful lights are designed for studio use. They are usually suspended from a fixed lighting grid made of heavy steel pipes, or from movable, counterweighted battens. **SEE 6.11** Portable lights for ENG and EFP are lighter and more flexible, but generally less powerful.

Spotlights

Spotlights produce a sharp, directional beam that illuminates a fairly distinct area. Most studio spotlights have glass lenses that help to collect the light rays and focus them into a precise beam. The most common studio spotlights are the Fresnel spotlight and the ellipsoidal spotlight. There are also a variety of portable spotlights, which differ greatly in size and beam spread.

Fresnel spotlight The workhorse of studio spotlights is the Fresnel (pronounced "fra-'nel") spotlight. Its steplike lens (developed by Augustin Jean Fresnel of France) collects the light into a distinct beam. The spread of the beam can be adjusted from a "spot" or "focus" position to a "flood" position by moving the lamp-reflector assembly toward or away from the lens. **SEE 6.12**

To flood, or spread the beam, you move the lamp-reflector assembly *toward* the lens. You will see the light beam become slightly more diffused, less intense, and the shadows softer than when focused. To focus the beam, you move the lamp-reflector assembly *away from* the lens. This will increase the sharpness and intensity of the beam and make its shadows fairly distinct and dense. Some Fresnel spots have a crank for moving the lamp-reflector assembly, others have a ring or knob

6.11

STUDIO LIGHTING BATTENS

Lighting battens consist of a large grid of steel pipes that support the various lighting instruments. In this case, the battens can be lowered or raised through a counterweight system.

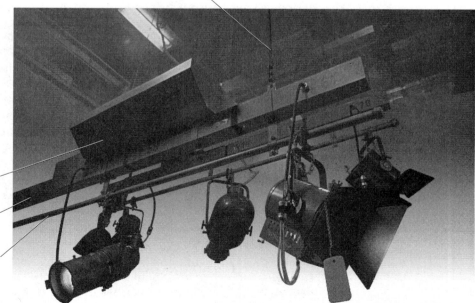

Suspension cable

Trough to catch power cable when batten is pulled up

Power rail with outlets

Batten

6.12

FRESNEL SPOTLIGHT

The Fresnel spotlight is the workhorse of studio lighting. Its lens creates a sharp light beam that can be partially blocked by barn doors.

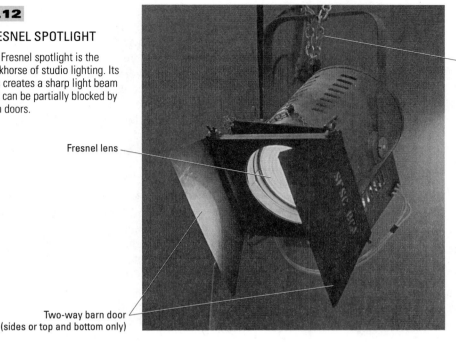

Safety chain

Fresnel lens

Two-way barn door
(sides or top and bottom only)

that can be turned from the studio floor with a lighting pole (a wooden pole with a metal hook on its tip).

You can further control the light beam by *barn doors,* shown in figure 6.12. They consist of movable metal flaps that swing open and close like real barn doors, blocking the beam on the sides or, when rotated, on top and bottom. Barn doors slide into a holder in front of the lens. To prevent them from sliding out of their holder and dropping, guillotinelike, on somebody, secure all of them to their instruments with a small chain or steel cable.

The size of Fresnel spotlights is normally given in the wattage of their quartz-halogen lamps. In the studio, the most commonly used Fresnels are the 1Ks (1 kilowatt = 1,000 watts) and the 2Ks (2,000 watts). Smaller 750-watt Fresnels are sometimes used on special light stands to illuminate small areas (such as trees behind a window, or a special display). The larger 5,000K Fresnels are sometimes used to illuminate large studio areas. All studio Fresnel spots burn at the indoor color temperature of 3,200°K.

During elaborate EFP or a large remote telecast, you may come across a special Fresnel spotlight, called an HMI. These (very expensive) spotlights have highly efficient arc lamps that deliver three to five times the illumination of a normal Fresnel spot of the same size, and use less electricity to do so. HMI spotlights burn at the outdoor standard of 5,600°K.

Ellipsoidal spotlight This spotlight is used for special effects. It produces an extremely sharp, high-intensity beam that can be given rectangular or triangular shapes by movable metal shutters. **SEE 6.13** Instead of sliding the bulb-reflector assembly toward or away from the lens, you can focus the ellipsoidal spotlight by

6.13

ELLIPSOIDAL SPOTLIGHT

The ellipsoidal spotlight produces an extremely bright and sharp beam. It is used to illuminate precise areas.

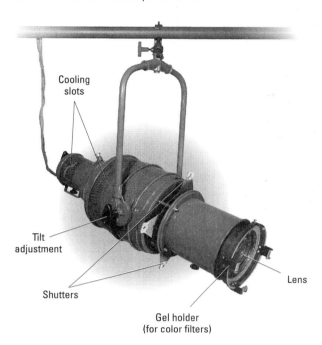

Cooling slots

Tilt adjustment

Shutters

Gel holder (for color filters)

Lens

6.14

COOKIE PATTERN

Some ellipsoidal spotlights double as pattern projectors. You can insert a variety of metal cutouts, called "cookies," whose patterns are projected by the spotlight onto a wall or other surface.

moving the lens away or closer to the fixed bulb-reflector assembly. Because it delivers such a precise beam, it does not need barn doors. Some ellipsoidals have a special slot right next to the beam-shaping shutters that can hold a variety of thin metal sheets with variously patterned holes. These metal sheets are called *cucalorus*, or more plainly, *cookies*. They are projected by the ellipsoidal spot onto a flat surface in order to break it up with freeform or geometric patterns. **SEE 6.14** The normal size of studio ellipsoidals is 750 watts.

Portable spotlights Most portable spotlights are hybrids between spots and floodlights. To keep their weight to a minimum, the portable spots are relatively small in size and "open-faced," which means that they do not have a lens. Without a lens, they cannot deliver as precise a beam as the Fresnel or ellipsoidal spots, even when in the "spot" or "focus" position. They are all designed to be mounted on a light stand or special clip-on devices. Some of the more popular models are the Lowel Omni and Pro lights. **SEE 6.15–6.16** An old standby is the clip light, with its reflector built into its

6.15

LOWEL OMNI LIGHT

This popular lightweight instrument doubles as a spot and floodlight and is used mainly in ENG or EFP. You can plug it into any normal household outlet and hold it or fasten it to a light stand or any other convenient mounting device.

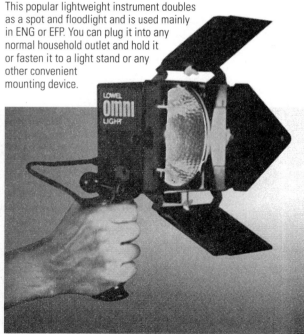

bulb. The PAR 38 lamp is especially well liked for illuminating outdoor walkways and driveways. You can use clip lights to supplement illumination of small specific areas. You can easily clip them onto furniture, scenery, doors, or whatever the clip will fit. Metal housings with little barn doors that fit over the clip light are also available. As with large ones, these barn doors can control the spread of the beam. **SEE 6.17**

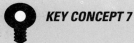 **KEY CONCEPT 7** **Spotlights produce a sharp, directional light beam. They cause fast falloff.**

6.16

LOWEL PRO LIGHT

The Pro is a small, powerful (200 watts) ENG/EFP spotlight that can be handheld, clipped on the camera, or mounted on a light stand.

6.17

CLIP LIGHT WITH BARN DOORS

You may find that small spotlights, which use ordinary internal reflector bulbs, are quite useful for illuminating small areas during field productions.

Metal housing

Barn doors

Internal reflector bulb

Gaffer grip or gator clip

▋ Floodlights

Floodlights have no lens because their purpose is to create not a sharp beam, but a highly diffused nondirectional light. Because their light is so diffused, the shadows are soft and transparent. When you illuminate an object with floodlights, the falloff will be much slower than with a spotlight. The more common studio floods are the *broad*, the *softlight*, and the *scoop*. Special floodlights include the fluorescent bank, the internal reflector bank, the strip or cyc light, and a great variety of small portable floodlights. All are relatively small, highly portable, and produce a great amount of diffused light.

The broad The broad is an open-faced instrument that houses one or more large tubelike lamps in a square or rectangular reflector. It produces a great amount of highly diffused light. You use the broad to illuminate large areas with even, slow-falloff, 3,200°K light. **SEE 6.18** News sets and interview areas are often lighted by a series of broads. Some small broads, which are primarily used for filling in the harsh spotlight shadows, have barn doors. The barn doors keep the light from spilling into certain set areas without reducing the softness of their "beam."

The softlight Softlights are similar to broads, except that the large opening is covered with a diffusing material that scatters the light so much that it renders the shadows virtually invisible. Because it produces such slow-falloff lighting, it is often used where flat lighting is important, such as product displays in commercials or instructional shows, or on models, when the softness and smoothness of the skin is especially important. Softlights come in various sizes and burn at an indoor 3,200°K color temperature. Most of the softlights are quite large and do not fit a cramped production space. **SEE 6.19**

The scoop Named after its scooplike reflector, the *scoop* is a relatively small and flexible floodlight that burns at the 3,200°K indoor color temperature. Some LDs (lighting directors) prefer it to the broads because its beam, however soft, is somewhat more directional and can therefore illuminate more precise areas. Scoops are often used as fill light for dense shadow areas to slow down falloff and to make the shadows more transparent. To diffuse the light beam even more, you can attach a scrim to the front of the scoop. A scrim is a heat-resistant spun-glass material that comes in rolls and can be cut with scissors like cloth. **SEE 6.20**

6.18

LARGE BROAD

This open-faced floodlight illuminates a large area with highly diffused "soft" light. It causes slow falloff.

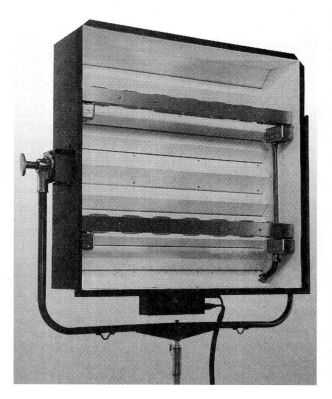

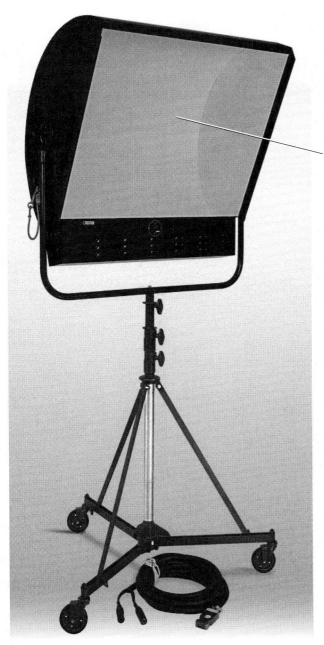

6.19

SOFTLIGHT

This floodlight is covered with diffusing material and delivers extremely diffused light. It causes extremely slow falloff and renders shadows virtually invisible.

Softlight reflector-diffuser

6.20

SCOOP WITH SCRIM

The scooplike reflector of this floodlight allows you to give its diffused beam some direction, which makes it a good fill light. With a scrim attached to its otherwise open face, it acts more like a broad.

Scrim holder with scrim

Special floodlights The *fluorescent bank*, which consists of a row of fluorescent tubes, used to be one of the main lighting devices in the early days of television. Now the bank has made its comeback. It is highly efficient, produces extremely diffused light and slow falloff, and does not generate the heat of the other floodlights. You can get fluorescent banks that burn at the outdoor norm of 5,600°K

FLUORESCENT BANK

The fluorescent bank consists of a series of fluorescent tubes. It produces very soft light with slow falloff. It is relatively large, but generates little heat.

FLOODLIGHT BANK

The floodlight bank consists of rows of internal reflector bulbs. It is used to illuminate large areas from some distance. Large banks are used in lighting scenes at remote locations, such as sporting events.

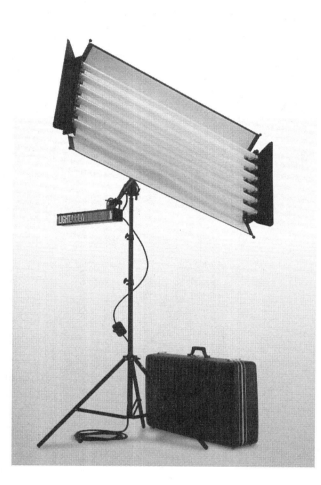

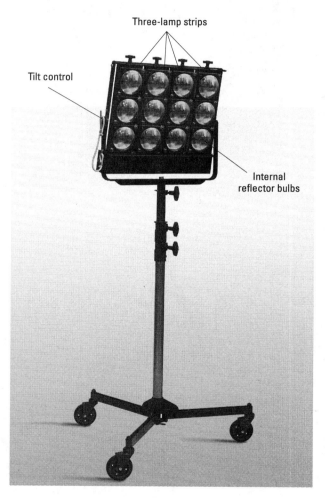

Three-lamp strips

Tilt control

Internal reflector bulbs

or with the 3,200°K indoor light. The disadvantage is that the banks are relatively large and unwieldy. **SEE 6.21**

The *floodlight bank* consists of strips of internal reflector bulbs. The smaller ones have two or three rows of three lamps each; the larger ones can have several rows of twelve or more. They are used to light large areas from some distance, similar to the lights you see in a sports stadium. **SEE 6.22**

The *strip,* or *cyc, light* is used to illuminate cycloramas (the seamless background curtain that stretches along studio or stage walls), drapes, or large areas of scenery. They are quite similar to theater border lights and consist of rows of three to twelve quartz lamps mounted in long, boxlike reflectors. Some of them

6.23

STRIP, OR CYC, LIGHT

These instruments are primarily used to illuminate cycloramas, drapes, or large scenic areas.

have color filters at the opening, which allow you to change the colors on your background without adding new instruments. They are usually positioned side by side on the studio floor and shine up onto the background. **SEE 6.23**

Portable floodlights When choosing a portable floodlight, you should look for one that is small, produces a great amount of diffused light, has a reflector that keeps the diffused light from spilling all over the area, can be plugged into an ordinary 120-volt household outlet, and is lightweight enough to be supported by a small light stand. **SEE 6.24** When mounted inside an umbrella reflector, a portable floodlight serves as a softlight.

Some portable floodlights have small barn doors to control excessive beam spread. The extension cables of most portable floodlights have a simple on/off switch close to the instrument so that you don't have to unplug it every time you want to turn it off. Because the instruments are so small and have such a great light output, they get extremely hot even if they have been switched on for just a short time. Be careful.

6.24

SMALL EFP FLOODLIGHT

This small EFP floodlight (Lowel Tota light) runs off ordinary household current and can be used to illuminate small areas. When mounted inside an umbrella reflector, it serves as a softlight.

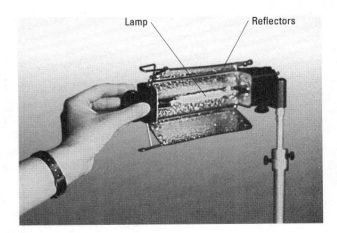

Lamp Reflectors

KEY CONCEPT 8 **Floodlights produce general, nondirectional illumination. They cause slow falloff.**

LIGHTING TECHNIQUES

Start your lighting with an idea of how you would like it to look on the video screen. Then choose the simplest way of achieving this look. Although there is no universal recipe that guarantees good lighting for every situation, there are some established techniques available that you can easily adapt to the specific task at hand. But do not become a slave to those techniques. Many times you may wish you had more instruments, more space, and especially more time to do justice to the lighting. At those times you should realize that the final criteria for video lighting is not how faithfully you observe the standards as outlined in a book, but how it looks on the monitor and, especially, how to get it done on time.

Let's take a look at some of the lighting basics: (1) operation of lights, (2) studio lighting, (3) field lighting, and (4) measuring illumination.

Operation of Lights

Lighting presents some obvious hazards: ordinary household current is powerful enough to kill; the lamps, barn doors, and sometimes the instruments themselves get so hot that they can cause serious burns. If placed too close to combustible material, lighting instruments can cause fires. The lighting instruments with barn doors are suspended far above studio areas and, if not properly secured, can come crashing down. Staring into a bright, high-intensity light beam can cause temporary vision problems. Even so, you don't need to be scared and give up lighting before getting started. You can easily eliminate these hazards by observing a few safety rules.

CHECKLIST: LIGHTING SAFETY

☑ *Electricity* Don't ever handle an instrument with wet hands, even if it is unplugged. Do not "hot-plug" the instrument; switch off the power before connecting or disconnecting the power cables or patch cords. Patch cords connect selected lighting instruments to specific dimmers. Wear gloves. Use wooden or fiberglass safety ladders rather than metal ones. Do not touch any metal while working with a power cable. If you need an adapter to connect a power cable or plug it in, tape the connection with electrician's tape. Do not waste electric energy. Use only those instruments that are absolutely necessary. Turn off the studio lights and use house lights for the basic blocking rehearsals. Turning off the lights will also extend the life of the (expensive) bulbs considerably.

☑ *Heat* The quartz lamps (quartz housing and a tungsten-halogen filament) get extremely hot. They heat up the barn doors and even the housing of the lighting instrument itself. Never touch the barn doors or the instrument with your bare hands once it is turned on. Use gloves or a light stick to adjust the barn doors or the instrument.

6.25

C-CLAMP

You use the C-clamp to fasten heavy lighting instruments to the lighting battens. Even when tightly fastened to the batten, the C-clamp allows the lighting instrument to be turned.

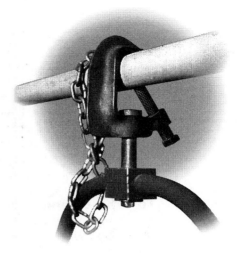

Keep the instruments away from combustible materials, such as curtains, cloth, books, or wood paneling. If you need to place a lighting instrument close to such materials, insulate the materials with a sheet of aluminum foil.

Let the bulbs cool down before replacing them. Do not touch quartz lamps with your fingers. Fingerprints or any other stuff clinging to the lamp will cause it to overheat at these points and burn out. Use a tissue, or, in case of emergency, your sweater or shirttail when exchanging the bulbs. Be sure the power is shut off before reaching into the instrument. If you can, let the larger instruments "warm up" through reduced power before bringing the dimmer up full.

☑ *Placing and securing the instruments* Before lowering movable battens, make sure that the studio floor is clear of people, equipment, and scenery. Give a warning before actually lowering the batten, such as "Batten 5C coming down!" Have someone watch the studio floor while you lower the batten. Securely tighten all necessary bolts on the *C-clamp*. **SEE 6.25** Secure the instrument to the batten, and the barn doors to the instrument, with a safety chain or cable. Check the power connections for obviously worn or loose plugs.

Whenever moving a ladder, watch for obstacles below and above. Don't leave your lighting wrench or other tools on top of the ladder. Don't take any unnecessary chances by leaning way out to reach an instrument. Whenever possible, have somebody steady the ladder for you.

☑ *Light beam* When adjusting an instrument, try not to look directly into the light. Work from behind, rather than in front of, the instrument. This way, you look with the beam, rather than into it. If you have to look into the light, do it very briefly and wear dark glasses.

🔑 *KEY CONCEPT 9* **Do not abandon safety for expediency.**

Studio Lighting

Now you are ready to do some actual lighting assignments. Although you may find yourself struggling with adequate lighting at remote locations more often than doing fancy studio lighting, you will find that learning to light is easier in the studio than in the field. As the Triple-I LD tells you, the art of lighting is neither mysterious nor complicated if you keep in mind its basic functions: (1) to reveal the basic shape of the object or person; (2) to lighten or darken the shadows; (3) to show where the object is relative to the background; and (4) to give some sparkle to the object or person.

The photographic, or triangle, lighting principle Still photographers have taught us that all these functions can be accomplished with three lights: (1) the *key light*, which reveals the basic shape; (2) the *fill light*, which fills in the shadows if they are too dense; and (3) the *back light*, which separates the object from the background and provides some sparkle. The various lighting techniques for video and motion pictures are firmly rooted in this basic principle of still photography, called the *photographic principle* or *triangle lighting*. **SEE 6.26**

6.26

BASIC PHOTOGRAPHIC PRINCIPLE

The basic photographic principle uses a key light, a fill light, and a back light. They are arranged in a triangle, with the back light at its apex, opposite the camera.

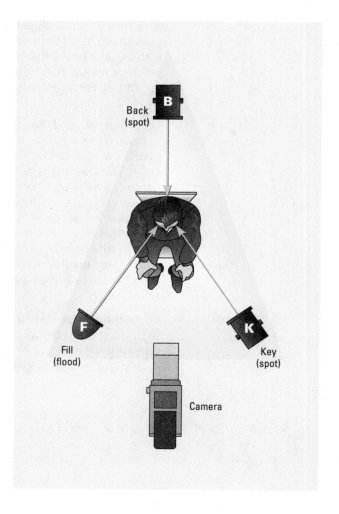

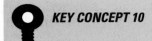 ***KEY CONCEPT 10*** **The basic photographic principle, or triangle lighting, consists of a key light, a fill light, and a back light.**

Applying the lighting triangle In the studio, Fresnel spots are normally used for key lights. Fresnels let you aim the beam at the object without too much spill into other set areas. By focusing or flooding the light beam, or by using the barn doors, you can further control its spread. But you can also use other instruments for a key light, such as an Omni light, a scoop, or even a softlight. As you can see, the key light is not defined by the instrument used, but by its function: to reveal the basic shape of the object. The key light is usually placed above and to the right or left of the front of the object. **SEE 6.27** Note that the key light produces fast falloff (a dense attached shadow).

6.27

KEY LIGHT

The key light is the principal light source. It reveals the basic shape of the object. A spotlight is generally used as a key.

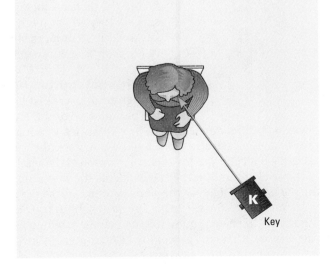

Key

6.28

BACK LIGHT

The back light outlines the subject against the background and provides sparkle. Focused spots are used as back lights.

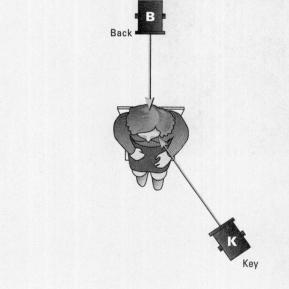

To outline the subject more clearly against the background, and especially to give the hair—and with it the whole picture—some sparkle and luster, you need some *back light*. Some lighting people think that it is the back light, especially, that gives the lighting its professional polish. **SEE 6.28**

As the name suggests, the back light falls on the back of the subject's head. You place it opposite the camera directly in back of, and above, the subject. Because the area to be illuminated by the back light is rather limited, you use Fresnel spots. To keep the back light from shining into the camera or being in the shot, place it fairly high behind the subject.

Some lighting directors insist on having the back light burn with the same intensity as the key. Such a rule makes little sense because the intensity of the back light depends on the relative reflectance of the object or subject. A blond woman who wears a white blouse certainly needs a less intense beam than a man in a dark suit who has black, curly hair.

To slow down falloff and thereby render dense shadows more transparent, you use a *fill light*. Because the purpose of the fill light is to "fill in" general dense shadow areas with some light and make the shadows more transparent, floodlights rather than spotlights are generally used. But you can, of course, also use Fresnel spots (or any other spotlight) as fill lights. Obviously, you place the fill light on the other side of the key light, opposite the camera, and aim it toward the shadow area. **SEE 6.29**

The more fill light you use, the slower the falloff. If the fill light is as strong as the key light, you have eliminated the attached shadow, and with it, any falloff; the pictures look flat. Many news or interview sets are lighted flat (with equally strong softlights for key and fill) in order to show the close-up faces of the news people or guests relatively wrinkle-free.

Additional lights Unless you want a rather dark background, you need additional light to illuminate the background or set. This additional source is called *background light* or *set light*. For a small set, you may need only a single Fresnel spot or scoop. **SEE 6.30** But a large set may require quite a few more instruments, each of which illuminates a specific portion of the set. To keep the attached shadows of the background on the same side as the foreground shadows, you must place the background light on the same camera side as the key light.

You can also use the background light to provide some visual interest to an otherwise dull background. You can either produce a slice of light, or a prominent cast shadow, that cuts across the background. To suggest nighttime when lighting an interior set, keep the background generally dark and illuminate only small

6.29

FILL LIGHT

The fill light slows down falloff and renders shadows more transparent. Floodlights are generally used to "fill in" the dense shadows.

6.30

BACKGROUND LIGHT

The background, or set, light illuminates the background and various set areas. Spots or floodlights are used on the same side as the key.

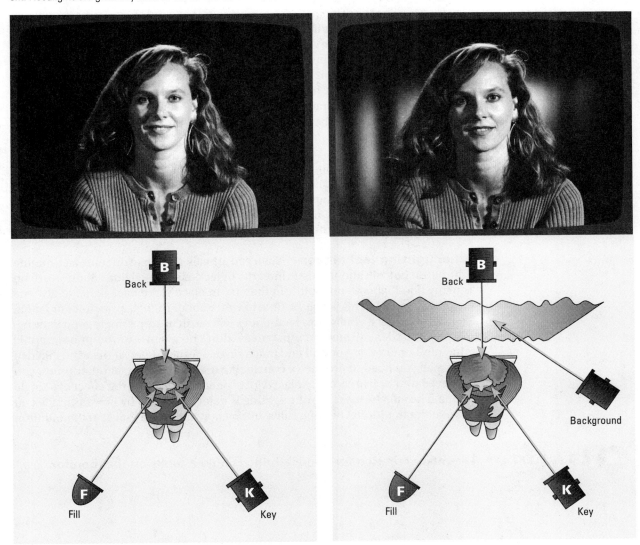

portions of it. If you want to evoke daylight, illuminate the background evenly. You can colorize a neutral gray or white background simply by putting specific color gels (color media) in front of your background lights. Colored lights can save you a lot of painting.

Designing multiple triangles What if you have two people sitting next to, or facing, each other? Do you need a key, fill, and back for each one? Yes, if you have enough instruments and time available. But you should always try to accomplish your lighting with as few instruments as possible. You will find that if

people sit opposite each other, the key light for one person may also serve as the other's back light, or that a single softlight can serve as fill light for more than one person. Sometimes the key light will spill over onto the background and thus eliminate the need for a special background (set) light.

You should keep in mind that when designing illumination, you *light for the camera.* Knowing the principal camera positions is essential for effectively applying the lighting triangle. If, for instance, you arc your camera around a person so that the key light is opposite your camera, the key light now functions as a back light.

Whenever possible, put up your set where the lights are rather than moving the lights to the set location. If, for example, you have to put up and light a simple interview set, look up at the lighting grid and find a key, fill, and back light triangle, and place the chair in the middle of it. Even if you can't find another lighting triangle (key, fill, back) for the other chair, you are still ahead: half of the lighting is already done.

Light plot For more complicated shows, you need to prepare a ***light plot.*** Once you have a detailed floorplan, which shows the scenery, the major action areas, and the principal camera positions, you can go to the studio and note the position, type, and functions of the lighting instruments needed. Arrows will indicate the approximate direction of the beam. **SEE 6.31**

Other lighting techniques When you are called upon to do some last-minute lighting, do not talk about artistic integrity or lack of assigned time. Simply turn on as many floodlights as possible and then try to place some back lights to give the scene some polish. This is not the time to worry about triangle principles or falloff. Every so often such emergency techniques will result in surprisingly good lighting.

Even under normal circumstances, don't be a slave to the photographic principle. Sometimes, you will find that a single Fresnel aimed at the windshield of a car is all you need to produce a convincing nighttime effect; at other times, you may need four or five carefully placed instruments to recreate the effect of a single candle. The effectiveness of your lighting is determined not by how faithfully you observe the traditional lighting rules, but by how the scene looks on the monitor.

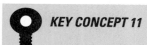 **KEY CONCEPT 11** **The major criterion for good lighting is how it looks on the monitor.**

Field Lighting

Whereas studio lighting is done exclusively with various types of lighting instruments, field lighting often extends to the control or augmentation of available light. When shooting outdoors, you are pretty much dependent on available light. Your lighting job is to manipulate sunlight so that it yields, at least to some extent, to the basic lighting principles. When shooting indoors, you can apply all studio lighting principles, except on a smaller scale. Windows always present a problem; you will need to mix outdoor and indoor light as well as their respective color temperatures.

6.31

LIGHT PLOT FOR TWO-PERSON INTERVIEW

The light plot shows the type and position of the lighting instruments used and the approximate direction of the beams. Sometimes light plots also indicate the size (wattage) of the instruments. Note that there are two overlapping lighting triangles—one for person A and the other for person B.

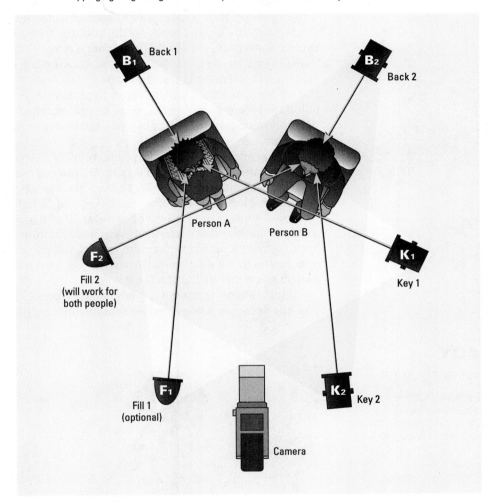

Outdoors—overcast An overcast or foggy day is ideal for outdoor shooting. The clouds and fog act as giant diffusion filters: the giant and brutally bright spotlight of the sun becomes a huge but gentle softlight. The highly diffused light produces slow falloff and highly transparent shadows. The camera likes such low-contrast lighting and produces crisp and true colors throughout the scene. Your scene is basically illuminated by high-intensity baselight. No wonder the LD of Triple-I began to relax as soon as the sky became overcast.

Bright sunlight The bright sun acts like a giant high-intensity spotlight. The key side is very bright and the falloff appropriately fast; the shadows are very dense and the contrast between light and shadow sides extremely high.

This extreme contrast presents a formidable exposure problem. If you close down your iris to compensate for the extremely bright light (high *f*-stop setting), your shadow areas will turn uniformly dark and dense; they will show no detail. If you open up your iris in order to see some detail in the shadow area, you will overexpose the bright areas in the picture. The automatic aperture in your camcorder is of no help in this situation; it simply adjusts to the brightest spot in the scene and renders all shadow areas equally dark. Even the most sophisticated camera will no longer know what to do.

What you must do, therefore, is to provide enough fill light to slow down the falloff, reduce the contrast, and make the attached shadows more transparent without overexposing the bright areas. But where in the field can you get a fill light strong enough to offset the sunlight?

In expensive and elaborate productions, high-intensity spotlights, which burn at 5,600°K, are used as outdoor fill lights. Or, you can use additional lights as powerful fill (as the LD did when shooting the beach scene). Fortunately, you can also trick the sun into serving simultaneously as key and fill lights. All you need is a reflector to bounce some of the sunlight back toward the shadow area. **SEE 6.32** You can use a simple white card as a reflector, crumpled aluminum foil that is taped onto a stiff backing, or any number of commercially available reflectors that prove effective over considerable distances. The closer you hold the reflector to the object, the more intense the "fill light" will get.

Avoid shooting against any bright background, such as a sun-drenched white wall, the ocean, or a lake. Anyone standing in front of it will turn into a silhouette,

6.32

USE OF REFLECTOR

The reflector acts like a fill light: it bounces some light back toward the dense shadow areas and slows down falloff.

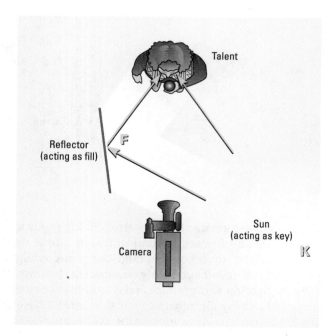

unless you use huge reflectors or other high-intensity fill lights. Whenever possible, find some shade in which to position your subject. A beach umbrella will not only provide some visual interest, but make your lighting job considerably easier.

Indoors without windows If the room is adequately illuminated, try to shoot with available light and see how it looks. If it looks good to you, there is no need for additional lights. Most indoor lighting can be easily improved by placing some back lights in the appropriate areas. The problem is that the light stands often show up on camera, or that the spotlight cannot be placed high enough to keep out of camera range. In this case, place the spot somewhat to the side, or use some 1 × 2 lumber to create a temporary lighting support for the back light. Move the back light close enough to the subject to keep it out of the camera's view.

When lighting a person who remains stationary in a room, as in an interview, use the same photographic principle as in the studio, except that you now have to place your portable lights on stands. Try to use the key or fill light to double as background light. To avoid the infamous reddish hot spot on the object and to make the light look generally softer, attach scrims (spun-glass material) on all three instruments. You can use wooden clothespins to attach the scrims to the barn doors. Because the useful lamp life is quite limited in portable instruments, keep the instruments turned off as much as possible. This will also keep the room relatively cooler. Just in case, bring along some spare light bulbs.

If you have only two lights to light a person indoors, you can use one as the key, the other as the back, and then use a reflector to act as the fill light. **SEE 6.33**

If you have only a single lighting instrument, such as an Omni light, you can use it as a key, with the reflector acting as the fill. In such a setup, you must necessarily sacrifice the back light. If the subject remains in one place, and if you shoot fairly tight, you may want to use the single light source as a back light, and bounce it onto the face of the subject with a large reflector. The reflector will act as key and fill lights. **SEE 6.34**

To light an ordinary-sized room so that you can follow somebody walking through it, use the portable lights in the flood position and reflect them off the ceiling or walls, or diffuse their beams with scrims. If available, use special light-diffusing umbrellas. Aim the instrument *into* the umbrella, and the *opening* of the umbrella *toward* the scene. You can apply the same technique for lighting a large interior, except that you need more instruments. The idea is to get as much baselight as possible with a minimum of instruments. **SEE 6.35**

6.33

REFLECTOR USED INDOORS

To achieve effective triangle lighting with two lights, use one for the key and the other for the back light. The fill light is provided by a reflector.

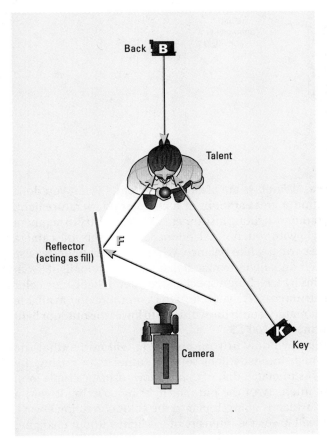

Back **B**

Talent

Reflector
(acting as fill)

F

Camera

K Key

6.34

REFLECTOR USED AS KEY

If the subject is stationary, you can use a single instrument as the back light, with the large reflector acting as key and fill lights.

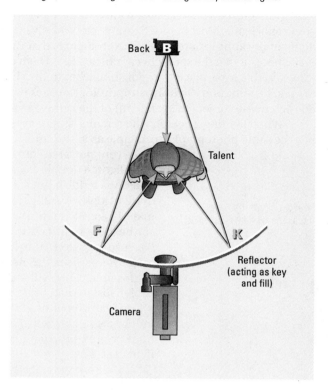

Back B

Talent

F

K

Reflector (acting as key and fill)

Camera

Interiors with windows Windows are always a problem. Even if you don't shoot against them, they admit a great amount of high color temperature light, which is hard to match with ordinary lighting instruments. If you now try to augment the bluish 5,600°K outdoor light with your normal indoor 3,200°K lights, the camera will have trouble finding the correct white balance. What you need to do is raise the color temperature of your indoor lights to match that of the outdoor light (from 3,200°K to 5,600°K). You do this by attaching a special blue filter or light-blue color medium to the lighting instruments. Or you can affix commercially available (expensive) light-orange filter material onto the windows to lower the outdoor light to the indoor color temperature of 3,200°K.

If you need to include a window in your shot, you will notice that the window is by far the most high-intensity light source. Rather than raising the intensity of your portable lights to match that of the window (usually a futile job), you can cut down the light intensity of the outdoor light by covering it with a plastic neutral density sheet, which is quite similar to the color correction sheets. Such a neutral density filter will lower the intensity of the light without changing its color temperature.

6.35

INTERIOR LIGHTING

To achieve even baselight in an interior, small portable floodlights are
further diffused by light-diffusing umbrellas.

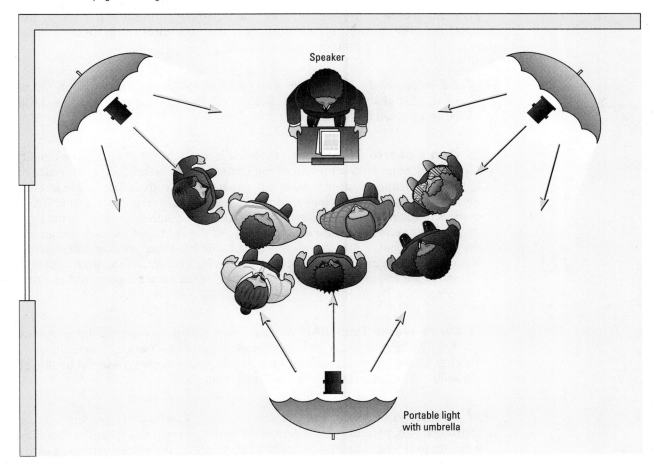

Speaker

Portable light
with umbrella

The best way of coping with windows is to avoid them in your shot. Draw the
curtains or persuade your client to sit opposite, or at least sideways to, the window.
Remember that if you use fill lights to slow down the window-light falloff, you need
to correct the fill lights for the proper outdoor color temperature (by attaching a
light-blue color medium or the appropriate outdoor light filter). See the guidelines
for simple field lighting which follow.

KEY CONCEPT 12 **In the field, light for visibility rather than artistic impact.**

GUIDELINES: FIELD LIGHTING

☑ *Scout ahead* Scout the location and determine the lighting requirements *before* the actual shooting date. Check the available power, the person who can give you access to the breaker box (name, address, home and work phone numbers), the nature of the outlets, and the extension cords needed. Have adapters available that fit the various outlets.

☑ *Be prepared* Always take with you a few rolls of gaffer's tape, a roll of aluminum foil, gloves, a small wrench, some wooden clothespins (plastic ones will melt), and a small fire extinguisher.

☑ *Don't overload circuits* Once on location, don't overload the circuit. Although a normal 15-amp household outlet will accommodate 1,500 watts of lighting instruments, do not plug more than 1,000 watts into a single circuit. Realize that several outlets may be on the same circuit, even if they are in different corners of the room. To test which outlets are on the same circuit, plug the light into various outlets and turn off the breaker. If the light goes out, you are on the designated circuit. If the light stays on, the outlet is connected to another circuit. You can also plug in 1,500 watts, leave them on for a while, and see what happens. If they trigger the breaker, you have too many lights on the circuit. If they hold, you are safe.

☑ *Don't waste bulb life* As mentioned before, turn on the lights only as needed. The light bulbs for portable lighting instruments have a limited life span. Turning off the lights as much as possible will preserve energy, extend the life of the bulb, and reduce the heat in the performance areas.

☑ *Secure your light stands* Be especially careful when placing lighting instruments on portable stands. Secure all light stands with sandbags so that they won't tip over when somebody brushes against them. Place your extension cords out of the main traffic pattern. If you have to string them across a hallway or threshold, tape them securely in place (here is where your gaffer's tape comes in handy) and put a rubber doormat over them.

☑ *Move cords carefully* Don't pull on an extension cord that is connected to a lighting instrument; light stands tip over easily, especially when the stand is fully extended.

◼ **Measuring Illumination**

In critical lighting setups you may want to check whether you have enough baselight or whether the contrast between light and dark areas falls within the acceptable limits (normally 40:1) before turning on the cameras. You can check this with the help of a light meter. A light meter simply measures the amount of foot-candles or lux emitted by the lighting instruments—the *incident light*—or reflected off an object—the *reflected light*.

Incident light An incident light reading gives you some idea of the baselight level in a given area. To measure general incident light, you must stand next to the illuminated person or object and *point the light meter toward the camera lens*. Such a quick reading of incident light is especially helpful when checking the prevailing light levels at a remote location.

If you want a more specific reading of the intensity of light coming from specific instruments, you *point the light meter into the lights*. To check the relative evenness of the incident light, point your light meter toward the major camera positions while walking around the set. If the needle stays approximately at the same intensity level, your lighting is fairly even. If the needle dips way down, your lighting setup has "holes" (unlighted or underlighted areas).

Reflected light The reading of reflected light is done primarily to check the contrast between light and dark areas. To measure reflected light, stand close to the lighted object or person and point the light meter at the light and shadow areas from the direction of the camera. The difference between the two readings will indicate the lighting contrast. Note that the lighting contrast is determined not only by how much light falls on the object, but also by how much light the object reflects back into the camera. The more reflective the object, the higher the reflected light reading will be. A mirror reflects almost all the light falling into it; a black velour cloth will reflect only a small portion of the illumination.

But don't become a slave to the light meter. After all, the best way to tell whether the lighting is right is to look at the video monitor.

You should now feel quite confident when talking to Triple-I's LD or his assistant. Such concepts as "shadow control," "triangle lighting," and "white balancing" are no longer a mystery to you.

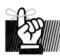

▪ **Types of Light and Light Intensity**

The two basic types of light are directional and diffused light. Directional light is focused and causes harsh shadows; diffused light is spread out and creates soft shadows. Light intensity is measured in European lux or American foot-candles. There are approximately 10 lux per foot-candle.

▪ **Shadows**

Shadows are classified into attached and cast shadows. Attached shadows are affixed on the object; they cannot be seen independently of the object. Cast shadows can be seen independently of the object that causes them. Falloff indicates the change from light to shadow and the contrast between light and shadow areas. Fast falloff means that the light area changes abruptly into dense shadow areas; the contrast is high. Slow falloff means that the light turns gradually into the shadow side; the contrast is low.

▪ **Colors**

Colors are generated through additive color mixing. All colors are mixed by adding the primary light colors—red, green, and blue—in various proportions. Color temperature refers to the relative reddishness or bluishness of white light. White balancing adjusts the camera to the color temperature of the prevailing illumination so that the camera will reproduce a white object as white on the video screen.

▪ **Lighting Instruments**

Lights are usually classified into spotlights and floodlights, and studio and portable lights. Spotlights produce a sharp, focused beam; floodlights produce highly diffused, nondirectional illumination. Studio lights are normally suspended from the ceiling. Portable lights are supported by collapsible light stands.

▪ **The Photographic Principle, or Triangle Lighting**

Lighting functions can usually be achieved with a key light (principal light source), a fill light (fills in dense shadows), and a back light (separates subject from background and gives it sparkle). Reflectors frequently substitute for fill lights. The background light is an additional light used for lighting the background and set area. In field lighting, it is often more important to provide sufficient illumination than careful triangle lighting. In the field, floodlights are used more often than spotlights.

▪ **Measuring Light**

When measuring incident light (the light falling on the object) you point the light meter from the position of the illuminated object at the camera lens or into the lights. When measuring reflected light, you stand close to the object and point the meter at the object from the camera position.

KEY CONCEPTS

- Lighting means deliberate illumination and shadow control.

- Attached shadows reveal form and texture.

- Cast shadows help to tell us where things are and when events take place.

- Falloff defines the contrast between light and dark areas and how quickly light turns into shadow.

- The additive primary light colors are red, green, and blue.

- Color temperature measures the relative reddishness or bluishness of white light. Reddish white light has a low color temperature; bluish white light has a high color temperature.

- Spotlights produce a sharp, directional light beam. They cause fast falloff.

- Floodlights produce general, nondirectional illumination. They cause slow falloff.

- Do not abandon safety for expediency.

- The basic photographic principle, or triangle lighting, consists of a key light, a fill light, and a back light.

- The major criterion for good lighting is how it looks on the monitor.

- In the field, light for visibility rather than artistic impact.

Note: The basic computer terms are listed in table 7.8

Super Short for superimposition. The simultaneous overlay of two pictures on the same screen.

Key Analog electronic visual effect in which the base image replaces the dark or blue (or green) areas of the key source.

Matte Key Letters of a keyed title are filled with gray or a specific color through a third video source.

Chroma Key Special key effect that uses color (usually blue) for the key source background. All blue areas are replaced by the base picture during the keying.

Wipe A transition in which one image seems to "wipe" off (replace) the other from the screen.

Digital Video Effects (DVE) Video effects generated by a computer with high-capacity hard drives and special graphics software. The computer system dedicated to DVE is called a *graphics generator*.

ESS System Stands for electronic still store system. Stores many still video frames in digital form for easy access.

C.G. (Character Generator) A small computer dedicated to the creation of letters and numbers in various fonts. Its output can be directly integrated into analog video images.

Visual Effects and Computer-Generated Video

NOW that you know what a video camera does and how to give lens-generated images effective composition, you can expand your creative efforts to synthetic video—images that are electronically manipulated or totally computer-generated. These synthetic images can be as simple as electronically generated titles that appear over a background image or a computer-generated landscape that changes with your point of view. Although the camera still supplies the majority of video images, synthetic images are becoming more and more important to video productions.

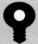 **KEY CONCEPT 1** **Video consists of lens-generated and computer-generated images.**

A visit to Triple-I's "Pixel Room" (formerly the art department) seems to substantiate this claim. Instead of the usual drafting boards, messy tables full of drawing pads, paints, and cans holding various brushes and pencils, you see a variety of computers, large color monitors, high-capacity hard drives, strange plastic drawing tablets, computer printers, fax machines, modems, and lots of cables. Tucked away in a corner are several video cassette recorders, more monitors, and even a music keyboard. A bookcase holds neatly stacked computer disks and a large row of software manuals. The art director tells you that video graphics "have moved from pencil to pixel" and that the entire video production scene "is a new ball game." She adds that computer-manipulated or computer-generated images have become an essential element in every phase of video production. According to her, a certain amount of computer literacy has become an essential prerequisite for anyone working in video production.

Let's start with how the basic computer system works and then move to the more specific aspects of image manipulation and computer-generated images. Specifically, we will take a closer look at—

▪ **DESKTOP COMPUTER SYSTEM**
Basic nature and function of digital computers, desktop computers, computer peripherals, and computer terminology

▪ **STANDARD ELECTRONIC EFFECTS**
Superimposition, key, chroma key, and wipe

▪ **DIGITAL IMAGES**
Digital video effects, synthetic image creation, and animation

DESKTOP COMPUTER SYSTEM

If you have a desktop computer, or if you know how to operate one, you can skip the next few pages. If not, the following section will introduce you to (1) the nature and function of a digital computer, (2) desktop computers, (3) computer peripherals, and (4) the basic terminology that you should know when working with word processing and graphics programs.

Basic Nature and Function of Digital Computers

The computer is not a thinking machine; it's a counting machine. Like the third-century abacus, which used movable beads to speed computation, the desktop computer uses electronic on/off switches. The difference between the two computing machines is speed. It would take even the most skilled abacus operator many years to do what you can accomplish in less than a second with a small desktop computer.

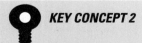 *KEY CONCEPT 2* **The computer is a high-speed counting machine.**

This high-speed processing makes it possible for the computer to handle a great amount of data and perform astonishing feats, such as video titles that tumble through screen space while taking on new colors and shapes at every turn. At first glance, such visual acrobatics seem to have little to do with counting; but they, too, are based on the same either/or, yes/no, on/off binary interpretation of the world. As far as we know, the computer does not even realize what its on/off switches are creating: budgets, video scripts, memos, floorplans, animated titles, or colorful landscapes. This knowledge is the purview of the programmers, who with great patience and skill create the *software*—a set of procedures and mathematical sequences, called *algorithms*, that instruct the computer what to do.

What you need to do now is learn how to use the programs that are especially helpful to your production needs. There are programs that help you to write a script, draw up a budget and keep track of your expenses, design animated titles, and assist you in video and audio postproduction editing. The many manuals you saw neatly stacked in the Triple-I Pixel Room are instructions on how to apply the software programs to various production tasks.

Desktop Computers

When you go to a computer store to buy some software, you will most likely be asked whether your desktop computer runs on a DOS, Windows, or Mac *platform*. All three "platforms" refer to the major computing system of your desktop computer. The IBM computers and the many other brands that use the DOS and Windows systems are commonly referred to as *PC*s (for personal computer); the *Mac* obviously uses the Apple Macintosh system. Generally, you cannot run a program designed for one specific platform on another. However, there is software available that lets you use the various programs regardless of platform. Also, the various computer systems have themselves become more and more compatible, which means you can run a specific program on all major types of desktop systems.

The *hardware*, which refers to the actual equipment, varies greatly in digital process design and digital computing and storage capacity. Even so, some basic elements are common to all desktop computer systems: (1) the computer itself, (2) the disk drives, (3) the monitor, and (4) the keyboard/mouse. **SEE 7.1**

7.1

DESKTOP COMPUTER SYSTEM

The basic desktop computer system includes the actual computer, monitor, hard disk drive, floppy disk drive, keyboard, and mouse.

Monitors

Computer with internal hard drive

Floppy disk drive

Keyboard Mouse

Computer Of the many important components of a computer, there are six that are especially relevant to video production: (1) the *random-access memory*, or *RAM*, which stores information while the computer is in use, but loses all information when the computer is turned off; (2) the *read-only memory*, or *ROM*, which contains the basic computer program that cannot be altered and is not erased when the computer is turned off; (3) the *storage capacity* of the hard disk drive, commonly called the *hard drive*, (4) the *central processing unit*, or *CPU*, which is the actual computer and manipulates incoming data according to instructions given by a program (how fast the computer reacts to your commands is mainly a function of the CPU); (5) a small loudspeaker; and (6) *input/output (I/O) ports*—jacks into which you can plug various auxiliary equipment, such as a printer, a modem, or external loudspeakers. Some computers that are specially designed for video production have I/O ports for regular NTSC video signals, so that you can exchange video images between a videotape recorder and the computer.

The RAM capacity is especially important, because it must be large enough to allow complex programs to operate (such as graphics or word processing programs), in addition to storing your own input, like the script you may be typing or the graphic you may be creating. Eight megabytes (8 million bytes) of RAM is not unusual for a good desktop computer. (See the list of computer terminology in figure 7.8 for an explanation of capacity designations.) Because the RAM read/write chip loses all its information when the power goes off, you should periodically save your work on a floppy disk or on the hard drive.

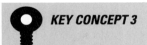

KEY CONCEPT 3 **RAM is temporary data storage and loses its data every time the computer is switched off. ROM is permanent data storage. It remains intact when the computer is switched off.**

Disk drives Desktop computers usually operate three types of disk drives: (1) floppy disk drives, (2) hard disk drives, and (3) CD-ROM drives. Many computers have all three types built-in; others require an external CD-ROM drive.

The *floppy disk drive*, built into the computer, operates the floppy disks, which are small 3.5-inch (or 5.25-inch) disks encased in hard plastic. The floppy disk is a read/write disk, which means that you can store information on it ("write") and then recover the information by putting it the computer's RAM ("read"). The advantage of using a floppy disk is that it is inexpensive and extremely portable. You can store it in a cardboard box, carry it in your pocket, or mail it in a small envelope. A normal floppy disk can store from 800 kilobytes to 1.4 megabytes (1.4 million bytes), but there are drives that can store many times that amount. Still, the drawback of the floppy is its limited storage capacity.

The hard disk drive, or more commonly called *hard drive*, operates a large-capacity read/write disk that lets you store and retrieve a great amount of digital information. A hard drive with even ten times the capacity of a "floppy" (some 150 megabytes) is considered low-end. If you use your computer mostly for graphics and motion effects, you will need hard drives with a storage capacity of 800

7.2

REMOVABLE HARD DISK CARTRIDGE

Some hard disk drives let you remove the disk, much like the drive that operates floppy disks.

Removable hard disk cartridge

Disk drive

megabytes or more. Some graphics systems require a hard drive storage capacity of several gigabytes (one gigabyte is 1,000 megabytes). These large-capacity hard drives are no longer built into the desktop computer, but are stand-alone units connected to the computer by cable.

There are hard drives that let you remove the hard disk, very much like an oversized floppy disk. The advantages of such *removable hard disk cartridges*, often mislabeled as "removable hard disk drives," are that you need only one disk drive to write and store information on as many hard disk cartridges as you can afford, that you can transport the 5.5-inch cartridges rather easily, and especially that your information is protected once you take it out of the disk drive. **SEE 7.2**

Through a process called *compression*, you can squeeze digital data so that they take much less disk space than noncompressed information. Compression software either organizes your data so that they are not scattered all over the disk, or, as in compressing video, ignores redundant information and then adds it again during playback. For example, when compressing video frames from your footage of somebody playing golf, the compression software may well decide to throw away most of the green color of the grass, because it rightly assumes that the green grass will probably not turn yellow during a putt. When you call up the frames again on the monitor, the computer quickly fills in the green color, pretending that nothing has happened. This process is called *decompression*. Because this process happens so quickly, you can show thirty such frames per second. Yes, you are right: you are now watching full-motion video.

Because large, full-screen video takes up considerably more space than a smaller video image, most animated sequences are displayed in reduced size. Developments in compression of data are essential for increasing the computer's ability to store the vast amount of information needed for running full-screen motion video sequences at thirty frames per second.

7.3

CD-ROM DRIVE AND DISCS

The CD-ROM drive operates high-capacity (650 megabytes or more) video discs that look exactly like audio CDs. Like the audio CD, CD-ROM discs can be used in the "read" mode only. No new information can be put on them.

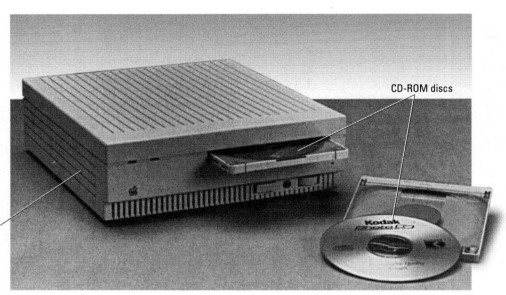

CD-ROM discs

CD-ROM disc drive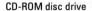

Many newer desktop models come with a built-in *CD-ROM* drive. The CD-ROM disc operates very much like a CD for your stereo system. Note the difference in spelling: regular floppy or hard disks are spelled with a *k;* optical discs with a *c.* A "read-only" optical disc looks just like a normal audio CD and that can hold a great amount of information (about 650 megabytes or more on a single disc).

Although you cannot use the CD-ROM directly for video production, it puts a great amount of information at your fingertips. A single CD-ROM disc can easily hold an entire encyclopedia, including illustrations. CD-ROM drives are extensively used for multimedia and interactive programs (see chapters 9 and 14). For instance, specific CD-ROM software can let you call up the inaugural speeches by famous presidents and almost instantly compare what they had to say on similar issues. Or you may want to use a CD-ROM program that helps you learn some major aspects of video production, such as lighting, camera handling, or editing. **SEE 7.3**

Monitor The high-definition computer monitor is very much like a high-quality color video monitor. Some of the large computer monitors can display two real-size pages side by side, which is ideal for people who use their computers primarily for word processing. Many graphics systems use two monitors, with one displaying the graphic image, the other the computer commands and manipulation tools.

Keyboard and mouse The *keyboard* looks like a slightly modified typewriter keyboard, with a few more keys added to speed the computer operation. Each key can perform multiple functions, depending on the specific option you select.

The *mouse* is a small box with a roller ball on the bottom and a button on top. It is connected to one of the I/O ports via a small cable that, with some imagination, looks like the tail of a mouse. By moving the mouse on a flat surface, you can move the cursor (a pointer on the display screen) into various positions to target menu commands (list of choices) and, by pressing the button on top,

7.4

REGULAR MOUSE AND TRACKBALL MOUSE

The mouse facilitates menu selection and commands to activate certain computer actions. The normal mouse (left) has the trackball on the bottom; it must be moved around on a smooth surface. The trackball mouse (right) has the ball on top; it remains stationary during operation.

call up and activate various menu choices. Some models have a large roller ball, called a *trackball*, on top, so that you don't have to move the mouse, but simply the ball. **SEE 7.4**

Computer Peripherals

The most common computer peripherals used in video production are (1) the printer; (2) the modem; (3) the digitizing, or drawing, tablet; and (4) the scanner.

Printer The printer prints anything that has been stored in RAM. There are three basic printer types available. (1) The *dot matrix printer* constructs an image by printing many tiny dots. The resulting image is low-definition, similar to that of a newspaper picture. (2) The *inkjet printer* prints fairly high-quality images by squirting colored ink onto the paper through tiny nozzles. (3) The *laser printer* works like a copy machine and produces high-resolution images. **SEE 7.5**

You can judge the quality of a printer by the picture resolution, the fidelity of color and grayscale, and by how fast it prints the various images. For example, the dot matrix printer is considerably slower than the inkjet or the high-end laser printer.

7.5

DOT MATRIX IMAGE AND LASER IMAGE

quality quality

A The dot matrix printer produces images with lower definition and density than either the inkjet printer or laser printer.

B The laser printer produces images that approach the quality of high-resolution professional typesetting.

Modem *Modem* is an acronym composed of *mo*dular and *dem*odular. A modem modulates (changes) the digital information from the computer into analog signals that can be transported over ordinary telephone lines (or fiber-optic cables or radio waves). It also translates the analog signals back into the digital language of the computer (demodulates). You need a modem to talk to other computers that are not directly connected to yours, such as the various large databases, or the ones that make e-mail (electronic mail) possible. Modems are judged by their transmission rate, which is expressed in *baud* (number of signal events per second). The faster the baud rate of the modem (such as 9,600 baud), the faster the transmission will be.

With a modem, you can also send your computer-generated art or audio information over telephone lines to the client for approval or changes. Sound designers often exchange their digitized sound tracks with various production houses for specific types of sound manipulation and mixing.

7.6

DIGITIZING TABLET
AND STYLUS

The digitizing, or drawing, tablet lets you draw images on the computer screen with an electronic stylus. You work the stylus similar to a pen; it responds to where you move it and how much pressure you put on it.

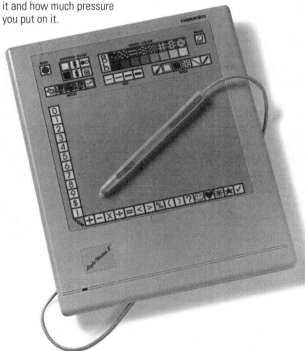

Digitizing, or drawing, tablet This computer peripheral is especially important to creators of video graphics. The tablet, which looks like a plastic drawing pad, acts as an input device similar to the mouse. With a stylus, which looks like a ballpoint pen, you can "draw" on the tablet. But unlike the actual drawing pad, which shows what you draw on it, the digitizing pad remains blank however much you may work your stylus. You can see your creation only on the computer screen. **SEE 7.6**

Scanner The scanner does the opposite from the printer. Instead of creating a hardcopy from digital computer data, the scanner dissects any type of hardcopy, such as a photograph, printed page of text, or color slide, and transforms the visual material into digital data that can be stored by the computer. With a scanner, you could transform the page you are now reading into digital information, store it on a floppy disk, and then reproduce it again as hardcopy with the printer. **SEE 7.7**

7.7

SCANNER

The scanner works in a reverse way from the printer; instead of translating the digital information into an image, the scanner translates images into digital information.

◼ Basic Computer Terminology

Knowing some of the common computer terminology will not make you an expert, but it will help you communicate, at least on a basic level, with computer people. Also, many computer terms are now part of the common video production vocabulary. **SEE 7.8**

After you have mastered the basic computer terminology, we can move on to a discussion of standard analog electronic effects, digital image manipulation, and digital image creation.

7.8

BASIC COMPUTER TERMINOLOGY

Alphanumeric The letters, punctuation marks, and other signs (alpha) and numbers (numeric) used by the computer.

Analog A signal that fluctuates smoothly and exactly like the original stimulus. When a sound gets gradually louder, the electrical signal from a microphone increases in strength exactly with the sound volume.

Baud Data transmission speed, expressed in number of signal events per second. The higher the baud number, the faster the transmission. Baud rates from 2,400 to 9,600 can be handled by normal telephone lines.

Binary Digit The smallest unit of information a computer can hold and process. The value of a bit is either *on* or *off*, usually represented by a 1 or a 0. Also called a *bit*.

Boot The loading of the computer's operating system or other software program. (The term originally referred to the computer "pulling itself up by its own bootstraps" to get going.) The computer now boots itself as soon as you turn it on.

Byte Normally a series of 8 bits.

CD-ROM Stands for compact disc–read-only memory. An optical disc, similar to an audio CD, that holds a great amount of digital data (text and pictures). Needs a special CD-ROM disc drive that is built into the computer or plugged into one of the computer ports.

Chip An integrated circuit made up of hundreds of thousands of transistors and other electronic components squeezed onto a very small piece of silicon.

Clone A computer or its software that duplicates the functions of a more expensive model.

Compression A process by which the data are neatly ordered so that they do not waste any available disk space, or the data are reduced during the storage process and restored during the retrieval.

Computer A device that can receive, store, process, and display a set of instructions in a programmable way. Most computers are digital.

CPU Central processing unit. The major part of the computer that processes information according to the instructions it receives from the software.

Cursor A special symbol, such as a line or a small rectangle, that can be moved to specific positions on the monitor screen.

Default A value, action, or setting that a computer system assumes, unless told otherwise.

Digital Pertaining to data in the form of digits (on/off pulses).

Digitize To convert an analog signal into digital (binary) form or to transfer information into a digital code.

Digitizing Tablet A tabletlike board that translates the movement of an electronic pencil (stylus) into specific cursor positions on the screen. Also called *bit pad* or *drawing tablet*.

Disk A magnetic storage device that is used for information storage additional to the computer's memory. *Floppy disks* are 3.5-inch magnetic disks encased in a hard plastic shell. They can hold more than 1 megabyte. Lower-capacity 5.25-inch disks are often used with earlier PCs but are less common today. Normal *hard disks* are built into the disk drive. They have a much higher storage capacity (anywhere from 80 megabytes to 1 gigabyte). Removable hard disk cartridges are also available; they offer the capacity of built-in hard disks and the portability of floppies.

Disk Drive The actual mechanism that turns the disk to read and write digital information.

DOS See *MS-DOS*.

Dot Matrix Printer A printer that creates its alphanumeric and other images with a series of small dots.

7.8

BASIC COMPUTER TERMINOLOGY *(continued)*

File A specific collection of information stored on the disk separately from other information. It is similar in application to placing papers into a regular file folder.

Floppy Disk See *Disk.*

Flow Chart A diagram in which certain symbols (diamonds, rectangles, arrows) represent the flow—the steps and their sequence—of an event. It is used by programmers to translate events into computer logic.

Gigabyte 1,000 megabytes.

Hardcopy A printout of computer text or graphics.

Hard Disk See *Hard Drive.*

Hard Drive A disk drive with a built-in high-capacity disk incorporated into the computer housing or connected to the computer by cable. Some hard disk cartridges can be removed from the drive like floppy disks. Also called *hard disk.*

Hardware The physical components of a computer and its auxiliary equipment, such as the disk drive, the monitor, and the printer.

Icon A graphic representation of an actual object, occasionally including graphic symbols representing an idea or a message.

Initialize To prepare a disk so that it can receive and store digital information in an orderly fashion.

Interactive The user is given a choice of what program to call up, how to sequence its parts, to repeat it at will—all in real time.

Interface Any device (software or hardware) that links the various components of a system in order to expand the capabilities of the system. For example, the cable that connects the computer with the printer is an interface. The computer itself can be an interface between the operation of video equipment and its operator.

K Stands for kilo, meaning 1,000. See *Kilobyte.*

Keyboard The piece of hardware that contains alphanumeric and other important keys that activate specific computer functions.

Kilobyte In the context of storage capacity, *K* stands for kilobyte, which translates into 1,024 bytes.

Language A set of symbols and their sequence that initiates a certain process in the computer. One language might be more practical for scientific calculations, another for word processing or graphics.

Laser Printer A printer that produces high-quality (high-resolution) images. The resolution is expressed in dpi (dots per inch). A 600 dpi printer is considered high quality. A laser printer is basically a laser-equipped desktop copier that translates computer data into hardcopy images.

Lock A mechanical device on a disk that secures the stored data from unwanted access or accidental erasure. It can also be a software program that prevents opening a file without a proper access code.

Mainframe Computer A very large, high-speed computer system that can accommodate several users simultaneously processing various tasks.

Megabyte 1,000 K, or somewhat over 1 million bytes.

Memory The storage device in a computer. Its capacity is given in numbers of bytes. See *RAM* and *ROM.*

Menu A list of the material stored or a set of options displayed after loading a computer program.

Menu Bar The strip across the top of the display screen that shows available menus.

Microcomputer The more formal name for a desktop computer.

Microprocessor A single chip containing a small-scale central processing unit with some memory.

Modem Stands for modulator/demodulator. Equipment that changes the digital computer signals into analog signals and back again so that digital information can be transmitted via normal telephone lines, fiber-optic cables, or radio waves.

Morph or Morphing Short for metamorphosis. Using a computer to animate the gradual transformation of one image into another (boy into old man, cat into lion).

Mouse A small box with a rolling ball and a button that is connected with the computer. It controls curser movement on the screen and triggers certain computer commands.

MS-DOS Stands for Microsoft disk operating system, commonly used in non-Macintosh computers. This system is a collection of software programs that help the computer process other software programs. Sometimes used to distinguish one computer system (such as IBM, which uses MS-DOS) from another (such as Macintosh, which has its own operating system).

Page Information that occupies the total display screen, or a designated quantity of memory that has a unique computer address.

7.8

BASIC COMPUTER TERMINOLOGY *(continued)*

PC Stands for personal computer. This is generally used to distinguish IBM desktop computers and their clones from the Apple Macintosh family.

Pixel Short for picture element. The smallest picture element, like the dot in a newspaper picture. In computer graphics, the smallest visual unit that can be addressed and processed by the graphics program.

Platform Designates the specific operating system (MS-DOS, Windows, Macintosh).

Port Jacks on the computer for plugging in cables that connect the computer with other peripheral equipment, such as a printer or modem.

Printer See *Dot Matrix Printer* and *Laser Printer*.

Program A sequence of instructions, encoded in a specific computer language, to perform specific predetermined tasks. The program is computer software.

RAM Stands for random-access memory. It is actually a read/write memory chip that makes possible storage and retrieval of information while the computer is in use. All information stored in RAM is lost when the computer is turned off. Important information should, therefore, be frequently transferred from RAM to floppy or hard disks.

Read/Write The retrieval (read) and storage (write) by a computer of data and/or their mechanisms.

ROM Stands for read-only memory, which includes the program that is built into the computer memory and cannot be altered. In contrast to RAM, the ROM does not disappear when the computer is turned off.

Scanner A device that translates images (such as any page of this book, including pictures) into digital information so that it can be stored, processed, and retrieved by the computer.

Soft Copy Text and graphics as displayed on the monitor screen.

Software The programs that instruct the computer to perform certain predetermined processes. These programs are stored on floppy disks, hard disks (called hard drives), or CD-ROM. After booting the computer, a copy of the software is transferred to RAM by the user.

Storage Storing the input information either in RAM or on one of the storage devices, such as the floppy disk or hard drive.

Terminal A keyboard through which a large computer can be given instructions, usually from a remote location. Most terminals also contain a monitor that displays the computer input/output. The "computers" at travel agencies or airline ticketing stations are merely terminals, connected to a large mainframe computer.

Windows A graphical user interface for IBM PC–compatible computers.

STANDARD ELECTRONIC EFFECTS

The standard analog electronic effects are achieved with an electronic switcher (see chapter 11) and a special-effects generator (SEG) that normally is built into, or connected to, the switcher. Many of the special effects have become so commonplace that they are no longer "special" but are part of the normal video vocabulary: (1) the superimposition, or super, (2) the key, (3) the chroma key, and (4) the wipe.

Superimposition

The *superimposition* (or *super* for short) shows two images at the same time, as in a double exposure. In a super, you can see both complete images at the same time and easily vary the strength of either the background (or base) image or the one

7.9

SUPERIMPOSITION

The superimposition, or *super* for short, shows two images simultaneously, as in a double exposure.

that is superimposed over the base image. **SEE 7.9** (Chapter 11 will give you more information about how to do a superimposition with the switcher.)

Supers are mainly used to show inner events—thoughts and dreams—or to make an image more complex. You are certainly familiar with the (overused) example of the close-up of a face over which various dream sequences are superimposed. You could, for instance, superimpose two slightly differing camera pictures of a ballet dancer, thereby revealing the complexity of the movement and its grace. This synthetic image now generates its own meaning. As you can see, you are no longer simply photographing a dance, but helping to create it.

 KEY CONCEPT 4 **The superimposition is a double exposure that shows two separate images simultaneously.**

Key

Keying is another method of combining two video images electronically. Contrary to a super, where you can see the base picture through the superimposed image, the keyed image (figure) will block out portions of the base picture (background) and, therefore, appear to be on top of it.

To understand how a *key* works, let us use the white lettering of a name that appears over the image of a scene. The C.G. (character generator) supplies the

7.10

KEYED TITLE

The keyed letters seem to be pasted on top of the background image.

white title against a black background; the studio camera supplies the picture of a scene. The C.G. title is called the *key source*, and the camera picture of the scene, the *base picture*. During the key, the base picture will replace all the dark areas around the title, but not overlap the lettering itself. The effect is that the letters are printed over the scene. **SEE 7.10** Instead of the C.G., you can also paint the white title on a black card, and have a second camera take a picture of it. Instead of the C.G. image, this camera picture is now the key source.

You can, of course, key any other electronic image into a base picture, such as lines that divide the screen into different areas, or boxes that highlight specific images.

Because the keying process can have some technical variations, we have different—and often confusing—names for them. You may hear the terms *key*, *matte*, *matte key*, or *chroma key* used interchangeably. Let's try to group them by the way they are commonly used: (1) the normal key, (2) the matte key, and (3) the chroma key.

Normal key In a normal key, you have only two video sources: the base picture and the key source. The normal key simply replaces all dark areas around the title, thus making the title appear to be "cut into," or written on top of, the base picture.

Matte key In this key, you add a third video source, which is either generated by the switcher or by an external video source. Most often, a ***matte key*** refers to the letters of a title that are filled with various colors or grays, or that have

NORMAL MATTE KEY

In the normal matte key, the letters are filled with gray or a specific color.

Letter filled with color

EDGE MODE

In the edge mode, the matte key puts a black border around the letters. This separation from the background makes them more readable.

different borders. **SEE 7.11** The matte keys that create various borders around the letters are subdivided into the *edge mode*, the *drop-shadow mode*, or the *outline mode*. **SEE 7.12–7.14**

Chroma Key

The *chroma key* process uses a specific color, usually blue or green, as background for the object or subject to be keyed into a second video source. A typical example of chroma keying is the weathercaster who seems to stand in front of a large weather map. All he actually does is stand in front of a plain chroma blue (an even, saturated medium-dark blue) background. The weather map is usually computer-generated. During the keying, the weather map replaces the blue areas and makes the weathercaster appear to be standing in front of it. When he turns to point to various areas of the map, he actually sees only a plain blue background. To coordinate his gestures with the "background" weather map, he must watch a monitor that shows the entire key effect. **SEE COLOR PLATE 5**

Because everything that is blue will disappear and be replaced by the second video image (base picture) during the key, the weathercaster cannot wear anything blue, nor can anything else in the foreground be painted blue. For example, if the weathercaster wore a blue sweater, you would see only his head and hands during the keying. His sweater would act like the chroma key background and be replaced by the weather map. As a matter of fact, chroma keying is used in such a way to achieve special effects. If, for instance, you cover a dancer's upper body and head with a chroma key blue material and have her move in front of the blue background, the key will show only her legs dancing.

You can also use the chroma key technique to simulate a variety of backgrounds. Let's recall the lighting problem you had when trying to avoid the silhouette

7.13

DROP-SHADOW MODE

The attached (drop) shadow gives the letters an added dimension and separates them from the background.

7.14

OUTLINE MODE

In the outline mode, you see only the contour of the letters. The outline mode needs a relatively simple background.

effect of the company executive who insisted on sitting in front of her large picture window (see chapter 6). One of the lighting solutions was to cover the window or, better yet, pull the drapes or have her sit sideways so that the window wouldn't be in the shot. Now you have a third solution: chroma keying. For example, you could cover the entire window with an evenly stretched blue cloth or paper, and then use a photo of the actual view from the window as the background source. During the chroma key, she would appear sitting in front of her picture window, except this time you could use normal triangle lighting without fear of having her silhouetted against the bright window. **SEE COLOR PLATE 6**

Chroma keying, which is also called the *blue-screen technique,* is extensively used for creating motion picture effects. In this case, the effect is first produced on videotape by high-quality electronic machinery (either photographed by HDTV—high-definition television—cameras or computer-generated) and later transferred to film.

You can also use other colors for chroma keying, such as green. The reason that blue and green are so popular in chroma keying is that they are relatively absent in skin or hair colors. What about blue and green eyes? Wouldn't they let the background show through during a key? Yes, they may do just that in an extreme close-up, in which case you need to have the talent wear different-colored contact lenses. Fortunately, even blue or green eyes normally reflect so many other colors that they reject the background signal.

 KEY CONCEPT 5　　**In a key, the base picture (second video source) replaces the dark or blue areas of the key source (first video source). The light or nonblue areas (such as a white title) will seem to be placed on top of the base picture.**

■ **Wipe**

In a *wipe*, a portion of or a complete video image is gradually replaced by another. It looks as though the new image pushes—wipes—the first one off the screen. Wipes come in a great variety of configurations and are usually displayed as icons (graphic representations of what the wipe looks like) on the switcher buttons with which you can preset a particular wipe. **SEE 7.15**

Some of the most common wipes are the horizontal and vertical wipes. In a *horizontal wipe*, the second image gradually replaces the base picture from the side. **SEE 7.16** A *split screen* is simply a wipe that is stopped in the middle. More often, split screens are generated by digital effects, which give more control over the size of the split image than the analog wipe. In a *vertical wipe*, the base picture is gradually replaced by the second image from the top down or from the bottom up. **SEE 7.17**

Other popular wipes are *corner wipes*, whereby the second image originates from one corner of the base image, or *diamond wipes*, where the second image originates in the center of the base image and spreads as an expanding diamond-shaped cutout. **SEE 7.18–7.19** In a *soft wipe*, the demarcation line between the two images is purposely camouflaged.

Don't go overboard with wipes, simply because they are so easily done. All wipes are highly visible and obvious transitions that need to fit the character and mood of the specific video material. Using a diamond wipe during a news program to reveal a more detailed shot of a murder scene is hardly appropriate, but quite acceptable when changing from a medium shot of a new computer model to a CU (close-up) to its high-capacity hard drive.

 KEY CONCEPT 6 **Use special effects only if they help to clarify or intensify the intended message.**

7.15

WIPE PATTERNS

A group of buttons on the switcher shows the various wipe patterns available. Elaborate systems offer up to 100 different patterns.

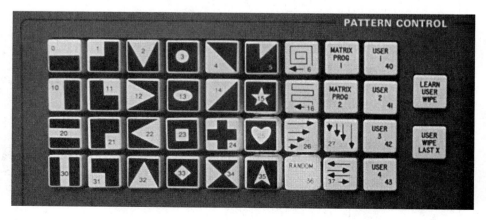

7.16

HORIZONTAL WIPE

In a horizontal wipe, the base picture (A) is gradually replaced by another from the side (B).

7.17

VERTICAL WIPE

In a vertical wipe, the base picture is gradually replaced by another from the bottom up or from the top down.

7.18

CORNER WIPE

In a corner wipe, the base picture is gradually replaced by another that starts from a screen corner.

7.19

DIAMOND WIPE

In a diamond wipe, the base picture is gradually replaced by the second image in an expanding diamond-shaped cutout.

DIGITAL IMAGES

The computer has greatly expanded the range of possibilities for manipulation of the lens-generated image; it can even create still or animated images that rival high-quality lens-generated images in every respect. To keep this topic manageable, we will give only a brief overview of these major aspects of digital image manipulation and image creation: (1) digital video effects, (2) synthetic image creation, and (3) animation.

Digital Video Effects

Digital video effects (DVE) change the normal analog video signal into digital data in order to create a variety of special effects. Basically, the DVE equipment can grab a video frame from any source (live camera or videotape), change it into digital information, store it, manipulate it according to the effects programs available, and retrieve the effect on command.

To understand the translating process, try to visualize how a photo is transformed into a mosaic. The photo represents the analog video signal; it shows a *continuous change* of shape, color, and brightness. When seen as a mosaic, the same image is now made up of a great number of tiles, each one representing a *discrete* picture element—a pixel. Because each pixel can be identified separately by the computer, you can now tell the computer which ones to take out, move to another place, or replace with one of a different color. Once satisfied with the image manipulation, you can store it in the computer and recall it at will. **SEE 7.20**

 KEY CONCEPT 7 **Digital video effects digitize and manipulate the normal analog video image.**

Electronic still store (ESS) system With an *ESS system,* you can grab any video frame, digitize it, and store it on a disk. These ESS systems—which can store hundreds or even thousands of frames—perform like a superfast slide projector. You can call up and display any of these stored images in a fraction of a second. Once in digital form, the still image can be changed in size, shrunk, expanded, and used in combination with other images. The famous box above the newscaster's shoulder is a digitized frame that is keyed into the base picture of the news set.

Frame store synchronizer Even with relatively simple DVE equipment, you can perform more effects than normally needed for good storytelling. The digital *frame store synchronizer*'s primary function is to stabilize a picture and to synchronize two different video sources so that they don't roll when switching from one to the other. But it can also be used for simple digital effects. With the frame store synchronizer, you can freeze a moving image similar to a photo snapshot, change it into a mosaic, advance it frame by frame at different rates, a process called *jogging,* or solarize it (increase the contrast by reducing subtle in-between shades). **SEE 7.21**

7.20

MOSAIC EFFECT

In the mosaic effect, the image is changed into equal-sized squares, resembling mosaic tiles. In an electronic mosaic, the size of the "tiles" can be changed.

7.21

SOLARIZATION

In solarization, the brightness values are reduced to a few steps, which gives the picture a high-contrast look. Highly contrasting pixel areas show up as lines.

7.22

STRETCHING

Stretching changes the format of the frame and the image contained in it.

7.23

CUBE

In the cube effect, the images seem to be glued to the sides of a rotating cube.

More sophisticated DVE equipment can change the size of the image (lettering or an actual scene), squeeze or stretch it, paste it on a cube and have the cube rotate, flip, and spin, or bounce and fly through the screen space. **SEE 7.22–7.25**

7.24

ROTATION

The image can tumble, flip, or spin. According to the normal x-, y-, and z-axes of three-dimensional space, rotation around the x-axis (horizontal axis) is a tumble; around the y-axis (vertical axis), a flip; and around the z-axis (depth axis), a spin.

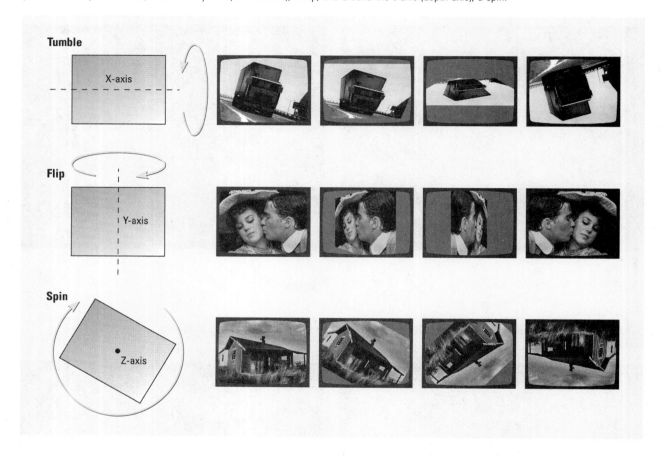

7.25

FLY

In the fly mode, the image zooms from a certain spot to a full image or recedes into another screen position.

Synthetic Image Creation

In addition to manipulating lens-generated images, the computer can create a great variety of images on its own, independent of the video camera. Such *synthetic images* range from simple lettering to complex motion sequences that rival well-shot and edited videotaped footage. Numerous software programs are available to help you generate a great variety of still or moving images. As you may remember, the people from Triple-I had several small and larger computer systems in the Pixel Room that were specially dedicated to the creation of synthetic images. Such systems are generally classified by their primary function: (1) *character generators* and (2) the more complex *graphics generators*.

KEY CONCEPT 8 **Synthetic images are entirely computer-generated.**

Character generator The *C.G. (character generator)* is designed to produce letters and numbers of different fonts (styles and sizes) and colors. It looks and works like a personal computer, and it is run by simplified word processing programs. A typical C.G. program will offer a menu from which you can select the font and color of your letters and numbers. You then type your copy on the keyboard, colorize your letters, center them or move them into a specific spot on your display screen, insert or delete copy, scroll it up or down the screen, or have it crawl sideways—all with a few simple commands. **SEE 7.26** Through the switcher, you can insert your copy directly into the video of the program in progress, or save and store it on a floppy disk for later retrieval.

The C.G. adds speed and flexibility to creating titles. For instance, if you don't like a particular font or color, you can change it to something else through a single command to the computer before keying it into the base picture. The C.G. is used extensively in telecasts of sporting events. During such live telecasts, the C.G. operator is fully occupied with typing names of players and statistics (or accessing

7.26

VIDEO CREATED BY CHARACTER GENERATOR

The C.G. is designed to generate specific titles.

7.27

IMAGE CREATED BY DRAWING PROGRAM

The drawing program facilitates technical drawings or two-dimensional images.

them from a disk). More elaborate C.G.s can create small graphic displays, such as block diagrams or sales curves. Each complete screen display constitutes a *page*, which can be accessed randomly. *Random access* means that you do not have to pass through pages 1, 2, 3, and 4 to get to page 5—you can call up page 5 directly.

Graphics generator Graphics generators are high-quality computer systems that are primarily used for the creation of graphic images. Because the complex graphics software and elaborate graphic designs take up a great amount of disk space, you need high-capacity hard drives or other such storage devices. Graphics software is usually divided into *drawing* and *painting* programs.

Drawing software is designed to create technical drawings, such as floorplans, line drawings, or other two-dimensional graphics. **SEE 7.27** Most weather charts and diagrams that visualize some progress or regress are produced with the help of drawing software. Some of the more elaborate drawing programs let you rotate the generated picture, stretch it, cut-and-paste other images onto it (very much like keying), show its mirror images, and duplicate it as many times as you want.

Painting software offers you a rich color palette and almost as many options as the drawing pad or canvas. The menu also offers a wide choice of pen, crayon lines, or brush strokes, literally thousands of colors, subtle shades, and anything from soft watercolor effects to bright, highly reflecting color areas. If you don't like a particular shape, color, or texture, you can erase your creation and substitute it with a new one with a stroke of your stylus. If you like the first version better after all, you can quickly retrieve the original version by simple computer commands. **SEE COLOR PLATE 7**

You can also simulate three-dimensional images that seem to occupy three-dimensional screen space. These images resemble lens-generated images and exhibit the same characteristics: assumed volume, attached and cast shadows, texture, and perspective that shows the object from a specific point of view.

Rotating the image will change the perspective from which you view the object. You will be able to see the object from below, from above, or from any angle you may choose that has been built into the graphics program. You can also change the direction and intensity of the key light, and with it the attached and cast shadows. **SEE 7.28** For example, you could change the key from its above-eye-

7.28

CHANGE IN PERSPECTIVE AND LIGHT

3-D images can be rotated from various points. The principal light source (key light), and with it the shadows, can also be moved into various positions.

level position to a below-eye-level position, or increase the intensity of light and thereby the speed of falloff.

With some special algorithms, called *fractals*, you can even "paint" free-form images, such as trees, mountains, or colorful patterns. **SEE COLOR PLATE 8**

Animation

Special software lets you animate a sequence by filling in all missing frames between a start and stop position of the intended motion sequence. You can then have the sequence run as slowly or as quickly as you like. Such programs also let you sketch in the background images or combine foreground and background motions. You can also link appropriate sounds with these animated sequences (which is one of the reasons you saw the audio keyboard in the Pixel Room of Triple-I). Other software lets you run moving videotape or film sequences that can be combined with still images and text.

One special animation technique is *morphing*. Morphing, which comes from the word *metamorphosis* (meaning the change or transformation of form, shape, and structure), lets you transform continuously and gradually a well-known shape into another. For example, you can *morph* the picture of a young boy into one that shows him as a ninety-year-old man, and then have this old man slowly grow into a lion. Morphing has been extensively used in monster movies, where people suddenly turn into wild beasts right before your eyes. **SEE COLOR PLATE 9**

You will find that synthetic image creation will become more and more common even in relatively simple video production processes and interactive video programs. You will read more about such computer-generated images and their applications in chapters 9 and 14.

You should feel less intimidated now when going back to the Pixel Room of Triple-I, and you may even enjoy creating some graphic images on the computer. But don't get carried away by all this digital wizardry. After all, the content of the package is still more important than its wrapping. Even the best DVE treatment will not change a basically insignificant message into a significant one. On the other hand, properly used effects can supply additional meaning and, like music, increase the energy of the screen event.

ONCE AGAIN, REMEMBER...

▥ Desktop Computer System

A basic desktop computer system consists of (1) the computer itself, (2) the disk drives, (3) the monitor, and (4) the keyboard/mouse. Not all desktop computers have the same operating system, which means that they cannot run each other's software unless special interplatform software is used or that they have built-in interoperative capabilities. Platform refers to the specific operating system of the computer, such as MS-DOS or Windows, or the Mac platform of the Apple Macintosh computers.

▥ Computer

Important components include RAM (random-access memory), which stores information while the computer is in use. RAM loses all information when the computer is turned off. ROM (read-only memory) contains the basic computer program that will not be erased when the computer is turned off. The processing speed of the computer is determined principally by the CPU, the central processing unit.

▥ Disk Drives

Floppy disks are small read/write disks with limited storage capacity. The floppy drive is built into the computer. Hard drives, normally built into the computer, can store and quickly retrieve a large amount of information. CD-ROM discs are read-only optical discs that hold a large amount of information. Some computers have the CD-ROM drive built-in; others must be connected to a separate drive. Video graphics and moving video images stored for editing require a great amount of RAM and hard drive storage space.

▥ Standard Electronic Effects

Standard video effects are analog, including superimposition, normal key, matte key, chroma key, and various wipes.

▥ Digital Images

Digital video effects (DVE) can be stored via an ESS (electronic still store) system and can be further manipulated by special DVE equipment. Character generators (C.G.s) are used to create titles; graphics generators are high-quality computer systems that can create and manipulate still and animated images.

KEY CONCEPTS

- Video consists of lens-generated and computer-generated images.

- The computer is a high-speed counting machine.

- RAM is temporary data storage and loses its data every time the computer is switched off. ROM is permanent data storage. It remains intact when the computer is switched off.

- The superimposition is a double exposure that shows two separate images simultaneously.

- In a key, the base picture (second video source) replaces the dark or blue areas of the key source (first video source). The light or nonblue areas (such as a white title) will seem to be placed on top of the base picture.

- Use special effects only if they help to clarify or intensify the intended message.

- Digital video effects digitize and manipulate the normal analog video image.

- Synthetic images are entirely computer-generated.

KEY TERMS

Pickup Pattern The territory around the microphone within which the mic can hear well.

Polar Pattern The two-dimensional representation of the pickup pattern.

Omnidirectional The microphone can hear equally well from all directions.

Bidirectional The microphone can hear best from two opposite sides.

Unidirectional The microphone can hear best from the front.

Cardioid A unidirectional microphone pickup pattern.

Dynamic Microphone A relatively rugged microphone. Good for outdoor use.

Condenser Microphone High-quality, sensitive microphone for critical sound pickup. Used mostly indoors.

Windscreen Acoustic foam rubber that is put over the microphone to cut down wind noise in outdoor use.

Ribbon Microphone High-quality, highly sensitive microphone for critical sound pickup. Produces warm sound.

Lavaliere A small microphone that is clipped onto clothing.

Fader A volume control that works by sliding a button horizontally along a specific scale. Identical in function to a pot. Also called *slide-fader*.

Jack A socket or receptacle for a connector.

VU Meter A volume-unit meter; measures volume units, the relative loudness of amplified sound.

XLR Connector A professional three-wire connector for audio cables.

RCA Phono Plug Small connector used for most consumer video and audio equipment.

Mini Plug Tiny connector used for some consumer audio equipment.

Sweetening The manipulation of recorded sound in postproduction.

ATR Stands for audiotape recorder.

DAT Stands for digital audiotape.

Audio and Sound Control

YOU have probably heard over and over again** that television is primarily visual. You have also often heard that the worst sin you can commit in video production is to show "talking heads." The Triple-I director you previously met at the MTV shoot thinks that this "talking head" idea is a total misconception and reveals that so many people still don't seem to understand the true nature of the video medium. She tells you that video programs rely on the sound portion much more than film. According to her, the audio portion not only conveys information, but also gives sequences added energy and structure. "There is nothing wrong with talking heads," she tells you, "as long as they talk well and have something worthwhile to say."

In fact, much of the information in television and video programs is conveyed by somebody talking. You can do a simple experiment to prove this point: First, turn off the video portion of the program and try to follow what is going on; second, turn on the video again, but turn off the audio. You will probably have little trouble following the story by hearing only the sound track; but you will, in most cases, have a rather difficult time knowing what is going on by seeing only the pictures. Even if you can follow the story quite easily by watching the pictures, the lack of sound leaves the message strangely incomplete.

You will find that most amateur video is not just characterized by the madly moving camera and fast zooms but by bad audio as well. Even professional video productions tend to suffer more from bad sound than bad pictures. Why? At first glance, the production of sound seems much easier to achieve than the corresponding video portion. When working your camcorder, you are probably concentrating so much on getting good pictures that you don't pay much attention to the sounds that surround you. You simply assume that the built-in microphone will do the job of picking up the necessary sounds.

Even experienced video production people are confronted by the audio issue. In simple productions, such as an interview with a company executive, the pickup of sound is, indeed, relatively simple compared to the video requirements (lighting and camera handling). If your sound production gets to be a little more challenging, such as doing an interview at a noisy street corner, or mixing music and sound effects with dialogue, the audio portion requires at least as much attention and skill as the video, and often more. When videotaping a musical number, audio is obviously the most demanding part of the production. However simple or complex your production may be, sticking a microphone into a scene at the last moment is not the way to go. You need to consider the audio requirements from the very beginning of the technical production planning (when you consider the medium requirements).

To learn about the various tools and techniques of producing good audio for video, let's examine briefly—

- **SOUND PICKUP PRINCIPLE**
 How microphones change sound waves into sound signals

- **MICROPHONES**
 How they can hear, how they are made, and how they are used

- **SOUND CONTROL**
 Working the audio mixer and audio console

- **SOUND RECORDING**
 Audiotape recorders and other audio recording devices

- **SYNTHESIZED SOUND**
 Computer-generated sounds

- **SOUND AESTHETICS**
 Environment, figure-ground, perspective, continuity, and energy

SOUND PICKUP PRINCIPLE

Like the translation process in video, where the lens image of the object is translated into the video signal, the sounds we actually hear are transduced (transformed) into electric energy—the audio signal. This signal is made audible again through the loudspeaker. The basic sound pickup tool is the microphone, or *mic* (pronounced "mike").

You can also create sounds synthetically, by electronically generating and recording certain sound frequencies. Yes, you are right, the process is quite similar to creating computer-generated video images. But let's first focus on microphone-generated sounds, and then we'll turn briefly to synthesized sounds.

KEY CONCEPT 1 **Microphones transduce (transform) sound waves into electric energy, the audio signal.**

MICROPHONES

Although all microphones fulfill the same basic function of translating sounds into audio signals, they do so in different ways and for different purposes. Good audio requires that you know how to choose the right mic for a specific sound pickup—not an easy task when faced with the great variety of mics available. Despite all the various brand names and numbers, you will find that you can make some sense out of the different microphones by classifying them by (1) how well they can hear, (2) how they are made, and (3) how they are used.

How Well They Can Hear: Sound Pickup

Not all microphones hear sounds the same way. Some microphones are built to hear sounds from all directions equally well; others favor sounds that come from a specific direction.

In general, you will find three types of *directional characteristics:* (1) omnidirectional, (2) bidirectional, and (3) unidirectional. The directional characteristic—the zone within which a microphone can hear well—is specified by its *pickup pattern*. The two-dimensional representation of the pickup pattern is called the *polar pattern*.

The *omnidirectional* mic hears equally well from all directions. Visualize the omnidirectional mic at the center of a sphere. The sphere itself represents the pickup pattern. **SEE 8.1** The *bidirectional* mic favors sounds that come from two

8.1

OMNIDIRECTIONAL
PICKUP PATTERN

The omnidirectional microphone hears equally well from all directions.

8.2

BIDIRECTIONAL PICKUP PATTERN

The bidirectional microphone best hears sounds that come from opposing sides.

8.3

CARDIOID PICKUP PATTERN

The unidirectional microphone favors sounds that are in front of it. Its pickup pattern is heart-shaped; that is why it is called *cardioid*. The hypercardioid pattern is especially narrow and gives the microphone its great reach.

opposing sides. There, you may imagine the pattern as two small balloons being tied to the front end of the mic. **SEE 8.2** The *unidirectional* mic is designed to hear especially well in one direction—from the front of the mic. Because the pickup pattern of the unidirectional mic is roughly heart-shaped, it is also called *cardioid*. **SEE 8.3** Cardioid mics are also somewhat sensitive to sounds that are coming from behind.

When this "heart" (pickup pattern) gets progressively thinner, we speak of supercardioid, hypercardioid, or ultracardioid mics. The "apple" of the cardiod pickup pattern has now been stretched to the shape of a cucumber. The hyper- and ultracardioid mics have a long "reach," which means that you can produce sounds that seem to come from fairly close by, although they may be a good distance away. Because these microphones are usually fairly long and are aimed at the direction of the sound source, they are commonly called *shotgun mics*.

 KEY CONCEPT 2 **The pickup pattern indicates how well the microphone can hear—its directionality.**

How They Are Made

When selecting a mic for a particular audio task, you need to consider both its specific pickup pattern and its basic mechanics—its *sound-generating element.* When classifying microphones by how they are made, there are three types: (1) dynamic, (2) condenser, and (3) ribbon.

The dynamic mic uses a small coil that moves within a magnetic field when activated by sound. The movement of the coil produces the varying sound signal. The condenser mic has a movable plate that oscillates against a fixed one in order to produce the sound signal. The ribbon mic has a small ribbon, rather than a coil, that moves in a magnetic field. But don't worry too much about exactly how these sound elements work; it is more important for you to know how these microphones differ in their use.

Dynamic *Dynamic microphones* are the most rugged. You can take them outside in all kinds of weather, and they can even withstand occasional rough handling. You can work them close to extremely loud sounds without distorting the sound too much or causing damage to the mic. Many dynamic microphones have a built-in *pop filter,* which eliminates the breath pops that occur when someone speaks into the mic at very close distance. **SEE 8.4**

Condenser These microphones are much more sensitive to physical shock and temperatures than dynamic mics, but they produce higher-quality sounds. *Condenser microphones* are generally used indoors for critical sound pickup. They are especially prominent in music recording. Unlike dynamic mics, condenser microphones need a small power supply to amplify the sound in the microphone before the signal enters the microphone cable. Some need a small battery that is

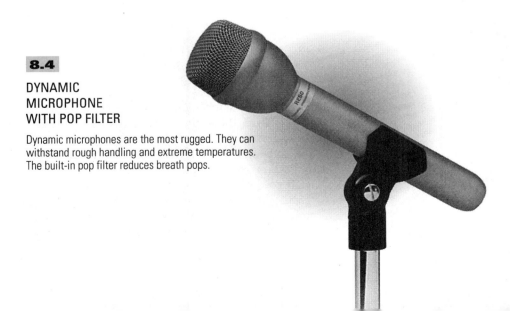

8.4

DYNAMIC
MICROPHONE
WITH POP FILTER

Dynamic microphones are the most rugged. They can withstand rough handling and extreme temperatures. The built-in pop filter reduces breath pops.

8.5

POWER SUPPLY FOR CONDENSER MICROPHONE

Most condenser microphones use a battery to preamplify the sound signal before it leaves the microphone. Some microphones receive this power from the audio console.

Battery bay

8.6

WINDSCREEN ON SHOTGUN MICROPHONE

The windscreen, made of porous material, protects the microphone from excessive wind noise.

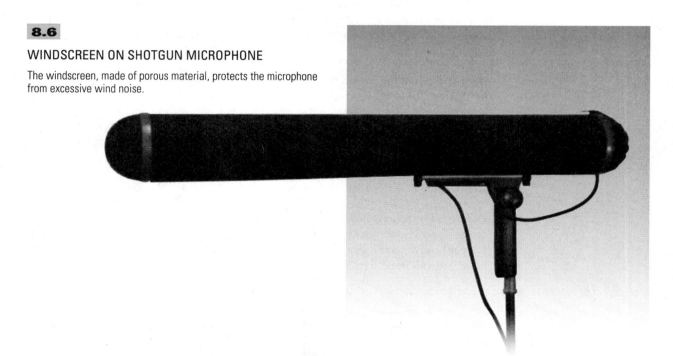

inserted in the microphone housing. **SEE 8.5** Others get their power supply through the cable from the audio console (usually called *phantom power*). If you use a battery, make sure that it is inserted properly (with the + and – poles as indicated in the housing), and that the battery is not run-down. Always have a spare battery handy when using a condenser mic.

If you use a condenser mic outdoors (as a condenser shotgun), you need to protect the whole microphone from wind noise by covering it *entirely* with a ***windscreen***. **SEE 8.6** Windscreens are made of acoustic foam rubber, which lets normal sound frequencies enter the mic but keeps most of the lower wind rumbles out.

RIBBON MICROPHONE FOR QUALITY SOUND PICKUP

The delicate ribbon microphone is often used by singers because it produces high-quality, rich sounds.
(Note: Beyer Dynamic is a trade name—not the type of microphone. The mic pictured here is a ribbon microphone.)

Ribbon *Ribbon microphones* (sometimes called *velocity mics*) are similar to the condenser mics in high pickup quality and sensitivity. **SEE 8.7** Ribbon mics produce a rich and warm sound, but they do not like rough handling, extreme temperatures, or loud sound blasts close by. In fact, a loud sound burst close to the ribbon mic can cause permanent damage. The hero of a television Western learned an impressive lesson about the ribbon mic's sensitivity quite accidentally during a live television promo for his series. When he punctuated his quick-draw skills by firing a blank close to the mic, he blew the delicate ribbon clear out of the microphone. Only a lip reader could follow his subsequent pitch.

 KEY CONCEPT 3 **Treat all microphones gently, even when turned off.**

How They Are Used

Now that you know the basic types of microphones, you need to learn how to use them effectively. Even the most sophisticated and expensive mic will not guarantee good sound unless it is placed in an optimum pickup position. In fact, the proper positioning of the mic relative to the sound source is often more important than its sound-generating element. In video production, microphones are often identified by the way they are used rather than how they are made: (1) lavaliere microphones, (2) hand microphones, (3) boom microphones, (4) desk and stand microphones, (5) headset microphones, and (6) wireless, or radio, microphones.

Lavaliere microphones The *lavaliere* mic, or *lav* for short, is a very small, rugged, omnidirectional microphone (dynamic or condenser) that is used principally for voice pickup. The quality of even the smallest one, which is about the size of your fingernail, is amazingly good. The combination of small size, ruggedness, and good quality have made the lavaliere indispensable in video production. It is usually clipped *on top of* the clothing, such as the lapel of a jacket, the front of a shirt or blouse, or a tie, about six to eight inches below the

CLIP-ON LAVALIERE MICROPHONE

The small lavaliere microphone is usually clipped onto the clothing of the performer. It is normally used for voice pickup.

chin. **SEE 8.8** Although primarily intended for voice pickup, you can also use the lavaliere microphone for a variety of music pickups. Sound people have used the lavaliere successfully on violins or string basses. Don't be overly influenced by the normal use of such microphones. Try them out in a variety of ways and listen to the sound they deliver. If it sounds good to you, you've got the right mic.

The obvious advantage of the lavaliere is that the talent has both hands free when he or she wears it. There are other important advantages to using a lavaliere mic: (1) Because the distance from mic to sound source does not change once the mic is properly attached, you do not have to "ride gain" (adjust the volume) as much as with a hand mic or a boom mic. (2) Unlike lighting for the boom mic, which must be done in such a way that the boom shadows are hidden from camera view, the lavaliere mic needs no special lighting considerations. (3) Although the talent's action radius is somewhat limited by the microphone cable, the lavaliere lets him or her move more quickly than with a boom mic or even a hand mic. For greater mobility, you can plug the talent's lavaliere microphone into a transmitter and use it as a wireless or radio mic.

Unfortunately, there are also some disadvantages to using a lavaliere mic: (1) If the environment is very noisy, you cannot move the mic closer to the talent's mouth. Consequently, the surrounding (ambient) noise is easily picked up. (2) You need a separate mic for each sound source. In a two-person interview, for example, you need a separate lavaliere mic for the host and for the guest. In a five-people panel show, you obviously need five mics. (3) Because it is attached to clothing, the microphone may pick up rubbing noises, especially if the talent moves around a great deal. You may also get occasional popping noises from static electricity that is generated by his or her clothing. (4) If the microphone has to be concealed under clothing, the sound often takes on a muffled character, and the danger of rubbing noises is greatly increased.

Here are some points to consider when using a lavaliere microphone:

▶ Be sure to put it on. As obvious as this sounds, talent has been discovered sitting on the mic instead of wearing it.

▶ To put on the microphone, bring it up underneath the shirt, blouse, or jacket and attach it securely on the outside. Do not put the mic next to jewelry or buttons. If you have to conceal the mic, don't bury it under layers of clothing; try to keep the top of the mic as exposed as possible. Tuck the microphone cable into the talent's belt or some piece of clothing so that the cable cannot pull the mic sideways or, worse, completely off. If there is extensive rubbing noise, put a small piece of foam rubber between the mic and the clothing, and try putting a loose knot into the small mic cable where it leaves the mic.

▶ Once the microphone is attached to the mic cable but not as yet to the talent, watch that you do not pull the mic off a table or chair and drop it on the floor.

Although the lavaliere is quite rugged, it does not like being mistreated. If you accidentally drop the mic during the setup or strike (clearing the production space), test it immediately to see whether it is still functioning properly. Once attached, ask the talent to avoid hitting the microphone with his or her hand or some object that might be demonstrated on camera.

▶ When used outdoors, attach the little windscreen that slips over the top of the mic.

▶ After the show, make sure that the talent does not get up and walk off the set without first removing the microphone. Again, watch that the microphone cable does not pull the mic off the chair or table.

Hand microphones As the name implies, hand microphones are handled by the talent. You use a hand mic in situations where you need to exercise some control over the sound pickup.

A reporter can move the mic closer to his or her mouth when working in noisy surroundings, thereby eliminating much distracting ambience; the reporter can also point it toward the person he or she is interviewing. Because the talent can point the microphone toward whoever is doing the talking, you need only one microphone for an interview with one, or even several, guests. Performers who do audience participation shows like the hand microphone because it allows them to walk up to various people and to talk to them spontaneously without any elaborate multiple-microphone setup.

A singer can control the intimacy of the sound (its presence) by holding the unidirectional hand mic very close to his or her mouth during an especially tender passage, and pulling it farther away when the song gets louder and more external. Experienced singers use the hand mic as an important visual element; they "work" the mic during a song by switching it from one hand to the other to signal—visually—a new song segment or change of pace or simply to supply additional visual interest. **SEE 8.9**

When the hand mic is used outdoors for numerous production tasks and under a great variety of weather conditions, you need a rugged mic that stands up well under rough handling and extreme conditions. You guessed it: dynamic

8.9

USE OF DIRECTIONAL MICROPHONE BY SINGER

To emphasize the richness of her voice, the singer holds the directional hand mic close to her mouth.

hand mics with built-in pop filters are a popular mic in field productions. Singers, on the other hand, demand much more sound quality than a field reporter and prefer high-quality condenser or ribbon hand microphones. But these sensitive hand microphones would not stand up well under some of the extreme weather and handling conditions during field productions, and are mostly confined to indoor use.

The major disadvantage of the hand mic is one we have just mentioned as one of the advantages: the control of the mic by the talent. Inexperienced talent often block their own and guests' faces; this no-no becomes especially apparent when the mic has a large colored pop filter attached to it. Also, in the excitement of the interview, an inexperienced reporter may aim the microphone toward the guest when asking the question, and then toward himself or herself when listening to the answer. As humorous as this unintentional comedy routine may seem to the bystander, it is certainly not to the production people who see their efforts being ruined by this maneuver.

Other disadvantages of using a hand mic are that the talent will not have his or her hands free to do other things, such as demonstrating a product. And, unless there is a wireless hand mic, pulling the cable while working the mic is not always the easiest thing to do.

Here are some hints for the talent using a hand microphone:

▷ During rehearsal, check the action radius of your mic cable. Also see that the cable has free travel and will not catch on pieces of furniture or scenery. Checking the reach of the cable is especially important when your mic is tied to the camcorder.

▷ Check out the microphone before the videotaping or live transmission. Say a few of the opening lines so that the audio engineer or camcorder operator can adjust the volume of the audio signal. When there are several microphones in your immediate vicinity and you need to find out which one is turned on, do not blow or whistle into it—or worse, whack it—rather, scratch the pop filter of your mic lightly. This scratching noise will enable the audio engineer to identify your microphone and separate it from all others.

▷ When using the hand mic in the field under normal conditions (the environment is not excessively loud, and there is little or no wind), hold the microphone at chest level and speak across rather than into it. **SEE 8.10** In noisy and windy conditions, hold the mic closer to your mouth. **SEE 8.11**

▷ When using a directional hand microphone, you must hold it close to your mouth and speak or sing directly into it, as shown in figure 8.9.

▷ When interviewing a child with a hand mic, do not remain standing, but stoop down so that you are on the child's level. This way you establish more personal contact with the child, and the camera can get a good two-shot. **SEE 8.12**

▷ If the microphone cable gets tangled during a take, do not panic and yank on it. Stop where you are and continue your performance while trying to get the attention of the floor manager or somebody else who can untangle it for you.

8.10

NORMAL POSITION OF HAND MICROPHONE

In a fairly quiet environment, the hand mic should be held chest high. The performer speaks across the mic rather than into it.

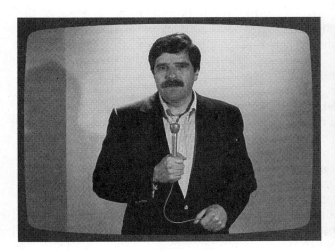

8.11

POSITION OF HAND MICROPHONE IN NOISY SURROUNDINGS

In noisy surroundings, the performer holds the mic closer to the mouth and speaks into the mic rather than across it.

8.12

INTERVIEWING A CHILD

When interviewing a child, you should stoop down when holding the mic toward the child. The child is now more aware of you than the mic, and the camera operator can include both faces in the shot.

▷ If you need to use your hands while holding a hand mic, tuck it temporarily under your arm so that it can still pick up your voice.

▷ When the hand mic is directly connected to a camcorder, the camera operator should also turn on the camera mic (built-in or attached). The camera mic will then supply the second audio track on the videotape with the surrounding (ambient) sounds without interfering with the hand mic, which is supplying the major audio. In fact, you should always have the camera mic turned on, even if you may not intend to use such sounds. Most likely, you will make use of the ambient sound during postproduction editing.

KEY CONCEPT 4 **Check the hand mic you are using before going on the air.**

Boom microphones Whenever the microphone is to be kept out of the picture, hypercardioid or supercardioid *shotgun mics* are used. As you recall, such highly directional microphones can pick up sounds over a fairly great distance and make them seem to come from close by. You can aim them toward the principal sound source while eliminating all other sounds that lie outside of their narrow pickup pattern.

When used for an elaborate studio production, such as the videotaping of a soap opera, these shotgun mics are suspended from a large boom, called a *studio boom* or *perambulator boom*. A boom operator, who stands on the boom platform, can extend or retract the boom, tilt it up and down, pan it sideways, rotate the microphone toward the sound source, and even have the whole boom assembly moved. This is all to move the microphone as close to the sound source as possible while keeping it out of the camera's view.

The problem with using a studio boom is that it is quite large and takes up a great amount of studio operating space. Furthermore, you will discover that operating a boom is at least as difficult as running a camera. Because of its size, the big boom cannot be used in field productions. This is why shotguns are more commonly suspended from a fishpole—or simply handheld—in field productions or studio productions that are shot in short segments.

A *fishpole* is a sturdy and lightweight metal pole that can be extended. The shotgun mic is attached to the pole with a *shock mount*, which absorbs the vibrations of the pole and the rubbing noises of the mic cable. Test your shock mount before each take to see whether the mic can be moved about without transferring the handling noise or pole vibrations. Even the best shotgun mic is rendered useless by a noisy pole or shock mount.

If the scene is shot fairly tight (with tight medium shots and close-ups), you can use a short fishpole—which, by the way, is much easier to handle than a long one. You can pick up the sound either from above or below. If your sound pickup is from above the source, hold the boom in your outstretched arms and dip it into the scene as needed. **SEE 8.13** If your sound pickup is from below the source, turn the pole so that the mic is pointing up toward the people speaking. **SEE 8.14**

When the shots are wider and you need to keep farther away from the scene, you must change to a long fishpole. Because the long fishpole is heavier and harder to handle, you should anchor it in your belt and raise and lower it as you would an actual fishing pole. The long fishpole is usually held above the sound source. **SEE 8.15**

Here are some additional hints for operating a shotgun mic mounted on a fishpole:

▶ With a fishpole, it is especially important that you check the reach of the microphone cable. Because you have to concentrate on the position of the mic during the pickup, you will not be able to monitor the cable at the same time.

8.13

SHORT FISHPOLE USED FROM ABOVE

The short fishpole is normally held high and dipped into the scene as needed.

8.14

SHORT FISHPOLE USED FROM BELOW

The short fishpole can also be held low with the mic pointed up for good sound pickup.

8.15

LONG FISHPOLE

The long fishpole can be anchored in the belt and raised and lowered much like an actual fishing pole.

▶ Make sure that the cable is properly fastened to the pole and that it does not tug on the microphone.

▶ If the performers walk while speaking, you need to walk with them, holding the mic in front of them. If the camera shoots straight on (along the z-axis), you need to walk slightly ahead and to the side of them, holding the mic in front of them. If the blocking is lateral (from one side of the screen to the other along the x-axis), you need to stay in front of them, walking backward. Because your eyes are glued to the performers and the mic, you need to be careful not to bump into obstacles on the way. Rehearse the walk a few times before the actual take. If possible, have a floor person guide you during the take.

▶ If you operate a long fishpole, anchor it in your belt and raise and lower it into the scene as needed.

HANDHELD SHOTGUN MICROPHONE

The shotgun mic should be held only by its shock mount. When used outdoors, the windscreen is a must.

▷ Always wear headsets so that you can hear what the mic is picking up (including unwanted sounds, such as the whirl of a helicopter during your Civil War scene). Listen especially for the low rumble of wind, which is easy to miss when concentrating on dialogue.

Handholding the shotgun mic is as simple as it is effective. You become the boom, and a very flexible one at that. The advantage of holding the shotgun mic is that you can walk up to the scene as close as the camera allows, moving and aiming the mic quickly and easily in various directions. **SEE 8.16** Some audio people insist on covering the handheld shotgun with a windscreen even if shooting indoors, but it is a must when shooting outdoors. Hold the microphone only by its shock mount—never directly. This minimizes the handling noises and also prevents covering up the microphone *ports*—the openings in the mic barrel that keep the mic directional.

Desk and stand microphones *Desk microphones* are hand mics fastened to a small stand. You use them for panel shows, public hearings, speeches, or news conferences. Because the people using them are usually more concerned with what they say than with quality audio, they frequently (and unintentionally) bang on the table or kick it while moving in their chairs, and sometimes even turn away from the microphone while speaking. Considering all these hazards, which microphones would you suggest for a desk mic? If you suggested an omnidirectional dynamic mic, you are right. This type of microphone is best suited to handle abuse. If you need more precise sound separation, you should use a unidirectional dynamic mic.

When placing the microphones, you can use a single mic for each performer or to serve two people simultaneously. Because microphones can cancel each

8.17

SETUP FOR MULTIPLE DESK MICROPHONES

When using several desk mics for a panel show, place the microphones at least three times as far apart as any mic is from its user.

other's frequencies when positioned too close together, you should place the individual mics at least *three times as far apart as any mic is from its user.* **SEE 8.17**

Despite your careful placement of the multiple desk mics, you will notice that inexperienced—and even experienced—users sometimes feel compelled to grab the desk mic and pull it toward them as soon as they are seated. To save your nerves and optimize sound pickup, simply tape the microphone stands to the table.

Stand mics are hand microphones that are clipped onto a sturdy microphone stand. They are used for singers, speakers, musical instruments, or any other sound source that has a fixed position. The quality of mics used on stands ranges from rugged dynamic mics for news conferences or speeches to high-quality microphones for singers and instrumental pickups.

For some performers, such as rock singers, the microphone stand serves as an important prop. They tilt it back and forth, hold themselves up by it, lift it, and even swing it through the air like a sword fighter (not recommended, by the way—especially if the microphone is still attached to it).

When setting up a stand microphone for a singer with an acoustic guitar, a single stand may support two microphones: one at the midpoint for the pickup of the guitar, and another at the top for the voice pickup. The 3:1 spacing rule of placing multiple desk mics also applies to this situation.

Headset microphones Sportscasters and other performers who are primarily announcing an event often use a headset microphone. **SEE 8.18** This type of

8.18

HEADSET MICROPHONE

The headset mic is a good-quality microphone attached to earphones. The earphones carry a split audio feed, with one earphone carrying the program sound and the other carrying instructions from various production people.

Mic

mic basically consists of an earphone headset with a good-quality microphone. The earphones can carry a split audio feed, which means that the talent can hear the program sound (including his or her own voice) in one ear, and special instructions from various production people in the other.

Wireless, or radio, microphones *Wireless microphones* are also called *radio mics* because they actually broadcast the audio signal from the microphone to a small receiver, which in turn is connected to the mixer or audio console.

The most popular wireless microphones are hand mics used by singers. These high-quality microphones have a small transmitter and antenna built into their housing. **SEE 8.19** The performer is totally unrestricted and can move about without having to worry about a microphone cable. The wireless microphone receiver is connected by cable to the audio console for sound control and mixing. Because each wireless mic has its own unique frequency, you can use several wireless mics simultaneously without signal interference.

Another popular wireless (or radio) mic is the wireless lavaliere. The wireless lavaliere is often used in EFP, and especially in sports. For example, if you are asked to pick up the groans of a bicycler during a race, or the breathing of a skier and the chatter of the skis during a downhill race, a wireless lavaliere is the obvious choice. Also, wireless lavaliere mics are sometimes used for dramatic studio productions instead of the boom microphone.

The wireless lavaliere microphone is plugged into a small transmitter that is worn by the talent. Normally, you simply tape the transmitter to the body and string the antenna along the pants, skirt, or shirt sleeve or around the waist of the performer. The receiver is similar to that used with wireless hand microphones. Actually, any microphone can become a semiwireless mic by plugging it into a special transmitter and plugging its receiver into the audio console.

Unfortunately, wireless mics are not without problems, especially when used outdoors. The signal pickup depends on where the talent is relative to the transmitter. If the talent walks beyond the transmitter's reach, the signal will first become intermittent, and then be lost. Also, if the talent moves behind a tall building, or if near high-voltage lines, X-ray machines, or strong radio transmitters, the audio may get distorted or totally overpowered by the extraneous signals. Even the talent's perspiration can influence the transmitter and reduce signal strength. Although your wireless equipment has an assigned frequency that is purposely different from police and fire transmissions, you may occasionally receive a police or fire call instead of your talent's comments.

8.19

WIRELESS HAND MICROPHONE WITH RECEIVER

The wireless hand mic has a small transmitter and antenna built into its housing. The sound signal is picked up by a small receiver and transported by cable to the audio console.

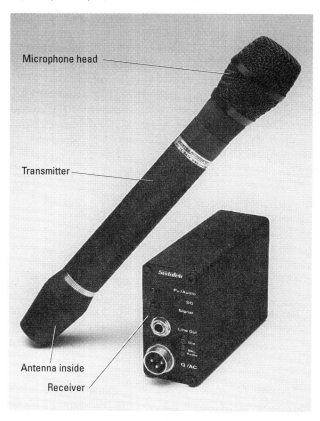

Microphone head

Transmitter

Antenna inside

Receiver

KEY CONCEPT 5 **Wireless, or radio, microphones are subject to interference when used outdoors.**

The microphone table below gives an overview of some of the most popular microphones. Realize, however, that new microphones are developed all the time, and that the model numbers change accordingly. **SEE 8.20**

8.20

TABLE OF MICROPHONES

MICROPHONE	TYPE AND PICKUP PATTERN	USE
Sennheiser MKH-70	Condenser Supercardioid	Studio boom, fishpole. Good for EFP and sports.
Electro-Voice RE-50	Dynamic Omnidirectional	Rugged hand mic. Good for all-weather ENG.
Electro-Voice RE-16	Dynamic Supercardioid	All-purpose hand mic. Good outdoors (ENG/EFP).
Shure SM 58	Dynamic Cardioid	Hand mic for singer. Crisp, lively sound.
Beyer Dynamic M 500	Ribbon Hypercardioid	Hand mic for singer. Warm sound.
Sony ECM-55	Condenser Omnidirectional	Lavaliere. Good voice pickup. Good studio mic.
Sony ECM-77	Condenser Omnidirectional	Lavaliere. Good voice pickup. Mixes well with boom mics.
Professional Sound Corp. PSC MilliMic	Condenser Omnidirectional	Extremely small lavaliere mic. Mostly used as concealed mic.

SOUND CONTROL

When you use your small camcorder to record a friend's birthday party, you are probably quite unconcerned about the various steps of audio control. All you need to do is make sure that the built-in microphone is turned on and is in the *AGC* (automatic gain control) mode. The AGC automatically adjusts the volume of the various sounds to normal levels—no need for any volume adjustment on your part. But if the audio requirement gets more demanding, such as controlling the volume during an interview or mixing two or more sound sources, you need to use special audio control equipment. This consists of (1) the audio mixer, (2) the audio console, and (3) the patch panel.

The Audio Mixer

The *audio mixer* amplifies the weak signals that come from the microphones and/or other sound sources. It lets you control the sound *volume* and *mix* (combine) two or more sounds. Actually, what you control and mix are not the sounds themselves but the signals, which are then translated back into actual sounds by the loudspeaker.

A normal monophonic audio mixer has three or four *inputs* (for instance, microphones, cassette recorders, videotape) and one *output* of the manipulated signal. A stereo mixer has two outputs, one for the left channel and another for the right. There is a rotary *pot* (for *potentiometer*), also called a *fader,* for each input; one *master pot* or *fader* (two for stereo mixers); and a monitor *jack* (outlet) for your earphones so that you can hear the outgoing signal. A *VU meter* (which measures volume units) helps you visually monitor the volume of each incoming source and the final *line-out* signal that leaves the mixer. **SEE 8.21**

8.21

AUDIO MIXER

The audio mixer allows you to control the volume of a limited number of sound inputs and mix them into a single output signal.

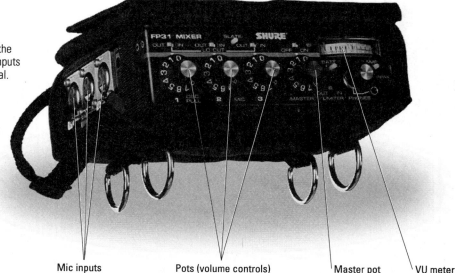

Mic inputs Pots (volume controls) Master pot VU meter

8.22

VOLUME UNIT (VU) METER

The VU meter indicates the relative loudness of sound. The scale is given in volume units, ranging from –20 to +3 (upper scale), and percentages, ranging from 0 to 100 (lower scale).

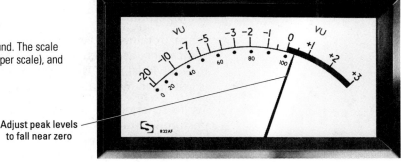

Adjust peak levels to fall near zero

Controlling the volume Controlling sound volume—or, as it is often called, *riding the gain*—is not only to make weak sounds louder and loud sounds softer, but also to keep the sounds to a level where they do not get distorted. To increase the loudness of a sound, you turn the pot *clockwise* or *push* the horizontal fader up, away from you. To reduce the sound volume, you turn a pot *counterclockwise*, or *pull* the fader down, toward you. The VU meter accurately reflects your gain adjustment by oscillating along a calibrated scale. **SEE 8.22**

If the volume is very low and the needle barely moves from the extreme left, you are riding the audio "in the mud." When loud sounds make the needle hit the right side of the meter, you are "bending the needle" and should turn the volume down in order to avoid sound distortion. Always try to have the needle move between 60 and 100 percent of the lower scale (or –5 and 0 on the upper scale). Don't worry if the needle spills occasionally into the red zone, but keep it from oscillating entirely in this overload zone. When working with digital audio, you need to keep especially close watch on proper audio levels. Overloading the volume not only results in distorted sound but adds considerable noise to your recording.

Some larger audio consoles have VU meters with LED (light-emitting diode) displays instead of oscillating needles, or meters that react to various aspects of loudness. All of them will visually indicate whether you have sound coming through and how loud the sound is relative to a given volume scale.

Live field mixing *Mixing* means combining two or more sounds. You don't need a mixer if you simply interview somebody in the field. You plug the interviewer's hand mic into the appropriate input on your camcorder, turn on the camera mic for ambience, and start your recording. But if you have a complicated audio assignment that requires more than two inputs or more exact volume control for all inputs than the AGC or the pots on the camcorder can give you, a small mixer will come in quite handy.

The following guidelines may help you in coping with some of the field mixing tasks:

- Even if you have only a few inputs, label each one for what it controls: mic for the host and guest, audio track of the portable videotape recorder, and so forth.

- Double-check all inputs from wireless microphone systems. For some reason, they have a habit of malfunctioning just before the start of an event.

▷ Always put a test tone at zero VU (100 percent) on the videotape before the actual recording.

▷ When working a mixer, you should adjust the volume of each incoming source first, and then set the master gain somewhat below the setting for the individual pots. The lower setting will minimize the inevitable hiss that is generated by sound amplification.

▷ Try to separate the inputs as much as possible. If you record sound for postproduction on an audiotape, try to put distinctly different sound sources on separate audio tracks. Even when recording sound on videotape, try to keep the major sound source on one track and the environmental sounds on the other. You can then mix the two sounds more carefully in the audio production room.

▷ If you have to do a complicated sound pickup in the field, protect yourself by feeding it not only to the VTR machine but also to a separate audiotape recorder as well.

The Audio Console

Although large audio consoles are rarely used for simple video productions, they are standard equipment in the audio control rooms and audio production rooms of television stations and major postproduction houses. The many buttons and levers of a large audio console look like some exotic control panel in a science-fiction spaceship, but there is no reason to be intimidated; even the largest of audio consoles operates similarly to the small mixers. Like the mixer, the audio console has inputs, volume controls, loudness meters, mixing circuits, and outputs for the manipulated signal. Unlike the mixer, the console has *slide faders* instead of rotary pots, and a variety of additional *quality controls* as well as *assignment* and *on/off switches*.

The reason the console is relatively large is that, instead of the four inputs of the small mixer, the audio console may have twenty-four or more. Each input has a separate slide fader, VU meter or some other loudness meter, and an array of quality controls and switches. The console has additional subgroup faders that control the mix of various inputs before it gets to the master fader, and two master faders that control the two channels of the outgoing stereo signal. **SEE 8.23**

An audio console lets you control the volume of all inputs, mix some or all of the input signals in various ways, and manipulate the quality of each sound and of the final mix. For instance, with the quality controls you can add reverberation (echo) to the incoming sounds; eliminate unwanted frequencies, such as a hum or squeal; boost or attenuate (reduce) the high, middle, or low frequencies of each sound; and move a sound to a specific horizontal position between the two stereo speakers. The switches allow you to turn off all other inputs except the one you want to hear. You can also group some inputs together into subgroups that can then be further mixed with other inputs or subgroups. The computer plays an important role in all of this. It helps you keep track of the various controls and activates some of the controlling equipment.

Why so many inputs? Because even a simple six-person panel discussion may use up to nine inputs: six inputs for the microphones (assuming that each panel

8.23

AUDIO CONSOLE

The audio console has many inputs (twenty-four for large video productions), each of which has its own slide fader volume control, a variety of quality controls, various on/off and assignment switches, and a volume meter.

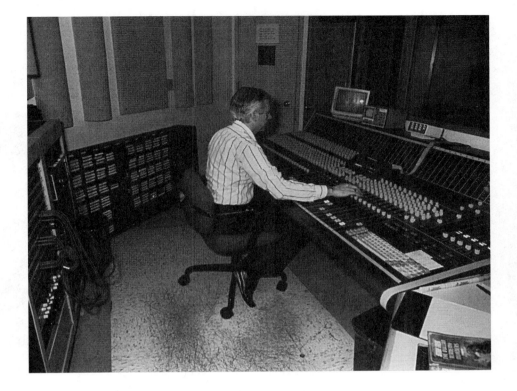

member has his or her own microphone), one input for the audio cassette that contains the opening and closing theme music, and two further inputs for the two videotape recorders that play back program segments during the discussion.

Considering the many microphones and other sound equipment used in a rock concert, even twenty-four inputs seem rather modest. Professional recording studios have even larger consoles. To ensure maximum flexibility, such consoles have a separate output for each input and are appropriately called *I/O* (input/output) *consoles.*

Cables and Patch Panel

Audio cables provide an essential link among the sound sources and the audio console or other recording equipment, such as the videotape recorder. Because a cable does not have any moving parts or complicated circuitry, we tend to consider it indestructible. Nothing could be farther from the truth. An audio cable, especially at the connectors, is quite vulnerable and must be treated with care. Avoid kinking it, stepping on it, or rolling a camera pedestal over it. Even if you have a perfectly good cable, it may pick up electrical interference from lighting instruments and produce a hum in the audio—another reason for checking out the audio system before the director calls for a rehearsal.

Another potential problem comes from the various connectors that terminate the cables. All professional microphones and camcorders use cables with three-

8.24

XLR CONNECTORS

All professional microphones and three-wire cables use
XLR connectors.

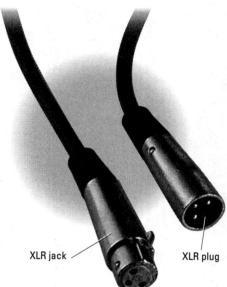

XLR jack XLR plug

8.25

AUDIO PLUGS

Besides the XLR connector, audio plugs include the phone plug,
RCA phono plug, and the mini plug. Many small consumer camcorders
use the mini plug.

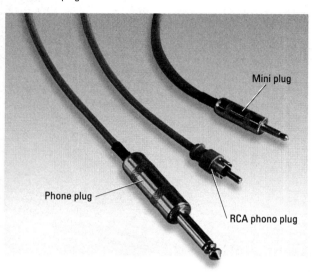

Mini plug

Phone plug

RCA phono plug

conductor *XLR connectors*. **SEE 8.24** You may remember that the salesperson pointed out the high quality of your camcorder by saying that it had, among other sterling features, an "XLR connector." As you now know, he was not kidding you. The XLR jack (input plug) on your camera means that you can use any professional audio cable to connect quality microphones to your camcorder.

Most consumer microphones and camcorders use the smaller *RCA phono plug* or the *mini plug*. Some audio cables terminate with the larger *phone plug*. **SEE 8.25**

Adapters are available that make it possible for you to hook up cables with different connectors. Although you should have such connectors readily available, try to avoid them as much as possible. An adapter is, at best, a makeshift solution and is always a potential trouble spot.

 KEY CONCEPT 6 **Make sure that your connectors fit the microphone output and the inputs at the other end (such as camcorder, mixer, or some recording device).**

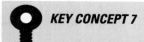 *KEY CONCEPT 7* **Keep your cable connections and adapters to a minimum; each one is a potential trouble spot.**

8.26

PATCHING

The four audio sources (lav 1, audio cassette, videotape playback, lav 2) are rerouted through patching (lav 1, lav 2, videotape playback, audio cassette).

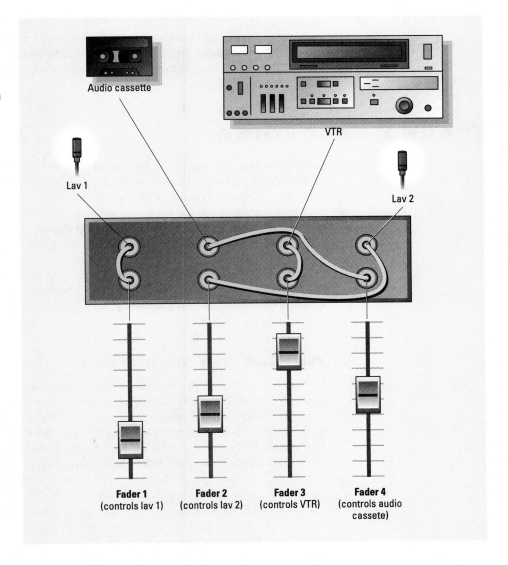

Audio cassette

VTR

Lav 1

Lav 2

Fader 1
(controls lav 1)

Fader 2
(controls lav 2)

Fader 3
(controls VTR)

Fader 4
(controls audio cassete)

Patching will make your life easier by bringing the various sound inputs (microphones, cassette players, remote inputs, audio tracks of videotape recorders) into a desired order on the audio console. For instance, if your various audio sources appear in widely dispersed faders on your audio console (such as the lavaliere mic of the interviewer at fader 1, the audio cassette in fader 2, the video playback in fader 3, and the second lavaliere mic in fader 4), you may want to move the two lavaliere mics to adjacent faders, with the video playback in position 3 and the audio cassette in position 4. Rather than changing the cables to different inputs, you simply patch these sound sources so that they appear in the desired order at the console.

Patching can be done in two ways. The old way is to physically connect the incoming signals (called *outputs* because they are carrying the audio signals that are to be connected with the audio console) to the various faders on the audio console (called *inputs*). **SEE 8.26** The new way is to have a computer take over the

signal routing, which will accomplish the same task faster and without many additional cables and connectors. Some of the more common connections are hardwired, which in audio lingo is called *normaled*. A normaled circuit does not have to be patched; but you may need a special patch to undo the hardwired connection.

SOUND RECORDING

In most of your video productions, your sound will be recorded on the audio tracks of the videotape simultaneously with the video (see chapter 9). However, some more ambitious projects require *audio postproduction*, which means that you try to eliminate some of the unwanted sounds or add something to the existing audio track on the videotape. This process is called **sweetening**. In audio postproduction, you can also create an entirely new audio track and add it to the video that has already been shot and edited.

The minimal equipment for using recorded sound during the production or for audio postproduction includes (1) an audiotape recorder, (2) cartridge and cassette machines, (3) compact disc players, and (4) a computer system with audio synchronization capabilities.

Audiotape Recorder

For home use, the reel-to-reel *audiotape recorder (ATR)* is almost extinct. Even for most professional applications—such as audio-recording interviews—small, highly portable cassette machines are preferred. Yet in the recording studio and the audio postproduction room of television stations and video postproduction houses, the reel-to-reel ATR is very much alive. Despite the great variety of ATRs available, they all operate on the same principle. The magnetic tape (in widths of ¼-inch, ½-inch, 1-inch, and 2-inch) moves from a *supply reel* to a *takeup reel* over at least three *heads:* the erase head, the record head, and the playback head. **SEE 8.27** When using the ATR for recording, the erase head clears the track that receives the recording of all material so that the record head can put the new audio on a clean tape. The playback head will then play the recorded material back for you. In the playback mode, the erase head and recording heads are not activated.

The audio signal is either recorded in *analog* or *digital* form. Analog ATRs record the amplified signals the way the microphone hears them. Digital audiotape

8.27

REEL-TO-REEL AUDIOTAPE RECORDER

In a reel-to-reel audiotape recorder, the tape moves from a supply reel over the head assembly to the takeup reel.

Erase head Record head Playback head

recorders select a great many tiny portions from the continually changing analog signal—a process called *sampling*—and translate these samples into corresponding digital on/off pulses. These digital audio recorders are called *DAT* recorders, which stands for digital audiotape.

Multitrack machines Simple stereo audiotape recorders use only two tracks, one for the left channel and the other for the right channel on a ¼-inch tape. More complex recorders have twenty-four or even more tracks on a 2-inch tape. Because each track needs its own erase, record, and playback head, the twenty-four-track recorder has, indeed, twenty-four of each in the head assembly. Additionally, each track requires its own VU meter so you can see whether the sound is within its volume limits. This means that there are twenty-four VU meters in our twenty-four-channel ATR. **SEE 8.28** DAT recorders can comfortably accommodate thirty tracks on a 1-inch tape.

Operational controls Despite their great variety, all ATR and DAT machines have the same five operational controls: (1) record, (2) play, (3) stop, (4) rewind, and (5) fast forward. **SEE 8.29**

8.28

TWENTY-FOUR-
CHANNEL ATR

This twenty-four-channel audiotape recorder uses a 2-inch-wide audiotape to accommodate the twenty-four separate audio tracks. Each channel has its own erase head, record head, playback head, and VU meter.

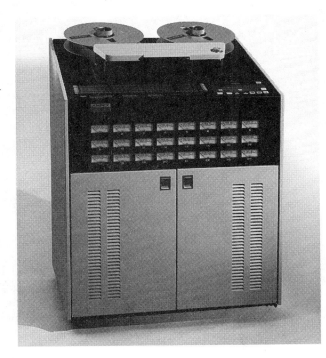

8.29

OPERATIONAL CONTROLS ON
AUDIOTAPE RECORDER

The standard operational controls on audiotape recorders are record, play, stop, rewind, and fast forward.

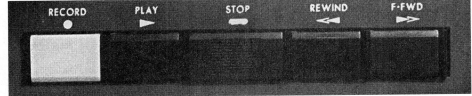

AUDIO CARTRIDGE

The audio cartridge has a single ¼-inch tape reel that can play back audio portions with an instant start.

Cartridge Machine

Cartridge machines can record and play back relatively brief audio segments, such as short ten-second announcements, musical bridges, or brief news items. Some longer cartridges can play back for up to forty minutes. The cartridge, or "cart," machines have an instant start, which means that they play back the audio as soon as you press the play button and cue themselves to the start of each segment. Because they operate with an endless tape loop, there is no rewinding necessary. **SEE 8.30** Some machines can hold several (ten or more) carts of different lengths.

Audio Cassette System

The audio cassette has two small reels encased in a plastic housing. One of the reels acts as the supply reel, the other the takeup reel. When the cassette is switched from its "A" side to the "B" side, the takeup reel becomes the supply reel and the supply reel the takeup reel. **SEE 8.31**

The major advantages of the cassette system over the cartridge system are that the cassette is smaller, it can hold more continuous information (up to 180 minutes for some special cassettes), and the recorders are much more portable than cartridge machines.

Compact Disc

The compact disc uses a laser beam for optically sensing the digital information that is compacted on a small (about 5-inch) shiny disc. The advantage of the CD is that it reproduces almost noise-free sound, assuming that the recording was relatively noise-free in the first place. A highly accurate LED read-out system, which

8.31

AUDIO CASSETTE

The audio cassette has two small reels, which serve as supply and takeup reels for the ⅛-inch tape. Machines for voice recording may use even smaller cassettes.

8.32

CD PLAYER

The CD player is a read-only device that cannot be used for recordings. It uses a laser light beam to retrieve the digital sound information from the disc.

functions much like a counter, allows you to select a precise starting point, regardless of how deep the segment may be buried in the disc. **SEE 8.32**

Because the sound on the CD is sensed by a light beam rather than a physical device (such as the needle of the old turntables), you can play the CD over and over again without any deterioration of the sound or the disc. However, you must treat the disc as carefully as the old records. Because the information is greatly compressed on a CD (hence its name), even a slight scratch or nick will do considerable damage to the recording. The disadvantage is that, like the old LP records, it is a read-only device; you cannot record your own material on it.

Computer System and Audio Synchronization

The computer is not only helpful in remembering and activating certain mixing functions, but also in sound editing. For editing, the computer takes information from the videotape or any other sound recording device and stores it on a hard drive. Because the sound is stored in digital form, it can be made visible. Assuming

8.33

COMPUTER DISPLAY OF DIGITAL SOUND

The computer can translate digital sound into a visible pattern. The audio screen display makes extremely precise sound editing possible.

that your computer has some small speakers attached to it, you can now hear the sound as well as see it displayed in some form on the computer screen. **SEE 8.33**

Once you have learned to "read" the sound image, you can select certain sound portions with great precision and put them into the desired sequence. To match the new sound track with the video, the computer provides each video frame and the accompanying (very brief) sound portion with a corresponding "house number." The most widely used address system is called the *SMPTE time code* (see chapter 9). The time code reads out elapsed hours, minutes, seconds, and frames (thirty frames per second), keeps both audiotape and videotape recorders running at exactly the same speed, locates specific "addresses" (frames), and ensures that the right sound portion is matched with each corresponding video frame. This process is called *audio synchronization.*

SYNTHESIZED SOUND

The computer can also be used to grab brief portions of a regular sound, such as a telephone ring, translate it into digital form, store it, and make it available for all sorts of manipulations. Through a specific digital device, called a *sampler*, or with the help of specific *sampling software* for your computer, you can now repeat the telephone ring as often as you want, transform it into a shrill beat, speed it up or slow it down, play it backward, have it overlap, or distort it in any other way so that you can no longer tell its origin.

Now, if we can translate sounds into digital information and manipulate it, could we not have the computer create digital information that can be translated into actual sounds? Yes. The computer, or a specialized *audio synthesizer*, commonly called a *keyboard*, can generate a great variety of complex frequencies that we perceive as sounds produced by various instruments. A single key can give you the sound of a piano, electric or acoustic guitar, organ, or trumpet. A synthesizer, which you can easily carry under your arm, offers you more sounds than a large rock band and symphony orchestra combined. **SEE 8.34**

8.34

ELECTRONIC KEYBOARD

The electronic keyboard is a sound synthesizer that can simulate a variety of instruments and drum beats.

KEY CONCEPT 8 **Sounds and sound mixes can be entirely computer-generated.**

SOUND AESTHETICS

Even the most sophisticated digital sound equipment is of little use if you cannot use your ears—that is, exercise some aesthetic judgment. Sounds can make us feel about pictures in a certain way. You can make the very same scene appear happy or sad by simply putting some happy or sad sounds behind it.

There are five basic aesthetic factors that can help you achieve an effective audio/video relationship: (1) environment, (2) figure-ground, (3) perspective, (4) continuity, and (5) energy.

Environment

In most studio sound-recording sessions, we try to eliminate as much of the background (ambient) sounds as possible. In the field, however, we find that the ambient sounds are often as important as the principal ones. Here, ambient sounds help establish the general environment of the event. If you shoot a scene at a busy downtown intersection, the sounds of cars, car horns, streetcars and buses, people talking, laughing, and moving about, the doorman's whistle for a taxi, and the occasional police siren are important clues to where you are, even if you don't show all these events in your video portion.

Or think of recording a small orchestra. If you do a studio recording, the coughing of one of the crew members or musicians during an especially soft passage would certainly prompt a retake. Not so in a live concert. We have learned to interpret the occasional coughing and other such environmental sounds as proof of the aliveness of the event.

As pointed out previously, in normal field recording you should try to use one mic and audio track for the main sound source, such as a reporter standing at the busy street corner, and another mic (usually the one attached to the camcorder) and the second audio track of your videotape for recording environmental sounds. Separating the sounds on different tracks makes it easier for you to mix the two sounds in the proper proportion later in postproduction editing.

Figure-Ground

One important perceptual factor is the *figure-ground* principle. This means that we tend to organize our environment into a relatively mobile figure (a person, a car) and a relatively stable background (wall, houses, mountains). If we now expand this principle a little, we can say that we can single out an event that is important to us and assign it the role of the figure, while relegating all other events to the background or, as we just called it, the *environment*.

For example, if you are looking for somebody and finally discover her in a crowd of people, that person immediately becomes the focus of your attention—the foreground—while the rest of the people become the background. The same happens with sound. We have the ability to perceive, within limits, the sounds we want or need to hear as the figure, while pushing all other sounds into the background. When re-creating such a figure-ground relationship with sound, we usually make the "figure" somewhat louder or give it a distinct quality in relation to the background sounds. In the same way, we can easily bring a background sound up in volume to become the figure and relegate the other sounds to the ground.

As you can see, separating the principal sound source (the figure) from the ambient sounds (ground) during recording gives you more flexibility in postproduction to emphasize the figure-ground relationship.

 KEY CONCEPT 9 **The figure-ground principle in sound means to make a specific sound or group of sounds (figure) louder and more distinct than the background sounds.**

Perspective

Sound perspective means that close-up pictures are matched with relatively "close" sounds, and long shots are matched with sounds that seem to come from farther away. Close sounds have more presence than far sounds—a sound quality that makes us feel as though we are near the sound source. Far sounds seem to be more distant from us.

This desirable variation of sound presence is virtually eliminated when using lavaliere mics. Because the distance between mic and mouth remains the same, regardless of whether the performer is seen in a close-up or a long shot, the sound has the same presence. This is why you should use boom mics when such sound presence is important. The boom mic can be moved quite close to an actor or performer during a close-up and somewhat farther away during a long shot—a simple solution to a potentially big problem.

KEY CONCEPT 10 **Close-ups need more sound presence than long shots.**

Continuity

Sound continuity is especially important in postproduction. You may have noticed the sound quality of a reporter's voice change depending on whether he or she was speaking on- or off-camera. In this case, the reporter used one type of microphone when on-camera, and another when off-camera. Also, the reporter changed environments from on-location to the studio. This change in microphones and locations gives speech a distinctly different quality. Although this difference may not be too noticeable when you are doing the actual recording, it becomes amazingly apparent when the audio is edited together in the final show.

What should you do to avoid such continuity problems? Use identical microphones for the on- and off-camera narration and, if necessary, mix the off-camera narration with some of the separately recorded ambient sounds. You can feed the ambient sounds to the reporter through earphones while he or she is doing the voice-over narration, which will help the reporter to re-create the on-site energy.

Sound is also one of the chief elements for establishing visual continuity. A rhythmically precise piece of music can help a series of pictures, which otherwise do not cut together very well, achieve continuity. Music and sound are often the important connecting link between abruptly changing shots and scenes.

 KEY CONCEPT 11 **Sound is an important factor in providing shot continuity.**

Energy

Good audio depends a great deal on your ability to sense the general energy of video sequences and to adjust the volume and presence of the sound accordingly. No volume meter in the world can substitute for your aesthetic judgment. Unless you want to achieve a special effect through contradiction, you should match the general energy of the pictures with a similar energy of sound. *Energy* refers to all the factors in a scene that communicate a certain degree of aesthetic force and power. Obviously, high-energy scenes, such as a series of close-ups of a rock band in action, can stand higher-energy sounds than a more tranquil scene, such as lovers walking through a field of flowers. Also, as you have just learned, close-ups should have more sound presence and energy than long shots.

 KEY CONCEPT 12 **High-energy pictures should be matched with high-energy sounds; low-energy pictures, with low-energy sounds.**

Although you might not be quite ready to place the microphones and work a large audio console for the complicated videotaping of a rock concert, you are certainly qualified to undertake somewhat simpler audio jobs, such as placing the mics for an interview or panel show and watching the audio levels during the performance. In any case, the Triple-I people will certainly be pleased by your understanding of the importance of sound in video production and your knowledge of various audio equipment and aesthetic requirements.

Sound Pickup Principle

Microphones transduce (transform) the sounds we hear into electric energy—the audio signal.

Microphones

Microphones are classified by how well they can hear (their directional pickup characteristics), how they are made, and how they are used.

Directional Characteristics

Omnidirectional mics can hear equally well from all directions; bidirectional mics can best hear sounds that come from opposite sides; unidirectional, or cardioid, mics can best hear sounds that come from the front.

Mechanics

Classified by how they are made, there are three types of mics: (1) dynamic (the most rugged), (2) condenser (high-quality but sensitive), and (3) ribbon (high-quality but very sensitive).

Use

Classified by how they are used, there are four types of mics: (1) small lavaliere microphones, clipped onto the clothing of the performer; (2) hand mics, which are carried by the performer; (3) boom mics, which are suspended from a small fishpole or large studio boom; and (4) desk and stand mics, which are mounted on a small desk stand or fairly heavy adjustable stand.

Audio Mixer and Console

The mixer amplifies the sound signals that come from microphones or other equipment, controls the volume of each sound, and mixes (combines and balances) them in specific ways. A mixer is small (it normally has four inputs) and is primarily used in the field. The audio console is much larger. It has many more inputs, each of which has a volume control and various quality and sound selection controls.

Sound Recording and Playback

High-quality reel-to-reel audiotape recorders (ATRs) use various tape widths, depending on the number of audio tracks recorded on them. Twenty-four-channel ATRs use a 2-inch tape. In video operation, cartridge machines and audio cassette recorders are used. Cartridge machines have instant starts but are more limited in playing time than cassettes.

Digital Recordings

Digital audiotape (DAT) recorders and CDs (compact discs) store audio information in digital form. The DAT recorder is a read/write machine, which can record and play back the audio signal, whereas the CD is read-only. Digital recordings are virtually noise-free.

■ **Synthesized Sound**

Once sounds are in digital form, the computer can manipulate the actual sounds, or create—synthesize—its own sounds. All sounds produced by the keyboard are synthesized.

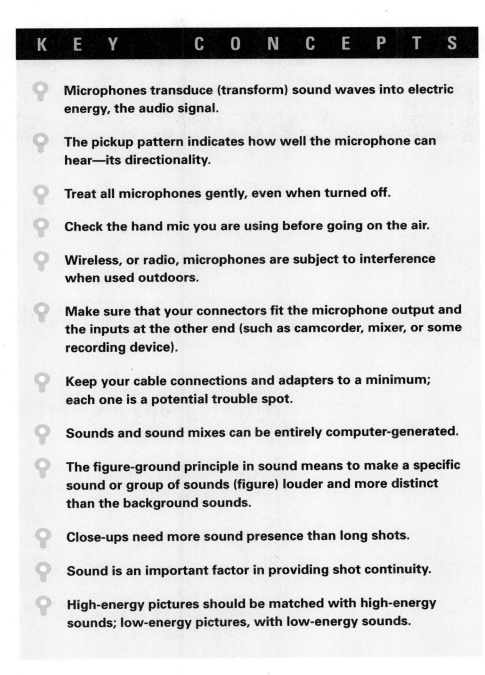

K E Y C O N C E P T S

- Microphones transduce (transform) sound waves into electric energy, the audio signal.

- The pickup pattern indicates how well the microphone can hear—its directionality.

- Treat all microphones gently, even when turned off.

- Check the hand mic you are using before going on the air.

- Wireless, or radio, microphones are subject to interference when used outdoors.

- Make sure that your connectors fit the microphone output and the inputs at the other end (such as camcorder, mixer, or some recording device).

- Keep your cable connections and adapters to a minimum; each one is a potential trouble spot.

- Sounds and sound mixes can be entirely computer-generated.

- The figure-ground principle in sound means to make a specific sound or group of sounds (figure) louder and more distinct than the background sounds.

- Close-ups need more sound presence than long shots.

- Sound is an important factor in providing shot continuity.

- High-energy pictures should be matched with high-energy sounds; low-energy pictures, with low-energy sounds.

P A R T **III**

C O N T E N T S

Video Recording, Storage, and Sequencing

EVERY time something goes wrong during a production, the Triple-I production people resort to the standard joke: "Don't worry, we'll fix it in post." But then they usually go back and do another take to fix whatever went wrong right then and there. Fixing even minor flaws in postproduction is usually difficult, time-consuming, and costly. Postproduction should not be seen as a convenient rescue operation for a sloppy production, but as an organic extension of the production process in which the various segments are given form and order. Postproduction is a time to build a program that has clarity and impact.

You probably recall that the Triple-I people asked you in the first interview to tell them how you would make a production sequence maximally effective and efficient. Because postproduction is usually the most time-consuming aspect of the whole production process, you can only fine-tune it by knowing the basics of video recording, storage, and sequencing. Part III deals with these processes, including chapters on the various video recording and storage systems, on editing principles, and on switching and post-production editing.

Video Track The area of the videotape used for recording the video information.

Audio Track The area of the videotape used for recording the audio information.

Control Track The area of the videotape used for recording the synchronization information.

Analog VTR System A videotape system that records the video signal in analog form.

Digital VTR System A videotape system that records the video and audio signals in digital form.

Composite System A system that combines the Y (black-and-white) and C (red, green, and blue) video information into a single signal. Also called *NTSC signal.*

NTSC Stands for National Television System Committee. Normally designates the composite video signal, consisting of combined chroma information (red, green, and blue signals) and the luminance information (black-and-white signal).

Component System Separating the Y and C components and treating the luminance and color as separate signals. Sometimes refers to the separate treatment of the RGB color signals. Also called the *Y/C system* or the *Y/C component system.*

RGB System A system in which all three color signals are kept separate throughout the video recording process. Sometimes called *RGB component system.*

Time Base Corrector (TBC) An electronic accessory to videotape recorders that helps to make playbacks or transfers electronically stable. It keeps slightly different scanning cycles in step.

Field Log A record of each take during the videotaping.

Nonlinear Storage System Storage of video and audio material in digital form on a hard drive or optical read/write disc. Each frame can be accessed by the computer independently of all others.

Interactive Video A computer-driven program that gives the viewer some control over what to see and how to see it. It is often used as a training device.

Multimedia The simultaneous computer display of text, still and moving images, and sound. Usually recorded on CD-ROMs.

Video Recording

YOU are desperate. The Triple-I people let you operate the videotape recorder for a rather complicated scene even though you have had little experience with videotape recording. Following the TD's instruction, you simply spot-check a few seconds of the tape to see whether you actually recorded the video and audio signals. The tape segments look good to you. But when you try to check the entire recording once again before delivering the tape to the videotape editor, you get nothing but distorted colors and images. The whole videotape seems to be ruined!

When you finally get enough nerve to tell the videotape editor the mysterious problem with your recording, she simply laughs and tells you not to worry. To calm you down, she plays a few seconds of your tape through her editing system. The recording looks beautiful. She tells you that you tried to play back a Y/C signal on an NTSC system, which, as you could see, does not work. What, exactly, is she talking about? All Triple-I postproduction people seem to have their own language. You hear them complain about a composite recording that should have been recorded in component form for extensive postproduction, or an RGB signal that needs three wires to be transported and, therefore, requires an entirely new editing system.

This chapter will help you understand this postproduction lingo and further inform you about—

▨ **VIDEOTAPE RECORDING SYSTEMS**
Various recording systems and recorders

▨ **VIDEOTAPE RECORDING PROCESS**
The necessary checklists: before, during, and after

▨ **NONLINEAR STORAGE SYSTEMS**
Computer disks, image storage systems, and CD-ROM

▨ **USE OF VIDEO RECORDING**
Interactive video and multimedia

VIDEOTAPE RECORDING SYSTEMS

All videotape recording systems operate on the same basic principle: the video and audio signals are recorded and stored in analog or digital form on magnetic tape and converted again into pictures and sound during playback. These systems vary greatly in how the signals are put on the videotape. Some videotape recorders, called *VTRs*, are designed for operational ease—for instance, the ones built into consumer camcorders or the popular VCRs (video cassette recorders). Others are designed for high-quality recordings whose pictures and sound will maintain their quality even after several dubbings during postproduction.

To make some sense out of the various systems, let's take a closer look at (1) basic videotape tracks, (2) analog and digital VTR systems, (3) composite, Y/C component, and RGB systems, (4) types of videotape recorders, (5) tape formats, and (6) the time base corrector.

Basic Videotape Tracks

All videotape recorders use separate tracks to record the video and audio, as well as various control data. Most videotape recorders put at least four tracks onto a videotape: the *video track* containing the picture information, two *audio tracks* containing all sound information, and a *control track* that controls the synchronization of the frames. **SEE 9.1**

 KEY CONCEPT 1 **Videotape recorders record video and audio signals and a variety of other information necessary for the proper operation of the tape and for the identification of each individual frame.**

To avoid a superfast tape travel when recording the high-frequency video signal onto videotape and to squeeze a maximum of information on the tape, all recorders move the tape as well as the video recording head or heads. In this way, the tape moves in a loop around a head drum, which contains the spinning video recording head or heads. **SEE 9.2**

Simple VCRs and camcorders use only one video head for recording and playback. More sophisticated models use separate spinning heads for recording and playback operations. You may remember the camcorder salesperson praising the "flying erase head" function of your camcorder. He meant that your videotape recorder did not have a stationary erase head, as you had seen in the audiotape head assembly, but that it was spinning with the video heads. The advantage of a "flying" erase head is that it can precisely erase each recorded frame without affecting the adjacent ones (remember, there are thirty frames for every second of video recording). As you will see, such precise erasure is an important prerequisite for stable edits.

The audio tracks—up to four high-fidelity digital tracks in the high-end digital VTRs—usually run lengthwise near the edges of the videotape. The control track, which also runs lengthwise, contains evenly spaced blips or spikes, called *sync pulses*, which keep the scanning in step, control the speed of the head drum, and mark each complete video frame—an important feature in videotape editing. **SEE 9.3**

9.1

BASIC VIDEOTAPE TRACK SYSTEM

The basic track system of a videotape consists of a slanted video track, two or more audio tracks, and a control track.

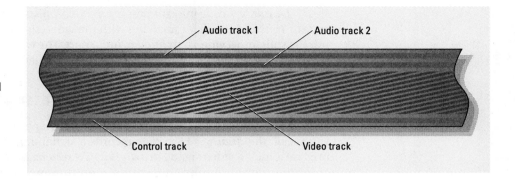

Audio track 1 Audio track 2

Control track Video track

9.2

VIDEO RECORDING HEAD

The videotape moves past the spinning head drum (or spinning heads inside the drum) at an angle, creating a slanted video track.

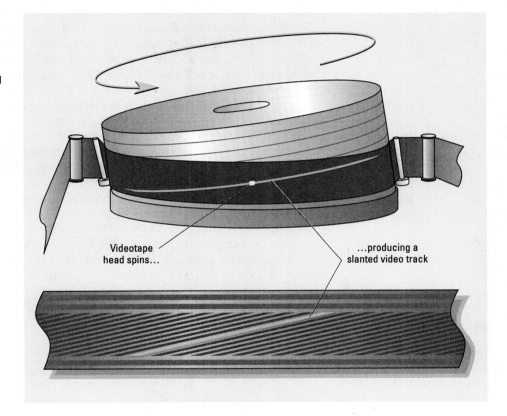

Videotape head spins... ...producing a slanted video track

9.3

CONTROL TRACK WITH SYNC PULSES

The control track consists of equally spaced sync pulses. Thirty such pulses indicate one second of video.

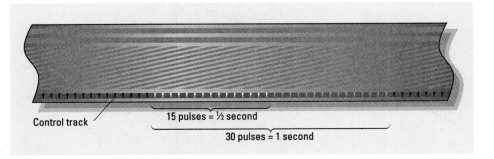

Control track

15 pulses = ½ second

30 pulses = 1 second

The *address code* information is recorded on still another track, the *address code* or *time code* track, or mixed in with the video signal. In the Hi8 system, each track is split into a video part and an audio part. The two parts are separated by the data area, which carries an address code. (See chapter 11 for more details.)

Analog and Digital VTR Systems

Video and audio signals can be recorded on videotape in analog or digital form. As you recall, the **analog VTR system** records a signal that *fluctuates* exactly like the original audio or video signal. In a **digital VTR system**, the original signal is sampled (selecting a great many essential parts of the signal) and changed into corresponding *on/off pulses*. The actual digital recording consists of a great number of binary digits. During playback, these digits are translated back into the continuous analog signal.

To remember the difference between analog and digital signals, you may want to visualize the analog signal as a ramp, which is a continuous way to reach a certain height. **SEE 9.4** The digital signal can be seen as a staircase, which consists of a number of discrete units (the steps) that will get you to the same destination. **SEE 9.5**

The great advantage of digital videotape recordings is that they do not deteriorate in quality even after many tape generations. A generation is one of a number of dubs (copies) away from the original. For example, the first generation dub is struck directly from the original; the second generation is two dubs away from the original. Some of the complex special effects we discussed in chapter 8 may necessitate as many as thirty generations.

With analog equipment, each subsequent generation amplifies the slight deterioration of the previous one, very much the way printed text deteriorates when you progressively duplicate photocopies. Even the best of analog equipment will show marked picture deterioration after a few generations.

When using digital videotape recorders, subsequent generations will produce pictures that are very close in quality to the original recording, an

9.4

ANALOG SIGNAL

The analog signal can be represented by a ramp, which leads continuously to a certain height.

9.5

DIGITAL SIGNAL

The digital signal can be represented by a staircase, which leads to a certain height in discrete steps.

attribute called *transparency*. The "on/off" pulses of the original digital recording can be accurately duplicated by computer, no matter how many times you do it. Some digital recording systems produce images that show little or no deterioration even after thirty generations.

Composite, Y/C Component, and RGB Systems

Composite, Y/C component, and RGB systems refer to how the video signals are transported inside, and recorded by, the videotape recorder. The *composite* system is the one used in normal video and broadcast television equipment. The *Y/C component* and the *RGB* systems are designed to produce higher picture quality than the composite system and to resist quick deterioration in multiple videotape generations.

Composite system The *composite system* uses a video signal that combines the color, or *C signal*, with the luminance (brightness), or *Y signal*. The RGB (red, green, blue) and grayscale information form a *single signal* that is transported inside and outside the VTR by a *single wire*. **SEE COLOR PLATE 10** This signal is also called the *NTSC signal*, or simply *NTSC*, because the configuration was adopted by the NTSC (National Television System Committee) as the standard for all normal video and broadcast television equipment. The advantage of this system is that regardless of the relative electronic sophistication of the VTR, or tape format (width) used, it can be used with other composite equipment, such as monitors or switchers. For instance, you can use the same monitor for displaying images from a top-of-the-line digital VTR or from a consumer VCR, so long as all operate with the composite (NTSC) system.

Not all countries in the world use the NTSC system. Many nations have standardized on other systems (such as PAL or SECAM), which are not compatible with the NTSC system. For instance, in order to play a videotape from Italy, which uses the PAL system, you need a standards converter—an electronic device that changes other systems to NTSC.

The disadvantage of composite systems is that the picture quality of the original recording is not as high as with other systems and that the pictures deteriorate rather quickly in multiple generations, unless you use an expensive professional studio VTR. Also, because the color information and luminance are mixed into one signal, they sometimes interfere with each other, creating strange video patterns called *artifacts*.

Y/C component system You can probably tell now how this system works. The Y signal, which is the luminance (black-and-white) information of the video picture, and the C signal (the color information) are kept separate until they are recorded on videotape. During the playback, the two video channels (Y and C) are separated again. Some technicians call this separation *Y/C component*, or simply the ***component system***; others prefer to call it the *Y/C system*. In any case, you need *two wires* to transport the Y/C signal. **SEE COLOR PLATE 11**

The advantage of this separation is that it ensures higher picture quality for the original recording and subsequent generations. To preserve this advantage, you

need special recorders, video monitors, and editing equipment that are designed specifically to handle the separate Y/C signals. Some systems use two wires to transport their signals through the videotape recorder, but then combine the signals into one when put on tape; others keep the Y and C signals separate even during the recording. Because of this Y/C separation, you can play back standard VHS cassettes on SVHS (which stands for super-VHS) videotape recorders; but you cannot play SVHS cassettes on a standard VHS recorder.

RGB system The *RGB system* preserves the original RGB (red, green, blue) video signals throughout the recording process. They are even recorded as three separate signals on the videotape. As you might have guessed, this system needs *three wires* to transport the three signals in the videotape recorder and in all associated equipment. **SEE COLOR PLATE 12**

Because the three signals are kept separate throughout the recording process, it is also called *component*. Confused? Well, it is somewhat confusing, because the terminology is inconsistent. Although technically not quite correct, you may simply want to remember that the NTSC one-wire system is composite (all signals are mixed into one). All others, which separate luminance from color or the three individual color signals (RGB), are component.

As with the Y/C system, the RGB system requires special video monitors, switching, and editing equipment to accommodate the three separate video signals. For example, even if you have a high-quality normal (NTSC) videotape recorder and color monitor, you cannot play back anything that has been recorded on component equipment, which makes the whole component operation rather expensive. The advantage of using a component system is that it maintains a high picture quality even through many tape generations. It is therefore used when doing extensive postproduction, such as building complex effects. Of course, you must convert the various component signals back into the standard NTSC signal for distribution or broadcast.

KEY CONCEPT 2 **Videotapes recorded on Y/C component or RGB VTRs cannot be played back on similar composite (NTSC) equipment.**

Types of Videotape Recorders

To make matters even more confusing, each of the three systems (composite, Y/C component, RGB) uses various recording methods. (Refer to the table of the major *analog* VTRs commonly used.) **SEE 9.6**

As with analog recorders, *digital* VTRs come in different types and tape formats. Some digital VTRs are designed for docking with ENG/EFP cameras; others are larger high-quality recorders specifically designed for extensive post-production. **SEE 9.7** (Refer to the table on page 222 for characteristics of the various major digital VTRs.) **SEE 9.8**

If you want to replace a composite analog VTR with a composite digital one, you can simply unplug the analog VTR and connect the digital one to the very same

9.6

TYPES OF ANALOG VIDEOTAPE RECORDERS

TYPE	CHARACTERISTICS
1-inch VTR	Old reel-to-reel model. Uses 1-inch tape format. NTSC composite. High quality.
U-matic	Old ¾-inch cassette recorder. NTSC composite. Good quality, but bulky.
Betacam SP	Uses ½-inch videotape cassette. Y/C component. High quality.
MII (pronounced "M-two")	Uses ½-inch cassette. Y/C component. NTSC composite or Y/C component output. High quality.
SVHS	Uses ½-inch cassette. Y/C system signal transport, but composite when actually recorded on tape. Good-quality first generation. Can play back VHS cassettes.
VHS	Uses ½-inch cassette. NTSC composite. Quality not good enough for professional productions, but is extensively used in off-line postproduction (product not intended for final release). SVHS cassettes cannot be played back on VHS recorders.
Hi8	Uses 8mm cassette (a little more than ¼ inch). Y/C or composite output. High-quality first generation.

9.7

HALF-INCH DIGITAL VTR

This D-3 ½-inch VTR can record up to four hours of program on a single cassette, which can be dubbed for many generations without noticeable quality loss. The function display shows various videotape information and audio levels.

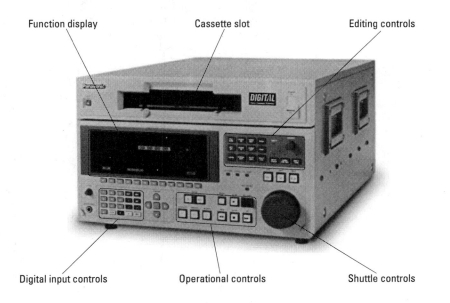

Function display Cassette slot Editing controls

Digital input controls Operational controls Shuttle controls

9.8

TYPES OF DIGITAL VIDEOTAPE RECORDERS

TYPE	CHARACTERISTICS
Digital Betacam	Uses ½-inch cassette. RGB component. Superior quality. Can be docked with ENG/EFP cameras.
D-1	Uses 1-inch reel-to-reel tape. RGB component. Superior quality through many generations.
D-2	Uses 19mm (about ¾-inch) cassette. NTSC composite. Superior recording quality. Excellent quality through many generations.
D-3	Uses ½-inch cassette. NTSC composite. Excellent recording quality. Can be docked with ENG/EFP cameras and used with standard NTSC equipment. Digital audio with compact-disc quality.
D-5	Uses ½-inch cassette. RGB component. Superior recording quality. Can be docked with ENG/EFP cameras. Can be used for extensive post-production without deterioration. Digital audio with compact-disc quality.

Note that there is no D-4. Rumor has it that the number 4, like our number 13, was skipped by the Japanese manufacturer because of superstition.

cables. All other equipment, such as monitors and switchers, will perform equally well with either machine. Not so with the Y/C component, or RGB digital (D-1, D-5) models, which need, as you already know, special component switchers, editors, and monitors that can handle the separate signals.

Tape Formats

Tape format refers to the *width* of the videotape. In the early days of videotape recording, the tape format was an important indicator of recording quality: the narrower the tape, the poorer the recording quality. Today, the *recording method* or videotape recorder *type*, rather than tape width, will tell you more accurately which is the highest-quality system. For example, the ½-inch Betacam SP or D-5 videotape recorders are better than the old 1-inch recorders; and the Hi8 system, which uses a tape width of 8mm (slightly more than ¼-inch), is definitely superior to the normal ½-inch VHS system.

Time Base Corrector

All but the top-of-the-line VTRs need additional picture stabilizing equipment to prevent jittery pictures or breakup. The ***time base corrector (TBC)*** helps to make videotape playbacks, dubs, or edits electronically stable by keeping slightly different scanning cycles in step. The digital *frame store synchronizer* performs a similar task and adjusts the sync from various video sources so that they all scan exactly alike. Switching from one source to another will not cause a temporary picture breakup or roll.

VIDEOTAPE RECORDING PROCESS

The relative ease with which we can operate a video cassette recorder may find us putting videotape recording at the bottom of our production priority list. Such an attitude often leads to disasters. Taking the wrong videotape cassettes on an EFP shoot is as serious a problem as forgetting the camcorders. Videotape recording requires careful preparation and meticulous attention to detail in the preproduction, production, and postproduction phases.

Like a pilot who goes through a checklist before every flight, you should establish your own "before, during, and after" VTR checklists. You will find that such checklists are especially helpful when doing field productions. The following lists include major production items only. You may need to adapt or add to these lists to meet your specific equipment and recording requirements.

THE "BEFORE" CHECKLIST

☑ **Schedule** Is the videotaping equipment actually available for the studio or field production? Most likely, your operation will have more than one type of VTR available. Which VTR do you need? Be reasonable in your request. You will find that the VTRs are usually available for the actual production or the remote shoot, but not always for your playback demands. If you need a VTR simply for reviewing the scenes shot on location, or for timing purposes, don't request a D-2 VTR, but have the material dubbed down to a regular ½-inch VHS format and watch it on your home VCR. Make sure that you request a VTR that can play back your videotapes. For example, if you shot your material with an SVHS camcorder, a regular VHS VCR will not produce acceptable images during playback. Likewise, the Betacam SP tape will not play back on an SVHS recorder.

☑ **VTR status** Does the VTR actually work? Always do a brief test recording and play it back before the actual videotaping. A simple head clog can put even the most expensive VTR out of service. You can detect dirty heads if the picture starts to become progressively noisy or even break up during playback. The heads in some VTRs can be cleaned by simply running a special head-cleaning tape for a while. Others need more direct cleaning procedures, which you had best leave to a professional.

☑ **Power supply** If you will use your VTR in the field, or if you use a camcorder, do you have enough batteries for the entire shoot? Are they fully charged? If you power your VTR, your camera, and perhaps even the camera light with the same battery, your recording time will be considerably less than if you run each of these pieces on separate batteries. If you use household current for your power supply, you will need the appropriate power adapter. Check whether the connectors of your power cable fit the plugs of your power supply and the camera. Don't try to make a connector fit if it isn't designed for your VTR. You may blow more than a fuse if you do.

☑ **Tape** Do you have the correct tape? Does the tape cassette match the type and format of your VTR? Although the difference between a ½-inch and an 8mm

tape is quite obvious, you may not see quite so readily the difference between a normal ½-inch VHS and a ½-inch digital cassette. Check whether the various boxes actually contain the correct tapes. Do not rely solely on the label of the box. Because cassettes can be loaded with various lengths of tape, look at the supply reel in the cassette to see whether it contains the amount of tape indicated on the box. Cassettes with large supply and takeup reels have little tape and, therefore, a short recording time.

Do you have enough tape for the proposed production? Videotape is relatively inexpensive and does not take up much room. Always take more cassettes along than you think you need. Running out of videotape during a field production does not win you any friends.

Are the cassettes in the recording mode? All cassettes have a small device to protect the videotape from accidental erasure. For example, the Betacam cassettes have a small tab that can be moved into or out of a record-protect position, similar to computer floppy disks. **SEE 9.9** VHS and SVHS ½-inch cassettes have a small tab on the lower left of the back edge. **SEE 9.10** When this tab is in the open position, or broken off, you cannot record anything on the cassette. To restore the cassettes to the record mode, move the tab into the record position; for breakaway tabs, cover the tab hole in the cassette with a small piece of adhesive tape. Routinely check the status of the tab before using the cassette for videotape recording. The cassette will play back with or without record protection devices in place.

☑ **Audio level** Unless you are using the AGC (automatic gain control), set the audio level before recording. When using a professional camcorder, have the talent deliver the opening lines so that you can adjust the volume controls for optimal audio levels. When using a studio videotape recorder, have the audio engineer feed you a "zero" level control tone (with the needle of the VU meter pointing to zero VU—100 percent). You can now adjust the VU meter on your videotape recorder so that it matches the zero VU. **SEE 9.11**

9.9

BETACAM CASSETTE TAB

The Betacam cassette has a movable tab that prevents accidental erasure, much like a floppy disk. Make sure the tab is in the closed position (so that the tab covers the opening) when videotaping. For playback, the tab can be in the closed or open position.

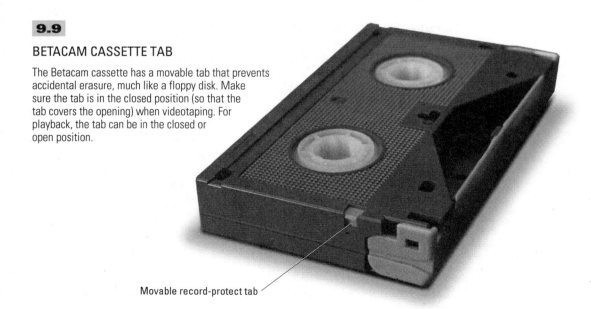

Movable record-protect tab

9.10

VHS CASSETTE TAB REMOVED

To protect VHS and SVHS cassettes from erasure, you need to break off the tab. To reuse the cassette for recording, you can put a small piece of tape over the opening.

Tab removed

9.11

SETTING ZERO VU LEVELS

Before videotape recording, you must match the audio level of the audio console with the VTR. Both VU meters must show a zero VU (100 percent volume).

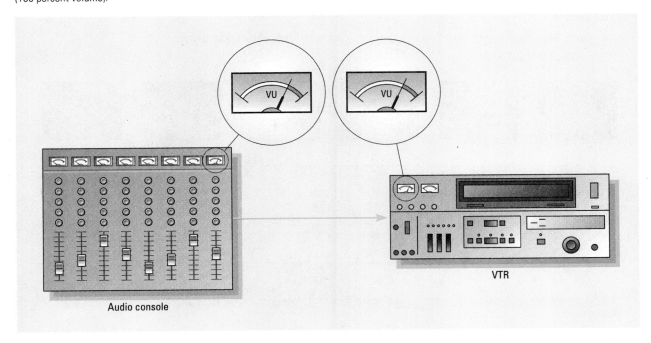

Audio console

VTR

☑ **Monitor** In EFP, you should play back the various scenes before moving on to the next scene. Watching the playback in the small viewfinder will tell you whether or not you got the scene on tape—but it will not let you do any critical viewing. To judge the color or the framing, you need a larger monitor. Be sure your monitor is compatible with the specific VTR type you are using. Remember: SVHS recorders need a Y/C monitor, whereas RGB systems need a monitor that can play back the separate RGB signals. Also, double-check the necessary video cables and power cable connectors. For example, a Hi8 camcorder needs special plugs and an adapter to be connected to the standard BNC video connector. When shooting in the field away from any AC power source, you need a monitor that has its own battery as power supply. Take a spare monitor battery along.

KEY CONCEPT 3 **Make sure that the cassette format matches the VTR and that the cassette tab is in place for recording.**

THE "DURING" CHECKLIST

☑ **Video leader** No matter how brief the recording, you should start each videotape with a *video leader*. It consists of a thirty- to sixty-second recording of color bars and a zero VU test tone, an identification slate, black or leader numbers (from ten to two) that flash on the screen every second for eight seconds, and two seconds of black before the first frame of the program video. **SEE 9.12**

9.12

VIDEO LEADER

The video leader helps to adjust the playback machine to the video and audio values of the record machine.

| Blank tape for threading | Color bars (30 to 60 seconds) | Slate visual (15 seconds) | Black or leader numbers (8 seconds) | Black (2 seconds) | Program video |

Video track

| Silence | Zero VU audio tone | Silence | 8 audio beeps (optional) | Silence | Program audio |

Audio track

9.13

CHARACTER-GENERATED SLATE

The slate gives vital production information and is recorded at the beginning of each major take.

Title: Breugel and Bosch

Producer: Kevin Jerome Walsh

Director: Belgium Mann

Date: 15 March

Scene: 26 Take: 3

Length: 2 minutes

Location: National Gallery

The *color bars* can be generated by the ENG/EFP camera you actually use, or, in a studio production, from the CCU (camera control unit). Most consumer camcorders cannot generate color bars. The zero VU test tone can come from a portable mixer or from the studio console.

During playback, you can use the color bars and test tone as important references to match the colors of the playback monitor and the playback volume with those of the videotape recording. Do not copy the video leader from another recording: you would be adjusting your playback equipment to the wrong standard.

The video *slate* shows vital production information, such as the show title; scene and take numbers; date, time, and location of the recording; and the name of the director and producer. The slate is usually done with a C.G. or the camcorder's built-in lettering facility. **SEE 9.13** In field productions, this information is sometimes handlettered on a special board, also called a *slate*. Each time you do another take, you need to update the take number on the slate.

The numbers that show the seconds remaining before the start of the program material are also produced by the character generator. These numbers, which were originally developed for film cuing, are used for cuing the videotape during playback. For instance, you can cue the tape at leader number four, which gives you a four-second preroll before the first frame of the program video appears. Sometimes these numbers are accompanied by corresponding audio beeps. Although helpful, such leader numbers and beeps are not essential, because the SMPTE/EBU time code or other address systems can let you cue up the videotape even more precisely. We will talk more extensively in chapter 11 about address systems and how they work.

KEY CONCEPT 4 **The video leader must be generated by the equipment actually used in the videotape recording.**

☑ *Tape counter* Even if you record some kind of address system on the videotape, you should reset your mechanical tape counter before starting the videotape. This device will enable you to locate quickly the approximate starting point when asked for a playback.

☑ *Preroll* When starting a VTR, do not record anything—not even the video leader material—until the VTR has reached operating speed. A certain amount of preroll time is needed to give the electronics a chance to stabilize. Most VTRs will indicate when they have reached operating speed (by some light signal) and are ready for recording. In order to avoid temporary video breakup, wait for this signal before putting the VTR in the record mode. To alert the director that the VTR has reached operating speed, give a "speed," "locked," or "in-record" cue.

During editing, most VTRs in camcorders back up the tape automatically for the required preroll (see chapter 11). In the playback mode, most VTRs reach operating speed within a fraction of a second; they deliver a stable picture even when you shift directly into play from the pause mode that displays a freeze frame.

☑ *Recording levels* Watch the video and audio recording levels carefully. Many camcorders indicate these levels in the viewfinder display or on small meters on the VTR section. Pay particular attention to the audio portion of the recording. You may get so carried away with the pictures that minor—or even major—audio problems escape your attention.

☑ *Recording for postproduction* When recording for postproduction, be sure to record enough of each segment so that the action overlaps the preceding and following scenes. Such *cushions* (or *pads*) greatly facilitate editing. If you have enough tape, videotape the camera rehearsals. Sometimes you will get a better performance during rehearsal than during the actual take. When in the studio, record a few seconds of black after each take before stopping the tape. This "run-out" signal again acts as a pad during editing or, if you do a live-on-tape recording, as a safety cushion during playback.

☑ *Retakes* As the VTR operator, tell the director right away if you feel that another take is necessary for some reason. It is far less expensive to repeat a take than to try to "fix it in post."

☑ *Record keeping* During the recording, keep accurate records of each take. You will be surprised how quickly you forget just where on the videotape the unforgettable scene is located. A carefully kept *field log* can save you much time in postproduction editing. The field log gives information on the production title, the taping date and location, the names of the producer and director, the scene and take numbers and their sequence, whether the takes are good or not, the tape counter number, and other production details that you consider important. **SEE 9.14** If there is only a single column for the take number, circle the good takes.

KEY CONCEPT 5 **Keep an accurate field log during the recording session and carefully label all videotapes.**

9.14

FIELD LOG

The field log is kept by the VTR operator during the production. It normally indicates scene and take numbers, the counter number of the VCR, whether the take was good or no good, and what the take was all about. It facilitates locating the various cassettes and shots during postproduction previewing.

Production Title:	Traffic Safety		Producer/Director: Elan Frank
Taping Date: 4/15		Location: Intersection of Bonita & Crest Roads	

Scene	Take	OK or No Good	Counter #	Event
1	①	OK	0082	Car running stop sign
	2	NG	0094	VTR problem
	③	OK	0251	Z-axis shot
	④	OK	0463	Camera pans past stop sign
2	1	NG	0513	Pedestrian too far from car
	②	OK	0766	Good Z-axis shot
6	1	NG	0992	Ball too soon in street
	2	NG	1332	Ball too late
	③	OK	1371	Ball rolls in front of car

THE "AFTER" CHECKLIST

☑ *Recording check* Before going on to the next scene or striking the studio set or remote location, check whether you have actually recorded the scene as planned. Rewind the tape to the beginning shot, then fast-forward it two or three times to spot-check the recording. If the tape looks and sounds good, move on to the next item on your production schedule.

☑ *Labeling* Label each tape with the the tape number and the title and number of the scenes. Label the box with the same information. It is more important to label the tape itself than the box. As obvious as such labeling seems, countless precious hours of postproduction time have been lost because the tape boxes, rather than the tapes, were labeled. Watch that the tape labels match the information of the corresponding field log.

☑ *Protection copies* As soon as possible, dub all source tapes in their entirety so that you have a protection (backup) copy of all material shot.

KEY CONCEPT 6 **Always make protection copies of all your source tapes.**

NONLINEAR STORAGE SYSTEMS

Regardless of whether the video information stored on videotape is analog or digital, you can only access it serially. For instance, you need to roll through the first twenty-six shots before reaching shot 27. Unlike the linear videotape system, *nonlinear storage systems* allow *random access*. When this digital information is stored on a hard drive or some kind of optical read/write disc, you can access shot 27 directly. Instead of having to wait for the tape to roll to the desired frame, you can now call it up in a fraction of a second, regardless of where it is located on the disk. The first frame of shot 1 is as easily accessible as that of shot 27. This random access to each digitized frame has revolutionized postproduction editing. You will learn more about nonlinear editing in chapter 11.

 KEY CONCEPT 7 **Nonlinear digital storage devices allow random and almost instantaneous access to each video frame.**

The problem with using digital video is that high-resolution, full-screen video needs a great amount of storage space, especially when dealing with moving images. However, new technical breakthroughs and equipment let you squeeze more and more information on smaller and smaller storage devices. The most popular nonlinear digital storage devices are (1) computer disks, (2) the electronic still store (ESS) system, (3) optical read/write discs, and (4) CD-ROM.

Computer Disks

Because video and audio information can be digitized, you can store it on any type of floppy or hard drive. The computer won't know whether the magnetic pulses it stores represent a reproduction of the Mona Lisa or your checkbook balance. As long as the image is not moving, you can store a great number of video images even on a regular 3.5-inch floppy disk.

Moving images need considerably more storage space. Considering that just one second of video takes thirty individual frames, ten minutes of full-screen motion display require a rather large storage capacity. You can now see why the video storage of original video footage for postproduction editing needs high-capacity (2 or more gigabytes) hard drives.

Fortunately, various *compression* methods let you cram more and more information onto ever smaller disks. Some compression methods simply find unused space on the disk and put the information in the best possible order; others drastically reduce the information in the recording process and then restore the full image during retrieval.

Electronic Still Store System

As mentioned in chapter 7, an *electronic still store* (ESS) *system* can grab any frame from any video source, digitize it, and store it on a disk. These electronic still store

systems perform like a superfast slide projector. You can call up and display any one of the stored frames in a fraction of a second. Even the simplest systems can store on a single tiny floppy disk (2-by-2.25-inch) up to fifty low-resolution and twenty-five high-resolution still images. Larger systems can store up to several thousand still frames.

Optical Read/Write Discs

These optical discs let you "read"—play back—previously recorded material and "write"—record—new material, just as with videotape. Much like the audio CD or the CD-ROM, read/write optical discs use a laser beam to retrieve the information. They come in various sizes and with varying degrees of sophistication. Even a small optical read/write disc (about 680 megabytes) the size of a regular CD lets you record and play back about seventy minutes of digital audio, and a relatively great amount of motion video. Again, the advantage of such an optical disc over videotape is that the disc allows random access, is easier to store, and does not wear out through repeated use.

CD-ROM

As you recall, the optical CD-ROM is a read-only disc. Like a regular audio CD, it comes with digital audio and video information permanently recorded on it. Unlike optical read/write discs, you cannot erase a CD-ROM and then record some other material on it. It is identical in size to the audio CD (about 4.5 inches in diameter) and holds an amazing 650 megabytes of video and audio information. The CD-ROM is primarily designed for use in desktop computers. A CD-ROM holds a large amount of information, such as an entire encyclopedia with text and illustrations, or a travelogue with maps, moving video sequences, and accompanying sound. Some computers come with CD-ROM playback drives; others can be hooked up to external drives.

USE OF VIDEO RECORDING

The original purpose of video recording was to temporarily preserve a live uninterrupted television program for repeated playing or for reference and study. Today, however, we use video recording for the careful building of a variety of video events through postproduction editing and the creation of computer-generated images.

The whole video field has gone way beyond the task of producing broadcast or cable television programs. Video recordings have become an important personal communication medium. The use of camcorders rivals that of the still camera, and VCRs are used to record broadcast programs that come at the wrong time and for watching movies and various other prerecorded program fare at home. But it was the marriage of computers and video that has brought about some significant developments: interactive video, multimedia, and desktop video. Although interactive video and multimedia still rely in part on basic video

production, they have become important communication media in their own right, but we will mention here only their major characteristics. Desktop video, on the other hand, has become an important tool in postproduction, and that will be explained in chapter 11.

Interactive Video

Interactive video means that the viewer has some control over what he or she wants to see and how to see it. The viewer is no longer passive, but has become an active partner in the communication process.

As a training device, interactive video may be used to view a critical traffic situation. You could then be asked by the computer what you, as the driver, would do to avoid an accident. An elaborate interactive program would then show you in a brief scene the consequences of your answer. A simpler program will at least let you know immediately whether your answer was right or wrong.

Or, after watching various scenes showing different shoppers in a department store, you may be asked to identify the shoplifter. The computer will then show you who was the actual culprit, and why. Video games are another well-known form of interactive video.

 KEY CONCEPT 8 **Interactive video allows the viewer to exercise choice with immediate feedback.**

Interactive television is a form of interactive video that is presented to you through the regular cable channels. In normal cable-transmitted interactive television, the television set might display a menu of choices very much like that of a CD-ROM computer program. With a special remote control you can then call up a program that suits your need or mood, watch a small preview of it, stop it in midstream, back it up, fast-forward it, or select a freeze frame from it. For instance, after you select a certain dramatic program, the on-screen menu might present various choices of how you may want to see a story end: happy ending, sad ending, mysterious ending, no ending. You simply click the menu on your television screen and watch the desired version. If you don't like your choice, you can stop it and switch to another one.

You can also call up various services, such as home shopping or information about the local bus schedule. All such interactive communication is part of the electronic superhighway you are presently learning to negotiate.

Multimedia

Multimedia is a term for the simultaneous display of text, still and moving images, and sound. The programs come on CD-ROMs and must be played with CD-ROM drives on personal computers. Multimedia programs are extensively used for

informational, instructional, and training programs, various types of presentations, and of course entertainment.

With multimedia, a travel brochure may now consist of a simultaneous screen display that shows the map of a specific country, a still shot of its capitol building, text that explains certain statistics, and a motion sequence of some of the more spectacular sights.

Closer to home, you may want to reinforce the section on lighting in this book with a multimedia program on video lighting. In this case, the CD-ROM menu could offer you a review of various definitions and lighting instruments and how they are best applied for the photographic principle. It can show you not only a simplified lighting plot, but at the same time show and explain via a voice track the actual light-shadow effect of your choice of instruments and their intensity. **SEE COLOR PLATE 13** The menu could then offer you a variety of exercises that help to test your lighting expertise.

Another CD-ROM exercise could show a rendering of a zoom lens with which you could zoom in and out using the computer mouse. Another part of the screen could display the actual scene and show you how angle of view and perspective of the picture change during the zooming. Each program segment could end by asking you a battery of multiple-choice questions on zoom lenses and their aesthetic effects. **SEE COLOR PLATE 14**

Once you have proved to the computer that you have an adequate grasp of basic lighting theory, it might invite you to engage in a more ambitious lighting project. During all such exercises, you can always go back and look at and listen to some of the explanations again or repeat some of the exercises. You can also call up other related subjects, such as color, white balance, or lens aperture, to learn how other production variables interact with your lighting decisions.

The nice aspect of this type of learning is that it is entirely private and in your control. You can now make as many mistakes as you will without having to be embarrassed about it, and you can repeat a section as often as you like until you finally master the concept. Obviously, multimedia is also a form of interactive video, except that you have a much greater choice in multimedia and a more varied form of screen display.

Although interactive video and multimedia are primarily computer-based media, they require a great amount of creative and efficient video production for their display.

Even if you haven't digested all the information in this chapter, you at least know now why your SVHS videotape recording did not play back on a regular VHS recorder. You will find that a little more actual experience will clarify many of the concepts that may have seemed difficult. Considering that when you first approached the Triple-I videotape editor you were in a panic over your playback problem, she will be pleasantly surprised by how much you have learned about videotape recorders, the various systems, and the recording process. You may even be moved to the postproduction section much sooner than you anticipated. The discussion in chapter 11 will help you prepare for postproduction editing.

Videotape Tracks

All videotape recorders (VTRs) use separate tracks to record the video and audio, as well as various control data. The basic tracks are the video track, which contains the picture information, the audio tracks, which record the sound information, and the control track, which contains the sync pulses. Some videotape recorders use still another track for their address code.

Analog and Digital VTR Systems

Most VTRs record the video signal in analog form. Digital VTRs translate the analog video signal into digital on/off pulses. Contrary to analog video recordings, digital recordings do not deteriorate even after many tape generations.

Composite and Component Systems

The NTSC (National Television Standard Committee) system combines the color (C) part and the luminance (black-and-white, or Y) part of the video signal into a single composite signal. The Y/C system separates the color (C) and luminance (Y) information, and is sometimes referred to as component Y/C. Still another system keeps the RGB channels separate during the entire recording process. This RGB system is sometimes referred to as a component RGB system.

Tape Format

Not all VTRs use the same videotape cassettes. Some consumer camcorders (such as the Hi8 models) use a much smaller tape cassette (8mm width) than the professional cameras (½-inch). The same tape width does not necessarily mean that the cassettes are interchangeable with all systems.

Videotape Recording Process

There are important *before, during*, and *after* procedures that must be observed when videotape recording.

Nonlinear Storage Systems

Unlike videotape systems (analog or digital), nonlinear systems allow random access of recorded visual material. When stored on a hard drive, some kind of optical read/write disc, or a CD-ROM, each frame can be accessed independently of all others. Electronic still store (ESS) systems can store several thousand still frames that can be quickly accessed for display on a video monitor.

Interactive Video and Multimedia

Interactive video means that the viewer has some control over what to see on the screen. Interactive learning programs give the user multiple choices and then either confirm the choice or tell the user why the choice was wrong. Interactive television allows the home viewer to exercise some control over the program choice, or even program content. Multimedia refers to the simultaneous display by the computer of text, still and moving images, and sound. Distributed on CD-ROM, these programs are extensively used for information, instruction, and entertainment.

K E Y C O N C E P T S

- Videotape recorders record video and audio signals and a variety of other information necessary for the proper operation of the tape and for the identification of each individual frame.

- Videotapes recorded on Y/C component or RGB VTRs cannot be played back on similar composite (NTSC) equipment.

- Make sure that the cassette format matches the VTR and that the cassette tab is in place for recording.

- The video leader must be generated by the equipment actually used in the videotape recording.

- Keep an accurate field log during the recording session and carefully label all videotapes.

- Always make protection copies of all your source tapes.

- Nonlinear digital storage devices allow random and almost instantaneous access to each video frame.

- Interactive video allows the viewer to exercise choice with immediate feedback.

Continuity Editing Assembling shots so that vector continuity is ensured.

Mental Map Tells us where things are or supposed to be on- and off-screen.

Continuing Vectors Graphic vectors that extend each other, or index and motion vectors pointing and moving in the same direction.

Converging Vectors Index and motion vectors that point toward each other.

Diverging Vectors Index and motion vectors that point away from each other.

Vector Line An imaginary line created by extending converging index vectors, or the direction of a motion vector.

Cutaway A shot of an object or event that is peripherally connected with the overall event and that is neutral as to screen direction. Used to intercut between two shots in which the screen direction is reversed.

Complexity Editing Building an intensified screen event from carefully selected and juxtaposed shots. Does not have to adhere to the continuity principles.

Jump Cut An image that jumps slightly from one screen position to another during a cut.

Jogging Frame-by-frame advancement of videotape, resulting in a jerking motion.

Editing Principles

EVERYBODY laughs. The head of the postproduction editing group at Triple-I has just shown to her colleagues a brief demonstration tape, which she intends to use for her weekend workshops. You smile politely, although the people in the scene or their actions aren't really that funny. But then you realize that the Triple-I people are not laughing at the content, but at the way the tape is edited: "Great jump cut!" "Loved that crossing-the-line bit!" "What vector chaos!" "Total destruction of the mental map!"

You learn that, in order to reduce the anxiety of her future students, the editor had included all sorts of classic editing mistakes in this demonstration tape. But what exactly are these mistakes? This chapter will help you recognize them. Specifically, you will be introduced to—

▉ EDITING PURPOSE
Why we edit

▉ EDITING FUNCTIONS
Combining, condensing, correcting, and building

▉ AESTHETIC PRINCIPLES OF CONTINUITY EDITING
The mental map, vectors, and on- and off-screen positions

▉ AESTHETIC PRINCIPLES OF COMPLEXITY EDITING
Intensifying the event and supplying meaning

EDITING PURPOSE

Editing means selecting certain portions of an event or events and putting them into a proper sequence. The specific nature of sequencing depends on the specific *editing purpose:* to cut a twenty-minute videotape of an important news story to twenty seconds to make it fit the format; to join a series of close-up details so that they make sense and flow without any visual bumps; or to juxtapose certain shots so that they take on added meaning.

Basically, we edit to tell a story with clarity and impact. All editing equipment is designed to make the selection of shots, and their joining through a variety of transitions, as easy and efficient as possible. But whether you work with very simple videotape editing equipment or a highly sophisticated nonlinear computerized editing system, the functions and basic aesthetic principles of editing remain the same.

KEY CONCEPT 1 **Editing means selecting significant event details and putting them into a specific sequence in order to tell a story with clarity and impact.**

EDITING FUNCTIONS

The specific editing functions are: (1) combine, (2) condense, (3) correct, and (4) build. Although these functions frequently overlap, there is always a principal one that determines your editing approach and style—the selection of shots, their length and sequence, and the transitions with which you join them.

Combine

The simplest kind of editing is *combining* program portions. For instance, you may want to combine the various segments you videotaped during your vacation so that they are in proper sequence on a single reel. Your carefully kept field log will aid you greatly in locating the reels and the various shots. Because you simply hook the various videotaped pieces together, there is no need for special transitions; you can use "cuts-only." The more you are aware of the desired sequence during the actual shooting, the easier it will be for you to combine the various shots in this postproduction phase.

Condense

Often you will edit simply to *condense* the material, thereby reducing the overall length of the program or program portion. The most drastic condensing is done in television news. As an editor of news footage, you are often called upon to cut extraordinary stories to unreasonably brief segments. It is not unusual for you to have to shorten a half-hour speech to ten seconds, the forty dramatic minutes of a rescue operation to a mere twenty seconds, or the fifty minutes of graphic war footage, videotaped by a daring camera crew, to a mere five seconds. The famous

"sound bites" are a direct outgrowth of such drastic editing. Statements by public officials are tailored to a series of brief and memorable catch phrases rather than sensible narrative, very much in the spirit of advertising slogans.

But even in less drastic editing, you will find that it is often hard to part with some of the footage, especially if it took extra effort to videotape. Try to detach yourself as much as possible from the preproduction and production efforts, and concentrate simply on what you *need* to show and say, rather than what you have available. Don't use three shots if you can communicate the same thing with one. Such editing requires that you identify the essence of an event and use only shots that best communicate this essence.

 KEY CONCEPT 2 **The condensing function of editing requires a recognition of event essence and the selection of shots that best express this essence.**

Correct

Editing to fix production mistakes can be one of the most difficult, time-consuming, and costly postproduction activities. Even simple mistakes, such as the company president misreading a word during her monthly address, can present a problem for you when trying to match the body positions and voice levels of the old (before the mistake) and new (after the mistake) takes. A good director will not pick up the speech exactly where the mistake was made, but go back to where a new idea is introduced in the speech so that a change in shots is properly motivated. Starting the "pickup" (new shot) from a different point of view (tighter or looser shot, different angle) will make the cut and a slight shift in voice level appear deliberate and ensure smooth continuity.

More serious production problems, such as trying to match uneven colors and sound, can become a real headache for the editor. White balancing the camera in each new lighting environment and watching the VU meter while listening carefully to the sound pickup is certainly easier than trying to "fix them in post."

Such seemingly minor oversights as the talent wearing her coat unbuttoned while standing up, and buttoned when sitting, cannot be "fixed in post" even by the most experienced editor; rather, they call for costly retakes. Again, meticulous attention to all preproduction details and keeping a close watch on every aspect of production can eliminate much of the costly "fixing in post" activities.

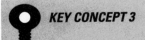 **KEY CONCEPT 3** **Careful attention to preproduction and production details can avoid most corrective editing.**

Build

The most satisfying editing is when you can *build* a show from a great many carefully taped shots. Some postproduction people think—not without cause— that the videotaping during the production provides merely the bricks and mortar,

and that it is up to the editor to construct the building, to give the raw material shape and meaning. Regardless of whether your editing is done to show an event as clearly as possible, or to reveal its intensity and complexity, or a combination of the two, you need to apply one or both of the major aesthetic editing principles: *continuity* and *complexity*.

AESTHETIC PRINCIPLES OF CONTINUITY EDITING

Continuity editing means to create seamless transitions from one event detail to the next so that the story seems to flow even though a great deal of information is purposely left out. The aesthetic principles of continuity editing are not so much concerned with the logic of the story line and narrative flow, but rather with how the pictures and sound from one shot carry over to the next. Unlike the painter or still photographer, who is concerned merely with the effective composition of a single image, you must now compare the aesthetic elements of one picture with those of another and see whether they lead smoothly from one to the other when seen in succession. Over the years of filmmaking, certain ways of achieving visual continuity became so firmly established that they matured from conventions to principles and now apply equally to video productions.

The major continuity editing principles are (1) the mental map, (2) vectors, and (3) on- and off-screen positions.

Mental Map

Every time we watch television or a film, we automatically try to make sense of where things are and in what direction they move on and off the screen. In effect, we construct a *mental map* that tells us where things are or are supposed to be. For example, if you see somebody look screen-left in a medium shot, he should also look screen-left in a close-up. **SEE 10.1**

10.1

MENTAL MAP

To help establish the mental map of where things are in off-screen space, you need to be consistent with where people look.

A When someone looks screen-left in a medium shot...

B ...he should look in approximately the same direction in a close-up.

If you see a person in a close-up look screen-right during a two-way conversation, your mental map suggests that the other person is located somewhere in the right off-screen space. **SEE 10.2** According to the established mental map, the next shot must show a close-up of the partner looking screen-left, with the first person having moved into the left off-screen space. **SEE 10.3** To show both persons

10.2

MENTAL MAP OF RIGHT OFF-SCREEN POSITION

If you show person A looking and talking screen-right in a close-up, we assume person B to be located in the right off-screen space, looking screen-left.

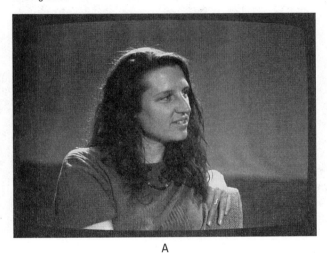

A

B

10.3

MENTAL MAP OF LEFT OFF-SCREEN POSITION

When we now see person B in a close-up looking and talking screen-left, we assume person A to be in the left off-screen space.

A

B

10.4

DIFFERENT MENTAL MAP OF OFF-SCREEN POSITION

Showing persons A and B looking in the same direction in subsequent close-ups would suggest that both are talking to someone else.

A B

looking in the same direction in subsequent shots would go against the mental map and suggest that they are talking to someone else. **SEE 10.4**

If, during a three-way conversation, you see a single person in a close-up first looking screen-right and then screen-left, you expect somebody to be sitting on both sides of him or her rather than two people on one side or the other. **SEE 10.5**

10.5

PERSON LOOKING SCREEN-RIGHT AND SCREEN-LEFT

When somebody in a close-up looks screen-right in shot 1, and then screen-left in shot 2, we expect the other people to sit on both sides of her.

Shot 1 Off-screen space

Off-screen space **Shot 2**

10.6

SCREEN-RIGHT POSITION OF PARTNERS

When somebody continues to look screen-right during a three-way conversation, we expect her two partners to sit in the right off-screen space.

10.7

ACTUAL SCREEN MOTIONS

When seen in a long shot, the mental map of off-screen space coincides with the actual positions of the three people.

But if you see in a close-up a woman consistently looking screen-right during the three-way conversation, you expect the two other people to sit screen-right of her, although we cannot actually see them. **SEE 10.6** The next shot shows you that your mental map was accurate. **SEE 10.7**

As you can see, the mental map not only covers on-screen space but also off-screen space. Once such a mental map is established, you must adhere to it, unless you want to shake the viewers purposely out of their perceptual expectations. Applying continuity principles will keep the map intact.

 KEY CONCEPT 4 **Continuity editing means preserving the location and motion of objects over a series of shots in order to help the viewer establish and maintain a mental map of where things should be or where they should move.**

Vectors

As you recall, vectors are directional forces that lead our eyes from one point to another on the screen, and even off it. They can be strong or weak, depending on how forcefully they suggest or move in a specific direction. To keep the mental map intact requires proper vector continuity.

Continuity of graphic vectors If you shoot a scene with a prominent graphic vector as the horizon line, such as a skyline, the ocean, the desert, or a mountain range, you need to make sure that the height of the horizon line matches in subsequent shots and that it does not jump up or down. **SEE 10.8** You can accomplish this vector continuity quite simply by marking the horizon line of your first shot with a piece of tape on your viewfinder and aligning all subsequent shots according to the tape.

10.8

GRAPHIC VECTOR CONTINUITY

To avoid the horizon line jumping up and down during subsequent shots, you need to make sure that it forms a continuous graphic vector from shot to shot.

Shot 1

Shot 2

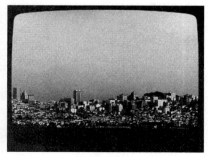
Shot 3

Directions of index and motion vectors Index and motion vectors can be: (1) continuing, (2) converging, or (3) diverging.

Continuing vectors follow each other or move or point in the same direction. **SEE 10.9** They must "continue"—point in the same screen direction even if shown in separate shots. **SEE 10.10** If you have one of the people look in the opposite direction in the close-up, you will jolt the established continuity.

10.9

CONTINUING VECTORS IN A SINGLE SHOT

Continuing vectors point or move in the same direction. The continuous vectors of these two people suggest that they are looking at the same target object.

A B

10.10

CONTINUING VECTORS IN SUCCESSIVE SHOTS

Even when seen in two successive close-ups (shots 1 and 2), these continuing index vectors suggest that the two persons (A and B) are looking at a common target object.

Shot 1 — A Shot 2 — B

10.11

VECTOR REVERSAL IN SUCCESSIVE SHOTS

By reversing one of the index vectors (shot 2), we assume that the two persons (A and B) are looking at each other instead of at a common target object.

Shot 1 — A　　　　　　　　　　　　　　**Shot 2 — B**

Instead of having the two people looking in the same direction, the mental map now tells us that they must be looking at each other. **SEE 10.11**

Converging vectors move or point toward each other. **SEE 10.12** You must maintain their direction in subsequent single shots in order to maintain the mental map. **SEE 10.13**

Diverging vectors move or point away from each other. **SEE 10.14** Again, subsequent close-ups must maintain the diverging vector direction. **SEE 10.15**

Of course, vectors can change their directions in a single shot. In that case, the follow-up shot must continue the index or motion vector as seen just before the cut. For instance, if you show somebody running screen-left, then turn in

10.12

CONVERGING INDEX VECTORS IN A SINGLE SHOT

Converging vectors must point or move toward each other. The index vectors of the two people (A and B) looking at each other converge.

A　　　　　　　　　　B

10.13

CONVERGING INDEX VECTORS IN SUCCESSIVE SHOTS

When seen in successive close-ups (shots 1 and 2), the index vector of A must converge with that of B.

Shot 1 — A

Shot 2 — B

10.14

DIVERGING INDEX VECTORS IN A SINGLE SHOT

When two persons (A and B) look away from each other in a two-shot, their index vectors are diverging.

A B

10.15

DIVERGING INDEX VECTORS IN SUCCESSIVE SHOTS

To show that the index vectors are diverging in successive close-ups (shots 1 and 2), the index vector of A must point away from that of B.

Shot 1 — A

Shot 2 — B

10.16

CONVERGING Z-AXIS INDEX VECTORS

Shot 1 establishes the index vectors of A and B as converging. By establishing that the vectors converge (shot 1), we perceive the subsequent z-axis close-ups of A and B in shots 2 and 3 also as converging.

A **Shot 1** B

Shot 2 — A

Shot 3 — B

midscreen and run screen-right, your subsequent shot must show the person continuing to run screen-right.

If someone looks directly into the camera or walks toward or away from it, we speak of a z-axis index or motion vector. As you recall, the z-axis is the depth dimension or the imaginary line that stretches from the camera to the horizon. Whether we perceive a series of z-axis shots as continuing, converging, or diverging depends on the *event context*. If you follow a two-shot, which shows two people looking at each other, with successive close-ups of one person looking into the camera and the other person doing the same in the next shot, we perceive their successive z-axis vectors as converging; they are still looking at each other. **SEE 10.16**

If the context (two-shot) shows that they are looking away from each other, we perceive the identical z-axis close-ups as diverging index vectors. **SEE 10.17**

KEY CONCEPT 5 **Graphic, index, and motion vectors play an important part in establishing and maintaining continuity from shot to shot.**

10.17

TWO-SHOT WITH DIVERGING INDEX VECTORS

If the context in shot 1 establishes the two people (A and B) as looking away from each other, the subsequent z-axis shots (2 and 3) are perceived as diverging vectors.

A **Shot 1** B

Shot 2 — A

Shot 3 — B

On- and Off-screen Positions

As you could see in figures 10.1 through 10.7, we tend to create a mental map that helps us tell where people are located even if we can't see them. Such an off-screen map helps to preserve visual continuity and ultimately to stabilize our environment. In vector terms, we place a person off-screen wherever the on-screen index vector points. The same is true for on-screen positions. Once we establish person A on screen-left and person B on screen-right, we expect them to remain there even if we cut to a different point of view. Such *position continuity* is especially important in over-the-shoulder and cross-shots. **SEE 10.18** In both shots, person A remains screen-left and person B screen-right. Our mental map would be greatly disturbed if we saw A and B change places in subsequent shots—we would perceive them as playing musical chairs, as shown in shot 3 of figure 10.18.

A slight position change from shot to shot is called a *jump cut*, because the object or person seems to jump, or jerk, from one place to another for no apparent reason. It often happens when you try to align your camera and subject in exactly the same position when setting up for the next shot. Unfortunately,

10.18

PRESERVING ON-SCREEN POSITIONS

When B is first seen screen-right (shot 1), we expect her to remain there even when cutting to a different point of view in this over-the-shoulder sequence (shot 2). Our mental map would be disturbed if B would appear screen-left in the over-the-shoulder shot (shot 3).

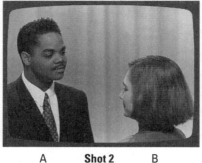

| A | **Shot 1** | B | A | **Shot 2** | B | B | **Shot 3** | A |

neither the camera nor the subject will remain in exactly the same place as the previous shot, but inevitably shift positions ever so slightly. When two shots are cut together, such a slight shift will appear as a sudden and highly noticeable jump. To prevent jump cuts, you should always change the angle and/or field of view, getting a looser or tighter shot.

Although the jump cut is undesirable in continuity editing, it has become an important device in complexity editing. We discuss this effect later in this chapter.

The vector line The navigation device that helps to maintain on-screen positions and motion continuity (as you will see later) is called the *vector line*, the *line of conversation and action*, the *hundredeighty* (for 180°), or simply, the *line*. The vector line is an extension of converging index vectors, or the extension of a motion vector in the direction of travel. **SEE 10.19**

10.19

FORMING THE VECTOR LINE

The vector line is formed by extending converging index vectors or by extending a motion vector.

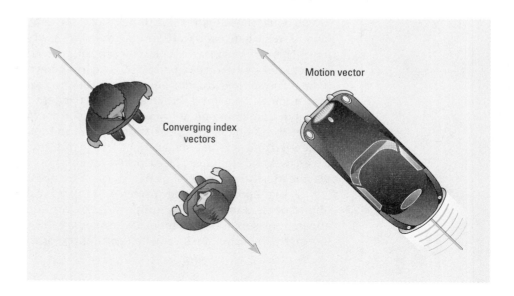

Converging index vectors

Motion vector

10.20

VECTOR LINE AND PROPER CAMERA POSITIONS

In order to maintain the screen positions of A and B in over-the-shoulder shooting, the cameras must be on the same side of the vector line.

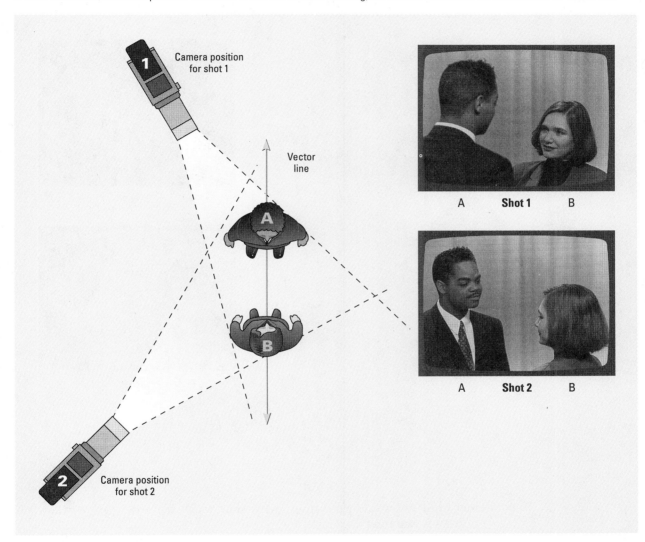

A **Shot 1** B

A **Shot 2** B

To maintain on-screen positions during over-the-shoulder shooting (with A screen-left and B screen-right), you must keep your cameras *on the same side of the vector line.* **SEE 10.20** *Crossing the line* would result in a musical chair–like position switch of A and B. **SEE 10.21** Although you may argue that you will not confuse A and B even if they switch screen positions, crossing the line will definitely disturb our mental map and generate a big continuity bump; it is considered a serious sequencing mistake.

A similar problem occurs if you shoot two side-by-side people from the front and the back along the z-axis. Such a sequencing problem is common when covering a wedding, when you shoot the bride and groom first from the front, and

10.21

CROSSING THE VECTOR LINE

Crossing the line with one of the two cameras will result in a position switch between A and B. They will seem to play musical chairs.

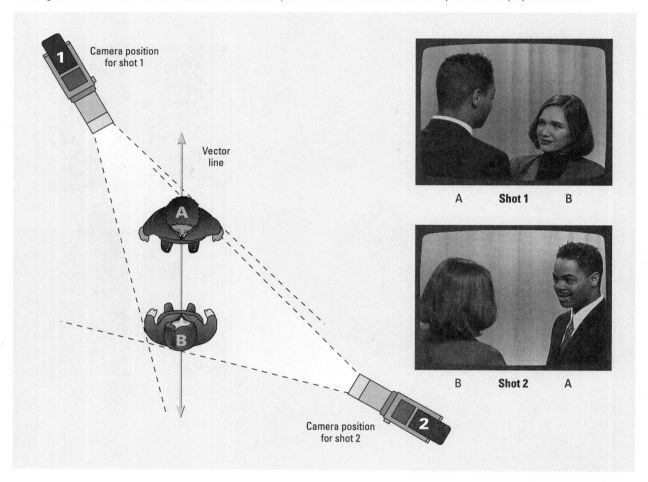

then from the back. When cutting the two shots together, the two people will switch positions. **SEE 10.22**

To get around this position switch, you can move to the side with the camera when the couple walks by and see them change positions within the shot. When cutting to the shot from behind, they have already switched positions.

When *cross shooting*, crossing the line will change the properly converging index vectors to improperly continuing vectors. Instead of having two people look at, and talk with, each other, they seem to be talking to a third person. **SEE 10.23**

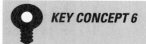 **KEY CONCEPT 6** **To maintain on-screen positions and vector continuity, both cameras must be kept on the same side of the vector line.**

10.22

Z-AXIS POSITION SWITCH

When shooting two people side by side (A and B) from the front and from the back along the z-axis, they will switch positions when the shots are edited together.

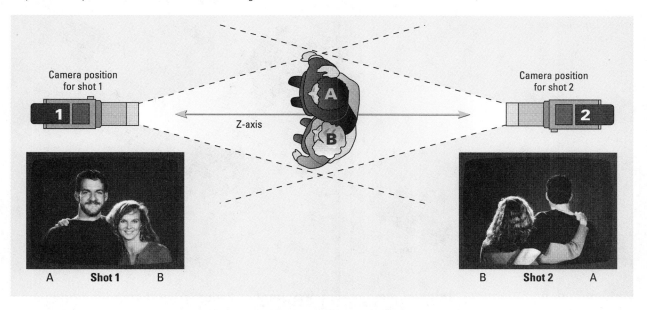

A **Shot 1** B

B **Shot 2** A

10.23

CROSSING THE LINE IN CROSS SHOOTING

When crossing the line in cross shooting, A and B seem to be looking in the same direction. The converging index vectors have become continuing ones.

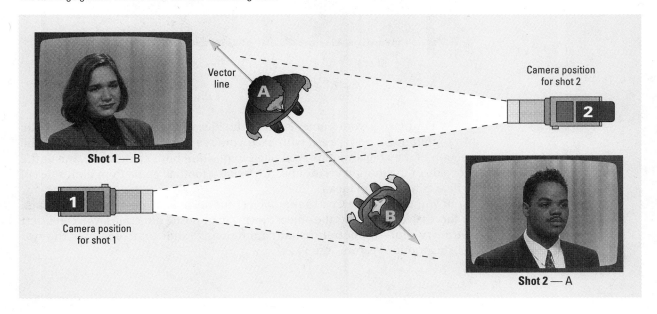

Shot 1 — B

Shot 2 — A

10.24

CROSSING THE MOTION VECTOR LINE

When crossing the motion vector line, the object motion will be reversed with each cut.

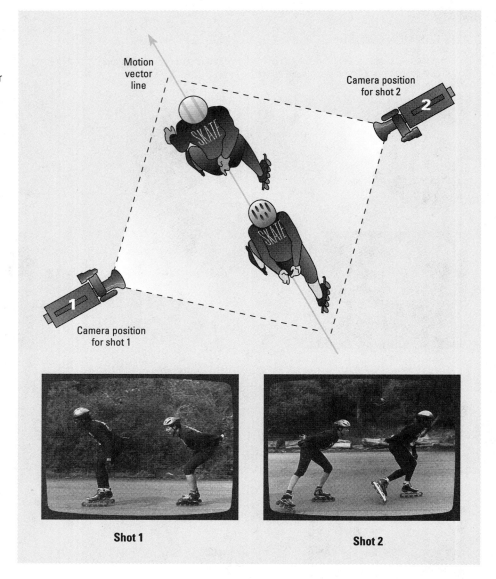

Motion vector line

Camera position for shot 2

Camera position for shot 1

Shot 1

Shot 2

When placing your cameras on both sides of the *motion vector line*, the object motion will be *reversed* with each cut. **SEE 10.24** In order to preserve the direction of the object motion, you need to position both cameras on one or the other side of the motion vector line. (Covering a football game from both sides of the field is not a good idea.)

If you need to pretend that an object moves in a single direction although two successive shots show the object moving in opposite directions, you can insert a *cutaway* shot—a neutral (usually nonmoving) shot that separates the two opposing motion vectors. **SEE 10.25**

10.25

CUTAWAY

If you want to show that somebody continues to move in the same direction although the successive shots show him moving in opposite directions (shots 1 and 3), you can establish a continuing motion vector by inserting a neutral cutaway (shot 2).

Shot 1

Shot 2

Shot 3

Now when recalling your Triple-I colleagues and how much they laughed at the various editing mistakes their head of postproduction had put into her demonstration tape, their comments—"Great jump cut!" "Loved that crossing-the-line bit!" "What vector chaos!" "Total destruction of the mental map!"—are no longer a mystery.

AESTHETIC PRINCIPLES OF COMPLEXITY EDITING

Complexity editing is primarily done to *intensify* an event and to give it *special meaning*. It is designed to help us gain a deeper insight into the event. In this sort of editing, you may not always want to follow the rules of continuity editing but instead opt to jar the viewer's mental map purposely.

Intensifying the Event

Although you were just advised not to shoot motion from both sides of the motion vector line, crossing the motion vector is one of the more popular intensification devices. For example, if you want to emphasize the power of a sports car, you might shoot it first from one side of the street (which represents the motion vector line), and then from the other. The converging motion vectors of the car will clash and thus help to increase the aesthetic energy of the shots. Because this is the only car in the two shots, we are not likely to perceive a switch in direction or see two cars, but a single one moving in the same direction. **SEE 10.26**

Crossing the vector line Many MTV segments show rapid switching of screen directions, such as dancers or singers who flip rapidly from looking and

10.26

INTENSIFICATION THROUGH CONVERGING MOTION VECTORS

Juxtaposing two converging motion vectors of a single prominent object, such as a powerful sports car, will intensify the object motion without destroying its vector continuity. Note that here the pictures of the car create index rather than motion vectors.

Shot 1

Shot 2

moving in one screen direction to the opposite one. You probably noticed that this effect is accomplished by purposely crossing the vector line with the camera. When shooting from both sides of the line, you reverse the singer's index and motion vectors every time you cut. The purpose of crossing the vector line is to increase the energy of the shot sequence. The more rapid the switching, the more frantic the sequence appears.

Jump cut The *jump cut* has become an important device in complexity editing. It became fashionable through newscasts, when editors did not have time to insert appropriate cutaways when editing interviews. They simply tried to find a few interesting spots on the sound track and cut these pieces together regardless of the video. Because most news interviews are shot with a single camera that is focused on the guest throughout, the final edited version of the interview shows a jump cut at each new segment.

Although the jump cut is traditionally considered an aesthetic offense, it was eventually accepted by the viewers because they were given some indication of where the interview had been trimmed. It is used in commercials and even dramatic situations—not so much as an indicator of condensing time, but rather as a perceptual prodding device. Like crossing the line, the jump cut jolts us out of our perceptual complacency.

Jogging *Jogging* produces a similar jolt to visual continuity. It consists of a slowed-down frame-by-frame advance of a motion, which is normally used to locate

a specific frame for editing. When shown within a high-intensity shot, it draws attention to the motion itself and can heighten the drama of the scene.

Sound track The *sound track* is, of course, one of the most effective and widely used intensifiers. There is hardly a car chase that—besides the squealing tires—is not accompanied by high-energy, highly rhythmic music. As you have undoubtedly experienced at rock concerts or other musical performances, it is primarily the rhythm, the beat, of the music that supplies its basic energy. We transfer this basic sound energy quite readily to the video event.

Supplying Meaning

You can create meaning not only through the actual content of the scene, but also by a specific shot sequence. For example, if we see in the first shot a police officer struggling with a person, then, in the second, the person running across the street, we presume that the culprit has escaped. However, if we see the person running first, and then the police officer struggling, we believe that the officer has caught up with the culprit.

You can supply additional meaning by juxtaposing the primary event with either related or contrasting events. For example, by showing how the homeless seek shelter in the city plaza and then switching to a scene with limousines driving up and elegant people entering the opera house across the street, you will not only intensify the plight of the homeless but also imply the idea of social injustice. Such a juxtaposition is called *collision montage*. A montage is a carefully calculated juxtaposition of two or more separate event images that, when shown together, combine into a larger and more intense whole.[1] You can also create video/audio montages, in which the audio event either parallels or counters the basic theme of the video event.

You need to realize that complexity editing does not imply that there are no sequencing rules. Ignoring the conventions and rules of continuity editing will not automatically lead to an event intensification, but more likely to viewer confusion. Exactly when and how to break the rules of continuity for effective complexity editing requires, first and foremost, a thorough knowledge of the rules, plus your deliberate judgment.

With the vector concept, you might now be even a little ahead of some of the video editors. At least one of the Triple-I editors felt that way. He told you that now he finally knows the reasons for what he has been doing intuitively for quite some time. Quite a compliment for an intern who is just beginning to learn the art of postproduction editing! Knowing the principles of editing will also help you greatly in understanding how to work the switcher for instantaneous editing, and the actual postproduction editing procedures discussed in chapter 11.

1. See Herbert Zettl, *Sight Sound Motion*, 2d ed. Belmont, Calif.: Wadsworth Publishing Co., 1990, pp. 299–330. See also Steven D. Katz, *Film Directing Shot by Shot.* Studio City, Calif.: Michael Wiese Productions, 1991.

ONCE AGAIN, REMEMBER...

Editing Functions

The basic editing functions are to combine various shots, condense footage, correct production mistakes, and build a show from various shots.

Continuity Editing

Continuity editing means to create seamless transitions from one event detail (shot) to the next.

Mental Map

Editing must help the viewer construct a mental map of where things are, where they should be, and where they are moving, even though only certain parts of the scene are shown in successive shots.

Vectors

Index and motion vectors can be continuing (pointing or moving in the same direction), converging (pointing or moving toward each other), or diverging (pointing or moving away from each other).

Vector Line

The vector line is established by extending converging index vectors or extending a motion vector. To maintain position and directional continuity, the camera must shoot from only one side of the vector line. In multicamera use, all cameras must shoot from the same side of the vector line.

Complexity Editing

Complexity editing frequently violates continuity principles, such as crossing the vector line, to intensify the screen event. The jump cut and jogging are employed as energizing devices.

KEY CONCEPTS

- Editing means selecting significant event details and putting them into a specific sequence in order to tell a story with clarity and impact.

- The condensing function of editing requires a recognition of event essence and the selection of shots that best express this essence.

- Careful attention to preproduction and production details can avoid most corrective editing.

- Continuity editing means preserving the location and motion of objects over a series of shots in order to help the viewer establish and maintain a mental map of where things should be or where they should move.

- Graphic, index, and motion vectors play an important part in establishing and maintaining continuity from shot to shot.

- To maintain on-screen positions and vector continuity, both cameras must be kept on the same side of the vector line.

Program Bus The bus (row of buttons) on the switcher, with inputs that are directly switched to the line-out.

Mix Bus Rows of buttons that permit the mixing of video sources, as in a dissolve or super. Major buses for on-the-air switching.

Fader Bar A lever on the switcher that activates buses and can produce superimpositions, dissolves, fades, keys, and wipes of different speeds.

Preview Bus Rows of buttons that can direct an input to the preview monitor at the same time another video source is on the air.

Downstream Keyer A control that allows the title to be keyed (cut in) over the picture (line-out signal) as it leaves the switcher.

Special-Effects Controls Buttons on a switcher that regulate special effects. They include buttons for various keys, wipe pattern selections, and digital video effects.

Clip Control Adjusts the luminance signal so that the title to be keyed appears sharp and clear.

M/E Bus A single bus that can serve mix or effects functions.

Linear Editing System Uses videotape as the recording medium. It does not allow random access of shots.

Nonlinear Editing System Allows random access of shots. The video and audio information is stored in digital form on computer disks.

Edit Controller A machine that assists in various editing functions, such as marking edit-in and edit-out points, rolling source and record VTRs, and integrating effects. This is often a desktop computer with a specific software program. Also called *editing control unit*.

Pulse-Count System An address code that counts the control track pulses and translates this count into elapsed time and frame numbers.

SMPTE Time Code A specially generated address code that marks each video frame with a specific number (hour, minute, second, frame of elapsed tape).

Window Dub A dub of the source tapes to a lower-quality tape format with the address code keyed into each frame.

Off-line Editing Refers to an editing process that will not produce an edit master tape. Equipment is used to produce a rough-cut or simply an edit decision list.

EDL Stands for edit decision list. It consists of edit-in and edit-out cues, expressed in time code numbers, and the nature and transitions between shots.

On-line Editing Produces the final high-quality edit master tape. High-quality VTRs are used for on-line editing.

Switching and Postproduction Editing

JUST **when you have mastered some major terms** of editing aesthetics, you are bombarded with another set of editing lingo: "downstream keyer," "linear and nonlinear," "off-line and on-line," "EDL," "AB-roll editing," "window dub," "assemble and insert editing."

But don't worry—once you put your aesthetic theory into practice and actually operate a switcher or do some postproduction editing, these terms will quickly become part of your routine production language. Keep in mind that all these terms and the dazzling variety of editing equipment are created to help you apply the basic aesthetic principles you have just learned in chapter 10. In this chapter, we will discuss these major topics—

■ **SWITCHING, OR INSTANTANEOUS EDITING**
Basic switcher layout, expanded and multifunction switchers, and switcher operation

■ **POSTPRODUCTION EDITING**
Linear and nonlinear systems, editing preparations, off-line and on-line editing procedures, and desktop video

SWITCHING, OR INSTANTANEOUS EDITING

Switching means that you select and join various video sources (such as the pictures supplied by two or more cameras) with various transitions (cuts, dissolves, wipes) while the production is going on. The *production switcher*, which is primarily used in multicamera studio productions or in large field productions, makes such instantaneous editing possible. There are also switchers that are used primarily in *postproduction*, where they function more as transition makers between two shots than shot selectors, or as devices that create and mix a variety of effects in the postproduction process.

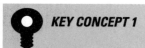

KEY CONCEPT 1 **Switching means instantaneous editing from simultaneously available video sources.**

Let's take a close-up look at (1) basic switcher layout, (2) the expanded switcher, (3) multifunction switchers, and (4) switcher operation.

Basic Switcher Layout

The *production switcher*, which you will find in production studios and large remote trucks, is specifically designed for instantaneous editing. At first glance, the production switcher looks as complex and complicated as a large audio console. But, similar to the audio console, the basic layout principle is relatively simple.

The Triple-I TD feels that the best way to understand the functions of a switcher is to build one—at least theoretically. So, he sits down with you and starts drawing the buttons and levers necessary to perform the normal switcher functions.

Program bus To select and connect certain shots, you need several *video inputs*. If all you had were two cameras and you simply wanted to cut (instantaneously switch) from one camera to the other, you could get by with only two switcher buttons—one that activates camera 1, and another for camera 2. By pressing the C-1 (camera 1) button, camera 1 would be put "on the air"; it would go to the line-out and from there to the videotape recorder and/or the transmitter.

Because you would probably want to select from additional video sources, which are labeled on your switcher "VTR," "CG," and "rem" (for remote), you already have five buttons in your switcher row, called a *bus*. To quickly dump the video and to "cut to black," you need still another button, called the *black button*. Your switcher now has six separate buttons in a single bus. By pressing any one except the black button, the designated video source will be put on the air; the black button takes it *off the air*. SEE 11.1 This bus, which sends the chosen video source directly to the line-out, is called the *program bus*.

Mix bus If you now want to *mix* two video sources (as in a dissolve, for example) don't you need two additional buses and some kind of lever to change gradually from one picture to the other? Yes, you do. They are called *mix buses;* the levers that switch from one bus to the other are the *fader bars*. As you can see, your "simple" switcher is getting a little bigger and slightly more complex. You now have a switcher with three buses: the program bus and the two mix buses. Note that the

11.1

SIMPLE PROGRAM BUS

Whatever button is punched up on the program bus goes directly to the line-out.

| Program bus | blk | C-1 | C-2 | VTR | CG | rem |

program bus now needs an additional button—"mix"—with which you can transfer the program bus functions to the mix buses. **SEE 11.2**

Preview bus Before putting the selected shots on the air, you will undoubtedly want to see whether the shots cut together properly—whether the sequence fulfills your aesthetic continuity or complexity editing requirements. You may also want to see whether a superimposition has the right mix of the two images. Your previewing requires more switcher buttons and monitors that let you see the various video choices and what is finally sent to the line-out. To preview the sources, the program bus buttons are simply repeated in an additional bus, appropriately called the *preview bus*. **SEE 11.3** As you can readily see, the number of buttons and buses has increased considerably. But since you now know what these buttons are for, they are no longer as bewildering as when you first glanced at an actual switcher.

11.2

MIX BUSES AND FADER BAR ADDED

The mix buses (A and B) enable the mixing of two video sources, such as in a dissolve or superimposition. The fader bar gradually activates either bus A or bus B, depending on how far it is moved toward either bus. In this case, bus B is activated. The program bus has an additional button ("mix") that assigns the switching to the mix buses.

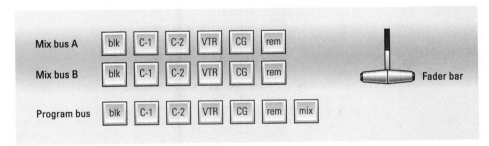

11.3

PREVIEW BUS

The preview bus lets you preview an upcoming source or effect before it is punched up on the air. The preview bus is identical to the program bus, except that its output goes to the preview monitor, not to the line-out.

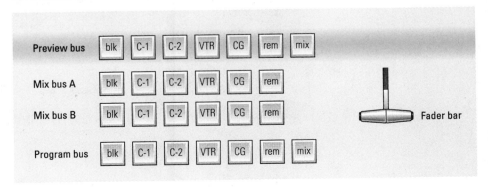

The Expanded Switcher

You may be wondering how we can perform such special-effects operations as keying, chroma keying, and the various wipes. Yes, you are quite right: your switcher needs still more buttons, levers, and controls to perform such feats. For instance, to accomplish a horizontal wipe from camera 1 to camera 2, you will need still two more buses, called *effects buses*, and an additional fader bar that lets you control the speed of the effect. You also need a cluster of buttons, called *wipe selectors*, that let you choose among a number of different wipes. To activate and preview the effects buses, you need an additional effects button—labeled "eff"— on the program bus, on the preview bus, and on each of the mix buses. **SEE 11.4**

Is that it? After all, this "simple" switcher is getting quite complicated. Not quite. You still need to add a **downstream keyer**, which lets you key in titles just when the line-out picture is leaving the switcher; **special-effects controls**, such as the *chroma key* and *color background* that can colorize the keying background without any external light changes; and a *key level control*, or **clip control**, that helps you adjust the brightness or color difference between the background and the video that is being keyed into the background (such as lettering) so that the edges of the key do not tear—loose their sharp edge—during the keying. Most switchers have a *cut* or *take* button that lets you switch between two preset video sources (such as cameras 1 and 2) by repeatedly pressing the same button, and one or more joysticks that let you position an effects pattern in a specific screen area. **SEE 11.5**

11.4

EFFECTS BUSES AND EFFECTS FADER BAR ADDED

In order to achieve such effects as wipes and keys, two effects buses are added. The effects fader bar operates similarly to the mix fader bar, gradually activating either effects bus A or effects bus B. Note that all other buses have effects buttons added, which activate the effects buses. The effects buses, in turn, have mix designation buttons added.

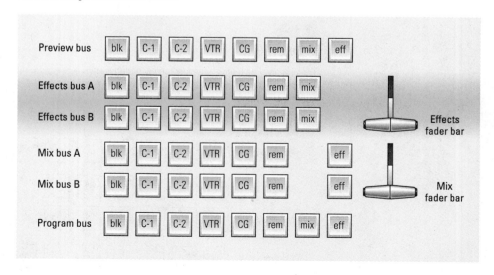

MULTIFUNCTION SWITCHER

Most production switchers combine the mix and effects buses through delegation controls. They also have additional controls, such as a downstream keyer, wipe and key controls, and joystick positioners.

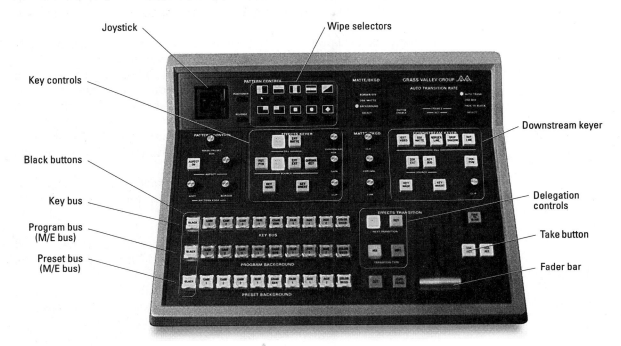

Joystick · Wipe selectors · Key controls · Black buttons · Key bus · Program bus (M/E bus) · Preset bus (M/E bus) · Downstream keyer · Delegation controls · Take button · Fader bar

Multifunction Switchers

To keep the switchers from getting too large and to keep the number of buses and fader bars to a manageable minimum, the buses are often made to perform several functions. Rather than having separate mix and effects buses, they are combined in *M/E buses*, which can be assigned to perform both functions. In fact, even the program bus can be made to perform several switching functions.

Program bus For example, the program/background bus of the switcher (as shown as the middle bus in figure 11.5) serves four functions: (1) that of a *direct switching bus*, which means that whatever you punch up on the program bus will *always* go to the line-out, and thus on the air; (2) as temporary *mix bus* A, with the bus below, called the *preset bus*, serving as temporary mix bus B. In this "mix" mode, you can now perform fades, dissolves, and supers between the program bus and the preset bus; (3) as temporary *effects bus* A, with the preset bus representing a temporary effects bus B; and (4) as *background* for the key source (such as a title) selected by the key bus above the program bus.

Delegation controls The various functions are assigned by pressing one of the *delegation buttons* in the "effects/transition" section of the switcher. But the

assignment of the program bus is *temporary*, because at the end of a dissolve or wipe, the new video source (which was punched up on the preset bus), *jumps back* up to the program bus, releasing the preset bus for a new source to which you can dissolve or wipe. Thus, the video on the air *always comes from the program bus*, regardless of what functions are assigned to it. All mix and effects transitions flow *from* the program bus *to* the preset source, but end up again with the program bus.

Preview bus What happened to the preview bus? Yes, it too has been eliminated. The multifunction switcher is designed to automatically route all sources that are punched up on the preset bus to the preview monitor, and to let you preview an effect simply by holding down a specific delegation button, or by pressing a specific preview button. As you can see, we have now reduced the six buses to three, and eliminated one fader bar.

All production switchers, including digital ones and the switching software used for desktop computers (the Video Toaster,™ for example), operate on this multiple-function principle.

Large computer-assisted production switchers have many more special-effects capabilities and a memory that lets you store and recall especially complicated effects.

Postproduction switchers *Postproduction switchers* are more concerned with the creation of various transitions and effects than with the instantaneous selection and sequencing of video sources. They are often connected via computer to the editing equipment so that they can carry out the computer's transition instructions. You can, of course, use a postproduction switcher for on-the-air switching, but it is not as user-friendly as the production switcher for this function. The desktop software for postproduction switching is obviously designed more to function as transition maker and special-effects generator than on-air production switcher.

KEY CONCEPT 2 **Switchers allow the selection of multiple video inputs and the immediate creation of various transitions and effects.**

Switcher Operation

It's time now for you to press a few buttons and learn how to select and mix various video inputs. Because multifunction switchers are more complicated in their design "architecture," and it is less obvious why you need to perform a certain maneuver to achieve a specific transition or effect, it might be easier to learn the basics of switching on the relatively simple switcher we have just designed and then show the differences of operating the multifunction switcher. You will then be briefly introduced to the basic switching procedures of the multifunction switcher.

Working the program bus: cuts-only As you recall, the program bus is basically a selector switch of video sources for the line-out. Whatever button you press on the program bus will send its designated video source to the line-out. For instance, if your director says "Ready one," you should be prepared to press the

11.6

SWITCHING ON THE PROGRAM BUS

If you do your switching on the program bus, all transitions will be cuts-only.

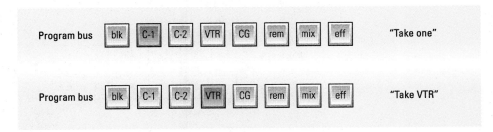

C-1 button on your program bus. On the "Take one" command, you press the C-1 button and send the camera 1 video to the line-out. To cut from camera 1 to the VTR, you would simply press the VTR button on the program bus: "Ready VTR" (put your finger on the VTR button); "Take VTR" (press the VTR button). The C-1 image will instantly change to the VTR video. To help you keep track of which video source is on the air, the button you press normally lights up. **SEE 11.6**

The program bus works in exactly the same way on our multifunction switcher. Whatever button you press on the program/background bus, located in the middle of the three buses, will be sent to the line-out and appear on the air (refer to figure 11.5).

 KEY CONCEPT 3 **The program bus sends the selected video inputs directly to the line-out. It is a cuts-only device.**

Working the mix buses: cuts, dissolves, supers, and fades Couldn't you also perform such cuts on the mix buses? Yes, but only if you have pressed the mix button on the program bus and thus activated one of the mix buses. Take a look at the next figure. Assuming that the mix button on the program bus is pressed, what would happen if you now pressed the C-1 button on mix bus A? Nothing. The reason is that the fader bar is in the down position, activating bus B rather than bus A. **SEE 11.7** What can you do to get camera 1 on the air by using the mix buses? You can either press the C-1 button on mix bus B (which is activated by the fader bar being in the bus B position), or move the fader bar up into the bus A position. **SEE 11.8** Once a mix bus is activated, it functions just like a program bus.

To dissolve from C-1 to C-2 with a temporary overlap of the two images, you will need to have C-1 punched up on bus A, with the fader bar in the bus A position. This puts the C-1 picture on the air. **SEE 11.9A** While the C-1 picture is on the air, you need to punch up C-2 on bus B. There will be no cut from C-1 to C-2 because bus B is not activated (the fader bar is still in the A position). By gradually moving the fader bar down from the A to the B position, you will make the C-1 picture gradually fade and the C-2 picture gradually appear. When the fader bar is in the B position, the C-1 picture will have disappeared, with the C-2 picture

11.7

MIX BUS B ACTIVATED

To activate bus B, the mix delegation button on the program bus must be punched up and the fader bar down in the B position.

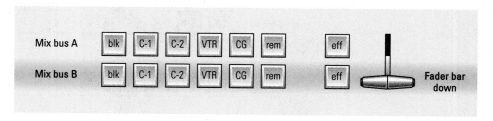

11.8

MIX BUS A ACTIVATED

To activate bus A, the mix delegation button on the program bus must be punched up and the fader bar up in the A position.

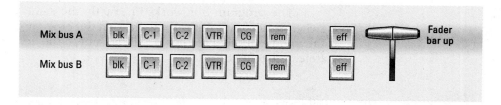

at full strength. **SEE 11.9B** With the fader bar in the middle, you will see both pictures at about half, yet equal, strength—you have a superimposition. **SEE 11.9C**

When moving the fader bar from bus B, on which the black button is punched up, to bus A, whose C-2 button is punched up, you get a gradual fade-in of C-2 from black. **SEE 11.10A** If you now pulled the fader bar down again from the A position (with C-2 on the air) to the B position (with the black button punched up), you will gradually fade to black. **SEE 11.10B**

In the mix mode, the multifunction switcher differs considerably from our basic switcher design.

Most importantly, the *fader bar no longer activates a bus,* but simply causes a gradual transition from the video source punched up on the program bus to the new video source selected on the preset bus. If you now want to dissolve from C-1 (punched up on the program bus and, therefore, on the air) to C-2, you need to press the C-2 button on the preset bus, then press the mix and background delegation buttons, and move the fader bar either up or down, or press the auto transition button. Even if the program bus serves temporarily as mix bus A (with the preset bus functioning as mix bus B), moving the bar will not transfer the switching function to the preset bus, but simply activate the dissolve. As soon as the dissolve from C-1 to C-2 is finished, C-1 (which was punched up on the program bus) will now be replaced by C-2 *on the program bus,* thus freeing the preset bus

11.9

DISSOLVE

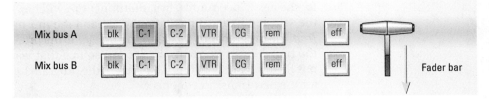

A To achieve a dissolve from camera 1 (on-the-air on mix bus A) to camera 2 (punched up on the deactivated mix bus B), you gradually pull the fader bar from the A position down to the B position.

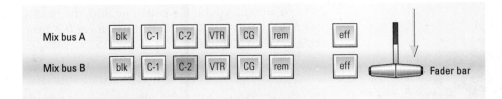

B This gradually activates bus B while deactivating bus A.

C When the fader bar is stopped midway, you have a super.

11.10

FADE-IN AND FADE-OUT

A To fade-in camera 2, you must have pressed the black button on the activated bus B, and then press the camera 2 button on the deactivated bus A. By moving the fader bar to the A position, camera 2's video gradually appears.

B By moving the fader bar back to the B position, you fade to black.
In effect, you dissolve from camera 2 to black.

for the next video source. In a multifunction switcher, the program bus always puts the selected image directly on the air, and the mix and wipe effects always move *from* the program bus (background image) *to* the preselected (preset) source. Once the transition is finished, the second source that was punched up on the preset bus (in our case, C-2) jumps back up to the program bus and is now the base picture for the new transition or effect.

With C-2 on the air, how can you now fade to black? You simply press the black button on the preset bus and move the fader bar in the other direction (regardless whether you move it toward or away from the program bus), or press the auto transition button. As soon as your fader bar reaches the other end point (or your auto transition the end of its run), the black command is transferred back to the program bus. The black button on the program bus has automatically replaced the C-2 button.

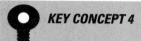

KEY CONCEPT 4 **Mix buses (or buses in the mix mode) let you do cuts, dissolves, superimpositions, and fades.**

Working the effects buses: wipes and keys To achieve a horizontal wipe on our switcher from C-1 to remote, you need to punch up first the horizontal wipe pattern, then C-1 on effects bus B, and, finally the remote button on effects bus A. By pressing the effects button on the program bus, you simply transfer C-1 from mix bus B to effects bus B. You will not notice this transfer on the monitor. When you now move the effects fader bar into the effects A position, you wipe from C-1 to the remote video. **SEE 11.11**

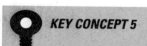

KEY CONCEPT 5 **The effects buses can accomplish various wipes, keys, and special effects.**

With the multifunction switcher, the various *wipe patterns* are accomplished exactly like a dissolve, except that you now need to select a wipe pattern from the wipe selector section, and press the background and wipe delegation buttons in the effects/transition section of the switcher. Moving the fader bar will activate the wipe and control its speed. The auto transition button will accomplish the wipe in the time specified. Again, once the wipe is accomplished, the second video source wiped to (as selected on the preset bus) will immediately transfer to the program bus.

Keying is a little more involved. Basically, you select the key source, such as a title from the C.G. and the background picture over which the title is to be keyed (usually the picture displayed by the line monitor). With the key controls, you can then cut the title into the base picture. With the downstream keyer, you can still key an additional title over the complete video image as it leaves the switcher.

11.11

EFFECTS SWITCHING

To achieve a wipe from camera 1 to the remote video, you need to press the camera 1 button on effects bus B and remote on effects bus A. By pressing the effects designation button on mix bus B, you activate effects bus B. What you are actually doing is cutting from camera 1 on the mix bus to camera 1 on the effects bus, which remains unnoticeable. Assuming that you have previously selected the desired wipe pattern, you can now activate the wipe by moving the effects fader bar to effects bus A.

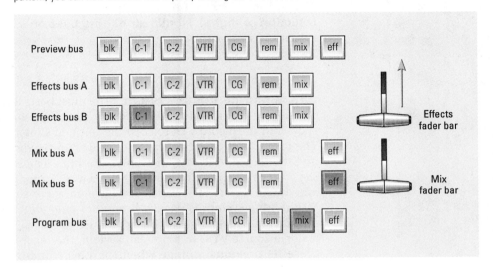

POSTPRODUCTION EDITING

Postproduction editing comprises the third and final stage of the production process. Assuming that your preproduction and production phases went according to plan, you can now select the various video and audio pieces and put them together to give the production its final shape. Some editors feel that postproduction editing is one of the most creative aspects of video production.

Postproduction editing is an exacting and painstaking activity. But you are far ahead of the game. By knowing the aesthetic principles of editing, you can now concentrate on the major operational aspects of postproduction: (1) linear and nonlinear editing systems, (2) editing preparations, (3) off-line and on-line editing, (4) off-line procedures, (5) on-line procedures, and (6) desktop video.

Linear and Nonlinear Systems

Whenever you use VTRs in the process, you have a *linear editing system*, whether the signal on the videotape is analog or digital, and whether the VTRs are run by a simple edit controller or a complicated computer program. Just to refresh your memory, videotape recording is linear when you cannot access the source material randomly. As you recall from chapter 9, you cannot directly call up shot 3 without first rolling through shots 1 and 2. For example, if you now want to edit

shot 14 to shot 3, you must roll through the next ten shots from shot 3 before you can get to shot 14.

With a *nonlinear editing system*, which normally uses large-capacity hard drives, you can call up shot 3 or shot 14 directly and independently of all other shots. Nonlinear systems work exclusively with *digital video and audio* information.

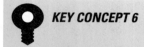

KEY CONCEPT 6 **The use of VTRs designates linear editing, whether the recording is analog or digital. Nonlinear editing uses only digital information stored on hard drives.**

Single-source linear system The most basic linear editing system consists of a *source VTR* and a *record VTR*. You use the *source VTR* to select the various shots and the record VTR to copy the selected shots and join them through cuts. The record VTR performs the actual video and audio edits. Both the source VTR and the record VTR have their own monitors. The source VTR monitor displays the source material to be edited; the record VTR monitor displays the edited video and audio. **SEE 11.12** Because you have only one source VTR, the single-source VTR editing system is usually limited to *cuts-only* transitions. There are some *preread* systems that allow you to produce dissolves, supers, and wipes with only a single source VTR. In a preread system, the record VTR will not automatically erase its previous footage when the new source video arrives, but mixes it according to your instructions.

Edit controller The *edit controller,* also called the *editing control unit,* will mark and remember exact frame locations on the source and record tapes, preroll

11.12

BASIC SINGLE-SOURCE SYSTEM

The source VTR supplies the chosen sections of the original video and feeds it to the record VTR. The record VTR copies the selections and joins them in the desired sequence through cuts. The source monitor displays the video of the source VTR, and the record monitor the video of the record VTR.

Source VTR and monitor Record VTR and monitor

and synchronize the VTRs, determine whether the audio should be treated with the video or separately, and tell the record VTR when to switch into the record mode—thereby performing the edit. Sophisticated edit controllers will also activate switchers and audio consoles for various video and audio effects. The normal edit controller has separate operational controls for the source and record VTRs (play, fast forward, rewind, variable search speeds) and for various common editing controls. **SEE 11.13**

Most edit controllers will perform these specific tasks:

▶ Control VTR search modes (variable forward and reverse speeds) separately for the source and the record VTRs to locate shots.

▶ Read and display elapsed time and frame numbers from either a pulse-count or an address code system for each VTR. (You will learn more about the address code later in this chapter.)

▶ Mark and remember precise edit points (in- and out-cues).

▶ Back up, or "backspace," both VTRs exactly to the same preroll point. On some editing control units, you will find a switch that gives you several preroll choices, such as a two-second or a five-second preroll. You may recall that prerolling the VTRs ensures that the tapes have achieved the proper speed and that all electronic circuits are operating as they should.

▶ Simultaneously start both machines and keep them running in sync.

▶ Run a trial edit so that you can preview it before telling the record VTR to perform the actual edit. This *preview* edit will appear on the monitor for the record (edit) VTR, although the record VTR has not yet performed the actual edit.

▶ Rewind the record VTR so that you can review the completed edit. The edited shots will again appear on the monitor of the record VTR, but this

11.13

EDIT CONTROLLER

The edit controller has separate operational controls for the source VTR and the record VTR, such as search and shuttle controls. The controls in the center activate the preroll and editing functions.

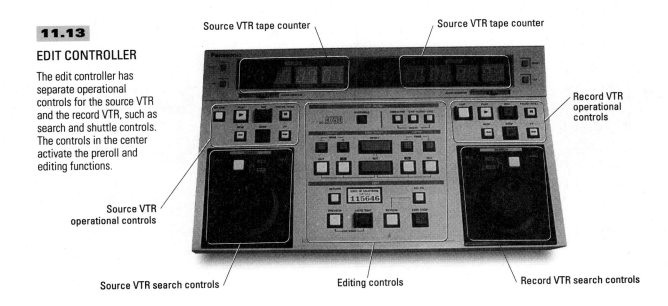

Source VTR tape counter

Source VTR tape counter

Record VTR operational controls

Source VTR operational controls

Source VTR search controls

Editing controls

Record VTR search controls

time the edit has actually been completed. You can now *review*, instead of preview, the edit.

▶ Tell the record VTR to edit either the video or audio track—or both. The actual edits will be performed by the record VTR.

▶ Make the record VTR perform either in the assemble or insert edit mode. (You will learn more about assemble and insert editing later in this chapter.)

▶ Permit expansion of the system by interfacing more source VTRs and special-effects equipment.

The diagram below shows how the edit controller fits into the single-source editing system. **SEE 11.14**

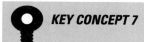

KEY CONCEPT 7 **Most single-source VTR editing systems are limited to cuts-only transitions.**

Multiple-source linear system This system uses two or more VTRs as source machines, normally labeled with letters (A-VTR, B-VTR), and a single record VTR.

With a multiple-source VTR system you can mix the shots from the A and B (and/or C) VTRs without having to change tapes. The big advantage is that you are no longer restricted to cuts-only transitions. You can now expand the transitions between the "A-roll" (the material on the source A VTR) and the "B-roll" (the material on the source B VTR) to dissolves and a great variety of wipes. To accomplish such transitions between the A-roll and the B-roll, you need to feed their video material into a postproduction switcher that will perform the actual switching function.

11.14

EDIT CONTROLLER IN SINGLE-SOURCE SYSTEM

The edit controller in a single-source system starts and synchronizes the source and record VTRs, locates the in- and out-points for both VTRs, and activates the audio mixer for audio mixing.

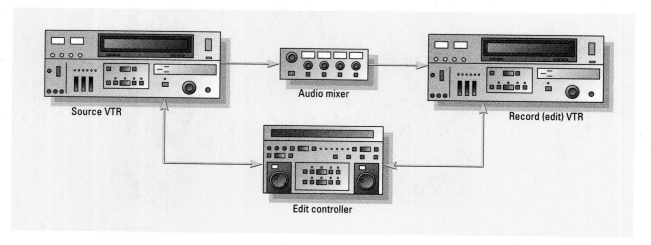

Source VTR

Audio mixer

Record (edit) VTR

Edit controller

Its line-out is then recorded by the record VTR. You can also feed special effects into the switcher for a great variety of transitions.

The edit controllers for such multiple-source systems are usually computer-driven. The computer will not only remember your various commands, such as shot selection from A- and B-rolls, type and length of transition, or special effects, but also make the source VTRs, the switcher, and the SEG (special-effects generator) perform various feats. The audio mixer—or, in larger productions, an audio console—allows you to control the volume of the different sound tracks and to mix in additional sounds. **SEE 11.15**

11.15

MULTIPLE-SOURCE EDITING SYSTEM

In a multiple-source system, two VTRs (A and B) supply the source material to the single record VTR. The video output of both source machines is routed through the switcher for various transitions, such as dissolves and numerous wipe effects. The audio output of both source VTRs is routed through an audio mixer (or console). Multiple-source systems are usually managed by a computer-driven edit controller.

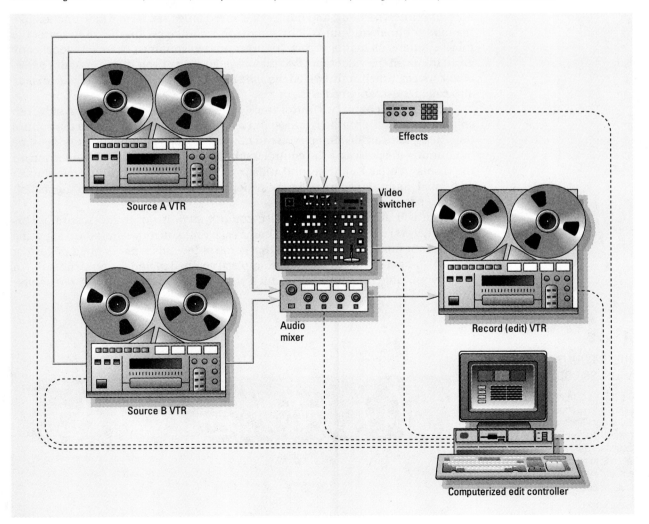

Effects

Source A VTR

Video switcher

Audio mixer

Source B VTR

Record (edit) VTR

Computerized edit controller

Note that despite the important part the computer plays, the editing is still linear: it uses videotape instead of some other nonlinear storage device, such as a large-capacity hard drive. If you have the feeling that things get a bit more complicated than what you expected from a discussion of video "basics," you are right. Postproduction editing is not only a formidable aesthetic challenge; it is also technically complex. Even so, postproduction editing is not unlike operating your desktop computer: once you have learned how to operate it, its technical complexity helps rather than hinders you in accomplishing many tasks.

KEY CONCEPT 8 **Multiple-source editing systems expand the transitions from cuts-only to dissolves and a great variety of wipes and special effects.**

Pulse-count and address code When you look at the edit controller, you see number displays for the source tape and for the record tape. The displays show hours, minutes, seconds, and frames of elapsed tape. **SEE 11.16** They function like the tape counters on your VCR or audiotape recorder, except that they are a little more accurate. As matter of fact, for exact editing you must be able to locate any given frame on the videotape. Two major systems assist you in this task: the *pulse-count system*, which is also called the *control track system;* and the *time code system*, also called the *address code system.*

The pulse-count, or control track, system uses the control track pulses to count and mark the various frames. You remember that each pulse on the control track designates a video frame; you can now locate a specific spot on the videotape by counting the pulses on the control track. Thirty frames make up one second on the display, so each new second rolls over after the twenty-ninth frame. Each additional minute is generated by the sixtieth second, as is the hour after the sixtieth minute. **SEE 11.17**

You will discover that the pulse-count system is not frame-accurate. This means that you will not get the same frame each time you move the tape to a specific pulse-count number. The reason is that some of the pulses are skipped or get lost in the high-speed tape shuttle. For example, if you had to find the tenth house on a street, you would have no trouble. But if you asked to go to the 3,600th house, you

11.16

PULSE-COUNT OR ADDRESS CODE DISPLAY

The pulse-count and address code displays show elapsed hours, minutes, seconds, and frames. The frames roll over (to seconds) after twenty-nine, the seconds to minutes and minutes to hours after fifty-nine, and the hours to zero after twenty-nine.

Hours Minutes Seconds Frames

11.17

PULSE-COUNT SYSTEM

The pulse-count, or control track, system counts the control track pulses to mark a specific spot on the videotape. Each thirty pulses make up one second of elapsed tape time.

Control track 15 pulses = ½ second 30 pulses = 1 second

would probably have quite a bit more difficulty finding it. Considering that 3,600 pulses constitute only two minutes of videotape recording, you may understand why the counter may be off a few frames when trying to find a specific spot some twenty or more minutes into the tape. Because this system begins to count from whatever starting point you assign, make sure that you *rewind the tape completely* and *set the counter to zero* before logging or editing.

The advantage of the pulse-count system is that it is quite fast and does not need a special address code generating and display device. For that reason, the pulse-count system is extensively used in editing news.

For more accurate editing, you have to use a *time code* or *address code* system. This system marks every single frame with a different number, and gives each frame a specific address. For example, to get to the tenth house, you would not have to count the previous nine, but could simply read the number 10 address. You could find the 3,600th house just as easily by looking at its house number. The most widely accepted address system is the **SMPTE time code** (pronounced "Sempty time code"); its full name is *SMPTE/EBU* (Society of Motion Picture and Television Engineers/European Broadcasting Union) *time code*. It gives each frame a specific address, which you can locate by looking at the read-out on the edit controller or on the computer display. **SEE 11.18** There are other similar time codes, but they are not compatible with the SMPTE code, and you cannot hook up and synchronize with other equipment that does not use the SMPTE time code.

11.18

TIME CODE ADDRESS SYSTEM

The time code system marks each frame with a unique address.

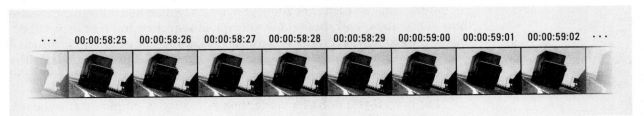

··· 00:00:58:25 00:00:58:26 00:00:58:27 00:00:58:28 00:00:58:29 00:00:59:00 00:00:59:01 00:00:59:02 ···

Regardless of where you start the videotape, the time code will faithfully and accurately find the frame requested. You can use the same time code for your audiotape, and you can have the computer match audio and video frame by frame. The disadvantage of the time code address system is that you need a special time code generator to record the time code on videotape or on one of the audiotape tracks, and a special reader to display it. But for accurate editing, you can't do without it.

You can record the time code while videotaping, or (as is common in smaller productions and EFP) add it later to one of the cue tracks or audio tracks of your videotape. Because videotape segments rarely exceed one hour, the hour digit is generally reserved to indicate the tape (or reel) number. For example, a time code of 04:17:22:18 would mean that the shot you are seeking is 17 minutes, twenty-two seconds, and eighteen frames into tape (or reel) number 4. This labeling is an added protection so that you can find the right reel even if the physical labels have come off the tape or—more commonly—were never put on it.

Editing Preparations

As with all other production activities, editing requires diligent preparation. The only editing where preparations are kept to a minimum is in news. There is no way you can predict the number and nature of stories you may have to edit every day, and you always have precious little time to make deliberate editing decisions. All you can do in this situation is try to select the most telling shots and sequence them into a story according to established continuity principles. News operations use single-source pulse-count systems almost exclusively for their daily new editing; they are much faster than the more accurate multiple-source time code systems.

Although all other productions allow you more time for postproduction, you will always wish you had more editing time. To make the best use of available editing time, you need to pay attention to these *editing preparations:* (1) shooting with continuity in mind, (2) making protection copies, (3) adding time code to the source tapes, (4) making a window dub, (5) reviewing and logging source tapes, (6) transcribing audio text, and (7) laying a control track on the edit master tape.

Shooting phase It may sound strange, but your postproduction process starts in the shooting phase. Good directors and camera operators have the ability not only to visualize each shot and give it a composition and meaning, they also think ahead about how these shots will look in sequence and how they will cut together. In complicated productions, such as dramas or carefully constructed video essays and commercials, sequencing is determined by a storyboard. The *storyboard* shows not only key visualizations, but also the major sequencing of the shots. **SEE 11.19**

But even if you don't have the time or luxury to prepare a storyboard, you can still facilitate postproduction editing by using the following list of tips during production:

11.19

STORYBOARD

The storyboard shows key visualizations and the major sequencing points, with action and audio information given below. It can be hand-drawn on special storyboard paper or computer-generated.

SC 1 — FADE IN — DISS TO

ACTION: LONG SHOT — DRAMATIC

The SUN rises behind a picturesque WINDMILL.

SC 2 — DISS TO

ACTION:

The light gleams through the windmill blades.

We hear: DISTANT JINGLING.

SC 3

ACTION:

MATCH CUT TO:

SC 3

ACTION: CLOSE ON A SILVER HARNESS-BELL

Slightly tarnished. It JINGLES from the motion of the horse. The sun gleams on its surface, the cross-cut of the bell's face reminiscent of the blades of the windmill.

SC 4

ACTION: WIDE — DRAMATIC

DON QUIXOTE and SANCHO PANZA ride toward camera, the bell on Don Quixote's harness JINGLING as his makeshift armor CLATTERS.

SC 5

ACTION:

D.Q. reacts dramatically to the windmill ahead.

DON QUIXOTE
Lo! The enemy is sighted!

PRODUCTION TIPS TO MAKE POSTPRODUCTION EASIER

☑ *Slate each take* Identify each take with a visual or at least verbal slate. As pointed out in chapter 9, such information is usually done with the C.G., as shown in figure 9.13. In the field, you should have a handheld slate that contains at least the date of the shoot, the tape number, the scene number, and the take (shot) number. If you don't have a visual slate available, slate the various takes verbally. Open the camera or the talent mic and have somebody read the information; record the audio on the videotape. After calling out the take number, count backward from five to zero. This counting helps to locate the approximate beginning of a shot after the slate. Such information will greatly speed up the editing process, especially if your slate is also recorded on a *field log*.

☑ *Leave margins for editing* When videotaping, *do not* stop exactly at the end of a shot, but record a few more seconds before stopping the tape. For instance, if the company president has finished showing the latest CD-ROM program on video production, have her remain silent and in place for a few seconds before cutting the action and stopping the tape. When starting the next segment, have the camera rolling for a brief period before calling for the action, and when finished have everybody remain in place for a few seconds before stopping the tape. Such pads will give you a little more flexibility in deciding on the exact in- and out-points.

☑ *Record background sounds* Always record a few minutes of ambient sound (room tone, traffic sounds, the sounds of silence in the mountains) before changing locations or finishing the taping. This sound will help make silent periods during the edit or within a shot less noticeable.

☑ *Keep a field log* Keep an accurate record of what you tape. Such a record, called a *field log*, should at least show the name of the production, the tape number, the scene number, and the number and subject of each take. Label all tapes and boxes with the tape number and the title of the production. The field log will aid you greatly in locating some of the videotaped material during the first screening. Even if you do your own editing, you will be surprised how quickly you forget on which tape, and just where on the tape, your unforgettable shots are located.

☑ *Tape cutaway shots* Get some cutaways for each scene. A cutaway is a brief shot with neutral vectors that will help improve or establish visual continuity between two shots. The cutaway is usually directly related to the event, such as a bystander looking at a parade or a reporter's camera during a hearing. Make the cutaways *long enough*—at least fifteen to twenty seconds. Cutaways that are too short are almost as frustrating to an editor as getting no cutaways at all. When cutaways are too short, they look more like mistakes than continuity links. When shooting cutaways, always let the camera run for just a few more seconds than you think necessary. The cutaway will now be just about long enough.

Protection copies Your production efforts are wasted if you lose your source tapes or damage them in some way. As pointed out in chapter 9, experienced production people always make protection copies of all source material as soon as possible after the taping. If you shoot in a videotape format that suffers from generation loss during extensive postproduction editing, such as VHS, Hi8, or SVHS, you should "bump up" (dub onto a higher-quality videotape format) your source footage. This dubbing fulfills a dual purpose: it gives you a protection copy of your original source tapes, as well as new high-quality source tapes that will have much less generation loss during extensive postproduction editing.

🔑 *KEY CONCEPT 10* **Always make a protection copy of your original source tapes.**

Adding time code Unless you recorded the time code during the videotaping, you need to add the time code to all source tapes. You do this by "laying-in" the time code signals from a time code generator on the address track of your videotape or one of the audio tracks. You can now set the hour digits of the code so that they match each tape number written on the label.

Window dub When you do your dubbing or make a simple dub for a protection copy, you should simultaneously do another dub, called the *window dub*. This dub is a lower-quality, bumped-down (usually VHS) copy that has the time code keyed over each frame. Each frame displays a box, called a *window*, which shows its time code address. **SEE 11.20** Even if you know which takes are unacceptable, it is usually easier to window-dub all video, regardless of whether the takes are OK or NG (no good). Every once in a while, the video from an initially NG take proves invaluable as a cutaway or substitute shot in the actual editing.

This window dub will now serve you in the accurate logging of all videotaped shots, preparing an *EDL (edit decision list)*, which lists the in- and out-points of each edit, and even in performing a *rough-cut* (a preliminary version of the edit master tape).

Reviewing and logging It is now time for you to make a list of everything recorded on the source tapes, regardless of whether the take was properly field slated and whether the take is usable or not. This log—called a VTR log—will help you locate specific shots without having to preview the source tapes over and over again. Although initially, logging may seem like a waste of time, a carefully prepared, accurate VTR log will save you time, money, and ultimately nerves during the actual editing. Besides the usual data, such as the production title, the

11.20

SMPTE TIME CODE DISPLAY

The time code can be keyed directly into the copy of the source tape for off-line editing. Each frame displays its own unique time code address.

11.21

VTR LOG

The VTR log contains all necessary information about all video and audio information recorded on the source tapes. Notice the notations in the vectors column: *g, i,* and *m* refer to graphic, index, and motion vectors. The arrows show the principal direction of the index and motion vectors. Z-axis index and motion vectors are labeled with ⊙ (toward the camera) or • (away from the camera).

Production Title: **Traffic Safety** Production No: **114** Off-line Date: **07/15**

Producer: **Hamid Khani** Director: **Elan Frank** On-line Date: **07/21**

Tape No.	Scene/ Shot	Take No.	In	Out	OK/ NG	Sound	Remarks	Vectors
4	2	1	01 44 21 14	01 44 23 12	NG		mic problem	⌢ ←
		②	01 44 42 06	01 47 41 29	ok	car sound	car A moving Through sTop sign	⌢ ←
		③	01 48 01 29	01 50 49 17	OK	brakes	car B puTTing on brakes (Toward camera)	⊙ ⌢
		④	01 51 02 13	01 51 42 08	ok	reacTion	pedesTrian reaction	→, i
	5	1	02 03 49 18	02 04 02 07	NG	car brakes ped. yelling	ball noT in fronT of car	⊙⌢ ←⌢ ball
		2	02 05 02 29	02 06 51 11	NG	"	Again, ball problem	⊙⌢ ←⌢ ball
		③	02 05 40 02	02 06 17 03	OK	car brakes ped. yelling	car swerves To avoid ball	⊙↳⌢ ←⌢ ball
	6	①	01 07 01 29	01 08 58 10	ok	ped. yelling	kid running inTo sTreeT	→, i ←⌢ child
		②	02 08 22 01	02 11 37 19	ok	car	cuTaways car moving	⊙•⌢ ↘↙
		3	02 10 05 29	02 10 35 15	NG	sTreeT	lines of sidewalk	↔ g

name of the director, and the production number and date, the VTR log should contain the following information: **SEE 11.21**

▷ tape number

▷ scene number

▷ take number

▷ beginning (in-number) and ending (out-number) of each shot

▷ whether the shot is acceptable or not (If you don't have a designated OK/NG column, you can simply circle the good takes in the third column.)

▷ prominent sounds

▷ special remarks (brief description of the scene or event)

▷ a vector diagram

Although you may not find one in commercially available VTR log forms or computer displays, a vector column provides extremely important logging information. For example, if you need to find a shot with an object moving into the opposite direction from the previous shot, you simply glance down the vector

column and look for the *m* symbol (indicating a motion vector) with an arrow pointing in the opposite direction.

As you can see, the vector notations in figure 11.21 use arrows for the main direction of *g* (graphic), *i* (index), and *m* (motion) vectors. A circled dot ⊙ indicates a z-axis vector toward the camera; a single dot • indicates a z-axis vector away from the camera. If you need a neutral cutaway of somebody looking straight into the camera, you would look for a shot with an *i* ⊙ symbol. Without logging the vectors, you would have had to roll through the source tapes again and again to find the appropriate converging shot. (To refresh your memory, you may want to reread the vector section in chapter 10.)

 KEY CONCEPT 11 **The vector notations in the VTR log facilitate locating shots for continuity and complexity editing.**

There are a variety of computer programs available for logging source tapes. Instead of filling out the log by hand, you enter all vital information on a computer form. Some software allows you to enter actual pictures of the first and last frames of each shot, and this is a great help when locating certain shots. In this case, you can skip the vector column because you can now clearly see the main vectors of the beginning and end frames of the various shots.

The advantage of a computerized log is that you can quickly find a particular scene by entering either the name of the scene or the time code number, and then having it automatically transferred to your final EDL, which will guide the "on-line" (final) sequencing of the edit master tape. When doing some preliminary sequencing, you can copy the log and shift the various entries into the desired sequence.

Transcribing speech Yes, transcribing all speech to typed pages is another time-consuming but important pre-editing chore. Once accomplished, it will definitely speed up your editing. For example, if you need to edit a long interview, or cut a speech so that it fits the allotted time slot, the printed page gives you a much quicker overview than listening to the videotape again. Because it is much less linear than the tape, the printed page lets you go back and jump ahead in the text with great speed. Of course, in news coverage you do not have time for such transcriptions; all you can do is run the tape and take notes about which portions you would like to keep and where in the tape you have to make the cuts.

Recording black Before starting with the actual editing, you must record a black signal *on the tape that is to become the edit master tape*. By recording black, you will also record a continuous control track whose sync pulses are essential as a common reference for precise editing, called insert editing. You will find more about the advantages of insert editing later in this chapter.

Nonlinear editing preparations are pretty much the same as those for linear editing. Because most nonlinear editing systems merely produce an accurate EDL but do not perform the actual editing, you still need to make protection copies of your source tapes. The main task in preparing for nonlinear editing is loading all videotapes onto the digital computer hard drives, a time-consuming affair.

Off-line and On-line Editing

Off-line editing is technically part of editing preparation, because it *does not produce the edit master tape* that represents your finished product. But in off-line editing, you are getting more serious about making actual editing choices than in the preparation phase. The edit master tape is produced in the subsequent *on-line editing*.

Because on-line systems use more sophisticated equipment, "on-line" is often confused with the quality of editing equipment used. High-quality equipment is labeled "on-line," and the lower-quality systems "off-line." However, what really distinguishes off-line from on-line editing is not so much the equipment as the *editing intent*. When you edit a tape for the sole purpose of having some idea what the final product will look like (similar to a "rough-cut" in film), you are engaged in off-line editing. When your editing is intended to produce the final edit master tape from the very beginning, your editing is on-line.

KEY CONCEPT 12 **If the intent is to produce an EDL or rough-cut, the editing is off-line. If the editing produces the edit master tape, it is on-line.**

Off-line Procedures

All *off-line editing* is done to create an *EDL* and occasionally a preliminary videotape (called a *rough-cut*) that serves as a model for the on-line master. It is in the off-line editing phase where there is the greatest difference between linear and nonlinear editing.

Linear off-line procedures The first step in linear off-line editing is to compile a workable EDL, which can then be used as a guide for the on-line editing of the master tape. A simple though not always highly accurate way of doing this is by *paper-and-pencil editing*. This is how it works:

1. Think again of *what it is* you want to tell the viewers. This means going back to the *process message* you originally stated. The actual videotaped material may suggest a slight variation or a restatement of the original process message; but don't let spectacular shots render your original process message obsolete. After all, how can you select and assemble essences if you don't know what the whole thing is all about?

2. *Watch*, once again, all the window-dubbed source tapes and see which shots strike you as especially relevant and effective. This review will not only refresh your memory of what you shot, but may also suggest, however indirectly, a tentative sequence.

3. Think more seriously about *sequencing* the shots. While recalling the process message and the available shots, you should prepare a rough storyboard. Now is the time to take a good look at the VTR log and locate the various key shots. List the pulse-count or time code numbers for the

beginning (in-number) and end (out-number) of each selected shot, as shown in figure 11.21.

4. *Fine-tune* your shot selection and sequencing. Look at each selected shot again and observe carefully the position of people at the beginning and end of each shot and the dominant vectors. For example, if the selected close-ups of two people talking to each other have continuing index vectors, the shots will not cut together. (Remember? Their index vectors need to be converging in the close-ups as they are in the original two-shot.) But don't worry. Simply look at the vector column of your carefully executed VTR log for another shot of person B with an index vector that will properly converge with that of person A. If two shots do not cut together well because of minor continuity problems, find an appropriate cutaway. Yes, your painstaking and careful logging is finally paying off.

5. Decide on the various *transitions* between shots. If you have a single-source system, you have no choice: all transitions will be cuts. But if you have a multiple-source system, your transition considerations are quite important.

6. *Prepare an EDL* (edit decision list). This list looks similar to your initial VTR log. It lists tape number, scene or shot number, the in- and out-numbers (pulse-count or time code), the desired transitions, and the sound. Because the in- and out-numbers designate the first and last frame of each shot, you do not need descriptions of the shot content. Also, the vector column is no longer needed, because you are no longer selecting shots but simply listing them for the editing procedure. The EDL is your road map for actual on-line editing. **SEE 11.22**

11.22

HANDWRITTEN EDIT DECISION LIST

The EDL is the road map for on-line editing. It lists the tape number, the scene and take numbers, the in- and out-numbers for each selected shot, the transitions, and major audio information.

Production Title: __Traffic Safety__ Production No: __114__ Off-line Date: __07/15__

Producer: __Hamid Khani__ Director: __Elan Frank__ On-line Date: __07/21__

Tape No.	Scene/ Shot	Take No.	In	Out	Transition	Sound
4	2	2	01 46 13 14	01 46 15 02	CUT	car
		4	01 51 10 29	01 51 11 21	CUT	car
	5	3	02 05 55 17	02 05 57 20	CUT	ped. yelling—brakes
	2	4	01 51 40 02	01 51 41 07	CUT	ped. yelling—brakes
	6	1	02 07 43 17	02 08 46 01	CUT	brakes

 KEY CONCEPT 13 **The EDL is the road map for on-line editing.**

Nonlinear off-line procedures Nonlinear off-line editing is done entirely by computer. Because the video is no longer stored on tape but compressed on high-capacity hard drives, you can now call up any shot directly by its time code address, without having to roll the videotape back and forth to locate it. Most systems are capable of displaying a variety of frames and running brief sequences so that you can preview the edit and see whether the shots cut together well. Do they fulfill the aesthetics of continuity or complexity editing? The computer will also display the in- and out-numbers and the length of the shot. You can hear the sound track when running the sequence and see it displayed in some visual form on the computer screen. **SEE 11.23**

Once you have located the desired shot, you do not have to rerecord it. You simply assign it a particular place in your program and put it back in its file on the hard drive. As you can see, the hard drive replaces both the source and record VTRs. Because all shots are equally available for sequencing, you no longer need two source VTRs to create dissolves, wipes, or other such transitions; you simply tell the computer what kind of transition you want between two shots, and the computer will faithfully remember and execute it.

Note, however, that the computer does not produce an edit master tape, but simply assigns a specific order to the selected shots and transitions. You are no longer copying parts of the source material onto the edit master tape, as you would do in linear editing, but are *managing* picture and audio computer *files*. The end result of most nonlinear editing is not an edited videotape but an accurate EDL. **SEE 11.24** Some top-of-the-line systems have enough storage capacity to produce images that rival high-quality videotape. Such nonlinear systems merge off-line and on-line editing; their output can be transferred directly to digital videotape and used as edit master tape.

11.23

NONLINEAR EDITING
SCREEN DISPLAY

Despite a great variety of nonlinear computer systems, most displays show at least the in- and out-numbers for each shot, the last frame of the previous shot and the first frame of the following shot, the logged title of the shot, and some kind of visual representation of the audio track.

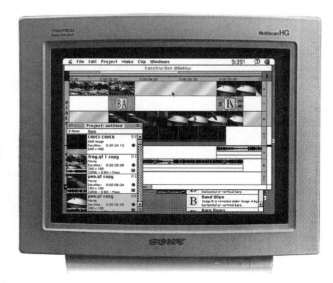

The advantages of nonlinear editing are that you have extremely quick random access to any frame stored on the hard drive. You can display side-by-side the various in- and out-frames of the shots to be sequenced, and you can run brief sequences to see whether they fulfill your aesthetic and storytelling requirements. Much like in word processing, you can easily eliminate some frames, add others, or shift whole sequences from one location to another.

Unfortunately, nonlinear editing has also some drawbacks. One is learning the editing program. You will find that some programs are quite complex and require considerable effort and practice before you can feel comfortable with them. Another is efficiency. You may think that the random access to video and audio makes nonlinear editing much faster than linear editing. Although the selection and sequencing of shots is much faster than in linear editing, you will need a great amount of time when transferring the source tapes to hard drives. Backing up compressed video files (strongly recommended) is also a slow process. Even skilled editors will tell you that, overall, nonlinear editing is usually slower than linear editing—but it is definitely more flexible.

 KEY CONCEPT 14 **Nonlinear off-line editing produces an EDL.**

11.24

COMPUTER-GENERATED EDL

Like the handwritten EDL, the computer-generated EDL contains the event (scene) number, source reel ID (source tape) number, edit mode, transition type, and the in- and out-numbers for each shot.

```
TITLE: TRAFFIC SAFETY
                              Header

001    003    V    C         00:00:03:12  00:00:05:14  01:00:20:01  01:00:22:03
001    004    V    W001 204  00:00:06:24  00:00:12:23  01:00:08:12  01:00:14:11
EFFECTS NAME IS SWING IN

002    004    V    C         01:16:22:03  01:16:29:02  01:00:06:24  01:00:13:25
002    001    V    W003 204  01:18:27:15  01:18:34:09  01:00:06:24  01:00:13:18
EFFECTS NAME IS SWING IN

003    004    V    C         01:18:33:15  01:00:25:14  01:00:13:18  01:00:20:12
003    001    V    W000 204  01:18:38:02  01:18:44:26  01:00:13:18  01:00:20:12
EFFECTS NAME IS SWING IN

004    004    V    C         01:19:10:02  01:19:15:03  01:19:20:12  01:19:25:12
004    001    V    W002 204  01:19:23:19  01:19:30:13  01:00:20:12  01:00:27:06
EFFECTS NAME IS SWING IN

005    004    V    C         01:34:12:02  01:34:16:04  01:00:22:05  01:00:26:06
005    001    V    W011 203  01:50:15:29  01:50:22:22  01:00:27:06  01:00:33:29
EFFECTS NAME IS ZOOM

006    003    V    C         01:52:14:25  01:52:16:05  01:00:33:29  01:00:35:15

007    001    V    C         01:39:08:00  01:39:14:24  01:00:58:15  01:01:05:09
```

Event number	Source reel ID	Edit mode	Transition type	Source in	Source out	Record in	Record out

On-line Procedures

On-line editing will produce the final edit master tape. Most on-line editing is linear, which means that you need one or more source VTRs to play your source tapes and a record VTR for editing the final master tape. As mentioned before, there are some high-quality nonlinear editing systems that can be used for on-line mastering of the final program version. But even then, the edited program stored on hard drives must eventually be transferred to tape or some kind of optical disc (such as a CD-ROM) before it can be distributed and properly played back.

In a way, on-line editing is easier than off-line editing, because the editing decisions have already been made in the off-line process and listed on the EDL. From now on, the EDL guides most of the on-line editing procedures. Sophisticated, computer-driven edit controllers will read the in- and out-numbers off a small floppy disk and perform the final editing more or less automatically.

When engaged in linear editing, you need to decide whether you want to edit in the *assemble* or the *insert* mode.

Assemble editing In *assemble editing*, your record VTR will *erase everything* (video, audio, control, and time code tracks) on its edit master tape in order to have a clean slate before copying the video and audio material supplied by the source tape. During the transfer, everything that is recorded on the selected portion of the source tape will be copied onto the edit master tape, even the control track.

To achieve a stable edit, the record VTR tries to align and space the sync pulses of the various source segments carefully so that they form a continuous control track. **SEE 11.25** Unfortunately, even fairly high-quality VTRs do not always succeed in this task. For example, when you add the control track of the first frame of shot 2 to the last frame of shot 1, their sync pulses may be just a little farther apart or closer together at the edit point than the rest of the pulses. This slight discrepancy will result in a "tear," which means that during playback the picture will break up or roll momentarily at the edit point.

Because *all tracks* of the source tape are transferred onto the edit master tape during each edit, you cannot edit audio separately from the video. Each source section will carry over its own audio track. If you need a new audio track, you can lay it in only after the video portion has been completely edited.

The advantage of assemble editing is that you do not have to record a continuous control track (by recording black) for the edit master tape before the actual editing. You can, if necessary, use a tape for your edit master even if it already has some video and audio material recorded on it (not recommended, by the way). The "flying erase head" in your consumer camcorder will erase the video track exactly at the edit point and thus facilitate a tear-free assemble edit—at least most of the time.

Insert editing *Insert editing* requires the previous recording of a continuous control track on the edit master tape. As pointed out earlier, you do this by recording black on the tape. The recording of black happens in real time, which means that you must run the blank edit master tape for thirty minutes in order to lay a thirty-minute control track. Only now do you have a *truly continuous* guide for the edit points **SEE 11.26**

During insert editing, the record VTR *does not transfer the control track* of the source tape, but places the new shot according to the existing control track.

11.25

ASSEMBLE EDITING

In the assemble mode, the control track of the selected portion is transferred from the source tape to the edit master tape. As you can see, the first sync pulse of shot 2 is accurately spaced from the sync pulse of shot 1 on the edit master tape. The sync pulses from both sections form a continuous track.

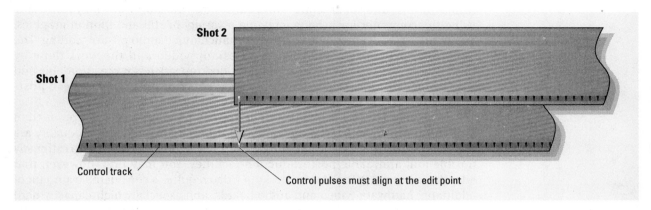

Shot 2

Shot 1

Control track

Control pulses must align at the edit point

11.26

INSERT EDITING

In the insert edit mode, the source material is transferred to the edit master tape without its control track and placed according to the prerecorded control track of the edit master tape.

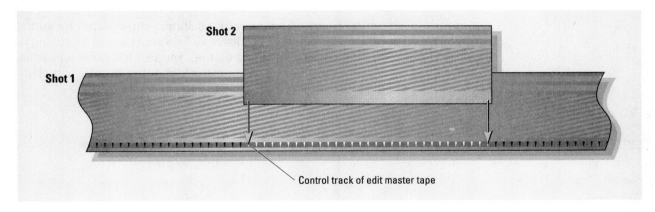

Shot 2

Shot 1

Control track of edit master tape

All edits are, therefore, highly stable and tear-free, even if you insert a new shot in the middle of the edit master tape.

Another advantage of insert editing is that you can separate the audio and video tracks. For example, many news and documentary editors prefer to edit the audio track first, and then match what is being said and heard on the audio track with the appropriate video. To speed up the editing process, they often have several "blackened" tapes on hand with the control track recorded on them.

 KEY CONCEPT 15 **For insert editing, the edit master tape must be prepared by recording black on it.**

Desktop Video

Desktop video means that you can use a desktop computer, such as a PC (DOS or Windows platform), Mac (Macintosh platform) or some other computer with a flexible platform, for a variety of preproduction and postproduction jobs. Desktop video may refer to using the computer as an edit controller that drives source and record VTRs or as a stand-alone nonlinear system. Desktop video may also mean using the computer for logging, creating a variety of still and motion graphics, animation, special effects, or video and multichannel audio off-line editing. The major distinguishing factor between desktop video and the work done by professional postproduction houses is that desktop video is more affordable and that it needs less complex equipment, so you can accomplish these post-production tasks at your own desk.

If you need high-quality video, a desktop computer is not the right production tool. But for many video production tasks, superior video and audio quality are not as important as superior content. Desktop video can provide you with extremely flexible and affordable postproduction facilities. You may find, however, that adapting a normal PC or Mac for desktop video requires a considerable amount of additional hardware (video and audio boards, and especially high-capacity hard drives) and a variety of expensive software programs. Because of the great variety of available desktop video peripherals, you may be tempted to buy more than you need. Don't invest in expensive special-effects and animation software and hardware if all you want to use your system for is logging your source tapes. You will find that more and more computers are especially designed to handle various video production tasks.

You have reached the point where you are no longer intimidated by all the buttons on a switcher. Now you can sit down and do some actual switching or editing. Once you have really done some editing, you can feel confident when called upon by one of the Triple-I editors to assist him or her in some actual off- and on-line editing projects.

 ONCE AGAIN, REMEMBER...

Switching

Switching is a form of instantaneous editing. It means that you select and join various video sources, such as the pictures supplied by live cameras, videotape recorders, or from the ESS, with various transitions (cuts, dissolves, wipes, fades) while the production is going on. This process is made possible by the switcher. The switcher can also be used in postproduction.

Production Switcher

The production switcher is used in production studios and large remote trucks. It has various buses (program, preview, and mix/effects) for specific switcher functions.

Linear Editing System

A linear editing system uses VTRs for its source machines and the record VTR. The video signal can be analog or digital. The end product is an edited videotape.

Nonlinear Editing System

A nonlinear system program works exclusively with digital video and audio information and uses high-capacity hard drives for the storage and retrieval of the video and audio material. The nonlinear system permits random access to every video frame and its accompanying audio. The end product of nonlinear editing is normally an EDL (edit decision list).

Edit Controller

The edit controller, also called the editing control unit, is used in linear editing to assist in various functions (marking edit points, rolling source and record VTRs in sync, integrating effects).

Address Code

The address code is a system that marks each frame with a specific address number. The more widely used systems are the pulse-count system and the SMPTE time code system.

Off-line and On-line Editing

Off-line editing produces a rough-cut and an EDL. On-line editing produces the final edit master tape.

K E Y C O N C E P T S

- Switching means instantaneous editing from simultaneously available video sources.

- Switchers allow the selection of multiple video inputs and the immediate creation of various transitions and effects.

- The program bus sends the selected video inputs directly to the line-out. It is a cuts-only device.

- Mix buses (or buses in the mix mode) let you do cuts, dissolves, superimpositions, and fades.

- The effects buses can accomplish various wipes, keys, and special effects.

- The use of VTRs designates linear editing, whether the recording is analog or digital. Nonlinear editing uses only digital information stored on hard drives.

- Most single-source VTR editing systems are limited to cuts-only transitions.

- Multiple-source editing systems expand the transitions from cuts-only to dissolves and a great variety of wipes and special effects.

- The time code provides a unique address for each frame of recorded video.

- Always make a protection copy of your original source tapes.

- The vector notations in the VTR log facilitate locating shots for continuity and complexity editing.

- If the intent is to produce an EDL or rough-cut, the editing is off-line. If the editing produces the edit master tape, it is on-line.

- The EDL is the road map for on-line editing.

- Nonlinear off-line editing produces an EDL.

- For insert editing, the edit master tape must be prepared by recording black on it.

CONTENTS

Talent and the Production Environment

THE Triple-I people are quite pleased with your progress as an intern. They tell you that you have worked hard to acquire a firm grasp of the basic production tools and their efficient and effective use, and that you have shown initiative. They are especially pleased that you can think creatively and come up with good ideas and innovative yet practical solutions to various production problems. But before moving you up to assist one of their topnotch directors, they would like you to learn more about the people who work in front of the camera—the talent—and what they must do to prompt the desired process message.

They would also like you to learn more about the studio and its associated control areas and how to use various field environments effectively in your video productions. These final three chapters can help you meet Triple-I's requirements.

KEY TERMS

Talent Collective name for all performers and actors who appear regularly in video.

Performer A person who appears on-camera in nondramatic shows. The performer does not assume someone else's character.

Actor A person who appears on-camera in dramatic roles. The actor always portrays someone else.

I.F.B. Stands for interruptible foldback or feedback. A prompting system that allows communication with talent while on the air. A small earpiece worn by on-the-air talent that carries program sound (including the talent's voice) or instructions from the producer or director.

Teleprompter A prompting device that projects the moving copy over the lens so that the talent can read it without losing eye contact with the viewer.

Cue Card A large hand-lettered card that contains copy, usually held next to the camera lens by floor personnel.

Blocking Carefully worked-out movement and actions by the talent and for all mobile video equipment used in a scene.

Moiré Effect Color vibrations that occur when narrow, contrasting stripes of a design interfere with the scanning lines of the video system.

Foundation A makeup base, normally done with water-soluble pancake makeup, that is applied with a sponge to the face and sometimes to all exposed skin areas. Pancake foundation reduces unwanted light reflection.

Talent, Clothing, and Makeup

THE **incredible amount of equipment and effort** that goes into making even a relatively simple production, such as somebody reading the latest company news, is generally lost on viewers. All they judge the show by is whether the person on the screen is likable and whether he or she is doing a credible job of delivering the news. Similarly, viewers attribute the success of a talk show to the host, not on how it is lighted or how the cameras are handled.

Video *talent* refers (not always too accurately) to all people performing in front of the camera. We divide talent into two groups: *performers* and *actors*. *Performers* are primarily engaged in nondramatic activities. They play themselves and do not assume the role of other characters; they are aware of the viewers and usually communicate directly with them by addressing the camera lens. *Actors*, on the other hand, always portray someone else; they assume a character role, even if the role is close to their own personality. They normally do not acknowledge the presence of the viewers, but interact with other actors. Because performance and acting requirements differ in several major ways, we will be discussing them separately. Specifically, this chapter focuses on—

■ **PERFORMING TECHNIQUES**
Performer and camera, audio and lighting, and timing and prompting

■ **ACTING TECHNIQUES**
Environment and audience, small screen and close-ups, and repeating action

■ **AUDITIONS**
How to prepare

■ **CLOTHING**
Texture and detail, and color

■ **MAKEUP**
Technical requirements, close-ups, and materials

297

KEY CONCEPT 1 **Talent refers to video performers and actors. Performers portray themselves; actors portray somebody else.**

PERFORMING TECHNIQUES

As a performer, you are always aware of the viewers. Your goal is to establish as much rapport as possible with the viewers and to have them share in what you do and say. Because video is normally watched by individuals or small groups of people who know one another, your performance techniques must be adjusted to this kind of communication intimacy. Always imagine that you are looking at and talking with somebody you know, seated comfortably a short distance from you. Some performers prefer to imagine that they are talking to a small group or a small family; in any case, don't ever envision that you are at a mass rally, addressing "millions of people out there in videoland." When viewers watch you at home, it is you who is "out there," and not they. They are not visiting you; you are visiting them.

To help you establish this intimate viewer contact and perform effectively in front of the camera, you need to familiarize yourself with some production aspects of (1) the camera, (2) audio and lighting, and (3) timing and prompting.

Performer and Camera

As a performer, the video camera is your communications partner; it represents the viewer with whom you are talking. As a novice performer, you may find it difficult to consider the camera your communications partner, especially when all you actually see while talking is the camera or the screen of the prompting device, a few lights shining into your eyes, and perhaps a few production people who are more interested in operating the equipment than in what you have to say.

Eye contact To establish eye contact with the viewer, you need to look at the *lens*, not the camera operator or the floor manager. In fact, good performers keep constant eye contact with the lens and seem to look *through* it, rather than merely at it. When pretending to look through the lens, you will more readily extend your glance *through the screen* toward the viewer than if you simply stare at the camera. Also, you must maintain eye contact with the lens much more directly and constantly than when engaged in a real interpersonal conversation. Even a small glance away from the lens will be highly distracting for the viewer; it will not be seen as a polite relief from your stare, but rather as an impolite loss of concentration or interest on your part.

If two or more cameras are used while demonstrating a product, you need to find out which of the two cameras will remain on you and which will take the close-up of the product. Keep looking at the camera (or, rather, through the lens of the camera) that is focused on you, even when the director switches to the close-up camera that is focused on the product. This way, you will not get caught looking at the wrong camera if your camera is unexpectedly switched back on the air.

If both cameras are on you and switched according to the director's cues, you must shift your view from one camera to the other in order to maintain eye contact. A good floor manager will greatly assist you in this task. He or she will warn you that a switch is coming up by pointing on the director's "ready" cue to the camera you are addressing and then motioning you over to the other camera on the "take" cue. On the floor manager's cue, shift your glance quickly but smoothly in the new direction. Unless told otherwise, always follow the floor manager's cues (as shown in figure 12.1) and not the tally light that indicates the hot camera.

If you discover that you are talking to the wrong camera, look down as if to collect your thoughts, and then look up into the on-the-air camera. Such a shift works especially well if you use notes or a script as part of your on-camera performance. You can simply pretend that you are consulting your notes, while changing your view from the wrong to the right camera.

 KEY CONCEPT 2 **Eye contact with the camera lens establishes eye contact with the viewer.**

Close-ups On video, you will be shown more often in a close-up than a medium or long shot. The camera scrutinizes and magnifies your expressions and every move. It does not look politely away when you scratch your ear or touch your nose; it reveals faithfully the nervous twitch or mild panic when you have forgotten a line. More so, the close-up does not give you much room to maneuver. A slight wiggle of the product you are holding will look in a tight close-up as though an earthquake had struck. The close-up also accelerates your actions. If you lift up a book at normal speed to show its cover, you will most certainly yank it out of the close-up camera's view. Here are a few important rules for working with close-ups:

▷ When on a close-up, do not wiggle, but remain as steady as possible.

▷ Keep your hands away from your face, even if you feel perspiration collecting on your forehead, or your nose itching.

▷ Slow down all movements.

▷ When demonstrating small objects, keep them as steady as possible. Better yet, put them on a display table.

▷ If they are arranged on a table, *do not pick them up.* You can point to them or tilt them a little to give the camera a better view.

There is nothing more frustrating for the camera operator, the director, and especially the viewer than a performer who snatches the object off the table just when the camera has a good close-up of it. A quick look at the studio monitor will tell you whether you are holding or tilting the object for maximum visibility.

Also, don't ask the camera to come a little closer to get a better look at what you are demonstrating. As you well know, the camera operator can get a close-up not just by dollying in with the camera, but much more quickly and easily by

zooming in. Quite generally, you will not make the director very happy by asking for specific shots when the shot is already on the air, or when there are technical problems that prevent the director from calling up the desired material. Talent—however talented and eager they may be to look good on the air—should not try to outdirect the director.

KEY CONCEPT 3 **When on a close-up, keep your gestures limited and slow.**

Audio and Lighting

A clear, resonant voice alone will not make you a good performer. Besides having something to say and saying it clearly and convincingly, you need to be aware of the various audio requirements.

Microphone techniques At this point, you should briefly review the use of microphones in chapter 8. At the risk of being somewhat redundant, here is a short summary of the main microphone techniques of concern to you, as a performer:

▶ Treat all microphones *gently*. They are not props, but highly sensitive electronic devices that translate your voice into electrical signals.

▶ If you work with a *lavaliere microphone*, don't forget to put it on. Run the cable underneath your jacket, blouse, or dress, and fasten the mic on the *outside* of your clothing. Once "wired," you have a highly limited action radius, unless you are wearing a wireless lavaliere. Don't forget to remove the mic and lay it gently on the chair before walking off the set.

▶ When using a *hand mic*, see how far the microphone cable will let you move. In normal situations, hold the hand mic chest high and speak across it, not into it. In noisy surroundings, hold it closer to your mouth. When interviewing a guest with a hand mic, hold it near you when speaking and toward the guest when he or she responds. Gently pull the microphone cable with your free hand when moving about. If you need both hands for something else, tuck the mic under your arm.

▶ Once a *desk mic* has been put in place for you by the audio engineer, don't move it. Check with the audio engineer if you think it should be closer to you or pointing more toward you. Talk toward it, not away from it.

▶ When using a *stand mic*, adjust the height of the stand so that the mic is a little below your chin, pointing toward your mouth.

▶ When a *fishpole* or *boom mic* is used, be aware where the mic is when you are moving, but don't look at it. Move slowly and avoid fast turns. If you see that the boom operator can't follow you with the mic, stop, and move on when the problem is fixed.

Taking a level When asked to test the mic or to take a level, don't blow into it, but speak your opening remarks *at the level you will use when on the air.* Performers who rapidly count to ten or speak with a low voice off the air and then blast their opening remarks when on the air will not help the audio engineer adjust the volume to an optimal level.

Do not speak louder simply because the camera moves farther away from you. Although you correctly assume that the camera is the viewer with whom you are communicating, the camera distance has nothing to do with how close the shot actually is. More importantly, the distance of the camera has nothing to do with how close the mic is. If you wear a lavaliere, you are heard at the same level regardless of whether the camera is 2 or 200 feet away from you.

KEY CONCEPT 4 **When taking a level, speak at the volume you will actually use during the performance, and speak long enough to set the volume on the audio console.**

Checking lighting Although, as a performer, you should not be concerned with lighting, it does not hurt to quickly check the lighting before going on the air. When outdoors, don't stand against a brightly lighted background, unless you want to be seen as a silhouette. When in the studio and there is no light hitting your eyes, you are not in the lighted area. Ask the director where you should stand so that you are in a properly lighted area. In a play, when you happen to get off the rehearsed blocking into a dark area, move a little until you feel the heat of the light or see the lights hitting you. Such concern for lighting should not encourage you to take over the director's function. Always check with the director if you have any questions about the technical setup and your activities in it.

Timing and Prompting

A good performer can accurately judge a thirty-second or ten-second duration without looking at a clock or stopwatch. Such timing skills are not inborn, but acquired through practice. Even if you think that you have an unfailing sense of timing, you should always mind the floor manager's cues.

As a performer, you need to be acutely aware of time, whether on the air or not. Even nonbroadcast video programs are packaged according to a rigid time frame. Because the audience has no idea about your time restrictions, you need to appear relaxed and unhurried even if you have only two seconds left or you have to fill unexpectedly for an additional fifteen seconds. Good radio personalities can teach you a lot in this respect. They seem to be totally relaxed and never hurried, even when working up to the last second of the segment. Don't put too much trust in your timing instincts; use a clock or stopwatch for precise timing. In any case, respond immediately to the floor manager's time cues.

Prompting device: The I.F.B. system As a performer, you must rely on—or put up with—a variety of *prompting devices.* The most direct prompting device is the *I.F.B.*—*interruptible feedback,* or, more precisely, *interruptible foldback*—

system. You have probably seen performers or interview guests touch one of their ears as though they were adjusting a hearing aid. This is exactly what they are doing.

When using interruptible foldback, you wear a small earpiece that carries the total program sound, including your own remarks, unless the producer or director (or some other production member connected to the I.F.B. system) interrupts the program sound with special instructions. For example, if you interview the C.E.O. of a new multimedia company, the producer may cut in and tell you what question to ask next, to slow down, to speed up, or to tell the guest that she has only fifteen seconds to respond to your request to explain the latest multiplatform software. The trick is that you cannot let the viewer know that you are listening to somebody other than the guest.

If you conduct an interview long-distance, with the guest in a different location, he or she may also wear an I.F.B. earpiece that transmits your questions on a separate I.F.B. channel. You may find that many guests experience some problem with the I.F.B. system, especially when the guest location is relatively noisy. If possible, test the system out to make the guest more comfortable using I.F.B.

Floor manager's cues Normal *time, directional,* and *audio* cues are usually given by the floor manager. As a performer, you will quickly learn that the floor manager is your best friend during the production. A good floor manager will always be in your vicinity, telling you whether you are too slow or fast, whether you are holding the product correctly for the close-up camera, and whether you are doing a good job. Unlike other prompting devices, the floor manager can react immediately to your needs and to unforeseen performance problems. Normally, the floor manager cues you through a variety of hand signals. **SEE 12.1**

As a performer, you must *react to the floor manager's cues immediately,* even if you think that the cue is inappropriate. Good performers don't think they can run the show all by themselves: they react to the floor manager's cues quickly and smoothly.

Don't look around for the floor manager when you think that you should have received a time cue; he or she will make sure that you see the signal without having to break eye contact with the lens. As you just learned, even a brief glance away from the lens will tend to interrupt the contact you have established with your viewers. Once you have seen a cue, don't acknowledge it in any way. The floor manager can tell by your subsequent actions whether or not you have received the cue.

KEY CONCEPT 5 **Always respond promptly to the floor manager's cues.**

Teleprompter The *teleprompter* makes it possible for you to read copy without taking your eyes off the lens. The teleprompter projects the copy off a small monitor onto a glass plate that is mounted directly in front of the lens. **SEE 12.2** While you can read the copy on the glass plate, the lens can view the scene through the plate without seeing the lettering. All newscasters and hosts

12.1

FLOOR MANAGER'S CUES

Because the microphone is live during production, the talent must rely on visual time, directional, and audio cues from the floor manager.

CUE	SIGNAL	MEANING	SIGNAL DESCRIPTION
		TIME CUES	
Standby		Show about to start.	Extends hand above head.
Cue		Show goes on the air.	Points to performer or live camera.
On time		Go ahead as planned. (On the nose.)	Touches nose with forefinger.
Speed up		Accelerate what you are doing. You are going too slowly.	Rotates hand clockwise with extended forefinger. Urgency of speedup is indicated by fast or slow rotation.
Stretch		Slow down. Too much time left. Fill until emergency is over.	Stretches imaginary rubber band between hands.

12.1

FLOOR MANAGER'S CUES *(continued)*

CUE	SIGNAL	MEANING	SIGNAL DESCRIPTION
		TIME CUES	
Wind up		Finish up what you are doing. Come to an end.	Similar motion to speed up, but usually with arm extended above head. Sometimes expressed with raised fist, good-bye wave, or hands rolling over each other as if wrapping a package.
Cut		Stop speech or action immediately.	Pulls index finger in knifelike motion across throat.
5 (4, 3, 2, 1) minute(s)		5 (4, 3, 2, 1) minute(s) left until end of show.	Holds up five (four, three, two, one) fingers(s) or small card with a number on it.
½ minute		30 seconds left in show.	Forms a cross with two index fingers or arms. Or holds card with number.
15 seconds		15 seconds left in show.	Shows fist (which can also mean wind up). Or holds card with number.
Roll VTR (and countdown) 2–1 Take VTR		VTR is rolling. Tape is coming up.	Holds extended left hand in front of face, moving right hand in cranking motion. Extends two, one finger(s); clenches fist or gives cut signal.

12.1

FLOOR MANAGER'S CUES *(continued)*

CUE	SIGNAL	MEANING	SIGNAL DESCRIPTION
		DIRECTIONAL CUES	
Closer		Performer must come closer or bring object closer to camera.	Moves both hands toward self, palms in.
Back		Performer must step back or move object away from camera.	Uses both hands in pushing motion, palms out.
Walk		Performer must move to next performing area.	Makes a walking motion with index and middle fingers in direction of movement.
Stop		Stop right here. Do not move any more.	Extends both hands in front of body, palms out.
OK		Very well done. Stay right there. Do what you are doing.	Forms an "O" with thumb and forefinger, other fingers extended, motioning toward talent.

12.1

FLOOR MANAGER'S CUES *(continued)*

CUE	SIGNAL	MEANING	SIGNAL DESCRIPTION
		A U D I O C U E S	
Speak up		Performer is talking too softly for present conditions.	Cups both hands behind ears or moves hand upwards, palm up.
Tone down		Performer is too loud or too enthusiastic for the occasion.	Moves both hands toward studio floor, palms down, or puts extended forefinger over mouth in *shhh*-like motion.
Closer to mic		Performer is too far away from mic for good audio pickup.	Moves hand toward face.
Keep talking		Keep on talking until further cues.	Extends thumb and fingers horizontally, moving them like a bird beak.

of newslike format shows use teleprompters, as do people who deliver on-camera speeches. The copy itself is normally generated by a word processing program and sent by a desktop computer to the teleprompter monitor on each camera that shoots the performer. The computer rolls the copy from the bottom of the teleprompter screen to the top exactly at your reading speed. If you have to change your reading speed to stay within the allotted time, the copy speed can be adjusted accordingly. Some of the older systems use a *copy-bed* device, in which the typed copy is transported at variable speeds along a small table (the

12.2

TELEPROMPTER

The teleprompter consists of a small video monitor that reflects the copy onto a glass plate directly over the lens. The talent can see the copy clearly, while it remains invisible to the camera lens.

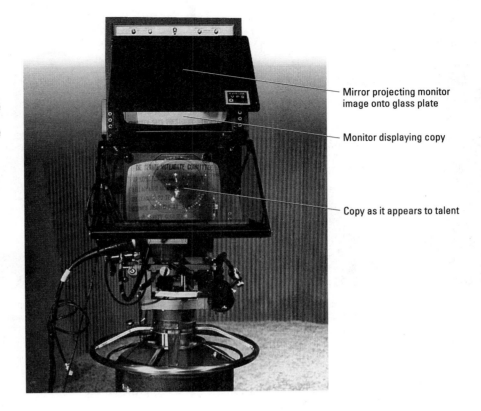

Mirror projecting monitor image onto glass plate

Monitor displaying copy

Copy as it appears to talent

copy-bed) and photographed with a small black-and-white camera. The camera's video is then sent directly to the teleprompter monitors.

When using a teleprompter, the camera needs to be far enough away so that the viewers don't see your eyes move back and forth while reading the copy, yet close enough so that you can clearly see the letters of the copy. Experienced performers still manage to look *through* the lens and to make eye contact with the viewer even while reading the copy in front of the lens.

There are small teleprompters that can be used in the field. Other prompters use a paper roll that projects the hand-lettered copy over a glass plate in front of the lens. Some field prompters simply mount the paper roll below or to the side of the lens. The roll is battery-powered and can be adjusted to various roll speeds.

Cue cards One of the simplest yet highly effective cuing devices is the *cue card*. Cue cards consist of sheets of paper or posterboard with the copy hand-lettered with a felt pen. How large the cards are depends on how well you can see and how far away the camera is when you're reading the copy. The floor person must hold the cards as close to the lens as possible so that you don't have to glance too far away, thereby losing eye contact with the viewer. You must learn to read the copy out of the corner of your eyes while looking at the lens. If possible, practice your peripheral reading with the floor person handling the cards. Decide on an optimal distance, then make sure that the cards are in the right order and that the floor person holds them close to the lens without covering the

HANDLING CUE CARDS

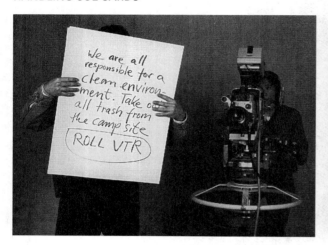

A This is the wrong way to hold cue cards. The card is too far away from the lens, and the floor person is covering some of the copy, is not reading it with the talent, and is therefore unable to change the cards when necessary.

B This is the correct way to hold cue cards. The cards are as close to the lens as possible, and the floor person reads along with the talent to facilitate smooth changes.

copy. **SEE 12.3** Practice changing the cards with the floor person; this must occur while you are reading the last few words. Tell the floor person not to dump the used cards on the floor, but to put them quickly and quietly on a nearby chair.

ACTING TECHNIQUES

To become a good video or television actor, you must first learn the art of acting. Whereas performers always portray themselves, *actors always assume somebody else's character and personality.* Even the best stage or film actors must adjust their acting methods and style to the specific requirements of the video medium. Some the major requirements are (1) working in a technical environment without an audience, (2) adjusting to the small video screen and the frequent use of close-ups, and (3) repeating the action.

Environment and Audience

As a video actor, you will be surrounded by much more technical equipment than if you were on stage. Worse, you do not have an audience whose reaction you can see or even feel. Unless you have a studio audience, all you see is lights, cameras, and production people who do not pay much attention to you. In fact, you will often feel that you are neglected even by the director. But you should realize that the director has to coordinate a great many pieces of production equipment and a great many personnel, and that some of the technical operations may need more of the director's attention than you do.

You may even feel more abandoned because of the lack of a live audience. Unlike the theater, where the audience remains in a fixed place and gives you direct or indirect feedback, the camera or cameras do not respond to your performance, but stare at you impassively and move quietly all around you. They may look at your eyes, your back, your feet, your hands, or whatever the director chooses for the viewer to see. It is a little like acting for a theater-in-the-round, except that in video the viewers, as represented by the cameras, sit at arm's length and even join you on the stage to get a better look.

Because the viewer is in such close virtual proximity, you need not, and should not, project your actions and emotions to somebody sitting in the last row. The camera, which is doing the projecting for you, makes a small gesture into a grand act. When on a close-up, there is no need for you to act out your role; instead, you must *feel* it. Internalization of your role is a key factor in acting for video.

KEY CONCEPT 6 **When acting for the video medium, you must feel the role, rather than merely act it out.**

This intimacy of video also influences the way you speak. You must reduce the customary stage declamation and voice projection to *clear but normal speech.* Good writers help you in this task. Instead of having you, as Oedipus, dramatically request "Who planned the crime, aye, and performed it, too?", on video you would simply ask: "Who did it?" Getting rid of exaggerated voice projection is one of the hardest things to learn when stage actors switch over to the video medium. Precise enunciation is often more important than speech volume and projection.

Most importantly, you must be able to memorize your lines quickly and accurately. Although you may have a variety of prompting devices available (mainly cue cards), you cannot and should not rely on them if you want to be convincing in your role. Because many of your lines serve as important video and audio cues and trigger all sorts of production activity, you cannot afford to ad-lib. Ad-libbing a cue line will inevitably cause chaos in the control room and prompt a retake of the scene.

Small Screen and Close-ups

The small screen and the frequent use of close-ups do not give you much room to move. Sometimes you must stand unnaturally close to other actors, or move much more slowly than normally without appearing to do so to stay within camera range. The close-up also limits your gestures. If, when seated, you lean back or move forward unexpectedly, you may fall out of focus, and weaving sideways just a little may move you out of the frame.

The close-up shots require you to be extremely exact in following the rehearsed blocking. *Blocking* means carefully working out your movements and actions relative to other actors and the camera. Even if you stray just a few inches from the rehearsed blocking, you may be out of camera range or obstructed by another actor. To help you remember the major blocking positions, the floor manager will usually mark the floor with chalk or a small piece of masking tape.

In an over-the-shoulder shot, if you or the other actor is off the mark, you may be obstructed from camera view by the other actor. You can tell whether the camera sees you simply by looking for the camera lens. If you see the lens, the camera can see you; if you don't see the lens, you aren't seen. If you can't see the lens, inch to one side or the other without obviously searching for it. Yes, the camera can also correct its shot to get the proper over-the-shoulder shot, but it is usually easier for you to move than the camera.

To remember blocking, you may want establish a mental road map that has prominent landmarks, for example: "First stop, the left corner of the table. Second landmark, couch. Move to the couch and sit on the right. Third landmark, telephone. Get up and move behind the telephone table facing the center camera. Pick up the phone with the left hand."

Although good directors will block you as much as possible so that your movements are natural, you will occasionally be in a position that seems entirely wrong to you. Do not try to correct this position until you have consulted the director. A special shot or effect may very well warrant such blocking.

 KEY CONCEPT 7 **Meticulously follow the rehearsed blocking during each take.**

▪ Repeating Action

Unlike the theater, where your performance is continuous and according to plot progression, video acting—like acting for film—is usually done piecemeal. You may have to switch from the happy opening scene to the intensely sad closing scene, merely because they both play in the same location. By remembering the exact blocking, you can also help to *preserve continuity*. For instance, if you held the telephone receiver in the right hand during the medium shots, don't switch it to your left hand during the close-ups.

In single-camera productions, it is quite normal to have you repeat the same scene over and over again. Such repetitions are done to get a variety of camera angles or close-ups or to correct major or minor technical problems. In repeats, you must not only duplicate exactly the lines and blocking for each take; you must also *maintain the same energy level* throughout. You cannot be "on" during the first takes and "off" later during the close-ups.

AUDITIONS

Auditions are a test of your ability as a performer or actor—and of your self-confidence. Not getting the part does not mean that you gave an inferior performance, but that somebody else was more suitable for the part. What you must do is to *take all auditions equally seriously*, whether you try out for a starring role in a big television drama or a one-line off-camera utterance for a product demonstration.

Although you may not know beforehand what will be asked of you in the audition, you can still prepare for it. Wear something that fits the occasion and looks good on camera. Be properly groomed. Get to the place on time and don't be intimidated by either the number or caliber of people auditioning with you. You all have an equal chance; otherwise you would not have been called to try out for the part. Have a brief monologue ready that shows the range of your ability. Keep your energy up even if you have to wait half a day before being asked to perform.

If you get a script beforehand, study it carefully. If the script has you talk about or demonstrate a specific product, such as a new computer, familiarize yourself with the product ahead of time. The more you know about the product, the more confidence shows in your delivery. Ask the person conducting the audition what shots the camera will take. If close-ups predominate, slow down your actions and avoid excessive movements. Remember that you are not addressing a large audience, but an individual or a small family seated not too far away from you.

As an actor, be sure that you understand the character you are to portray. If you are not sure what the segment you are to read or the character you are to portray is all about, ask the person conducting the audition (casting director, producer); but don't ask for the proper motivation. As a professional actor you are expected to know how to motivate yourself. Be inventive, but don't overdo it. When working in video, little mannerisms, such as a specific way of keeping your eyeglasses from slipping down your nose, playing with keys, or using a slightly rusty fingernail clipper while engaged in a serious conversation, tend to sharpen your character more readily than simply working up to a high emotional pitch.

CLOTHING

What you wear is dependent not only on your preference and taste, but also on how the camera sees what you wear. Because the camera can look at you from extremely close range or from a distance, you need to consider the overall line as well as the texture and details of your clothing.

The video camera has the tendency to give you a few extra pounds. Clothing that is cut to a *slim silhouette* looks usually more favorable than something loose and baggy. Avoid horizontal stripes; they emphasize width instead of length and make you look wider around the middle.

Texture and Detail

Because of the frequent close-ups in video, you need to pay special attention to *texture and detail*. Textured material and ties look better than plain, so long as the texture is not too busy or contrasting. Even the best video cameras have a difficult time handling closely spaced and highly contrasting patterns, such as black-and-white herringbone weaves or checks. The electronic scanning of the video image simply cannot keep up with switching between the high-contrast lines, and shows its frustration by producing all sorts of vibrating rainbow colors and patterns, called the *moiré effect*.

Prominent, high-contrast horizontal stripes may also extend beyond the clothing fabric and bleed through surrounding sets and objects as though you were superimposing venetian blinds. On the other hand, extremely fine detail in a pattern will either look busy or, more likely, show up on the screen as smudges.

You can always provide the necessary texture by adding such details as a prominent tie or scarf, or jewelry. Although you will undoubtedly prefer wearing jewelry you like, refrain from wearing overly large or too many pieces. Too much jewelry tends to look gaudy on a close-up, even if the jewelry is of high quality.

Color

Again, the colors you select are not entirely up to you, but must fulfill certain technical requirements. If the set you work in is primarily beige, a beige dress or suit will certainly get lost in it. *Avoid wearing saturated blue* if you are part of a *chroma key*. As you recall, the chroma key process renders transparent everything blue and lets the background show through. If you wear a nice blue tie or a blue dress, you will see the keyed background image in place of the tie or the dress.

Although you may like red, the video camera doesn't. Except for top-of-the-line cameras, most video cameras will show *highly saturated reds* as *vibrating and bleeding* into other areas. Such video problems, called *artifacts*, are especially noticeable in low-lighting conditions.

You should also avoid wearing colors of *highly contrasting brightness*, such as dark blue and white, or black and white. If you wear a black jacket over a reflecting white shirt or blouse, the camera, or the video operator, does not quite know whether to adjust for the high brightness values of the white or the low values of the black. If the VO tries to lighten the black areas so one can see some shadow detail, your white areas will become overexposed and begin to "bloom." If the VO tries to control the overly bright areas by "clipping the whites," your shadow areas will collapse into a uniformly dark area and your skin tones will also get a few shades darker. Obviously, if you are a dark-skinned performer, you should not wear a starched white shirt or blouse. If you wear a dark suit, reduce the brightness contrast by wearing a pastel, rather than a white, shirt.

This contrast problem is especially noticeable when the camcorder is on automatic iris. The automatic iris will seek out the brightest spot in the picture and close down the aperture to bring this excess of light under control. As a consequence, all other picture areas will darken accordingly.

MAKEUP

All makeup is used for three reasons: (1) to improve appearance, (2) to correct appearance, and (3) to change appearance.

Most video productions require makeup that accentuates your features rather than changes them. As a woman performer, normal makeup will do just fine on camera; as a man, you may need some makeup primarily to reduce the light reflections off your forehead and perhaps to cover up some of your wrinkles and skin blemishes. In both cases, you need to adjust your makeup to the technical requirements of the camera and the tight scrutiny of the close-up.

KEY CONCEPT 8 **Makeup is used to improve, correct, or change appearance.**

Technical Requirements

The video camera likes warmer (more reddish) makeup colors better than cooler (more bluish) ones. Especially under high color temperature lighting (outdoor or fluorescent lighting, which is bluish), bluish red lipsticks and eye shadow look unnaturally blue. Warm makeup colors, with their reddish tint, look more natural and provide sparkle, especially when used on a dark-skinned face.

Regardless of whether you are a dark-skinned or light-skinned performer, you should use *foundation* makeup that matches your natural skin color. This foundation is available in various types of *pancake* makeup. If you perspire readily, you should use a generous amount of foundation makeup. The foundation makeup will not prevent your perspiration, but will make it less visible to the camera.

Close-ups

Because the camera usually takes a close look at you, your makeup must be *smooth and subtle*. This requirement is the reverse of theatrical makeup, which you need to exaggerate as much as possible for good effect for the spectators sitting some distance from the stage. Good video makeup should accentuate your features but remain invisible, even on a close-up.

If possible, check your makeup by having the camera take a close-up of you. You may consider this method a frivolously expensive mirror, but it will benefit you during the performance.

Always do your makeup in the *lighting conditions in which the production is done*. If you do your makeup in a room that has bluish fluorescent (high 5,600°K color temperature) lights, and then perform under normal studio lights (with a lower color temperature of 3,200°K), your makeup will be excessively reddish; your face will look pink. The opposite is true if you do your makeup in especially low-color reddish lights (below 3,200°K). When moving into the performance area with the normal indoor illumination (3,200°K), your makeup will look unnaturally bluish.

If you need to use makeup to change your appearance, you should have a professional makeup artist do it for you.

KEY CONCEPT 9 **Do your makeup under lights that have the same color temperature as those in the performance area.**

Materials

You can easily find a great variety of excellent makeup materials for video. Most large drugstores can supply you with the basic materials for improving a performer's appearance. Women performers are generally experienced in using cosmetic materials and techniques; men may, at least initially, need some advice.

The most basic makeup item is a *foundation* that covers minor skin blemishes and cuts down light reflections from oily skin. Water-based pancake makeup foundations are preferred over the more cumbersome grease-based foundations. The Max Factor CTV-1W through CTV-12W pancake series is probably all you need

for most makeup jobs. The colors range from a warm light ivory color for light-skinned performers to a very dark tone for dark-skinned performers.

Women can use their own lipsticks or lip rouge, so long as the reds do not contain too much blue. Other materials, such as eyebrow pencils, mascara, and eye shadow, are generally part of every performer's makeup kit. Special materials, such as hair pieces or even latex masks, are part of the professional makeup artist's inventory. They are of little use in most nondramatic productions.

A solid knowledge of basic video production techniques will aid you greatly not only when working behind the camera but also when working in front of it. In fact, talent who know basic production techniques seem to be more relaxed in front of the camera and more prepared to cope gracefully with unexpected problems while on the air than performers who know little or nothing about video production.

Even if you don't aspire to become a video performer or actor, the Triple-I people will be especially happy to see you understand and successfully deal with video talent, and able to give expert advice to those who are standing in front of the camera for the first time.

ONCE AGAIN, REMEMBER...

Talent

Talent are people who work in front of the camera. Talent includes performers, who are primarily engaged in nondramatic activities, and actors, who portray someone else.

Performance Techniques

The performer must imagine the video camera as his or her communications partner, keep eye contact with the lens when addressing the viewers directly, handle the various microphones for optimal sound pickup, and use prompting devices without making the viewer aware of it.

Acting Techniques

Good video actors learn how to work well within a highly technical environment, adjust to the small video screen and the frequent use of close-ups, and repeat certain actions the same way and at the same intensity level.

Prompting Devices

In addition to the floor manager's cues, the major prompting devices are the I.F.B. (interruptible foldback) system, the studio or field teleprompter, and cue cards.

Clothing

On-camera clothing should have a slim silhouette, and textures and colors that are not too busy or contrasting. The camera does not like closely spaced, high-contrast herringbone weaves or checks, and highly saturated reds.

Makeup

Makeup is used to improve, correct, and change appearance.

K E Y C O N C E P T S

- Talent refers to video performers and actors. Performers portray themselves; actors portray somebody else.

- Eye contact with the camera lens establishes eye contact with the viewer.

- When on a close-up, keep your gestures limited and slow.

- When taking a level, speak at the volume you will actually use during the performance, and speak long enough to set the volume on the audio console.

- Always respond promptly to the floor manager's cues.

- When acting for the video medium, you must feel the role, rather than merely act it out.

- Meticulously follow the rehearsed blocking during each take.

- Makeup is used to improve, correct, or change appearance.

- Do your makeup under lights that have the same color temperature as those in the performance area.

KEY TERMS

Cyclorama A U-shaped continuous piece of canvas or muslin for backing of scenery and action. Hardwall cycs are permanently installed in front of one or two of the studio walls. Also called *cyc*.

Intercom Short for intercommunication system. Used for all production and engineering personnel involved in the production of a show. The most widely used system has telephone headsets to facilitate voice communication on several wired or wireless channels. Includes other systems, such as I.F.B. and cellular telephones.

P.L. Stands for private line or phone line. Major intercommunication device in video studios.

S.A. Stands for studio address system. A public address loudspeaker system from the control room to the studio. Also called *studio talkbalk* or *P.A.* (public address) system.

Studio Control Room A room adjacent to the studio in which the director, producer, various production assistants, TD (technical director), audio engineer, and sometimes the LD (lighting director) perform their various production functions.

Monitor (Video) High-quality video receiver used in the video studio and control rooms. Cannot receive broadcast signals.

Master Control Controls the program input, storage, and retrieval for on-the-air telecasts. Also oversees technical quality of all program material.

Flat A piece of standing scenery used as background or to simulate the walls of a room. There are hardwall and softwall flats.

Props Short for properties. Furniture and other objects used by talent and for set decoration.

Production Environment: The Studio

IT'S time for a studio visit. Although the Triple-I people have their own small studio, they usually rent local video production studio facilities for their bigger jobs. Of course, you have been in a studio before, but only as an observer. There were certain areas, such as the control room, you never got to see. At that time, the director did not want to have any visitors because he felt that they might distract the people working in the control room and break their concentration during the production. But since you were promoted to assist one of Triple-I's best directors, they open all doors for you—even that of the control room. In fact, the Triple-I people begin to treat you more like a colleague than an intern; they feel that it is high time you get acquainted with the studio and control room and the various support areas.

Why use a studio? After all, the highly portable camcorders and lights make it possible to originate a video program anywhere, indoors or outdoors. In tandem with portable transmission equipment and satellite uplinks, you have the whole earth as a stage. The reason video production studios are still used extensively is that they offer *maximum production control* and *optimal use of the production equipment*. They provide for the proper environment and coordination of all major production elements—cameras, lighting, sound, scenery, and the action of production personnel and performers. Studios make video production highly efficient.

On our studio visit, we will take a closer look at—

■ **THE VIDEO PRODUCTION STUDIO**
Physical layout and major installations

■ **THE STUDIO CONTROL ROOM**
Image control, sound control, and lighting control

■ **MASTER CONTROL**
Functions

317

■ **STUDIO SUPPORT AREAS**
Scenery and property storage, and makeup

■ **SCENERY, PROPERTIES, AND SET DRESSINGS**
Softwall and hardwall flats, set and hand props, and set dressings

■ **SET DESIGN**
Floorplan, prop list, setup, and evaluating the floorplan

THE VIDEO PRODUCTION STUDIO

Video production studios are designed not only for multicamera productions and team work, but also to provide an optimal environment for single-camera video productions. Most studios are fairly large rectangular rooms with smooth floors and high ceilings from which the lighting instruments are suspended. They have a number of other technical installations that facilitate a great variety of productions and help to make them highly efficient. **SEE 13.1**

 KEY CONCEPT 1 **The studio provides maximum production control.**

13.1

VIDEO PRODUCTION STUDIO

A well-designed studio provides optimal control for multicamera and single-camera video productions. It facilitates teamwork and the coordination of all major production elements.

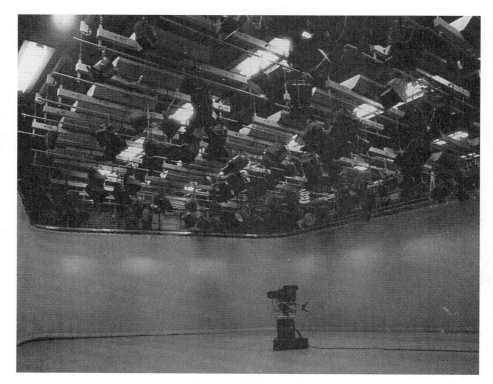

◼ Physical Layout

When evaluating a production studio, you should look not only at the electronic equipment it houses, but also at its physical layout—its size, floor and ceiling, and doors, walls, and air-conditioning.

Size If you just do an interview, or have a single performer talking to the audience on a close-up, you can get by with amazingly little studio space. But if you plan on doing a more ambitious project, such as a large panel discussion or the videotaping of a music show or drama, you need a larger studio. In general, it is easier to place a small show into a large studio than a large show into a small one. But you will quickly learn that large studios are usually harder to manage than small ones. Somehow, large studios need more energy to get a production started than smaller ones; they require longer camera and audio cables, more lighting instruments, and usually more crew.

If you have a choice, use a studio that fits your production needs. You don't need a Hollywood sound stage for a two-person interview. In fact, some news sets are placed right in the middle of an actual newsroom. On the other hand, don't try to squeeze a large dance troupe into a small studio just because you feel the small studio is more manageable.

Because studios are often used to store scenery or large set properties, the actual usable floor space of a studio is considerably smaller than the floorplan might indicate. Make sure that your floorplan is based on *usable floor space*.

Floor and ceiling A good studio must have a *hard, level, and even floor* so that cameras can travel freely and smoothly. Most studios have a concrete floor that is polished, or covered with hard plastic or seamless linoleum. Wood floors are simply too soft to withstand the constant moving of scenery, heavy set properties and platforms, and camera dollies.

One of the most important design features of a good studio is adequate *ceiling height*. The ceiling must be high enough to accommodate normal 10-foot scenery, to provide enough space for the lighting grid or battens. Although you may get by with a minimum ceiling height of 14 feet for very small studios, most professional studios have ceilings that are 30 or more feet above the studio floor. Such a high ceiling makes it possible to suspend the lighting instruments above even tall scenery, and leaves enough space above them to dissipate the heat.

Doors, walls, and air-conditioning *Studio doors* seem rather unimportant until you have to move scenery, furniture, and large equipment in and out. Undersized studio doors can cause not only a great deal of frustration for the production crew, but frequently damage to equipment and scenery. Good studio doors must also be soundproof enough to keep all but the loudest noises from leaking into the studio.

All studio walls and the ceiling are normally treated with *sound-absorbing material* to "deaden" the studio. A fairly "dead" studio minimizes reverberation, which means that it keeps the sounds from bouncing indiscriminately off the walls.

At least two or three sides of the studio are normally covered with a **cyclorama**, or *cyc*, which, as you have learned, is a continuous piece of muslin or canvas suspended from a pipe or heavy curtain track. The light-gray or light-blue colored cyc serves as a convenient neutral background for a variety of setups, as

13.2

GROUND ROW

The ground row is a curved piece of scenery that is placed on the studio floor in front of the cyclorama in order to blend the two into a seamless background.

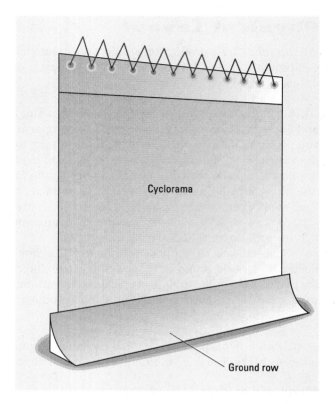

Cyclorama

Ground row

shown in figure 13.1. A *ground row*, which is a curved piece of scenery placed on the studio floor in front of the cyc, helps to blend the vertical cyc into the studio floor to form a seamless background. **SEE 13.2**

Some cycloramas are suspended from a double track, with the front track holding a variety of additional curtains, called *drops*. The most frequently used drops are the chroma key drop, which consists of a large piece of chroma-key blue cloth, and a black one, used for special lighting effects.

Some studios have hardwall cycs built into them. They are erected directly in front of one of the studio walls. The ground row is part of the hardwall cyc. **SEE 13.3**

The advantages of a hardwall cyc are that it does not wrinkle or tear even after longtime use and that it can be easily repainted when soiled. The disadvantages of a hardwall cyc are that it has a high degree of sound reflectance, often causing unwanted echoes, and that it takes up considerable studio space.

Many studios suffer from air-conditioning problems. Because the lighting instruments generate so much heat, the air-conditioning system must work overtime. When going full-blast, all but the most expensive systems create air noise, which is inevitably picked up by the sensitive studio mics and duly amplified in the audio console. You must then decide to keep the air-conditioning going despite the noise it makes, or turn it off, exposing talent, crew, and equipment to uncomfortably high studio temperatures.

13.3

HARDWALL CYC

The hardwall cyc is constructed of fiberboard and placed in front of one of the studio walls.

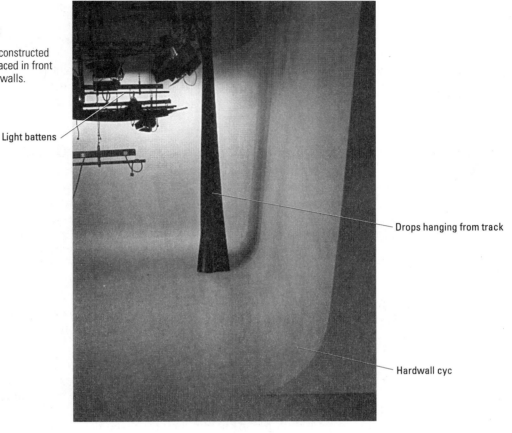

Light battens

Drops hanging from track

Hardwall cyc

Major Installations

Regardless of size, all studios have similar basic technical installations, which include lights, wall outlets, intercom systems, monitors, and studio speakers.

Lights As you remember from chapter 6, most of the lighting instruments used in a video production studio are suspended from a lighting grid or movable battens, as shown in figure 13.3. Hanging the lighting instruments above the scenery and action keeps the lights out of camera range, allows the cameras and people to move freely about, and minimizes the time needed for lighting a scene. Many studios have the lighting patchbay (which routes various lights to a specific dimmer), and even the actual dimmer controls, in the studio itself.

Outlets You may not consider wall outlets an important factor in studio design, unless you discover that there are not enough of them or that they are in the wrong places. There should be several groups of outlets for cameras, microphones, monitor

lines, intercommunication headsets, and regular AC power, distributed along all four walls. If all the outlets are concentrated on only one wall, you will have to string long cables and extensions throughout the studio in order to get the equipment into the desired positions around the scenery.

All outlets must be clearly marked so that you will not plug a certain piece of equipment into a wrong outlet. This marking is especially important when the outlets are behind the cyc, where it is usually dark and where you have little space to maneuver.

Intercommunication system　　Reliable *intercom* systems are one of the most important technical installations. Normal studio intercoms use *P.L.* and *I.F.B.* systems. The *P.L.* *(private line* or *phone line)* system allows all production and engineering personnel to be in constant voice contact with one another. Each member of the production team and technical crew wears a headset with a small microphone for talkback. Such systems can be wired (through the camera cables or separate intercom cables) or, in larger studios, wireless. Most P.L. systems operate on at least two channels, so that different groups can be addressed simultaneously yet separately.

As you already know, the I.F.B. (interruptible foldback or feedback) system allows the director or producer to communicate directly with the talent, who wear tiny earpieces instead of telephone headsets while on the air.

Studio monitors　　You need at least one fairly large monitor in the studio that shows the line-out pictures to everyone on the floor. By viewing the line-out picture, the production crew can anticipate a number of production tasks. For example, the camera that is not on the air can vary its shot so that it does not duplicate that of the on-the-air camera, or the floor manager can see how close he or she can move up to the talent for the necessary signals without getting into camera range.

News- and weathercasters often work with several studio monitors that carry not only the line-out pictures, but also the remote feeds and videotape playbacks. Because the weathercaster actually stands in front of a plain chroma key backdrop when pointing to the various areas on the (nonexistent) weather map, the monitor, which shows the complete key including the map, is essential for guiding the talent's gestures. For audience participation shows, you need several monitors to show how the event looks on the screen.

Studio speakers　　The *studio speakers* do for the program sound what video monitors do for the video portion. The studio speakers can feed the program sound, or any other sounds—music, telephone rings, crashing noises—into the studio to be synchronized with the action. They can also be used for the *S.A.* (studio address) system (also called *P.A.,* for public address system), which allows the control room personnel (usually the director) to talk to the studio personnel who are not on headsets. The S.A. system is obviously not used on the air, but it is quite helpful for calling the crew back to rehearsal, reminding them of the time remaining for the rehearsal, or advising them to put on their P.L. headsets.

THE STUDIO CONTROL ROOM

The *studio control room* is housed in a separate area adjacent to the studio. It is designed to accommodate the people who make the decisions while production is under way and the equipment necessary to control the video and audio portions of the production.

The people normally working in the control room are the director and producer and their associates, the TD, the C.G. operator, the audio engineer, and sometimes the LD.

The control room equipment is designed and arranged to coordinate the total production process. Specifically, it facilitates the selection and sequencing of available *video images*, the selection and mixing of various *sound inputs*, and the *lighting control*.

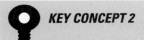 **KEY CONCEPT 2** **The control room is designed to coordinate the studio production process.**

Image Control

The image control section contains the equipment necessary to select and sequence the various video inputs, to coordinate the video with the audio, and to communicate with the production people, technical crew, and talent.

Monitors When you walk into a control room, you will probably be quite amazed at the great number of *video monitors* arranged in stacks. **SEE 13.4** It is not

13.4

CONTROL ROOM MONITOR STACK

The control room monitors show all available video sources, such as the studio cameras, remote video, VTRs, C.G., electronic still store, or special effects. The large color monitors show the preview video (the upcoming shots) and the line monitor (what is being sent to the videotape machine and/or the transmitter).

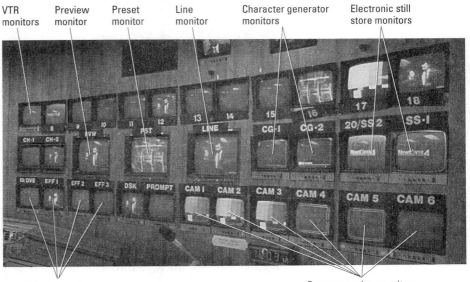

VTR monitors · Preview monitor · Preset monitor · Line monitor · Character generator monitors · Electronic still store monitors

Effects monitors · Camera preview monitors

uncommon to find thirty or more monitors in the control room of a medium-sized studio. Each of the monitors displays a separate video input.

Even a small control room requires a surprising number of monitors. Let's count them and identify their functions. **SEE 13.5**

Camera preview	3	(one for each camera)
VTRs	3	(one for each playback VTR)
Remote	2	(remote feeds; can also be used for additional cameras)
C.G.	1	
Still store	1	
Special effects	1	
Preview	1	
Line	1	
Air	1	(If an on-the-air or cable station studio, this monitor will show what the home viewers see.)
Total	14	monitors

These monitors are stacked in a variety of configurations in front of the director and TD. The preview (or preset) and line monitors are usually relatively

13.5

SIMPLE MONITOR STACK

Even this simple control room display requires fourteen monitors: three camera previews; three VTRs; two remote feeds; one each for C.G., ESS (electronic still store), and special effects; and one large color monitor each for preview, line, and air.

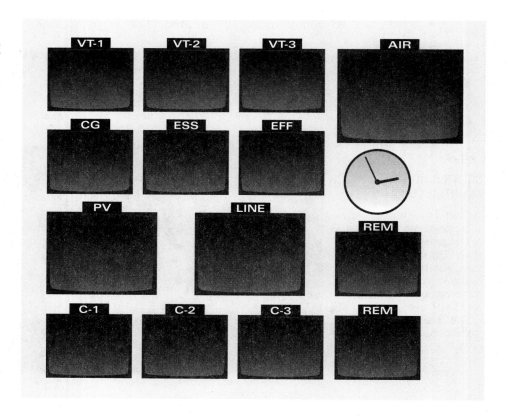

large color monitors, placed side by side. The air monitor is also a large color monitor. All other preview monitors are smaller and black-and-white. The C.G. operator has a separate color monitor for composing the text. The text or title is then sent to the preview monitor or a separate color C.G. monitor.

You may ask how anybody can ever watch all of these monitors at the same time. Actually, you don't pay full attention to all of them all the time, but focus your attention on the monitors that carry the video most important to you. Nevertheless, you must always be aware of what the rest of the monitors are showing. Such an overview takes practice, and it is quite similar to a conductor reading a complex score while conducting an orchestra.

Intercom The director also has easy access to a variety of intercom switches that control the P.L., S.A., and I.F.B. systems. The associate director, who sits next to the director, uses the same switches. The producer, who sits next to the director or, more commonly, behind him or her, will normally have a duplicate set of intercom switches. This extra set will enable the producer to communicate with various production people and talent without interfering with the director.

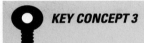

KEY CONCEPT 3 **A reliable and flexible intercom system is essential for effective teamwork in multicamera studio productions.**

Program sound In addition to watching the preview monitors, giving instructions to various production people, and listening to the P.L., the director must also listen to the line-out audio in order to coordinate the video portion with the sound. A separate volume control enables the director to adjust the control room speakers without affecting the volume of the line-out audio. You will find that listening to the program sound is one of the hardest things to learn as a beginning director.

Switcher The video switcher is located right next to the director's position. This proximity enables the TD (who is normally doing the switching) to use the same monitor stack as the director and be in close physical proximity with him or her. This way the director can communicate with the TD not only through the P.L. system, but also through hand gestures. For instance, by moving his or her arm at a certain speed, the director can indicate to the TD how fast a dissolve should be.

When fast cutting is required, some directors prefer to do their own switching (labor unions permitting), or snap their fingers, rather than calling for a take once a shot has been readied. Such physical cues are faster and more precise than the verbal ones. **SEE 13.6** In smaller productions, directors often do the switching, a practice not recommended for complex shows.

KEY CONCEPT 4 **The director and TD must sit next to each other in the control room.**

13.6

PRODUCTION SWITCHER IN CONTROL ROOM

The production switcher is located right next to the director's position.

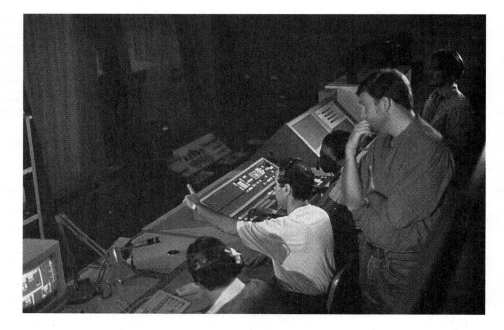

Character generator The C.G. and the C.G. operator are also located in the control room. Although most of the titles are usually prepared ahead of production, there are always some changes that need to be made. Especially during live or live-on-tape productions, the producer or director may call for titles that have not been preprogrammed. By having the C.G. operator in the control room, such changes are easily communicated and quickly done.

Clocks and stopwatches These timing tools are essential in broadcast operations where the programs are aired according to a second-by-second schedule. But even if your productions are videotaped for postproduction, the clock will tell you whether your taping session is on schedule, and the stopwatch will guide you when inserting other recorded material. Digital stopwatches—actually little clocks— give you a choice of running forward from the start of the program, or backward from the end-time. When running backward, the stopwatch will display the time actually left in the program.

Sound Control

The audio booth is a little audio studio attached to the control room. It is usually isolated from the video control room so that the audio engineer is not disturbed by all the talk going on in the video control room. Most audio booths have a window that allows the audio engineer to see the activities in the control room and perhaps even the director's preview monitors. Although well-equipped audio booths have a preview and line monitor, the additional preview monitors aid the audio engineer in anticipating and executing tight audio cues.

The audio booth contains an audio console, a patchbay, reel-to-reel audiotape machines, cart and cassette recorders, and CD players. The audio engineer can listen

Video monitor (line monitor) Audio computer function display monitor Reel-to-reel recorder Patchbay

Assignment switches Sound quality controls Volume controls

13.7

AUDIO CONTROL BOOTH

The audio control booth is located next to the control room. It contains all the major audio control and playback equipment, such as the audio console, audiotape and cassette machines, and CD players.

to the director either via P.L. headsets or a small cue speaker, and can talk to the control room and studio through the P.L. and S.A. system. The program sound is monitored by high-quality program speakers. **SEE 13.7**

Lighting Control

Some control rooms house the lighting dimmer board, which enables the LD to activate certain lighting instruments and adjust their intensity. The advantage of having the lighting control in the control room rather than the studio is that major and minor adjustments can be relayed by the producer or director to the LD more directly, so that the cuing is more precise.

MASTER CONTROL

If you use the studio strictly for producing videotaped programs, you don't need a master control room, assuming that your CCUs are located somewhere in the studio control room. But if you are in the business of telecasting programs over the air or cable, master control becomes an essential electronic nerve center.

Master control normally houses the studio CCUs, various on-line VTRs and computer-controlled video cart machines, electronic still store systems, and various installations that monitor the technical quality of every second of programming that is sent to the transmitter or cable.

13.8

PROGRAM LOG

The program log is a second-by-second listing of all programs telecast during a broadcast day. It shows the scheduled (start) times, program title and type, video and audio origin (tape, live, or feed), the house number, and other pertinent broadcast information.

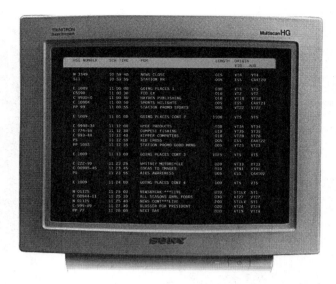

The basic functions of master control are overseeing the technical quality of all program material and controlling program input, storage, and retrieval. *Program input* means that master control keeps track of all incoming programs, regardless of whether they come via satellite, cable, or mail. All videotaped material is stored either in special bins in the master control area or in special storage rooms. To aid retrieval, each program, however long or short, is given an identification code, often called the *house number. Program retrieval* means the selection, ordering, and distribution (on-the-air, cable, or satellite transmission) of the program material.

The *program log* is a document that dictates program retrieval and determines which program goes on the air at what time. It lists every second of programming aired on a particular day, and other important information, such as the title and type of each program and its origin (local live, videotape, network feed). The log is distributed throughout the station by computer display and as a hardcopy. **SEE 13.8**

The actual switching from program to program is mostly done by computer. Just in case the computer decides to go on strike, however, an operator monitors the automatic switching and is ready to press the manual master control switcher into service.

 KEY CONCEPT 5 **Master control checks the technical quality of all programs, and it facilitates program input, storage, and retrieval.**

STUDIO SUPPORT AREAS

No studio can function properly without support areas that house scenery and properties, and makeup and dressing rooms. Unfortunately, even large studios are usually underbuilt for such support areas. As a consequence, the studios

themselves become partial storage areas for scenery, and even serve as makeup and dressing rooms.

Scenery and Property Storage

One of the most important features of scenery and property storage is *ease of retrieval*. The floor crew must be able to find and pull each piece of scenery without having to dig it out from under all others. The prop areas and boxes must be clearly labeled, especially if you store small hand props in various boxes.

Makeup

Wherever you do your makeup, it must be done in *lighting conditions that are identical to those in the studio*. Most makeup rooms have two types of illumination: *standard indoor* color temperature of 3,200°K, and *standard outdoor* color temperature of 5,600°K. Always check your makeup on-camera before the dress rehearsal and again before the performance.

SCENERY, PROPERTIES, AND SET DRESSINGS

Scenery and properties are used to create a specific environment in which the action takes place. When dealing with scenery and properties in video production, you must always keep in mind that it is the *camera that looks at the scenic environment*, not the crew or casual studio visitor. The set must be detailed enough to withstand the close-up scrutiny of the camera, yet plain enough to avoid cluttered pictures and to draw attention away from the performers or actors. It must also allow for optimal camera movement and angles, microphone placement and mobility, appropriate lighting, and maximum action by the talent.

 KEY CONCEPT 6 **Scenery must create a certain environment and must allow for optimal lighting, audio pickup, and camera movement.**

Scenery

Although the design and construction of scenery requires special training and skills, you should know what standard set units are and how to use them for creating simple environments. Here we will discuss (1) softwall flats, (2) hardwall flats, (3) cycloramas and drops, and (4) special set pieces.

Softwall flats A *flat* is a freestanding piece of scenery used as background or to simulate the walls of a room. *Softwall flats* are background units constructed of a lightweight wood frame and covered with muslin. The wood frame consists of 1 × 3 lumber that is glued together and then reinforced at the corners by ¼-inch

SOFTWALL FLATS

Softwall flats are made of
1 x 3 lumber and covered with
muslin. The hardware is
needed to connect the flats
for background scenery.

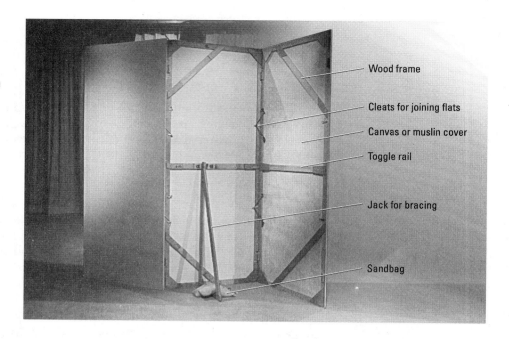

Wood frame

Cleats for joining flats

Canvas or muslin cover

Toggle rail

Jack for bracing

Sandbag

plywood pieces. To keep the frame from twisting, it is further strengthened by two corner braces and a toggle rail. **SEE 13.9**

The traditional, and still most practical, way to tie softwall flats together is by using *lashlines*. When joining flats, you actually lash two pieces of scenery together with a clothesline that is attached to the right top rail of each flat and pulled through the various lash cleats. The process is quite similar to lacing the hooks of a boot. **SEE 13.10** Flats are supported by *jacks*, wood braces that are hinged to the flats and are weighted down and held to the studio floor by sandbags or metal weights.

Standard softwall flats have a uniform height but various widths. The height is usually 10 feet, or 8 feet for small sets or studios with low ceilings; width ranges from 1 to 5 feet. When two flats are hinged together, they are called *twofolds* or *books* (because they open like a book). When three flats are hinged together, you have a *threefold*.

Softwall flats are easy to move about, assemble, and store, but their simple construction is also a disadvantage. The flats tend to shake when you close a door or window on the set, or if someone or some piece of equipment brushes against them. They are ideal for rehearsal and for less demanding productions.

Hardwall flats Most professional video production sets are constructed with *hardwall flats.* They are usually built for a specific set and do not always conform to the standard dimensions of softwall scenery. Although there is no standard way of building hardwall scenery, most flats are constructed with a sturdy wood frame or slotted steel frame (which looks like a big erector set) and covered with plywood or pressed fiberboard. Most hardwall scenery is moved with the help of built-in casters, and joined with bolts or C-clamps. **SEE 13.11**

The advantage of hardwall scenery is that it is extremely sturdy; if a scene calls for slamming the door, you can do so without fear of shaking the whole set.

13.10

FLATS JOINED BY LASHLINE

Softwall flats are connected by lashing them together with a clothesline, called a *lashline*, and supported by a wood brace, called a *jack*. Jacks are weighted down with sandbags or metal weights.

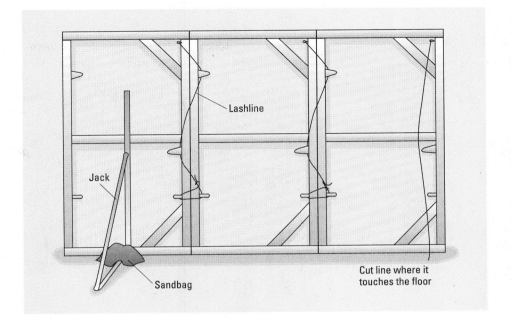

Lashline

Jack

Sandbag

Cut line where it touches the floor

13.11

HARDWALL SCENERY

Hardwall scenery is built with a sturdy wood or metal frame and is covered with plywood or fiberboard material. Most hardwall scenery has built-in casters or is placed on small wagons for mobility.

Braces with casters

Covered with hardwall material (thin plywood facing)

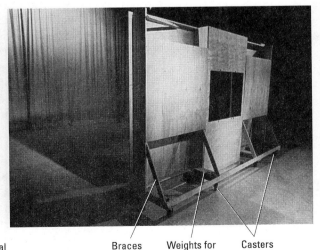

Braces

Weights for bracing flats

Casters

You can also attach pictures or posters the way you would on a real wall. The disadvantages of hardwall flats are that they are expensive to build, hard to move and set up, and even harder to store. Also, hardwall scenery is apt to reflect sound and cause unwanted reverberations.

13.12

SEAMLESS PAPER BACKDROP

Seamless paper comes in various colors and can be stapled onto softwall flats for neutral backdrops.

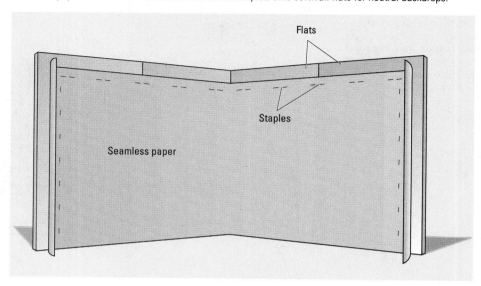

Flats

Staples

Seamless paper

Set modules Smaller video production companies, whose scenery demands are usually limited to interview and office sets, or environments in which various products are displayed and demonstrated, often use *set modules*. A set module is a series of hardwall flats and three-dimensional set pieces whose dimensions match whether they are used vertically (right-side up) or horizontally (on their sides). They can be assembled in different combinations, similar to children's toys that can be stuck together in various ways. For example, you might use a modular hardwall set piece as a hardwall flat in one production, and as a platform in the next. Or you might dismantle a modular desk and use the boxes (representing the drawers) and the top as display units. A variety of set modules are commercially available.

Seamless paper and painted drops As you recall, the cyclorama is a large, plain, seamless drop that serves as a neutral background, as shown in figure 13.1. In the absence of a cyc, you can construct a limited neutral area by simply unrolling sideways and stapling a roll of seamless paper (usually 9 feet wide by 36 feet long) on softwall flats. **SEE 13.12** Seamless paper rolls come in a variety of colors and are relatively inexpensive.

Painted drops, on the other hand, usually refer to rolls of paper or canvas with background scenes painted on them. They are often used as stylized settings where you want the viewer to be aware of scenic pieces or a constructed environment.

Special set pieces, platforms, and wagons *Set pieces* consist of *free-standing three-dimensional objects*, such as pillars, pylons (which look like three-sided pillars), sweeps (curved pieces of scenery), folding screens, steps, and

13.13

SET PIECES

Set pieces are freestanding three-dimensional scenic objects used as background or foreground pieces.

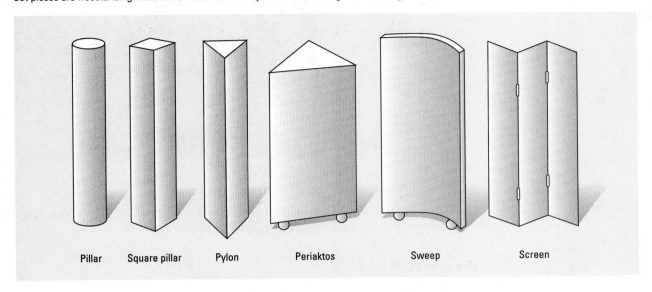

Pillar Square pillar Pylon Periaktos Sweep Screen

periaktoi (plural of *periaktos*). A periaktos is a large three-sided standing unit that looks like a large pylon. It moves and swivels on casters. **SEE 13.13**

You may want to paint a periaktos differently on at least one of the three sides to make it more versatile. For example, if one of the sides of a periaktos is painted a chroma-key blue, with the remaining two sides colored a warm yellow, you can quickly provide a chroma key background by simply swiveling the periaktos (or series of periaktoi) to the blue side.

Set pieces are often constructed in modular dimensions so that you can fit them together in various combinations. When working with set pieces, make sure that they are safely anchored and secured so that they do not tip over when bumped by a crew member, talent, or a piece of equipment. It is always better to overbrace than underbrace the set.

Platforms are elevation devices. Normal platforms are 6 inches, 8 inches, or 12 inches high and can be stacked. Sometimes the whole platform is called a *riser*, although technically a riser is only the elevation part of the platform without its top. Platforms are often used for interview and panel discussion sets so that the cameras will look at the participants straight-on rather down on them. When used for interviews, the entire platform should be covered with a piece of carpet. The carpet will make the set attractive; it will also absorb the hollow sounds when people are moving on the platform. You can further deaden these sounds by filling the interior of the platform with foam rubber.

Some 6-inch platforms have four heavy casters, which make the platforms into *wagons,* which can support scenery and set pieces. When mounted on a series of wagons, a heavy set becomes quite mobile and can be repositioned with relative

13.14

STANDARD WAGON

Wagons are sturdy 6-inch-high platforms that roll on four heavy swivel casters. Wagons can support scenery and set pieces and serve as platforms for sets.

ease. Once in place, wagons should be secured with wood wedges and/or sandbags so that they do not move unexpectedly. **SEE 13.14**

Properties

In video production, *properties* (commonly called ***props***) and *set dressings* are often more important to signify a particular environment than the background scenery. You will work with two kinds of properties: set props and hand props.

Set props Set props include the furniture you use on a set, such as the chairs for an interview, the table for a panel discussion, the desk from which the corporate manager delivers her weekly address, the bookcase and file cabinet for the office set, or the inevitable couch used in situation comedies.

When choosing set props, look for functional furniture that can be used in a variety of settings. For instance, small, simple chairs are more useful and more versatile than large, upholstered ones. Most regular couches are too low and make sitting down and getting up look awkward on camera. You can easily remedy this problem by padding the seats or elevating the entire couch. Some set props, such as news desks or panel tables, are custom-made. Do not go overboard with such custom furniture, especially if most of your scenes show only medium shots or close-ups of the performers.

Hand props Hand props are items *actually handled* by the talent, including telephones, desktop computers, dishes, silverware, books, magazines, glasses, and flowers. The important thing about hand props is that they are *real* and that they *work*. A bottle that doesn't open on cue can cause costly production delays. Because hand props are the extension of the talent's gestures and actions, and because of the close scrutiny by the video camera, you cannot get by with fake props. A papier-mâché chalice may look regal on stage, but on the video screen it looks ridiculous. You get a similar reaction when you pretend to toil under the weight of an empty suitcase. Whereas the theater audience may have some

sympathy for your toil, the television viewer will more likely consider it a comic routine or unfortunate production mistake.

If you have to use food, make certain that it is fresh, and the dishes and silverware are meticulously clean. Liquor is generally replaced with water (for clear spirits), tea (for whiskey), or soda pop (for white and red wine). With all due respect for realism, such substitutions are perfectly appropriate.

Set Dressings

Set dressings include things that you would place in your own living quarters to make them look attractive and to express your taste and style of living. Although the flats may remain the same from one type of show to another, the dressing *gives each set its distinguishing characteristic* and helps to establish the *style of the environment*. Set dressings include such items as draperies, curtains, pictures, sculptures, posters, lamps, indoor plants, decorative items for your desk and bookshelves, or your favorite toy that survived childhood. Secondhand stores or flea markets provide an unlimited source for these things. In case of emergency, you can always raid your own living quarters or office.

KEY CONCEPT 7 **Properties and set dressings determine the style of the environment.**

SET DESIGN

Although you may never be called upon to design a set, you will certainly have to tell the set designer what environment you envision and why. You will also have to know how to "read" a set design so that you can evaluate the set relative to the process message and technical requirements (such as lighting, camera and talent movement, and audio pickup).

Process Message

Once again, a clear statement of the process message will guide you in designing the appropriate environment. For example, if the process message of an interview is to have the viewer get to know the guest as intimately as possible and probe her feelings and attitudes, what kind of set do you need? Because you should show the guest in intimate close-ups throughout most of the show, you don't need an elaborate interview set. Two simple chairs in front of an uncluttered background will do just fine.

On the other hand, if the process message is to have the viewer see how the guest uses the physical environment of her office to reflect her power, you had better have the host conduct the interview on-location from the guest's actual office, or in a studio set that is a close copy of it.

As with all other medium requirements, in designing or evaluating a set you need to have a pretty good idea of what it is you want the viewer to see, hear, and feel. Once you have interpreted the process message as to scenic requirements, you must then learn to evaluate and translate the scene design—the floorplan—into an actual studio set.

The Floorplan

The floorplan is a diagram of scenery and set properties drawn onto a grid pattern that resembles the usable floor area in the studio. To help you locate a certain spot on the studio floor, the floorplan has the lighting grid superimposed, or a regular grid drawn over the floor area similar to the orientation squares of a map. By using the lighting grid, the floorplan can also be used for drawing a light plot.

Elaborate set designs are always drawn to scale, such as the common ¼ inch = 1 foot. There are templates that have in-scale cutouts for the typical set pieces, such as tables, sofas, chairs, beds, or chests of drawers. You can also use one of the many computer programs on the market that are available for architectural layouts.

If you have a relatively simple setup, the art director may make only a rough sketch that shows the background scenery and set props and the approximate location of the set, leaving it up to the floor manager to place the set in the most advantageous spot in the studio. **SEE 13.15** You may recall that it is much easier to place a set according to existing lighting—key, fill, back, and background lights—than trying to rehang lighting instruments to suit an arbitrary set location. The floorplan should indicate all scenery, including doors and windows, as well as the type and location of set props and major hand props. **SEE 13.16**

When drawing a floorplan, keep in mind that the set must be workable for the cameras: it must provide adequate backing for a variety of camera angles. A common mistake by inexperienced set designers is to show inadequate backing for the set props and talent action. Somehow, the furniture in the set always seems to take up more room than anticipated. This problem is especially apparent when the floorplan is not drawn to scale.

Another frequent mistake is that the set design exceeds the available floor space. As mentioned earlier, the cyc and the items stored in the studio can radically reduce the usable floor space. The floorplan must show the space that is *actually available.* To help the lighting people direct the back lights at the performance areas at not too steep an angle and avoid unwanted shadows on the background flats, all *active furniture* (furniture actually used by the talent) must be placed at least 6 to 8 feet from the background flats, as shown in figure 13.16.

Prop List

Even if the floorplan shows some of the major set and hand props, all props must be itemized on a *prop list.* Some prop lists itemize set props, set dressings, and hand props separately; but you can combine them in a single list, provided that you don't forget anything. Confirm with the property manager that the props you requested are actually available on the day or days you need them, and inspect each one to see whether it fits the intended scene design. For example, a Victorian chair would certainly look out of character in an otherwise supermodern office set. During the actual props checkout, verify that all listed props are actually

13.15

SIMPLE FLOORPLAN

The floorplan grid (often the lighting grid) helps to locate the position of scenery and set props.

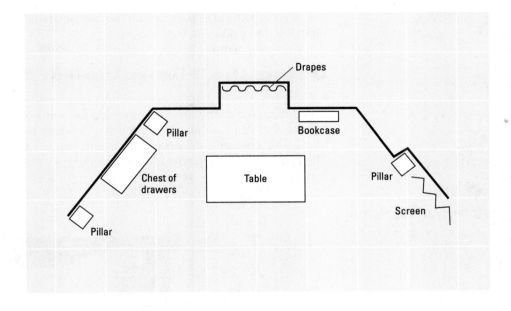

13.16

FLOORPLAN WITH SET AND HAND PROPS

More elaborate floorplans indicate the type and position of the set props (furniture, lamp, sculpture, paintings) and major hand props (newspaper, tea set, magazines).

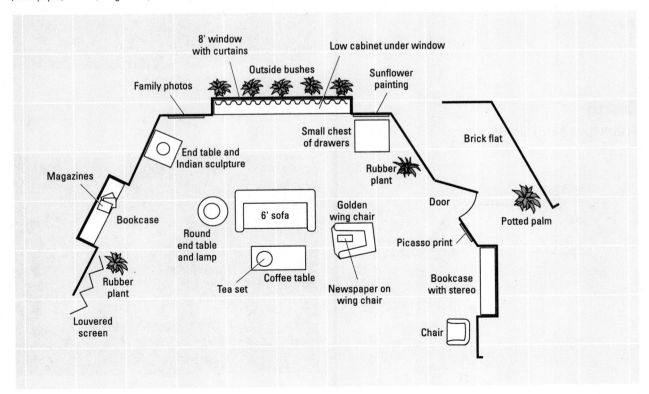

delivered to you and make sure that they are not damaged in any way before taking them into the studio.

Using the Floorplan for Setup

A floorplan is pretty useless unless you can translate it into an actual set and performance environment. You must acquire some of the skills of an architect or builder who can look at a blueprint of a building and visualize what it will look like when erected and how people will move through and function in it. The following three figures show how simple floorplans translate into the corresponding setups. **SEE 13.17–13.19**

13.17

FLOORPLAN 1 AND SETUP

Floorplan

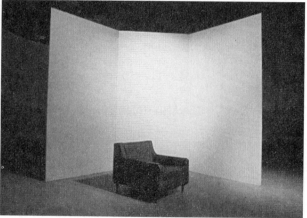

Setup

13.18

FLOORPLAN 2 AND SETUP

Floorplan

Setup

13.19

FLOORPLAN 3 AND SETUP

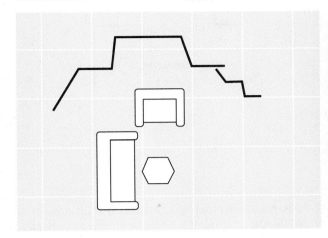

Floorplan

Setup

Being able to "read" a floorplan is important for all major production personnel. A good floorplan helps the floor manager and crew to put up and dress the set fairly accurately and independently of the designer. The director can map out the major talent positions and movements and design the principal camera shots, positions, and movements before setting foot in the studio. The lighting director can lay out the basic light plot, and the audio engineer can determine the basic mic placement. Also, by knowing how to read the floorplan, you can catch and often solve production problems before they occur. Because the floorplan is such an important factor in production efficiency, you should insist on having one drawn even if the setup and production are relatively simple.

Evaluating the Floorplan

Take a close look at floorplan 4. Give it a close reading and list all the potential production problems you can find. **SEE 13.20** The floorplan shows a set for a two-camera live interview. Now, let's compare our lists:

▷ Assuming that the flats are drawn to the customary scale (¼ inch = 1 foot), the back wall is a 4-foot flat—hardly enough backing for two chairs and a table. The chairs and coffee table are obviously drawn to another, smaller scale.

▷ The chairs are too close to the back and side walls for good lighting. The back lights would have to come in at an extremely steep angle, and the key lights would have to strike the subjects directly from the front—not exactly what you would call good lighting.

▷ There is no way you can use two cameras. The set opening is too narrow to have the cameras stand side by side and engage in any kind of cross shooting. The only way you can use this set is to have a single camera shoot straight into the box at the chairs.

13.20

FLOORPLAN 4

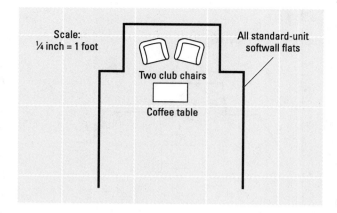

Scale: ¼ inch = 1 foot

Two club chairs

Coffee table

All standard-unit softwall flats

▶ The box set is bound to cause audio problems. The parallel walls are apt to reflect the sound back and forth, creating the infamous "inside a barrel" sound.

Let's do the same with floorplan 5. This one shows an office interior in which two actors demonstrate the dos and don'ts of a job interview. **SEE 13.21** The script for the two-camera live-on-tape production calls for frequent over-the-shoulder and cross-shots. Don't read on before listing the potential production problems.

Now let's compare notes:

▶ Yes, the interviewer's chair is much too close to the background for good back lighting.

▶ The file cabinet and bookcase are useless; they are out of camera range unless one of the cameras takes an extreme straight-on long shot. But then the camera will overshoot the back wall.

▶ The applicant is sitting much too close to—oops—the studio wall. There is no backing indicated, and that means that we would see the blank studio wall. Also, there is no way to hang a back light that close to the wall.

▶ The way the people are positioned makes over-the-shoulder or cross shooting impossible. There is no room behind the interviewer for a camera, and the file cabinet will prevent the other camera from squeezing behind the applicant.

▶ Even if there were enough room for the cameras for proper over-the-shoulder shooting, the rug would make it very difficult, if not impossible, for the studio cameras to move into the set.

▶ If you removed the file cabinet and managed to have the camera look over the applicant's left shoulder, the rubber plant would be directly in back of the interviewer. Such an arrangement is bound to cause composition problems by showing the plant as if it were growing out of the interviewer's head.

How does your list compare? Did you foresee most of the production problems? What, then, would be your recommendations to change the set so that it is more workable? A revised floorplan 5 shows one possible solution. **SEE 13.22**

13.21

FLOORPLAN 5

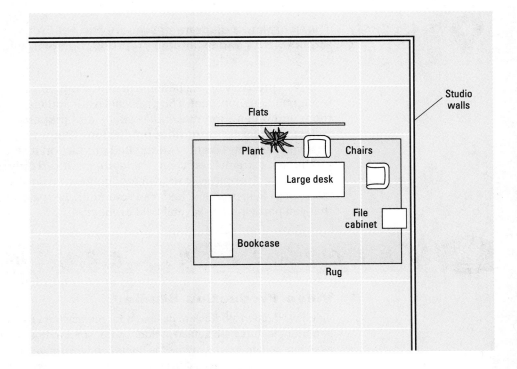

13.22

REVISED FLOORPLAN 5

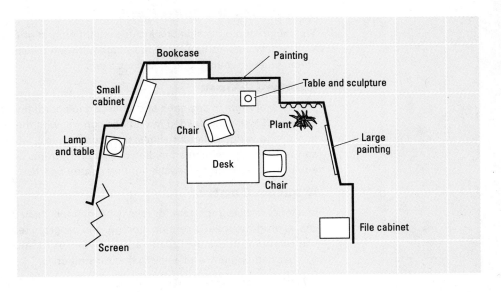

The rug is gone, and there is enough room for the cameras to maneuver for the over-the-shoulder shots. The background for each shot is interesting without competing for attention. The screen on the left side of the set and the file cabinet are a helpful way of showing the camera operators the outer limits of the set and thus prevent overshooting.

You can also create believable backgrounds electronically. We will briefly discuss such synthetic environments in chapter 14.

KEY CONCEPT 8 **The floorplan, a diagram of scenery and set props, shows the setup requirements and facilitates preproduction planning.**

You probably have a better idea now about how a studio provides an optimal production environment. The physical layout and major installations, the control room equipment, the makeup, scenery, and property areas are all designed to facilitate a great variety of video productions. Although studio operations require a relatively large and highly coordinated production team, the studio makes video production extremely efficient. This studio visit certainly answered your question to the Triple-I people as to why all productions are not done in the field. As though the Triple-I field producer had read your mind, he suggests as your final experience that you participate in several field productions.

O N C E A G A I N , R E M E M B E R . . .

■ Video Production Studio

Video production studios are designed for multicamera productions and teamwork. Important features are sufficient floor space, smooth floor for the cameras, adequate ceiling height so that the lights can be suspended, large doors, acoustically treated walls, and relatively quiet air-conditioning.

■ Major Studio Installations

The major studio installations include a lighting grid or movable battens, various wall outlets, intercommunication system between the studio and control room, studio video monitors, and studio speakers.

■ Control Room

The control room is designed and arranged to coordinate the total production process. It is usually divided into image control, with the switcher, C.G. monitor banks, and various intercom lines; the sound control, which resembles a small audio studio, containing an audio console and various recording and playback equipment; and sometimes the lighting control board.

■ Master Control

Master control is important for television stations. Its basic functions are quality check, program input, program storage, and program retrieval. Most master control rooms house the CCUs, various on-line VTRs and other automated video playback equipment, and a link to the transmitter.

■ Studio Support Areas

Studio support areas include the scenery and property storage, and the makeup and dressing rooms.

■ Scenery and Properties

The major video scenery consists of softwall and hardwall flats, a cyclorama and various drops, set pieces, platforms, and wagons. Properties include set props (such as furniture), hand props (items actually used by talent), and set dressings (wall hangings, lamps, and decorative plants).

KEY CONCEPTS

- The studio provides maximum production control.

- The control room is designed to coordinate the studio production process.

- A reliable and flexible intercom system is essential for effective teamwork in multicamera studio productions.

- The director and TD must sit next to each other in the control room.

- Master control checks the technical quality of all programs, and it facilitates program input, storage, and retrieval.

- Scenery must create a certain environment and must allow for optimal lighting, audio pickup, and camera movement.

- Properties and set dressings determine the style of the environment.

- The floorplan, a diagram of scenery and set props, shows the setup requirements and facilitates preproduction planning.

Field Production Any video production that happens outside the studio.

Remote A production of a large, scheduled event done for live transmission or live-on-tape recording.

Remote Survey An inspection of the remote location by key production and engineering persons so that they can plan for the setup and use of production equipment. Also called *site survey*.

Contact Person A person who is familiar with, and who can facilitate access to, the remote location and key people. Also called *contact*.

ENG Stands for electronic news gathering. The use of portable camcorders, lights, and sound equipment for the unplanned production of daily news stories. ENG is usually done for live transmission or immediate postproduction.

EFP Stands for electronic field production. Video production done outside the studio that is usually shot for postproduction (not live).

Remote Truck The vehicle that carries the control room, audio control, VTR section, video control section, and transmission equipment.

Uplink Truck Small truck that sends video and audio signals to a satellite.

Synthetic Environment Electronically generated settings, either through chroma key or computer.

Virtual Reality Computer-simulated environment with which the user can interact and that can change according to the user's commands.

Field Production and Synthetic Environments

FINALLY, you are taken by the Triple-I people to a field production. There are quite a few new activities you did not observe in the studio productions. The director and TD have already gone to the location where the production is to take place and now exchange their information with the crew and talent. The crew is meticulously checking and rechecking the equipment that is to be taken on location, and the producer worries about the weather. Even the VTR operator, who is normally quite unconcerned about the preproduction activities, is listening intently to the preproduction discussion by the director. There is obviously a big difference between studio and field productions.

Field production does not mean that you have to move your production to an actual field; rather, it refers to any video production that happens *outside the studio*. The MTV production that the Triple-I crew videotaped in the street was a field production. Field production also includes documentaries that are shot on location, or the elaborate remotes of a Thanksgiving Day parade or a football game. In field production, although you normally have no choice of the environment in which the event takes place, you still can make the environment work for you instead of against you. Field productions usually refer to productions that are planned; however, we will include ENG (electronic news gathering) here because it also happens outside the studio.

Synthetic environments are created by computer. The action is either done by real performers and actors and keyed into the computer-generated setting, or it is part of an entirely computer-generated event.

Specifically, this chapter focuses on—

▨ **GENERAL FIELD PRODUCTION**
Preproduction remote survey, production equipment checklist and other production considerations, and postproduction activities

▨ **ELECTRONIC NEWS GATHERING**
News gathering and transmission

■ **ELECTRONIC FIELD PRODUCTION**
Shooting outdoors and shooting indoors

■ **BIG REMOTES**
The remote truck and remote transmission

■ **COMPUTER-GENERATED SETTINGS**
Virtual reality and interactive virtual reality

GENERAL FIELD PRODUCTION

Field production includes the relatively small-scale electronic field production (EFP) and the much more elaborate *remote*. Camcorders, portable lights, and audio equipment make it possible to move video production outside the studio. In effect, you have the whole world as your stage. The trade-off for moving outside the studio into the field is control. In field productions, you simply cannot create and control a specific production environment, but must *adapt* to one. Necessarily, field productions have specific preproduction, production, and even postproduction requirements.

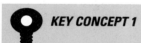 *KEY CONCEPT 1* **In field production, you must adapt to the environment.**

■ **Preproduction: Remote Survey**

Except for ENG (electronic news gathering), all field productions require careful preproduction. Because you need to adapt to a specific environment, it makes sense to look at it before going there with talent, crew, and production gear.

A field inspection is called a *remote survey*, or *site survey*. You should do a remote survey even if the field production is relatively simple, such as inter-viewing someone in a hotel room. Looking at the hotel room beforehand will help you decide where to put the guest and interviewer, and where to place the camera. It will also give you important technical information, such as specific lighting and sound requirements.

For example, the small table and the two chairs may be adequate for getting optimal shots of the interviewer and guest, but the large picture window behind the table will certainly cause lighting problems. If you shoot against the window, your guest and interviewer will appear as silhouettes. Drawing the curtains will require lighting the interview area with portable instruments.

Are there enough and convenient outlets for your lighting instruments? Perhaps you can put the table and chairs away from the window. Will the new setup still be workable for the interviewer and guest, and, most importantly, for the camera? Will the background be reasonably interesting or will it interfere with the shots? Now listen to the room. Is it relatively quiet or do you hear noises coming

through the door, window, or from the air-conditioning? Can you disconnect the telephone so that it won't ring during the interview?

Survey team Even this relatively simple field production can benefit a great deal from your preproduction survey. For more complex productions, careful remote surveys are an essential preproduction activity. What you need to find out is just *what* the event is all about, *where* the event is to take place, *how to adapt* the environment to the medium requirements, and *what technical facilities* are necessary for videotaping or telecasting the event. For a relatively simple field production, the director and/or producer usually make up the survey team. For more complex productions, you need to add a technical expert—the TD or engineering supervisor. If possible, have a contact person accompany you on the initial survey.

Contact person The *contact person*, or *contact*, is someone who is familiar with the remote location and who can help you adapt the environment to the various production requirements. Let's go back to the hotel room interview. Your contact person at the hotel should not be the guest you are about to interview, but someone who has the knowledge and authority to get certain things done in the hotel. If you overload a circuit with your lighting instruments, your contact person should be able to call maintenance immediately and have the circuit breaker reactivated. To prevent the telephone from ringing during the interview, your contact person should be able to call the hotel operator to hold all calls, or the maintenance people to disconnect the phone line temporarily. The contact person might even find you an empty hotel room that is better suited for videotaping the interview than the one the guest actually occupies.

If your field production involves the coverage of a scheduled event over which you have no real control, such as a parade or sports event, your contact person must be thoroughly familiar with the event and supply you with vital information, such as names and order of the parade entries. Most importantly, your contact person should help you gain access to restricted areas or to facilities at times when they are ordinarily locked up. Make sure that you get the contact's full name, title, address, business and home phones, and fax number. Also, establish an alternate contact and have one or the other accompany you on the initial remote survey.

The survey Whenever possible, try to conduct the survey at the same time of day as the scheduled field production so that you can see just where the sun will be. The position of the sun will ultimately determine where to place your camera or cameras when shooting outdoors, or indoors when large windows are in camera view.

Be sure to prepare a good *location sketch,* which is similar to a studio floorplan. The location sketch should show the major streets and structures of the outdoor production environment, and the main features of the indoor production space, such as hallways, doors, windows, and major furnishings. Even if your field production happens in an actual field, make a sketch that indicates the approximate size of the production area, the major crossroads, and the location of the sun. Include in your outdoor location sketch such items as parking facilities, location of the EFP vehicle or remote truck, and the closest toilet facilities. **SEE 14.1–14.2** The remote survey table on page 349 lists the major survey items and the key questions you should ask. **SEE 14.3**

14.1

OUTDOOR LOCATION SKETCH

An outdoor location sketch should show the main streets, buildings, and facilities of the immediate production area. It should also indicate the location of the EFP vehicle and the nearest toilet facilities. Also note the location of the sun during the scheduled production period.

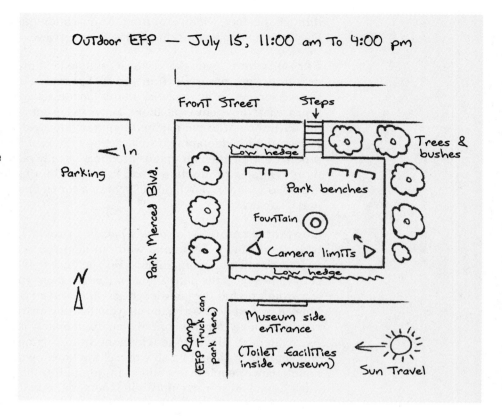

14.2

INDOOR LOCATION SKETCH

The indoor location sketch should show the principal production areas (room, hallway), windows and doors, and major furnishings, such as desks, chairs, plants, or file cabinets.

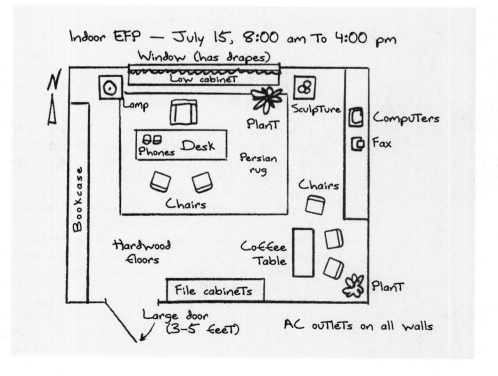

14.3

REMOTE SURVEY

SURVEY ITEM	KEY QUESTIONS
Contact	Who is your principal contact? Title, address, business phone, home phone, fax. Who is your alternate contact? Title, address, business phone, home phone, fax.
Place	Where is the exact location of the telecast? Street address, telephone number. Where can cast and crew park and eat? Where are the closest toilet facilities?
Time	When is your remote telecast? Where is the sun at the beginning and end of the telecast?
Event	What type of action can you expect? Where does the action take place?
Cameras (Stationary)	Where are the major positions of your camcorder? When doing a multicamera remote, how many cameras do you need to cover the event? Try to use as few as possible. What are the locations of your cameras? Do not shoot from, or place the cameras on, opposite sides of the action. In general, the closer together the cameras are, the easier and less confusing the cutting will be. Shoot with the sun, not against it. Try to keep the sun behind or to the side of the cameras for the entire telecast. Are there any large objects blocking the camera view, such as trees, telephone poles, or billboards? Will you have the same field of view during the actual time of the telecast? Spectators may block a camera's field of view, although at the time of the survey the view was unobstructed. Do you need special camera platforms? How high? Where? Can the platforms be erected at this particular point? If your camera is connected to a power outlet or CCU, what is its action radius? How long a cable run do you need?
Lighting	If you need additional lighting, what kind, and where? Can you use reflectors? Can the lighting instruments be conveniently placed? Can you place back lights so that they are out of camera range? Are there windows that let in a large amount of daylight? Can they be covered or filtered so that they do not cause silhouette or color temperature problems? How many watts can each circuit handle?
Audio	What type of audio pickup do you need? Where do you need to place what microphones? What is the exact action radius as far as audio is concerned? Which are stationary mics, and which are handled by the talent? Do you need wireless microphones? Otherwise, how long must the mic cables be? Do you need special audio arrangements, such as audio foldback or a speaker system that carries the program audio to the location? Do you need long-distance mics for sound pickups over a great distance? Where should the mics be located?
Power	What is your power source? Even if you run your camcorders by battery, what about your lights? Does your contact person have access to the power outlets? If not, who does? Make sure that he or she is available at the times of the remote setup and the actual production. Do you need special extension cables or power cables? Do your extension cables fit the power outlets on the remote location?
Intercommunications	What type of intercom system do you need? In a multicamera production, you need to set up a system that is similar to the studio intercom. How many I.F.B. channels and/or stations do you need, and where should they go? Do you need walkie-talkies to coordinate the crew efforts? Do you need a cellular phone hookup?
Location of Production Vehicle	If you need a large production vehicle, such as a remote truck, where can you park it? Are you close enough to the event location? Does your production vehicle block normal traffic? Make sure that parking is reserved for the production vehicle and the cars of talent and crew.
Miscellaneous	Will you need the assistance of the local police to control vehicle and pedestrian traffic, or to secure parking?

If you have scheduled your field production outdoors, what will you do if it rains or snows? Obviously, it is a good idea to have alternate dates for your field production, unless the event is going on regardless of weather conditions, such as a football game or the Thanksgiving Day parade.

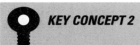

KEY CONCEPT 2 **The remote survey is an essential preproduction activity.**

The checklist The success of the production depends a great deal on your thorough preproduction and on how well you have prepared the production schedule. Contrary to the studio, where all major installations and equipment are readily available, you need to transport every single piece of equipment to the field production site.

Prepare a *checklist* for *all* equipment and verify every item that is loaded onto the EFP vehicle. Use the same list when reloading the equipment for the return trip. The type and amount of equipment you need depends on the production requirements and, specifically, on your preproduction survey. Check the following list of equipment items you need to consider for EFP.

CHECKLIST: FIELD PRODUCTION EQUIPMENT

☑ **Camcorders** How many do you need? If one is available, take a spare camera along, even if it is of lower quality. In case of emergency, a properly lighted interview shot with a Hi8 camera will certainly be better than no camcorder at all.

☑ **Camera mounts** Always take a tripod along, even if you think that you will work the camera from your shoulder. Also, do you need special camera mounts, such as tripod dollies, jib arms, or beanbags?

☑ **Videotape** Do you have the proper cassettes for your camcorders and VTRs? Not all ½-inch cassettes fit all ½-inch VTRs. Always take plenty of cassettes along. Running out of tape is excusable when you are a tourist, but not when doing a field production. Check whether the actual length of the tape matches that of the label on the box. If the cassette has large reels and little tape on it, you can be sure that it will not give you ninety minutes worth of recording time, even if the label on the box says so.

☑ **Power supply** How are you going to power your camcorder? Are the batteries fully charged? Take several along. If you use an AC/DC power supply, do you have enough AC extension cords to reach the AC outlet? You also need extension cords for your portable lighting instruments and for a field monitor. If your monitor is battery-powered, do you have the right battery? Is it fully charged? Do you have a spare battery for the monitor?

☑ ***Audio*** In addition to lavaliere microphones, take at least one shotgun and one hand mic along. For a more ambitious EFP, you need to match the mics to the acoustics of the location. Are the mic cables long enough to reach the camcorders or audio mixer? All remote mics need windscreens. Do you need special mounting equipment, such as clamps, stands, or fishpoles? Do you need a mixer or an additional audiotape recorder? Take plenty of audio cassettes or audiotape along. Check the ATR (audiotape recorder) before taking it on location. Don't forget headsets for the mic operator and the audio recording technician.

☑ ***Cables and connectors*** Do you have the appropriate cables and connectors? Most professional equipment operates with BNC connectors for the video coax cables and XLR connectors for audio cables, as shown in figure 8.24. Consumer-type equipment usually comes with RCA phono and mini jacks and plugs, as shown in figure 8.25. Bring some adapters along for video and audio cables. Double-check all connectors and adapters. If you need to connect the camera to an RCU, do you have enough camera cable?

☑ ***Monitor and test equipment*** Be sure to take a monitor along for playback. If you do a multicamera EFP with a switcher, each camera input needs a separate preview monitor. If you have a narrator describing the action, you need a separate monitor for him or her. In field productions that require high-quality pictures, you need an RCU (remote control unit) for each camera, and special test equipment. Ordinarily, the TD is responsible for such items, but you still should see to it that these items are part of the equipment package.

☑ ***Lighting*** Always take along one or two portable lighting kits, each containing several lighting instruments, barn doors, diffusers, light stands, and spare bulbs. Use floods (softlights) or diffusion umbrellas for large area lighting. Do the spare bulbs actually fit the lighting instruments used? Do they burn with the desired color temperature (3,200°K or 5,600°K)? Use light-blue and pale-orange gels on the lighting instruments if you need to raise or lower the color temperature, unless the lights come with special color temperature filters. White diffusion material is always needed to soften shadows. You may also need sheets of pale-orange (warm) color media for windows if you need to change the high outdoor color temperature to the lower indoor one, or sheets of ND (neutral density) filters that lower the light intensity without changing the color temperature.

Your lighting package should also include: a piece of muslin to cover an off-camera window; a piece of black cloth to cut down on unwanted reflections; reflectors and diffusion umbrellas; a light meter; extra light stands; and special clamps and sandbags for securing the light stands. Unless you have access to sophisticated expandable battens, take some pieces of 1 × 3 lumber along; they will come in handy for constructing supports for small lighting instruments. Always carry a roll of aluminum foil for making heat shields or makeshift barn doors. Take enough AC extension cords, and adapters that fit the various household outlets.

☑ ***Intercom*** In small field productions, you do not need special intercom setups. But you should always leave a telephone number at home base where you can be reached in case of an emergency. A cellular phone is a must if you primarily do EFP. For larger field productions, you need a small power megaphone or walkie-talkies

to reach a spread-out crew. If you use a multicamera and switcher system, you need intercom headsets.

 Miscellaneous Here is what you should take along on every EFP: extra scripts and production schedules; field log forms; a slate and water-based marker; several large rain umbrellas and "raincoats" (plastic covers) to protect equipment and crew in case of rain; a white card for white balancing; a large newsprint pad and marker pen for writing cue cards or other information for the talent while on the air or recording; if necessary, a remote teleprompter with batteries and all necessary cables; several rolls of gaffer's tape and masking tape; white chalk; several clothespins to hold things in place; a makeup kit; a large bottle of water; a small plastic bowl; paper towels; a broom and trash bag; and lots of sandbags.

Test all equipment before loading it in your vehicle. At least, you should do a brief recording with your camcorder to see whether video and audio portions can be properly recorded. If you don't have a battery tester, attach the batteries you are taking along one by one to the camera and see whether they are properly charged. Test each mic and each lighting instrument before loading it on the EFP vehicle. All this checking may seem like a waste of time until you get stuck far away from your production facility with a malfunctioning camcorder, mic, or light you forgot to test.

KEY CONCEPT 3 **Prepare a checklist of all equipment items needed, and test all equipment before taking it to the remote location.**

Production: Field Activities

Each field production has its own requirements and difficulties. Your careful preproduction survey should have eliminated most of the production problems. However, here are a few items to consider that are not part of your remote survey.

Respecting property Whenever you are on someone else's property, be mindful that you are a guest and actually intruding with your video gear and production people. Working in video does not give you a special license to invade people's homes, upset their routines, or make unreasonable demands on them. When you shoot a documentary in somebody's well-kept garden, don't trample on flowers or other plants that have been carefully tended just to get a good camera position. Dragging equipment dollies or camera cases along polished floors or valuable rugs is usually not appreciated by the owner. Even if pressed for time, do not get caught up so much in the production activities that you lose common sense.

Safety As in studio productions, in the field you need to be constantly aware of proper safety precautions. Don't be careless with extension cords, especially if you string them outside in damp weather or rain. Tape all connections so that they become waterproof. If you have to lay cables across busy corridors or doorways,

tape them down with gaffer's tape and put a rubber mat over them. Better yet, try to string them above so that people can walk below them unhindered. When shooting in rain, protect your cameras with raincoats. If possible, have someone hold an umbrella over the camera and operator. Ask the police to assist you when shooting along a freeway or in downtown traffic.

Logging During the shoot, keep an *accurate field log* of all takes, good or bad. *Label all tapes* and the boxes, and put them in a container used solely for transporting the videotaped material. Pull the tabs or activate other protection devices so that the source tapes cannot be erased.

Putting things back and cleaning up If you have to rearrange furniture or pictures when shooting indoors, ask whether it is all right for you to do so, and tell the person in charge why you need to do it. Before you start moving things around, make a rough sketch of where the items are located or take several Polaroid pictures of the interior.

When you are finished, make sure that all things are put back where you found them. Remove all gaffer's tape that you may have used to tape down cables, pick up all extension cords, sandbags, and especially empty soft drink cans and other lunch remnants. An EFP team, who had finally gained access to an old and venerable family farm only after weeks of pleading by the show's producer, was invited back with a smile for the follow-up show because the production team had brought a broom along and swept the area clean.

Loading the equipment When loading the equipment after the shoot, it is time to pull out the checklist again. Mark on the list every item that is loaded in the remote vehicle for the return trip. Look for missing items right away; it is usually easier to find them right after the production than days or weeks later. Make sure that you have all source tapes properly labeled and that the field logs match their labels. Keep them close to you until you arrive back home.

 KEY CONCEPT 4 **After the production, make sure that you left the location the way you found it and that you brought back everything you took to the field.**

Postproduction: Wrap-up

As mentioned earlier, the first thing you need to do is make protection copies of all your source tapes. If necessary, you can combine this dubbing with simultaneously bumping up the source tapes to a higher-quality format with time code for on-line editing, and making VHS copies with time code windows for off-line editing. If you have used a high-quality camcorder (such as a Betacam SP) and generated the time code in the field while shooting, make VHS copies for off-line editing and save the original source tapes for the on-line editing process.

As with all other postproduction activities, you now need to review the tapes and prepare an accurate VTR log that lists all shots by in- and out-numbers, identifies good and bad takes, indicates predominant vectors, and lists the principal audio for each shot. Then it is up to the postproduction people to put it all together into a comprehensive message that, hopefully, will trigger the intended process message.

ELECTRONIC NEWS GATHERING

By its very nature, *ENG,* or *electronic news gathering,* cannot be planned. All you can do is run after the breaking news story and do your best to cover it. This does not mean that you give up all control over production procedures. Preproduction in ENG means that you have your equipment ready to go anywhere at any time and that your equipment will be functioning properly regardless of where you are and under what conditions you need to shoot.

News Gathering

As a news videographer, you are responsible not only for videotaping the story, but also for making the decisions on just how to tell it. In a breaking story, you must be able to assess the situation, have the equipment functioning, and capture the essence of the event all in a matter of minutes. You simply have no time to consult your news producer or anyone else about what is going on or how to shoot it. But even in such intense situations, good videographers are able to deliver well-composed shots that can be edited into a smooth sequence.

If you are sent out to cover a story with a reporter, the news-gathering process is slightly less hectic. You usually have some flexibility about where to place the field reporter for his or her "standup" report and in selecting the most effective shots for your story. You can now choose as a background for the reporter a location that underlines the principal story (such as the city hall, college campus, county hospital, or airport).

Whenever possible, have the reporter stand in a shaded area rather than in bright sunlight or, worse, in front of a brightly lighted building. Bright sunlight will cause unflattering fast falloff and dense shadows, and the bright background will cause the reporter to be seen in silhouette. Even if you have a reflector handy to slow down the falloff, you will usually find it easier to place the reporter in a shaded area than to fight excessive sunlight. Do not forget to white balance your camera for every new lighting situation. Watch what is behind the reporter so that you do not have street signs, trees, or telephone poles "growing" out of the reporter's head.

Be mindful of all audio requirements. Don't have the reporter deliver his or her report on the windiest corner of the street; instead, find a spot that is relatively protected from the wind. Small rooms or corridors with bare walls have a tendency to produce unwanted echoes or make reporters sound as though they are speaking inside a barrel. Take an audio level before each videotaping. Always have the camera mic open at the same time to record ambient sound on a second sound track of the

videotape. At the end of the report, record some ambient sound only, which may help the editor to bridge the sound changes at the edit points.

Transmission

When a live transmission of the news story is required, you need a production van that has the proper transmission equipment to relay the video and audio signals back to the station and ultimately to the station transmitter or satellite **SEE 14.4**

The signal can be sent from the camera to the van by ordinary camera cable or by a small tripod-mounted microwave transmitter connected to the camera. From the van, the signal can be further relayed by microwave to the transmitter. If the signal must be directly "uplinked" to a communications satellite (positioned 23,300 miles above the earth), you need a special truck that contains the satellite transmitting equipment, called the *uplink*. **SEE 14.5** Because these trucks are especially designed to uplink news, they are called *SNVs* (satellite news vehicles).

14.4

ENG/EFP PRODUCTION VAN

For routine productions, a large car or station wagon can serve as a production van. If the signal must be relayed to the station for live transmission or videotaping, a special van is used that contains VTRs, generators, and microwave transmission equipment.

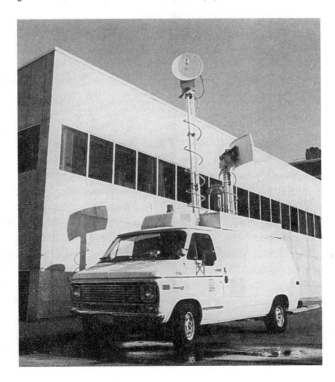

14.5

SATELLITE UPLINK TRUCK

The satellite uplink truck is a portable station that sends the video and audio signals to a specific satellite.

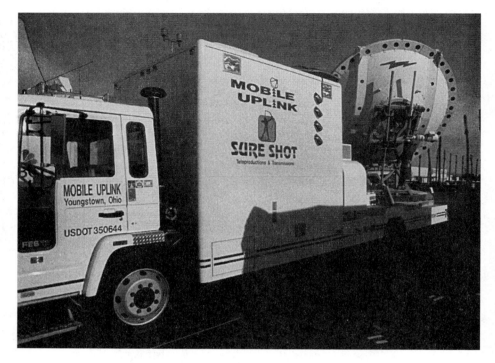

The satellite then amplifies the signal and sends it back to the receiving earth station or stations, called *downlinking*.

Although the signal transmission is always done by qualified engineers, you should at least know what is needed to get the live signal from the camera to the station transmitter. The friendly chitchat between the host in the studio and the various guests located in different corners of the world requires a great amount of technical equipment and know-how.

ELECTRONIC FIELD PRODUCTION

Electronic field production, or *EFP,* includes all out-of-studio productions except news and the big remotes that more resemble multicamera studio productions than single-camera field productions. Documentaries, magazine news stories, investigative reports, travel shows, and exercise programs that are shot outdoors are all electronic field productions. Because all field productions are planned, you can prepare for them in the preproduction phase. The more preproduction that goes into a field production, the more likely it is to succeed.

Shooting Outdoors

When shooting outdoors, not only can you select a particular environment, but you can also decide on which portions of the environment you want to show.

14.6

SHIFTING HORIZON LINE

To avoid jump cuts, the horizon line should be kept in the same screen portion of the various shots. In this sequence, the shifting horizon line would create jarring jump cuts. (Compare with figure 10.8.)

Foreground　With a prominent foreground piece in the shot—a tree, fence post, mailbox, or traffic sign—you can dramatically improve the scene, make the composition more dynamic, and give it depth. If there is no natural foreground piece, you can often "plant" one. Instead of looking for a convenient foreground tree, you might simply handhold and dip a small tree branch into the shot. The viewer's mind will fill in the rest and "see" the whole tree.

Background　Always look beyond the main action to the background to avoid odd juxtapositions between foreground and background. But you must also be careful to maintain background continuity in postproduction editing. For instance, if you show a truck passing in the distance in shot 1 but not in shot 2, the truck will seem to have mysteriously disappeared when the two shots are edited together. An alert editor will probably rule against such an edit.

　　Jump cuts can be caused not only by slight position changes of the foreground pieces but also by a background shift. To avoid background jump cuts, try to keep a prominent horizon line or an especially conspicuous background object, such as the single tree on a distant hill, in the same screen portion in subsequent shots. **SEE 14.6**

Weather　When outdoors, you are at the mercy of the weather. Always be prepared for bad weather. As mentioned before, take raincoats along for the cameras (a plastic sheet will do in an emergency) and real rain gear for the crew. As old-fashioned it may seem, a large umbrella is still one of the most effective means of keeping the rain away from people and equipment.

　　If you move from a chilly outside location to indoors, let the camcorder or VTR warm up a bit. The extreme temperature change might cause condensation in the videotape recorder, shutting down its operation automatically. Such a shutdown will certainly put a crimp in your production schedule. In extreme cold weather, zoom lenses and even the videotape transport in your camcorder have a tendency to stick. Keep the camera in your vehicle and run the camcorder for a while when it

is exposed to the cold temperature to prevent the lens and VTR from sticking. Some mics will refuse to work properly in extremely low temperatures unless protected by a windscreen. Have an *alternate production plan* in case it is raining or snowing.

Most importantly, watch the weather for shot continuity. If videotaping a brief scene of two people talking to each other requires several takes that stretch over an hour or so, you may have a cloudless sky as the background for the first few takes and a cloudy one for the last takes. The sudden appearance of clouds between question and answer does not exactly contribute to smooth continuity. As long as you are aware of the problem, you can try to choose a background that does not show the time progression, or arrange your shooting schedule so that the time change does not jeopardize your postproduction editing.

KEY CONCEPT 5 **When shooting outdoors, watch the weather and background for shot continuity.**

Shooting Indoors

When shooting indoors, you will find that you may have to rearrange the furnishings and (more often) the pictures on the wall in order to get optimal shots. As pointed out earlier, always make a record of what the room looks like (by drawing a small sketch, taking Polaroid shots, or videotaping the room with a small camcorder) before you start moving things around. Such a record will greatly assist you in putting things back where they belong.

Lighting Be especially aware of the specific lighting requirements. Again, check the available outlets. Be extremely careful when placing lights inside a room. Do not overload the circuits. Turn the lights off whenever you don't need them. Sandbag all light stands, and make a heat shield out of aluminum foil, especially when the lighting instrument is close to curtains, sofas, books, or other combustible material.

Even on a cloudy or foggy day, the color temperature of the light coming through an outside window is considerably higher than that of indoor lights. In this case, you must make a decision to boost the color temperature of the indoor lights, or lower the daylight color temperature coming through the window.

Audio Except for simple interviews, good audio always seems to be a bigger problem than good video. The main reason for this is that the microphones are often placed at the last moment without adequate consideration of the acoustics of the room or special sound pickup requirements. What you should do is include a brief audio rehearsal in your EFP production schedule so that you can listen to the sound pickup before starting with the videotaping. If you have brought several types of mics along, you can choose the one that sounds best in that environment.

As you recall, it is better to record the principal sounds and ambient sounds on separate videotape tracks rather than mixing them in the field. If careful

mixing between foreground and background sounds is required, you can do it much better in the postproduction studio than in the field. If you have mixed the sounds in the field, you have eliminated any further adjustment of the mix in postproduction.

Yes, you have heard it before! But, please, put everything back where it was before you started to rearrange the production environment. Also, use your checklist to see whether you have every piece of equipment loaded before departing the remote location.

BIG REMOTES

While learning basic video production, you will probably not be called upon to participate in a *big remote*. However, you should have a least some idea of what a big remote is all about and what major equipment it uses for its field production.

Big remotes are devoted to the live or live-on-tape coverage of large scheduled events, such as parades, sports, significant international events, and political gatherings. Big remotes resemble multicamera studio productions in every respect, except that the "studio" is now a remote location: the plaza in front of city hall, the major sports stadium, or the senate chambers. Also, the event is not staged specifically for video (at least not obviously).

All big remotes use high-quality field cameras (studio cameras with special zoom lenses that can zoom from an extreme long shot to a tight close-up) and high-quality EFP cameras. All cameras are connected to the remote truck by cable.

The *remote truck* represents a compact studio control room and equipment room. It contains the following: an *image control center* with preview and line monitors; a switcher with special effects; a character generator; various intercom systems (P.L., P.A., and elaborate I.F.B. systems); an *audio control center* with a fairly large audio console, ATRs, monitor speakers and intercom systems; a *VTR center* with several high-quality VTRs that can handle regular recordings, do instant replays, and play in slow-motion and freeze-frame modes; and a *technical center* with CCUs, technical setup equipment, and patchbays for camera, audio, intercom, and light cables. **SEE 14.7**

Although remote trucks can draw power from available high-capacity electrical sources, most engineers prefer to use their own portable power generators. Because big remotes are often done live, remote trucks have various microwave transmission facilities that range from small links from camera to truck, to larger ones that transmit the signal from truck to transmitter. Some large trucks have their own satellite uplink; others connect to a special *uplink truck* if a direct satellite feed is necessary. In very big remotes, one or more additional trailers may be used for supplemental production and control equipment.

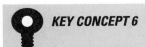

KEY CONCEPT 6 **Big remotes resemble multicamera studio shows, except that the event takes place outside the studio, and the control room is located in a truck.**

14.7

REMOTE TRUCK

The remote truck is a complete control center on wheels. It contains image, audio, lighting, and technical controls (CCUs, intercom) similar to a well-equipped studio control room and part of master control. It also contains a number of VTRs, character generators, and special-effects equipment.

COMPUTER-GENERATED SETTINGS

Not all environments are lens-generated (photographed by the video camera); they can be *synthetic*—electronically generated—as well.

You can create a great variety of backgrounds through the *chroma key* process. Just to refresh your memory, the chroma key process uses a specific color, usually blue, for the background into which various still or moving images can be keyed. The foreground action then appears to be playing in the keyed environment. **SEE COLOR PLATES 5 AND 6** Because you can use any photograph, videotape, or computer-generated effect as a chroma key source, your choices of background are almost unlimited.

Virtual Reality

Despite all the skills you might have acquired to adapt the real environment to your video needs, the computer offers you new alternatives. One of these is virtual reality. *Virtual reality* stands for an entirely synthetic, computer-generated environment. Computer programs can simulate anything from a Western street to a moon landscape.

Such a computer-generated visual environment can be used instead of elaborate studio sets or field locations. The computer can also animate the landscape or simulate motion through it. Depending on the program, you can also generate objects, animals, or even people, and place them in, or have them move through, this virtual environment. There are synthetic environments that appear three-dimensional, provided you wear special glasses when viewing the video screen.

Whether you have a two- or three-dimensional virtual display, you can key actors or performers into this environment and show them walking through it. When combining foreground action with a synthetic environment, you must pay special attention to the size relationships between foreground and background. Unless you want to achieve a special effect, your synthetic environment should fit the dimensions of the people keyed into it.

Interactive Virtual Reality

Virtual reality displays are called *interactive* when you, as the viewer, have some control over the display. For example, there are programs that produce from a floorplan the actual scenic environment. Once the virtual scenery is set up, you can then try out a number of color schemes and textures for the walls, doors, windows, and floor. For example, you may put in a blue rug by pressing a single computer control, change it to red or beige, and take it out again if you don't like it. You can also put virtual furniture into your set and dress it with various items. All you need to do is select the various items from a menu and drag them with the mouse into the desired positions. If you don't like what you have selected, simply erase the images and put in new ones.

An additional virtual reality program may let you light the set. A menu will offer you various lighting instruments which you can drag into the set and aim at the various portions of the virtual production environment. You can test various lighting setups until you are satisfied with the chosen illumination. Finally, you can then have a virtual camera move through this virtual space to show you just what shots you can get from various angles and lens settings. You can even generate little people to represent your talent and move them through this synthetic space.

Even if you do not use the virtual display as the "actual" environment for your production, such interactive virtual reality displays of various setups, colors, and camera and talent positions are an invaluable preproduction aid.

When combined with live action, such virtual environments can create startling effects. The availability of high-speed computers and high-capacity hard drives in nonlinear editing setups bring virtual reality environments closer to reality even for a relatively modest production company. All you need now is a thorough knowledge of video basics and plenty of imagination.

 KEY CONCEPT 7 **Synthetic environments are not lens-generated; they are computer-generated.**

Congratulations! You are now no longer a novice to video production, but are quite capable of using the video medium efficiently, effectively, and creatively. The Triple-I people should now be interested in you as a potential employee—and they are. They tell you that, when you read this book and get a little more practice, they would certainly consider you for full-time employment. The producer who always tells everybody "once again, remember," gives you a last bit of advice:

> You are now in command of a powerful means of communication and persuasion. Use it wisely and responsibly. Treat your viewers with respect and compassion, regardless of whether they are third-graders, the local university alumni association, bank employees, or a world-wide audience. Whatever role you play in the production process— pulling cables or directing a complex show—you influence your viewers. Because they cannot communicate back to you very readily, they must—and do—trust your professional skills and judgment. Do not betray this trust.

ONCE AGAIN, REMEMBER...

Field Production

All productions that happen outside the studio are called field productions, including ENG (electronic news gathering), EFP (electronic field production), and large remote telecasts.

Preproduction: Remote Survey

Remote surveys are necessary for all field productions except ENG. They will supply important information about such technical items as power availability, lighting, and sound requirements, and will give the director an idea of where to place the camera or cameras. Establishing a reliable contact person is an important aspect of preproduction.

Production: Field Activities

All equipment must be thoroughly checked before it is taken to the field. Respecting the people and their property used for the field production and minding all safety precautions are important as well. When shooting outdoors, changing weather conditions and random sounds are a constant hazard and must be carefully monitored.

Big Remotes

Big remotes are devoted to live or live-on-tape coverage of large scheduled events, such as parades, sports, and significant international events. Big remotes are coordinated from the remote truck, which houses a complete program control room, audio control, elaborate intercom facilities, videotape and video control sections, various other technical facilities, and transmission equipment.

Computer-Generated Settings

Environments can be electronically generated through the chroma key process and computer-generated backgrounds. Interactive virtual reality programs can create an entirely synthetic, computer-generated environment. These programs can also simulate certain production situations (camera positions, scenery colors, or lighting), which can be changed by the user in order to find the most effective one. Such a simulation is an important preproduction aid.

KEY CONCEPTS

- In field production, you must adapt to the environment.

- The remote survey is an essential preproduction activity.

- Prepare a checklist of all equipment items needed, and test all equipment before taking it to the remote location.

- After the production, make sure that you left the location the way you found it and that you brought back everything you took to the field.

- When shooting outdoors, watch the weather and background for shot continuity.

- Big remotes resemble multicamera studio shows, except that the event takes place outside the studio, and the control room is located in a truck.

- Synthetic environments are not lens-generated; they are computer-generated.

Selected Readings

Alten, Stanley R. *Audio in Media*. 4th ed. Belmont, Calif.: Wadsworth Publishing Co., 1994.

> An excellent, comprehensive, and practical introduction to audio principles and techniques, including audio for video production. Gives specific information on sound pickup, mixing, post-production, and the latest digital sound techniques.

Armer, Alan A. *Writing the Screenplay*. 2d ed. Belmont, Calif.: Wadsworth Publishing Co., 1993.

> A thorough and easy-to-read discussion of the writing processes for video and film, as well as such aspects as format, style, conflict, dialog, and the elements of entertainment. There are numerous helpful script samples.

Barr, Tony. *Acting for the Camera*. New York: HarperCollins, 1986.

> A thoughtful and practical treatment of how to perform in front of the camera and how to visualize dialog in various contexts. It is a must-read for talent and the video director.

Breyer, Richard, and Peter Moller. *Making Television Programs*. 2d ed. Prospects Heights, Ill.: Waveland Press, 1991.

> A practical approach to the basic processes of video production explained through the ways various production personnel deal with specific production problems.

Burrows, Thomas D., Donald N. Wood, and Lynne Schafer Gross. *Television Production*. 5th ed. Dubuque, Iowa: Wm. C. Brown Co., 1992.

> Covers basic equipment and techniques of television production.

Compesi, Ronald J., and Ronald E. Sherriffs. *Video Field Production and Editing*. 3d ed. Boston: Allyn & Bacon, 1994.

> Well-organized illustrated text on all major aspects of field production. Explains video field production tools and their optimal use.

Gayeski, Diane. *Corporate and Instructional Video*. 2d ed. Englewood Cliffs, N.J.: Prentice Hall, 1991.

> Surveys the processes and functions of nonbroadcast video.

Gross, Lynne S., and Larry W. Ward. *Electronic Moviemaking*. 2d ed. Belmont, Calif.: Wadsworth Publishing Co., 1994.

> Discusses in detail the common elements of film and single-camera video production. Written from a film production perspective, it shows how to transfer traditional film techniques to video production.

Hausman, Carl. *Institutional Video: Planning, Budgeting, Production, and Evaluation*. Belmont, Calif.: Wadsworth Publishing Co., 1991.

> A guide to the design and production of corporate and instructional video programs.

Holsinger, Erik. *MacWeek Guide to Desktop Video*. Emeryville, Calif.: Ziff-Davis Press, 1993.

> Combines easy-to-understand video and computer technology and how to use both for effective video productions. Discusses up-to-date hardware and software tools available for learning or improving video production. The computer discussion is entirely based on the Macintosh platform. Accompanied by a CD-ROM.

Hyde, Stuart. *Television and Radio Announcing*. 7th ed. Boston: Houghton Mifflin Co., 1995.

> Presents up-to-date information on performance techniques, voice and diction, and the proper use of American English on the air. Contains tips on effective announcing in specific programs, such as interviews, news, music, and sports.

Journal of Communication. Vol. 42, No. 4, 1992.

> Includes a variety of excellent articles on multimedia and virtual reality.

Kenney, Ritch, and Kevin Groome. *Television Camera Operation*. Burbank, Calif.: Tellem Publications, 1987.

> A helpful and practical discussion of how to handle studio and field cameras in various production situations. Discusses the subject from the point of view of a longtime, successful studio and field camera operator.

Lindheim, Richard D., and Richard A. Blum. *Inside Television Producing*. Boston: Focal Press, 1991.

> Gives an overview of what a television producer does; includes case histories.

Mathias, Harry, and Richard Patterson. *Electronic Cinematography: Achieving Photographic Control over the Video Image*. Belmont, Calif.: Wadsworth Publishing Co., 1985.

> An important technical treatise on how to achieve the "film look" with video. Includes such topics as how to read the waveform monitor and vectorscope.

Millerson, Gerald. *The Technique of Lighting for Film and Television*. 3d ed. Boston: Focal Press, 1991.

> Covers the technical aspects of lighting for television and film. Emphasis is on major studio productions.

Millerson, Gerald. *The Technique of Television Production*. 12th ed. Boston: Focal Press, 1990.

> Highly detailed reference to television equipment and primarily studio-based production processes. British orientation.

Morley, John. *Scriptwriting for High-Impact Videos: Imaginative Approaches to Delivering Factual Information*. Belmont, Calif.: Wadsworth Publishing Co., 1992.

> A practical guide to strategies and techniques for writing informative videos with flair.

O'Donnell, Lewis B., Carl Hausman, and Philip Benoit. *Announcing: Broadcast Communication Today*. 2d ed. Belmont, Calif.: Wadsworth Publishing Co., 1992.

> Covers the principles and practices of on-air announcing and performing; stresses the announcer-performer as a communicator. Includes a wealth of practice material.

Smith, David L. *Video Communication*. Belmont, Calif.: Wadsworth Publishing Co., 1991.

> An excellent treatment of how to organize instructional material for effective, goal-directed video programs. Shows how to structure content for video communication to achieve a precisely defined communication goal. Good sections on audience analysis.

Viera, Dave. *Lighting for Film and Electronic Cinematography*. Belmont, Calif.: Wadsworth Publishing Co., 1993.

> Covers basic principles for planning lighting setups for film and video, and offers "Lighting Analyses" for over sixty photos. Includes a section on electronic cinematography that applies film lighting concepts to video.

Whittaker, Ron. *Television Production*. Mountain View, Calif.: Mayfield Publishing Co., 1992.

> A detailed treatment of tools and technical aspects of television and video production.

Zettl, Herbert. *Television Production Handbook*. 5th ed. Belmont, Calif.: Wadsworth Publishing Co., 1992.

> A comprehensive treatment of television and video tools and production processes. Includes detailed chapters on production and directing.

Zettl, Herbert. *Sight Sound Motion: Applied Media Aesthetics*. 2d ed. Belmont, Calif.: Wadsworth Publishing Co., 1990.

> Detailed analysis of the major aesthetic image elements—light, space, time-motion, and sound—and how they are used in video and film.

Glossary

Note: For computer terminology, please see Table 7.8, pp. 161–163.

Above-the-Line Category for nontechnical personnel, such as producers, directors, and talent.

AB-Roll Editing Creating an edit master tape from two source VTRs, one containing the A-roll, and the other the B-roll. Transitions other than cuts, such as dissolves and wipes, are possible.

AC Stands for alternating current; electric energy as supplied by normal household outlets.

Actor A person who appears on-camera in dramatic roles. The actor always portrays someone else.

Actual Process Message The real effect of the program on the viewer.

AD Stands for associate or assistant director. Assists the director in all production phases.

Additive Primary Colors Red, green, and blue. Ordinary white light (sunlight) can be separated into the three primary light colors. When these three colored lights are combined in various proportions, all other colors can be reproduced.

Address Code An electronic signal that marks each frame with a specific address. See *SMPTE Time Code.*

Ad-lib Speech or action that has not been scripted or specially rehearsed.

AGC Stands for automatic gain control. Regulates the volume of the audio or video levels automatically, without using pots.

Ambience Background sounds.

Analog Signal that fluctuates smoothly and exactly like the original stimulus.

Analog Sound Recording Audio recording system in which the electrical sound signal fluctuates exactly like the original sound stimulus over its entire range.

Analog VTR System A videotape system that records the video signal in analog form.

Aperture Iris opening of a lens; usually measured in *f*-stops.

Arc To move the camera in a slightly curved dolly or truck.

Assemble Editing Adding shots on videotape in a consecutive order without first recording a control track on the edit master tape.

ATR Stands for audiotape recorder.

Attached Shadow Shadow that is on the object itself. It cannot be seen independently of (detached from) the object.

Audio The sound portion of video and its production. Technically, the electronic reproduction of audible sound.

Audio Track The area of the videotape used for recording the audio information.

Auto Iris Automatic control of the aperture (lens opening).

Background Light Illumination of the set pieces and backdrop. Also called *set light.*

Back Light Illumination from behind the subject and opposite the camera.

Barn Doors Metal flaps in front of a lighting instrument that control the spread of the light beam.

Baselight Even, nondirectional (diffused) light necessary for the camera to operate optimally. Refers to the overall light intensity.

Beam See *Electron Beam.*

Beam Splitter Optical device within the camera that splits the white light into three primary colors: red, green, and blue.

Below-the-Line Category for technical personnel, including such crew members as camera operators, floor persons, and audio engineers.

Betacam SP A high-quality ½-inch VTR format. Cannot be interfaced with other ½-inch VTR formats, such as VHS or SVHS.

Bidirectional The microphone can hear best from two opposite sides.

Big Remote A production outside the studio to televise live and/or record live-on-tape a large scheduled event that has not been staged specifically for television. Examples include sporting events, parades, political gatherings, or special hearings.

Blocking Carefully worked-out movement and actions by the talent and for all mobile video equipment used in a scene.

Boom (1) Audio: microphone support. (2) Video: part of a camera crane. (3) To move the camera via the boom.

Bump-Down Copying a videotape to a lower-quality tape format. Also called *dub-down.*

Bump-Up Copying a videotape to a higher-quality tape format. Also called *dub-up.*

Calibrate the Zoom Lens To preset a zoom lens to keep in focus throughout the zoom.

Camcorder A portable camera with the VTR either attached to it (ENG/EFP camcorder), or built into the camera (consumer camcorder).

Camera Chain The camera and associated electronic equipment, consisting of the power supply, the sync generator, and the CCU (camera control unit).

Camera Control Unit (CCU) Equipment, separate from the actual camera, that allows the VO (video operator) to adjust the color and brightness balance before and during the production.

Cam Head A camera mounting head that permits extremely smooth tilts and pans.

Cant Tilting the camera sideways.

Cap (1) Lens cap: a rubber or metal cap placed in front of the lens to protect it from light, dust, or physical damage. (2) Electronic device that eliminates the picture from the camera CCD.

Cardioid A unidirectional microphone pickup pattern.

Cart See *Cartridge.*

Cartridge An audiotape recording or playback device that uses tape cartridges. A cartridge is a plastic case containing an endless tape loop. Also called *tape cartridge,* or *cart* for short.

Cassette A plastic case containing tape that runs on two reels, a supply and a takeup reel. Used for audio and video recording and playback.

Cast Shadow Shadow that is produced by an object and thrown (cast) onto another surface. It can be independent of the object.

CCD Stands for charge-coupled device. An image-sensing element that translates the optical image into a video signal.

C-clamp A metal clamp with which lighting instruments are attached to the lighting batten.

CCU See *Camera Control Unit.*

CD Stands for compact disc. A small, shiny disc that contains audio and/or video information in digital form.

C.G. (Character Generator) A small computer dedicated to the creation of letters and numbers in various fonts. Its output can be directly integrated into analog video images.

Chroma Key Special key effect that uses color (usually blue) for the key source background. All blue areas are replaced by the base picture during the keying.

Clip Control Adjusts the luminance signal so that the title to be keyed appears sharp and clear.

Close-up (CU) Object or any part of it seen at close range and framed tightly. The close-up can be extreme (extreme or big close-up) or rather loose (medium close-up).

Closure Short for psychological closure.

Color Bars A color standard used in video production for the alignment of cameras and videotape recordings. Color bars can be generated by most professional portable cameras.

Color Temperature Relative reddishness or bluishness of light, as measured in Kelvin degrees. The norm for indoor video lighting is 3,200°K, for outdoors, 5,600°K.

Complexity Editing Building an intensified screen event from carefully selected and juxtaposed shots. Does not have to adhere to the continuity principles.

Component System Separating the Y and C components and treating the luminance and color as separate signals.

Sometimes refers to the separate treatment of the RGB color signals. Also called the *Y/C system* or the *Y/C component system*.

Composite System A system that combines the Y (black-and-white) and C (red, green, and blue) video information into a single signal. Also called *NTSC signal*.

Condenser Microphone High-quality, sensitive microphone for critical sound pickup. Used mostly indoors.

Contact Person A person who is familiar with, and who can facilitate access to, the remote location and key people. Also called *contact*.

Continuing Vectors Graphic vectors that extend each other, or index and motion vectors pointing and moving in the same direction.

Continuity Editing Assembling shots so that vector continuity is ensured.

Control Track The area of the videotape used for recording the synchronization information.

Converging Vectors Index and motion vectors that point toward each other.

Crane To move the boom of the camera crane up or down. Also called *boom*.

Cross-Shot (X/S) Similar to over-the-shoulder shot, except that the camera-near person is completely out of the shot.

CU See *Close-up*.

Cue Card A large hand-lettered card that contains copy, usually held next to the camera lens by floor personnel.

Cut (1) The instantaneous change from one shot (image) to another. (2) Director's signal to interrupt action (used during rehearsal).

Cutaway A shot of an object or event that is peripherally connected with the overall event and that is neutral as to screen direction. Used to intercut between two shots in which the screen direction is reversed.

Cyc See *Cyclorama*.

Cyclorama A U-shaped continuous piece of canvas or muslin for backing of scenery and action. Hardwall cycs are permanently installed in front of one or two of the studio walls. Also called *cyc*.

DAT Stands for digital audiotape.

DC Direct current.

Defined Process Message The desired effect of the program on the viewer.

Delegation Controls Controls that assign a specific function to a bus.

Depth of Field The area in which all objects, located at different distances from the camera, appear in focus. Depends primarily on the focal length of the lens, its *f*-stop, and the distance from the camera to the object.

Desktop Video The use of a desktop computer, such as a PC (DOS or Windows platform), Mac (Macintosh platform), or some other type, for a variety of pre-production and postproduction jobs.

Diffused Light Light that illuminates a relatively large area with an indistinct light beam. Diffused light, created by floodlights, produces soft shadows.

Digital Recording Audio or video recording systems that translate original analog information (sound and picture signals) into digital information.

Digital Video Effects (DVE) Video effects generated by a computer with high-capacity hard drives and special graphics software. The computer system dedicated to DVE is called a *graphics generator*.

Digital VTR System A videotape system that records the video and audio signals in digital form.

Dimmer A device that controls the intensity of light by throttling the electric current flowing to the lamp.

Directional Light Light that illuminates a relatively small area with a distinct light beam. Directional light, produced by spotlights, creates harsh, clearly defined shadows.

Diverging Vectors Index and motion vectors that point away from each other.

Dolly To move the camera toward (dolly in) or away from (dolly out) the object.

Downstream Keyer A control that allows the title to be keyed (cut in) over the picture (line-out signal) as it leaves the switcher.

Dress (1) What people wear on camera. (2) Dress rehearsal: final rehearsal with all facilities operating. The dress rehearsal is often videotaped. (3) Set dressing: set properties.

Drop Heavy curtain suspended from a track (usually in front of the cyc). A painted drop is a large piece of canvas with a background scene painted on it.

Dub The duplication of an electronic recording. The dub is always one generation away from the recording used for dubbing. In analog systems, each dub shows increased deterioration.

Dub-Down See *Bump-Down*.

Dub-Up See *Bump-Up*.

Dynamic Microphone A relatively rugged microphone. Good for outdoor use.

Edit Controller A machine that assists in various editing functions, such as marking edit-in and edit-out points, rolling source and record VTRs, and integrating effects. This is often a desktop computer with a specific software program. Also called *editing control unit*.

Editing Control Unit See *Edit Controller*.

EDL Stands for edit decision list. It consists of edit-in and edit-out cues, expressed in time code numbers, and the nature and transitions between shots.

EFP Stands for electronic field production. Video production done outside the studio that is usually shot for postproduction (not live).

Electron Beam A thin stream of electrons, generated by the electron gun in back of the video tube, which strikes the photosensitive color dots at the face of the tube.

ENG Stands for electronic news gathering. The use of portable camcorders, lights, and sound equipment for the unplanned production of daily news stories. ENG is usually done for live transmission or immediate postproduction.

ENG/EFP Camera Highly portable, self-contained electronic news gathering or electronic field production camera.

ESS System Stands for electronic still store system. Stores many still video frames in digital form for easy access.

Facilities Request Written communication that lists all facilities needed for a specific production.

Fade The gradual appearance of a picture from black (fade-in) or disappearance to black (fade-out).

Fader A volume control that works by sliding a button horizontally along a specific scale. Identical in function to a pot. Also called *slide fader*. See *Pot*.

Fader Bar A lever on the switcher that activates buses and can produce superimpositions, dissolves, fades, keys, and wipes of different speeds.

Falloff The speed (degree) with which a light picture portion turns into shadow areas. Fast falloff means that the light areas turn abruptly into shadow areas and there is a great difference in brightness between light and shadow areas. Slow falloff indicates a very gradual change from light to dark, and a minimal brightness difference between light and shadow areas.

Fast Lens A lens that permits a relatively great amount of light to pass through (low *f*-stop number). Can be used in low-lighting conditions.

Field One-half of a complete scanning cycle, with two fields necessary for one television picture frame. There are sixty fields per second, and thirty frames per second.

Field Log A record of each take during the videotaping.

Field of View The portion of a scene visible through a particular lens; its vista. Expressed in symbols, such as CU for close-up.

Field Production Any video production that happens outside the studio.

Fill Light Additional light on the opposite side of the camera from the key light to illuminate shadow areas and thereby reduce falloff. Usually done with floodlights.

Fishpole A suspension device for a microphone; the mic is attached to a pole and held over the scene for brief periods.

Flat A piece of standing scenery used as background or to simulate the walls of a room. There are hardwall and softwall flats.

Floodlight A lighting instrument that produces diffused light.

Floorplan A diagram of scenery, properties, and set dressings drawn on a grid.

Focal Length How much of a scene the lens can see and how magnified the distant object looks.

Foldback The return of the total or partial audio mix to the talent through headsets or I.F.B. channels.

Foot-candle The unit of measurement of illumination, or the amount of light that falls on an object. One foot-candle is the amount of light from a single candle that falls on a 1-square-foot area located 1 foot away from the light source. See *Lux*.

Formative Evaluation Assessment of each step during the entire production process.

Foundation A makeup base, normally done with water-soluble pancake makeup, that is applied with a sponge to the face and sometimes to all exposed skin areas. Pancake foundation reduces unwanted light reflection.

Frame A complete scanning cycle of the electron beam (two fields), which occurs every thirtieth second. It represents the smallest complete television picture unit.

Framestore Synchronizer Image stabilization and synchronization system that has a memory large enough to store and read out one complete video frame. Used to synchronize signals from a variety of video sources that are not locked to a common sync signal. Can also produce a limited number of digital effects.

Fresnel Spotlight One of the most common spotlights, named after the inventor of its lens, which has steplike concentric rings.

***f*-stop** The calibration on the lens indicating the aperture. The larger the *f*-stop number, the smaller the aperture; the smaller the *f*-stop number, the larger the aperture.

Gel Generic name for color filter put in front of spotlights or floodlights to give the light beam a specific hue. *Gel* comes from *gelatin*, the filter material used before the invention of much more heat- and moisture-resistant plastic material. Also called *color media*.

Generation The number of dubs away from the original recording. A first-generation dub is struck directly from the source tape. A second-generation tape is a dub of the first generation dub (two steps away from the original tape), and so forth. The greater the number of nondigital generations, the greater the loss of quality.

Graphics Generator A computer specially designed for creating a variety of images and colors. Also called *paint box*.

Hand Props Objects, called *properties*, that are handled by the performer or actor.

HDTV (high-definition television) Camera A special camera system that produces high-quality, high-resolution pictures.

Headroom The space left between the top of the head and the upper screen edge.

I.F.B. See *Interruptible Foldback or Interruptible Feedback*.

Incident Light Light that strikes the object directly from its source. To measure incident light, the light meter is pointed at the camera lens or into the lighting instruments.

Insert Editing Produces highly stable edit. Requires the prior "laying" of a continuous control track by recording black on it.

Instantaneous Editing Same as *switching*.

Interactive Video A computer-driven program that gives the viewer some control over what to see and how to see it. It is often used as a training device.

Intercom Short for intercommunication system. Used for all production and engineering personnel involved in the production of a show. The most widely used system has telephone headsets to facilitate voice communication on several wired or wireless channels. Includes other systems, such as I.F.B. and cellular telephones.

Interruptible Foldback or Interruptible Feedback (I.F.B) A prompting system that allows communication with the talent while on the air. A small earpiece worn by on-the-air talent that carries program sound (including the talent's voice) or instructions from the producer or director.

Iris Adjustable lens-opening mechanism. Also called *lens diaphragm*.

Jack A socket or receptacle for a connector.

Jib Arm A small camera crane that can usually be operated by the camera person.

Jogging Frame-by-frame advancement of videotape, resulting in a jerking motion.

Jump Cut An image that jumps slightly from one screen position to another during a cut.

Kelvin Degrees The standard scale for measuring color temperature, or the relative reddishness or bluishness contained in white light.

Key Analog electronic visual effect in which the base image replaces the dark or blue (or green) areas of the key source.

Key Light Principal source of illumination. Usually a spotlight.

Lavaliere A small microphone that is clipped onto clothing.

Leadroom The space left in front of a laterally moving object or person.

Lens Optical lens, essential for projecting an optical image of the scene onto the front surface of the camera imaging device. Lenses come in various fixed focal lengths or in a variable focal length (zoom lenses), and with various maximum apertures (lens openings).

Level (1) Audio: sound volume. (2) Video: video signal strength.

Lighting Triangle Same as *photographic principle*. The triangular arrangement of key, back, and fill lights. Also called *triangle lighting*.

Light Intensity The amount of light falling on an object that is seen by the lens. Measured in lux or foot-candles. Also called *light level*.

Light Level Light intensity measured in lux or foot-candles. See *Foot-candle* and *Lux*.

Light Plot A plan, similar to a floorplan, that shows the type, size (wattage), and location of the lighting instruments relative to the scene to be illuminated and the general direction of the light beams.

Linear Editing System Uses videotape as the recording medium. It does not allow random access of shots.

Line Monitor The monitor that shows only the line-out pictures that go on the air or on videotape.

Line-out The line that carries the final video or audio output.

Live-on-Tape The uninterrupted videotape recording of a live show for later unedited playback.

Location Sketch A rough, hand-drawn map of the locale for a remote telecast. For an indoor remote, the sketch shows the dimensions of the room and the locations of furniture and windows. For an outdoor remote, the sketch indicates the buildings and the location of the remote truck, power source, and the sun during the time of the telecast.

Location Survey Written assessment, usually in the form of a checklist, of the production requirements for a remote.

Long Shot (LS) Object seen from far away or framed very loosely. The extreme long shot shows the object from a great distance. Also called *establishing shot*.

Lumen The light intensity power of one candle (light source radiating in all directions).

Luminance The brightness (black-and-white) information of a video signal.

Luminance Channel A separate channel within color cameras that deals with brightness variations and allows color cameras to produce a signal receivable on a black-and-white television.

Lux European standard unit for measuring light intensity. One lux is the amount of 1 lumen (one candle-power of light) that falls on a surface of 1 square meter located 1 meter away from the light source. 10.75 lux = 1 foot-candle. Most lighting people figure roughly 10 lux = 1 candle.

Makeup Cosmetics used to enhance, correct, or change facial features.

Master Control Controls the program input, storage, and retrieval for on-the-air telecasts. Also oversees technical quality of all program material.

Matte Key Letters of a keyed title are filled with gray or a specific color through a third video source.

M/E Bus A single bus that can serve mix or effects functions.

Medium Requirements All personnel, equipment, and facilities needed for a production, as well as budgets, schedules, and the various production phases.

Medium Shot (MS) Object seen from a medium distance. Covers any framing between a long shot and a close-up.

Mental Map Tells us where things are or supposed to be on- and off-screen.

Mini Plug Tiny connector used for some consumer audio equipment.

Mix Bus Rows of buttons that permit the mixing of video sources, as in a dissolve or super. Major buses for on-the-air switching.

Mixing (1) Audio: combining two or more sounds in specific proportions (volume variations) as determined by the event (show) context. (2) Video: combining two shots as a dissolve or superimposition via the switcher.

Moiré Effect Color vibrations that occur when narrow, contrasting stripes of a design interfere with the scanning lines of the video system.

Monitor (1) Audio: speaker that carries the program sound independently of the line-out. (2) Video: high-quality video receiver used in the video studio and control rooms. Cannot receive broadcast signals.

Monochrome One color. In video it refers to a camera or monitor that produces a black-and-white picture.

Mounting Head A device that connects the camera to its support. Also called *pan and tilt head*.

Multimedia The simultaneous computer display of text, still and moving images, and sound. Usually recorded on CD-ROMs.

Narrow-Angle Lens Same as long-focal-length lens. Gives a narrow vista of a scene.

Noise (1) Audio: unwanted sounds that interfere with the intentional sounds, or unwanted hisses or hums inevitably generated by the electronics of the audio equipment. (2) Video: electronic interference that shows up as "snow."

Nonlinear Editing System Allows random access of shots. The video and audio information is stored in digital form on computer disks.

Nonlinear Storage System Storage of video and audio material in digital form on a hard drive or optical read/write disc. Each frame can be accessed by the computer independently of all others.

Noseroom The space left in front of a person looking or pointing toward the edge of the screen.

NTSC Stands for National Television System Committee. Normally designates the composite video signal, consisting of combined chroma information (red, green, and blue signals) and the luminance information (black-and-white signal).

Off-line Editing Refers to an editing process that will not produce an edit master tape. Equipment is used to produce a rough-cut or simply an edit decision list (EDL).

Omnidirectional The microphone can hear equally well from all directions.

On-line Editing Produces the final high-quality edit master tape. High-quality VTRs are used for on-line editing.

Over-the-Shoulder Shot (O/S) Camera looks over the camera-near person's shoulder (shoulder and back of head included in shot) at the other person.

PA Production assistant.

Pan Horizontal turning of the camera.

Pancake A makeup base, or foundation makeup, usually water-soluble and applied with a small sponge.

Patchbay A device that connects various inputs with specific outputs. Also called *patchboard*.

Pedestal To move the camera up or down via a studio pedestal.

Performer A person who appears on-camera in non-dramatic shows. The performer does not assume someone else's character.

Photographic Principle The triangular arrangement of key, back, and fill lights, with the back light opposite the camera and directly behind the object, and the key and fill lights on opposite sides of the camera and to the front and side of the object. Also called *triangle lighting*.

Pickup Device In a video camera, converts the optical image into electric energy, the video signal. Also called *imaging device*.

Pickup Pattern The territory around the microphone within which the mic can hear well.

P.L. Stands for private line or phone line. Major intercommunication device in video studios.

Polar Pattern The two-dimensional representation of the pickup pattern.

Pop Filter A bulblike attachment (either permanent or detachable) on the front of the microphone, which filters out sudden air blasts.

Postproduction Any production activity that occurs after the production. Usually refers to either videotape editing or audio sweetening.

Postproduction Editing The assembly of recorded material after the actual production, in contrast to instantaneous editing with the switcher.

Postproduction Team Normally consists of the video editor and, for complex productions, a sound designer who remixes the sound track.

Pot Short for *potentiometer*, a sound-volume control. See *Fader*.

Preproduction Preparation of all production details.

Preproduction Team Consists of people who plan the production. The preproduction team normally includes the producer, director, writer, art director, and technical supervisor or the TD. Large productions may include also a composer and a choreographer. In charge: producer.

Preroll To start a videotape and let it roll for a few seconds before it is put in the playback or record mode in order to give the electronic system time to stabilize.

Presetting the Zoom Lens To adjust a zoom lens to keep in focus throughout the zoom. Same as *calibrating a zoom*.

Preview Bus Rows of buttons that can direct an input to the preview monitor at the same time another video source is on the air.

Preview Monitor Any monitor that shows a video source, except for the line and off-the-air monitors.

Process Message The message actually received by the viewer in the process of watching a video program.

Producer Creator and organizer of video programs.

Production The actual activities in which an event is videotaped and/or televised.

Production Schedule A time line that lists the start times of major production events.

Production Switcher Switcher designed for instantaneous editing, located in the studio control room or remote truck.

Production Team Consists of a variety of nontechnical and technical people, such as producer and various assistants (associate producer and PA), the director and assistant (AD), and the talent and production crew. In charge: director.

Program Bus The bus (row of buttons) on the switcher, with inputs that are directly switched to the line-out.

Properties See *Props*.

Props Short for properties. Furniture and other objects used by talent and for set decoration.

Psychological Closure Mentally filling in missing visual information that will lead to a complete and stable configuration.

Pulse-Count System An address code that counts the control track pulses and translates this count into elapsed time and frame numbers.

RCA Phono Plug Small connector used for most consumer video and audio equipment.

Reflected Light Light that is bounced off the illuminated object. To measure reflected light, the light meter is pointed close to the object from the direction of the camera.

Remote A production of a large, scheduled event done for live transmission or live-on-tape recording.

Remote Survey An inspection of the remote location by key production and engineering persons so that they can plan for the setup and use of production equipment. Also called *site survey*.

Remote Truck The vehicle that carries the control room, audio control, VTR section, video control section, and transmission equipment.

RGB Stands for red, green, and blue video signals.

RGB System A system in which all three color signals are kept separate throughout the video recording process. Sometimes called *RGB component system*.

Ribbon Microphone High-quality, highly sensitive microphone for critical sound pickup. Produces warm sound.

S.A. Stands for studio address system. A public address loudspeaker system from the control room to the studio. Also called *studio talkback* or *P.A.* (public address) *system*.

Scanning The movement of the electron beam from left to right and from top to bottom on the television screen.

Scene Event details that form an organic unit, usually in a single place and time. A series of organically related shots that depict these event details.

Scenery Background flats and other pieces (windows, doors, pillars) that simulate a specific environment.

Scoop A scooplike floodlight.

Sequencing The control and structuring of a shot sequence.

Shot The video contained between transitions. Also called *take*.

Shot Sheet A list of every shot a particular camera has to get. It is attached to the camera to help the camera operator remember a shot sequence.

Shotgun Microphone A highly directional mic with a shotgunlike barrel for picking up sounds over a great distance.

Signal-to-Noise Ratio The relation of the strength of the desired signal to the accompanying electronic interference (the noise). A high signal-to-noise ratio is desirable (strong video or audio signal and weak noise).

Slant Track The video track that is recorded on the videotape in a slanted, diagonal way.

Slate (1) To identify, verbally or visually, each videotaped take. (2) A little blackboard or whiteboard upon which essential production information is written, such as the title of the show, date, and scene and take numbers. It is recorded at the beginning of each videotaped take.

Slow Lens A lens that permits a relatively small amount of light to pass through (high f-stop number). Can be used only in well-lighted areas.

SMPTE Stands for Society of Motion Picture and Television Engineers.

SMPTE Time Code A specially generated address code that marks each video frame with a specific number (hour, minute, second, frame of elapsed tape).

Sound Perspective People (or other sound-producing sources) sound farther away in long shots than in close-ups.

Source VTR The videotape recorder that supplies the various program segments to be edited by the record VTR.

Special-Effects Controls Buttons on a switcher that regulate special effects. They include buttons for various keys, wipe pattern selections, and digital video effects.

Spotlight A lighting instrument that produces directional, relatively undiffused light.

Storyboard A series of sketches of the key visualization points of an event, with the corresponding audio information given below each visualization.

Strike To remove certain objects; to remove scenery and equipment from the studio floor after the show.

Strip Light Several self-contained lamps arranged in a strip. Used mostly for illumination of the cyclorama. Also called *cyc light.*

Studio Camera Heavy, high-quality camera and zoom lens that cannot be maneuvered properly without the aid of a pedestal or some other type of camera mount.

Studio Control Room A room adjacent to the studio in which the director, producer, various production assistants, TD (technical director), audio engineer, and sometimes the LD (lighting director) perform their various production functions.

Studio Pedestal Heavy camera dolly that permits raising and lowering of the camera while on the air.

Studio Talkback A public address loudspeaker system from the control room to the studio. Also called *S.A.* (studio address) or *P.A.* (public address) *system.*

Summative Evaluation The final evaluation of the finished production.

Super Short for superimposition. The simultaneous overlay of two pictures on the same screen.

Sweep Curved piece of scenery, similar to a large pillar cut in half.

Sweetening The manipulation of recorded sound in postproduction.

Switcher (1) Production person who does the video switching (usually the technical director). (2) A panel with rows of buttons that allows the selection and assembly of various video sources through a variety of transition devices, and the creation of electronic special effects.

Switching A change from one video source to another during production with the aid of a switcher. A form of instantaneous editing.

Sync Electronic pulses that synchronize the scanning of various video equipment.

Sync Generator Part of the camera chain; produces electronic synchronization pulses.

Synthetic Environment Electronically generated settings, either through chroma key or computer.

Take The video contained between transitions. Also called *shot.*

Talent Collective name for all performers and actors who appear regularly in video.

Tally Light Red light on the camera and inside the camera viewfinder, indicating when the camera is on the air (switched to the line-out).

Tape Format See *Videotape Format.*

Telephoto Lens Gives a close-up view of an event relatively far away from the camera. Also called *long-focal-length,* or *narrow-angle, lens.*

Teleprompter A prompting device that projects the moving copy over the lens so that the talent can read it without losing eye contact with the viewer.

Threefold Three flats hinged together.

Tilt To point the camera up or down.

Time Base Corrector (TBC) An electronic accessory to videotape recorders that helps to make playbacks or transfers electronically stable. It keeps slightly differing scanning cycles in step.

Time Line A production schedule listing the start times of major production events.

Tongue To move the boom with the camera from left to right or right to left.

Triangle Lighting The triangular arrangement of key, back, and fill lights. Also called *photographic principle.*

Triaxial Cable Thin camera cable in which one central wire is surrounded by two concentric shields.

Tripod A three-legged camera mount.

Truck To move the camera laterally by means of a mobile camera mount. Also called *track.*

Twofold Two flats hinged together. Also called a *book.*

Two-Shot Framing of two people in a single shot.

Unidirectional The microphone can hear best from the front.

Uplink Truck Small truck that sends video and audio signals to a satellite.

Variable-Focal-Length Lens See *Zoom Lens.*

Vector A directional screen force. There are graphic, index, and motion vectors.

Vector Line An imaginary line created by extending converging index vectors, or the direction of a motion vector.

Video Leader Visual and auditory material that precedes any color videotape recording. Generally called *academy leader*.

Videotape Format Indicates the width and other characteristics of a videotape that fits a specific videotape recorder.

Video Track The area of the videotape used for recording the video information.

Viewfinder A small video monitor on a camera that displays the picture the camera generates.

Virtual Reality Computer-simulated environment with which the user can interact and that can change according to the user's commands.

Visualization Mentally converting a scene into a number of key video images. Such visualizations are necessary for drawing a storyboard.

Volume The relative intensity of the sound; its relative loudness.

VTR Log A record of each take on the source tapes.

VU Meter A volume-unit meter; measures volume units, the relative loudness of amplified sound.

White Balance The adjustments of the color circuits in the camera to produce a white color in lighting of various color temperatures (relative bluishness and reddishness of white light).

Wide-Angle Lens A short-focal-length lens that provides a large vista.

Window Dub A dub of the source tapes to a lower-quality tape format with the address code keyed into each frame.

Windscreen Acoustic foam rubber that is put over the microphone to cut down wind noise in outdoor use.

Wipe A transition in which one image seems to "wipe" off (replace) the other from the screen.

Wireless Microphone A system that sends audio signals over the air, rather than through microphone cables. The mic is attached to a small transmitter and the signals are received by a small receiver connected to the audio console or recording device.

XLR Connector A professional three-wire connector for audio cables.

Y/C The separate processing of the Y (luminance, black-and-white) and C (color, red-green-blue) signals. See *Component System*.

Z-axis Indicates screen depth. Extends from camera lens to horizon.

Zoom Lens Variable-focal-length lens. All video cameras are equipped with a zoom lens.

Zoom Range The degree to which the focal length can be changed from a wide shot to a close-up during a zoom. The zoom range is stated as a ratio, such as 10:1.

Zoom Ratio See *Zoom Range*.

Index

PHOTO CREDITS

AKG Acoustics, Inc.: 8.6
Ampex Corporation: 8.28
Angenieux Corporation of America: 5.22
Audio-Visual Center, San Francisco State
 University: 5.24
Beyerdynamic: 8.7, 8.20
Broadcast Microwave Service, Inc.: 14.4
Cinekinetic PYT, Ltd., Australia: 5.20, 5.21
Cooperative Media Group: 7.27, 7.28, 8.33,
 11.23, color plates 8, 9, 13, 14
Electro-Voice, Inc.: 8.4, 8.20
Expressly Portraits: 6.5
Fidelipac: 8.30
The Grass Valley Group, Inc.: 7.15, 11.5
Gotham Audio Corporation (Newmann): 8.5

Ideas to Images: color plate 7
Lara Hartley: 3.2, 3.9, 3.12, 3.16, 3.19, 3.20,
 4.1, 4.2, 4.8, 4.13, 4.14, 4.15, 4.16, 4.17,
 5.2, 7.10, 7.16 (right), 7.17 (bottom), 7.18,
 7.19 (center), 7.20, 7.21, 7.22, 7.24 (flip
 and spin), 8.9, 8.10, 8.11, 8.12, 8.23, 8.24,
 8.25, 8.31, 9.10, 12.1, 12.3, 13.7, 13.14
Ikegami Electronics (USA), Inc.: 3.13
Lewis Communications: 5.18
Lowel-Light Manufacturing, Inc.: 6.15,
 6.16, 6.21, 6.24
Larry Mannheimer: 3.8, 4.9, 4.10, 4.11,
 4.12, 4.21, 4.22, 4.23, 4.24, 5.3, 5.4, 5.5,
 5.6, 5.13, 6.3, 6.4, 6.6, 7.1, 7.2, 7.3, 7.4,
 7.6, 7.7, 7.16 (left), 8.32, 8.34, 9.9, 10.9,
 10.10, 10.11, 10.14, 10.15, 10.16, 10.17,
 10.18, 10.20, 10.23, 10.24, 10.26, 11.20

Matthews Studio Equipment: 5.8
MCI: 8.27
Miller Fluid Heads (USA), Inc.: 5.9
Mole-Richardson Co.: 6.13, 6.17, 6.18,
 6.19, 6.22, 6.23
Panasonic Communications: 9.7, 11.13
Professional Sound Corporation: 8.20
Steve Renick: 5.10, 5.11, 5.12, 5.23, 5.26,
 6.11, 12.2
Selco Products Company: 8:22
Sennheiser Electronic Corporation: 8.20
Shure Brothers Inc.: 8.20, 8.21
Sony Corporation (photo courtesy CRN):
 3.11
Sony Electronics Inc.: 3.17, 8.20

Stanton Video Services, Inc.: 5.19
Swintek Enterprises, Inc.: 8.19
Vinten Broadcast, Inc. (photos courtesy
 Gardner & Co., Inc.): 5.14, 5.16
Herbert Zettl: 3.5, 3.6, 3.7, 3.15, 3.21, 4.3,
 4.4, 4.5, 4.6, 4.7, 4.18, 4.20, 4.25, 4.26,
 4.28, 4.29, 4.30, 5.1, 5.7, 5.17, 5.25, 6.1,
 6.7, 6.8, 6.9, 6.10, 6.12, 6.14, 6.20, 6.25,
 6.27, 6.28, 6.29, 6.30, 7.9, 7.17 (top), 7.19
 (background), 7.23, 7.24 (tumble), 7.25,
 8.8, 8.13, 8.14, 8.15, 8.16, 8.18, 8.29, 10.1,
 10.2, 10.3, 10.4, 10.5, 10.6, 10.7, 10.8,
 10.12, 10.13, 10.22, 10.25, 11.12, 11.18,
 13.1, 13.3, 13.4, 13.6, 13.9, 13.11, 13.17,
 13.18, 13.19, 14.5, 14.6, color plates 5, 6
The storyboard (11.19) courtesy of Bob
 and Sharon Forward.